12007

12007

CHRISTIE'S PICTORIAL HISTORY
OF
# EUROPEAN POTTERY

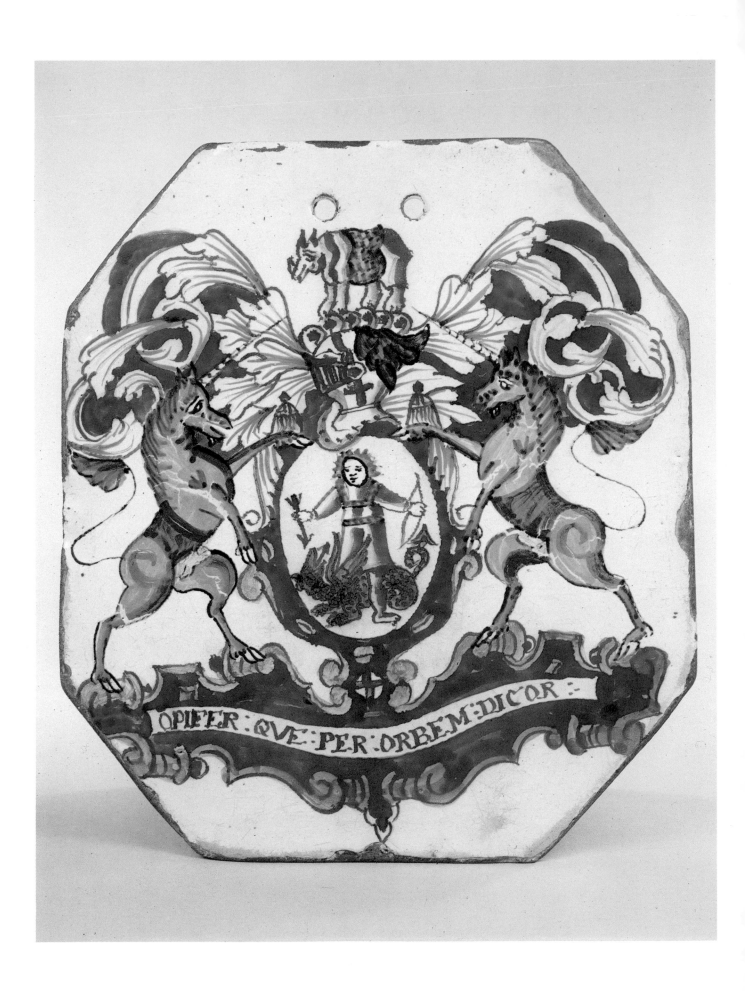

# CHRISTIE'S PICTORIAL HISTORY
## OF
# EUROPEAN POTTERY

## HUGO MORLEY-FLETCHER
### AND
## ROGER McILROY

PHAIDON · CHRISTIE'S

OXFORD

*Frontispiece:*
A London delft polychrome pill-slab
with the arms of the Society of Apothecaries, 1660-70
27.5 cm. high

Phaidon · Christie's Limited
Littlegate House, St Ebbe's Street, Oxford

First published 1984

British Library Cataloguing in Publication Data
Morley-Fletcher, Hugo
Christie's pictorial history of European pottery
1. Pottery, European—History
I. Title  II. McIlroy, Roger
738.3'094  NK4483

ISBN 0-7148-8009-4

Edited by Sandra Raphael

Design by Joanne McEwan
Logos Design & Advertising, Datchet, Berkshire

Printed in Great Britain by
Blantyre Printing & Binding Co. Ltd, Glasgow

# CONTENTS

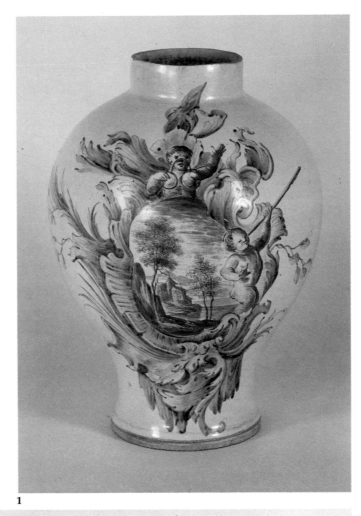

1

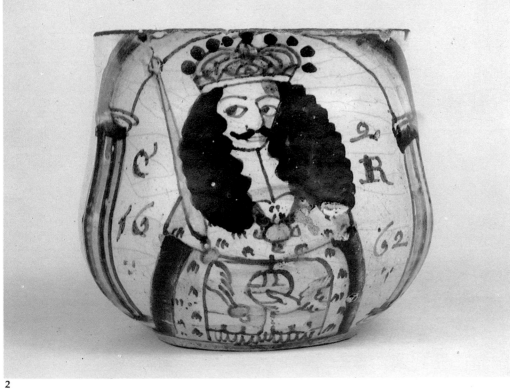

2

**1.** A Höchst faience vase painted by Ignaz Hess *en camaïeu rose*, green wheel mark and painter's mark E.H., circa 1750
24 cm. high
With Johann Zeschinger, Hess was the leading decorator of Höchst faience

**2.** A London delft polychrome Royalist caudle-cup with a portrait of Charles II in his coronation robes, flanked by the inscription CR2 and the date 1662
7.5 cm. high

**3.** A Dutch Delft blue and white plaque painted by Frederik van Frijtom, circa 1695
34 cm. x 26.5 cm.

# INTRODUCTION

The history of European pottery, as distinct from that of porcelain, has tended to be neglected. Many are the works which cover the activities of the porcelain manufacturers of the eighteenth and nineteenth centuries, but a general survey of the wide and varied output of the potteries of Europe from 1400 to 1800 is lacking.

The tin-glazed wares and their Islamic antecedents have been brilliantly discussed by Alan Caiger-Smith in *Tin-glaze Pottery*, but this of its nature does not deal with the stonewares, the sgraffito wares, the redwares, the earthenwares, and the creamwares with which the tin-glazed pieces co-existed and by which they were eventually to be supplanted.

At its outset, pottery in Europe was a purely functional material. Thanks to the impetus from the Islamic world,

pottery as an art-form entered south-western Europe and was gradually to progress via Italy into France and north-western Europe.

Till the arrival of Chinese and Japanese porcelain and the subsequent discovery of a similar European ware, pottery had of course no rival in the markets of Europe. It was essential to the poor and an object of luxury and admiration for the rich, and this imposed on it a somewhat stratified history in which the needs of varying societies and social classes were to be satisfied in differing ways by different solutions to the same basic problems.

There is constantly a very narrow distinction between pottery that is useful and beautiful and pottery that is too beautiful to use. Examples of the latter are to be seen in the grand *istoriato* chargers of Renaissance Italy, in the

**1.**  A berettino armorial dish of
Casa Pirota type, circa 1530
29 cm. diam.

**2.**  A Rouen helmet-shaped ewer
(*hanap*), 1700-1720
28.5 cm. high

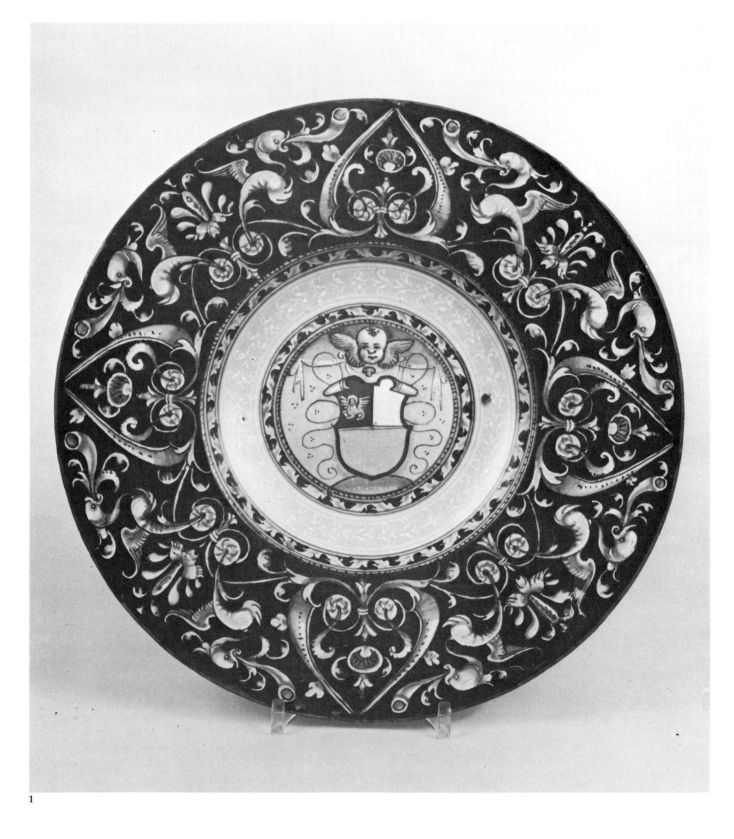

1

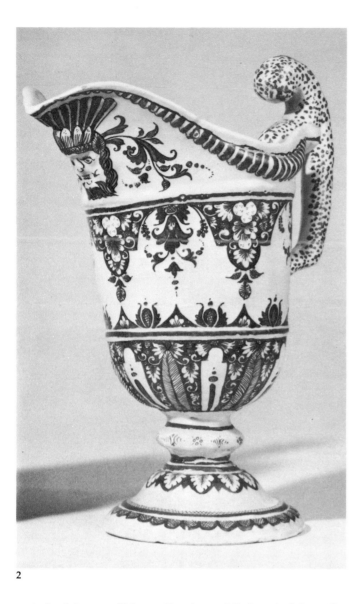

2

*petit feu* faience of Veuve Perrin and Robert in Marseilles and the Delft potters circa 1750. The albarello from Valencia through Italy to France and the Netherlands remains, however, a robust and efficient container which possesses also a simple and pure beauty of form. Its shape is Islamic in origin but its name is a curious linguistic phenomenon. It started as an Arabic corruption of the Venetian word *baril* into *albaril* and this was duly readopted in Italy as *albarello*. This pure simplicity is visible also in the drinking vessels of Germany, both in stoneware and faience, and in that most English of objects, the earthenware teapot, which throughout the eighteenth century was to afford a constantly varied series of solutions to these questions of aesthetic and practical requirements.

It would have been simple to reproduce one thousand objects in pottery from the leading museums of the world. These would depict the absolute cream of the European potters' art. Sadly, they would also represent that which is beyond the reach of today's collector. Everything illustrated here has been available within the

last fifteen years or so, in one of Christie's auctions in London, Geneva, Rome, Amsterdam, or New York. It has thus been, during this period, within the reach, if not the financial compass, of the buying public.

The resultant spectrum is, of course, not a perfect one: there are many types of object we would dearly love to have sold, and thus to be able to illustrate. However, it does mirror the kind of pieces that have been available and though what appears on the market is dependent on the whims, finances, and lifespan of collectors and their descendants, it reflects the kinds of pieces an aspiring collector may hope still to find.

Auction catalogues by their nature tend not to illustrate pieces of relatively small commercial value, and this imposes a limitation on the range of items illustrated here. Despite the large number of pieces and types you will find reproduced here, we do not lay claim to a monopoly of pottery sales! Much of equal interest is sold elsewhere: the range of pieces will, however, still be much the same.

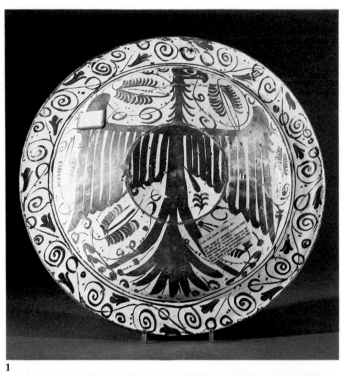

**1 and 1A.** A Hispano-Moresque gold and copper-lustre armorial dish, Valencia, early 15th century
44.8 cm. diam.
This dish forms part of a group, all with coats of arms and displayed eagles on the reverse. The British Museum example bears the arms of the Counts of Ribagorza and Prades. The painting on the front of this dish is apparently by the same hand

1

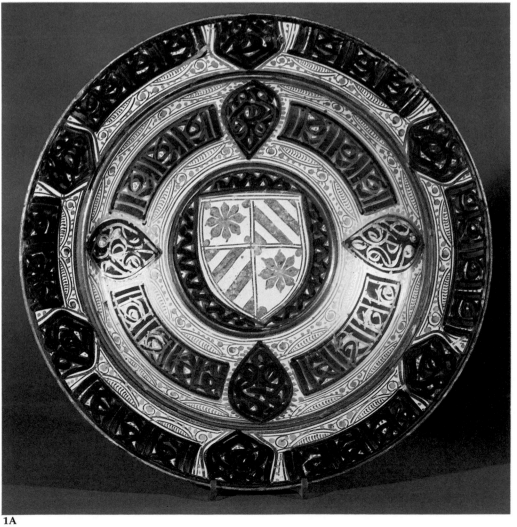

1A

# SPAIN AND PORTUGAL

The Moorish occupation of Spain is the ultimate source of inspiration and technical skills which were to lead to the flowering of maiolica, faience, and delft throughout the continent of Europe. It is easy to forget how long the Moors remained in possession of Spain, for they had a significant presence there from the seventh century till the fall of their last kingdom, Granada, in 1492. With them, the Moors brought the arts and skills of the Islamic world: there grew up an artistic tradition generally called Hispano-Moresque, which was a subtle blend of the Islamic and the Spanish.

The major centres of Moorish power were along the southern seaboard. Their potteries began to produce wares which, while reflecting many of the forms and techniques developed in the eastern Mediterranean, were blending these with local tastes and requirements to produce the first great pottery of western Europe.

The massive "Alhambra vases" were made around 1300 A.D., destined to stand in the great palace of that name in Granada. Of enormous proportions and decorated all over with felicitous inscriptions, these tall winged vases were almost certainly made without any practical purpose in mind. They came from the kilns at Malaga, then the dominant pottery centre.

By the beginning of the fifteenth century, the major centres of production had moved away north-east towards Valencia and into Catalonia. Here there were Moors living and working in the Christian kingdom of Aragon. At Manises and around Barcelona, pottery was produced throughout the fifteenth century in lustre, both copper-coloured and golden, combined with a skilful use of blue. This was a direct continuation of techniques already evolved at Malaga in the preceding century.

At first the shapes and designs were plain and strong. The balance between the lustre and the blue was perfect and the relationship between the designs and the forms on which they were deployed was subtle and splendid. The most magnificent pieces were generally dishes, centred on coats of arms or the sacred trigram I.H.S., painted with radiating bands of vine or bryony leaves in lustre and blue. Similar decoration is to be found on albarelli, storage jars of Islamic origin. This cleverly designed and practical shape, waisted so that a single jar could be grasped from a row, was the ancestor of many thousands of similar jars throughout Europe. Many armorial pieces exist with identifiable Italian arms and it is clear that there was considerable traffic in lustre wares between both the kingdom of Naples, which was ruled throughout the fifteenth century by the kings of Aragon, and Tuscany. The great lustred dishes of this era were decorated not merely on the front; their reverses were also painted in lustre with imperial eagles and foliage. Many of them were pierced for suspension before they were fired or glazed and it is clear from this alone that they were items intended purely for display. These were expensive pieces made for the rich. The number made can never have been enormous: very few have survived outside permanent collections.

After the middle of the century, an element of plasticity began to creep in. The plain surface of the ware was now incised with foliage or moulded with central bosses and spirally gadrooned borders, echoing contemporary brass dishes. The aesthetic content of the ware was hardly enhanced by this step. The Catherine-wheel dish, with its raised radiating spokes inspired by the arms of Navarre, is the most successful product of the period.

Apart from the armorials and the foliage, a wide range of decorative motifs of Islamic and Christian origin was used. Sometimes the potter had so far lost sight of the original meaning of an inscription that he reduced it to nonsense while still preserving an aesthetically satisfactory pattern. As time went by the decoration became more diffuse and much less precise.

Hispano-Moresque lustre wares reached their peak around the second quarter of the fifteenth century and then died away gradually over the next hundred and fifty years, finally killed by anti-Islamic sentiment during the Counter-reformation.

Puento del Arzobispo, Talavera, Thania, and Toledo were all to produce wares in the seventeenth and eighteenth centuries more reminiscent of Italian white-ground *compendiario* wares than of their native lustre forerunners. The Puento pieces, painted in manganese, iron-red, and blue with strong stylized foliage are the most successful.

Portugal did not have a distinctive native style of its own. Although there was from an early date an extensive production of tiles, the sole really interesting pottery was that at Rato, which also produced tureens in animal form. Portugal was a major market for Chinese export wares and the Rato pottery clearly reflects their influence.

Alcora, in eastern Spain, is almost a French faience that happened by a geographical accident to be in Spain. The most important figure involved was Joseph Olerys, although his Spanish sojourn was but a formative interlude before his work at Moustiers.

After its early splendours, the pottery of Spain became rather a backwater, but the initial impetus that the Hispano-Moresque potters provided was to have results down many centuries and across the whole continent.

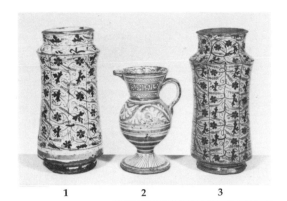

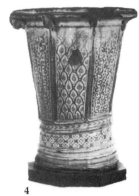

1. An albarello, third quarter of the 15th century
29 cm. high

2. A gold-lustre ewer, late 15th century
21 cm. high

3. An albarello, third quarter of the 15th century
29 cm. high

4. A pale blue and gold-lustre neck from an Alhambra vase, circa 1460
39.5 cm. high

5. A cylindrical albarello, circa 1480
28 cm. high

6. An armorial blue and gold-lustre albarello, late 15th century
31 cm. high

7. An albarello, 16th century
25 cm. high

8. A cylindrical albarello, 16th century
28 cm. high

9. A dish, the reverse with MOAAB mark, early 15th century
35 cm. diam.

10. A four-handled blue and copper-lustre vase, late 15th century
28.5 cm. high

11. An armorial gold-lustre dish, late 15th century
47.6 cm. diam.

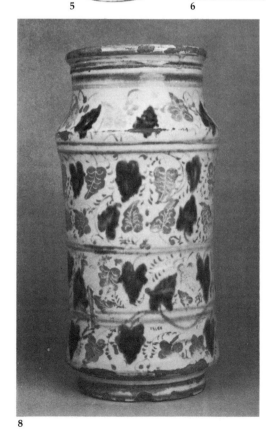

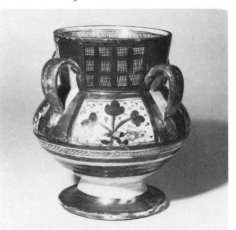

**12.** A copper-lustre dish, early 16th century
39 cm. diam.

**13.** A copper-lustre cwer, late 16th century
33 cm. diam.

**14.** A copper-lustre dish, late 15th century
39 cm. high

**15.** Two berrettino ground albarelli, 16th century
30 cm. high

**16.** A blue and white Catalan albarello, 17th century
32 cm. diam.

**17.** A blue and gold-lustre waisted albarello, 15th century
29 cm. high

**18.** A blue and copper-lustre waisted albarello, Valencia, 15th century
29 cm. high

**19 and 19A.** A gold-lustre dish, Manises, 15th century
41.6 cm. diam.

**20.** A copper-lustre armorial dish, late 15th century
47.5 cm. diam.

**21.** A copper-lustre armorial dish, late 15th century
48 cm. diam.

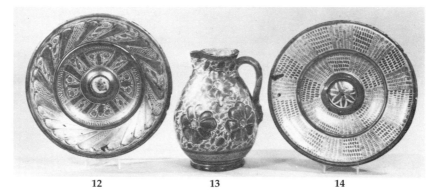

12    13    14

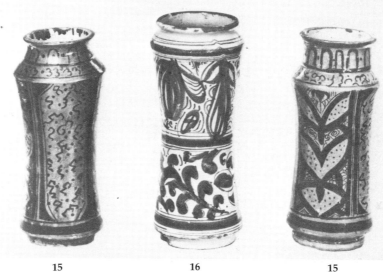

15    16    15

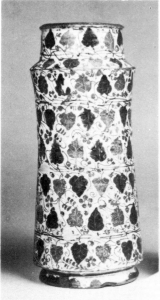

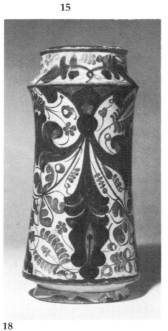

19    19A

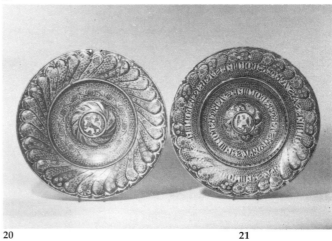

17    18    20    21

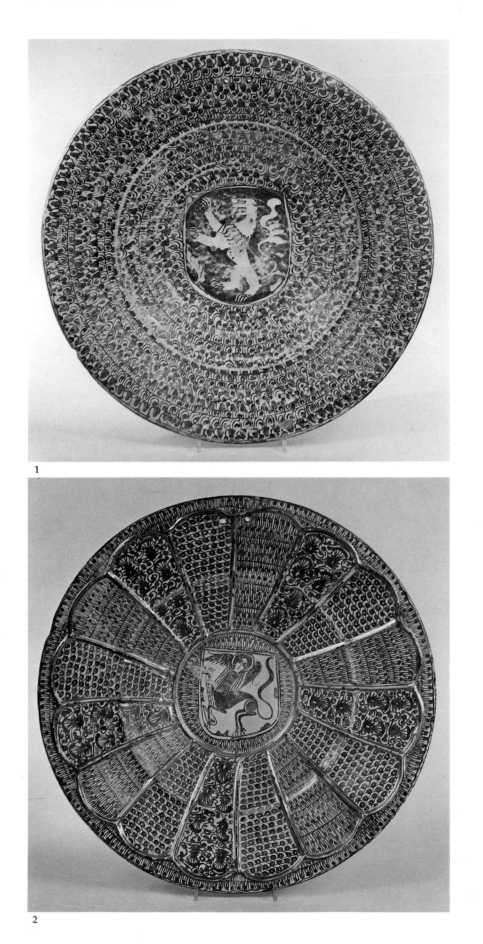

**1.** A pale copper-lustre armorial dish, late 15th century
42.5 cm. diam.

**2.** A gold lustre armorial Catherine-wheel dish, circa 1480. 46.5 cm. diam.
Although dishes of this type are not uncommon, very few are recorded with differing grounds within the spokes.

**3.** A massive blue-ground jardinière, 16th century
51 cm. diam. 54 cm. high

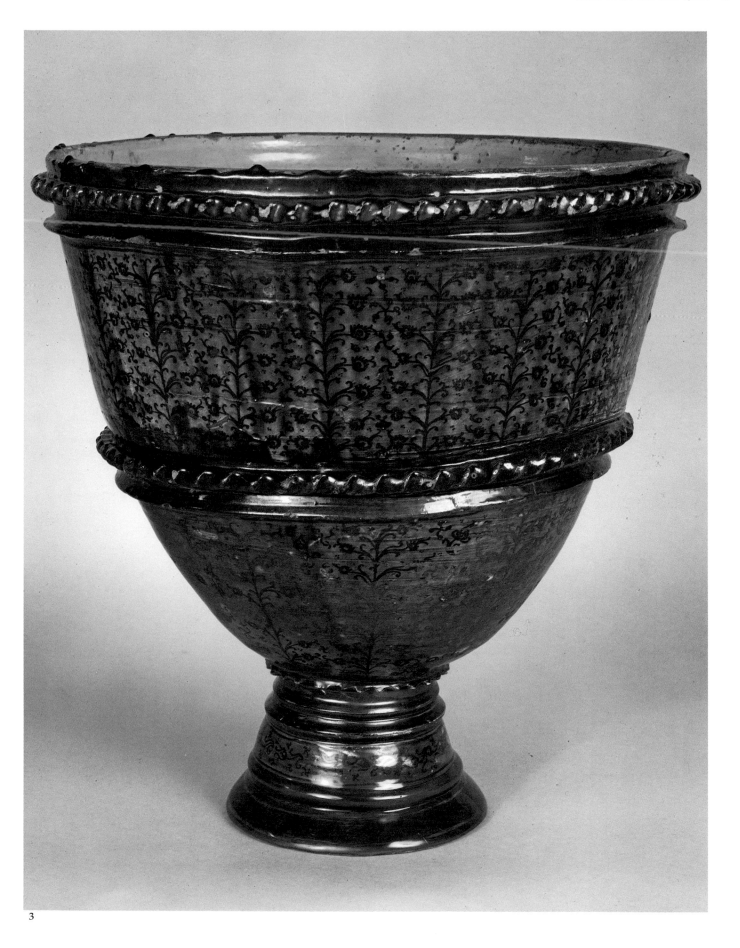

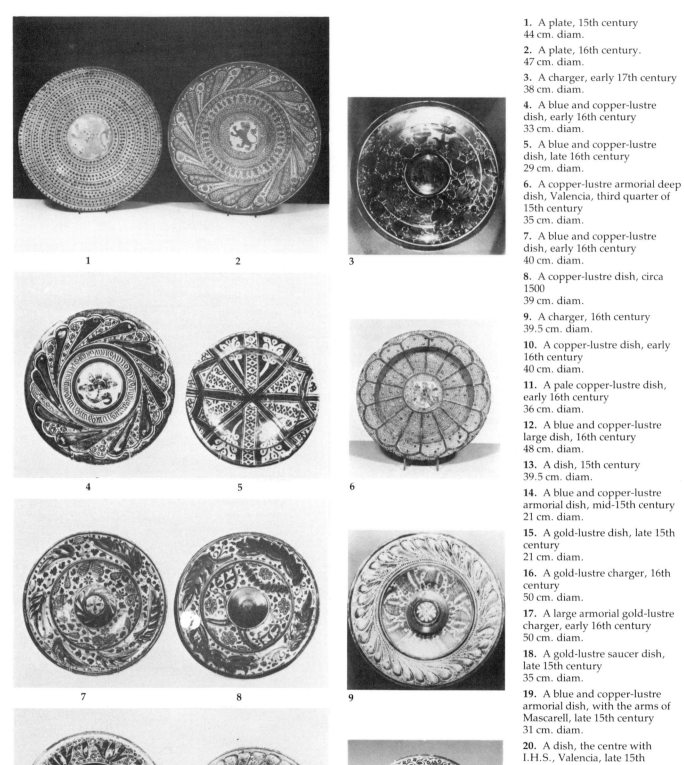

**1.** A plate, 15th century
44 cm. diam.

**2.** A plate, 16th century.
47 cm. diam.

**3.** A charger, early 17th century
38 cm. diam.

**4.** A blue and copper-lustre dish, early 16th century
33 cm. diam.

**5.** A blue and copper-lustre dish, late 16th century
29 cm. diam.

**6.** A copper-lustre armorial deep dish, Valencia, third quarter of 15th century
35 cm. diam.

**7.** A blue and copper-lustre dish, early 16th century
40 cm. diam.

**8.** A copper-lustre dish, circa 1500
39 cm. diam.

**9.** A charger, 16th century
39.5 cm. diam.

**10.** A copper-lustre dish, early 16th century
40 cm. diam.

**11.** A pale copper-lustre dish, early 16th century
36 cm. diam.

**12.** A blue and copper-lustre large dish, 16th century
48 cm. diam.

**13.** A dish, 15th century
39.5 cm. diam.

**14.** A blue and copper-lustre armorial dish, mid-15th century
21 cm. diam.

**15.** A gold-lustre dish, late 15th century
21 cm. diam.

**16.** A gold-lustre charger, 16th century
50 cm. diam.

**17.** A large armorial gold-lustre charger, early 16th century
50 cm. diam.

**18.** A gold-lustre saucer dish, late 15th century
35 cm. diam.

**19.** A blue and copper-lustre armorial dish, with the arms of Mascarell, late 15th century
31 cm. diam.

**20.** A dish, the centre with I.H.S., Valencia, late 15th century
46 cm. diam.

**21.** A copper-lustre dish, late 15th century
24 cm. diam.

**22.** A dish, late 16th century
39.5 cm. diam.

**23.** A dish, 16th century
37 cm. diam.

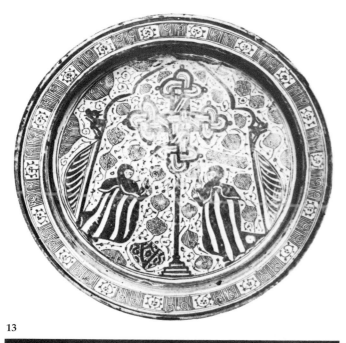

13

14                          15

16                          17

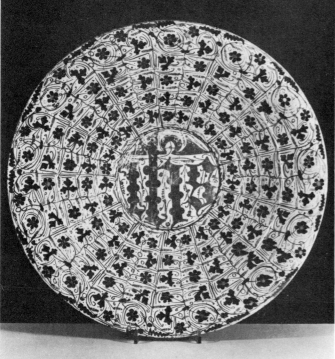

20

18                          19

21

22                          23

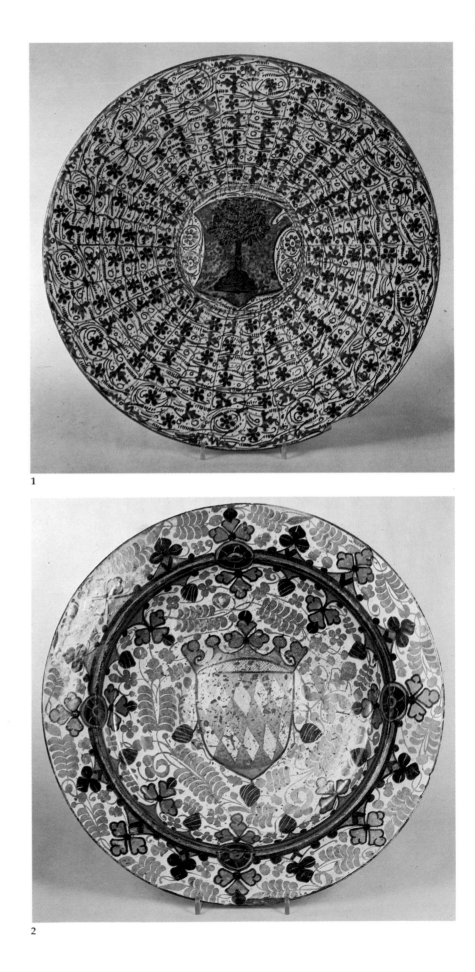

1

2

**1.** A blue and copper-lustre armorial dish, circa 1440
46 cm. diam.

**2.** A blue and copper-lustre armorial dish, 1430-1440
44 cm. diam.
The arms are apparently those of Wittelsbach, though a similar lozengy coat was borne by the Grimaldi of Genoa

**3 and 3A.** An armorial blue and gold-lustre dish with the coat of arms of Cardinal Despuig, second quarter of 15th century
46 cm. diam.
The eagle on the reverse of this piece appears to indicate Valencian origin, whilst the pattern of diapering may have been brought from the potteries of Malaga

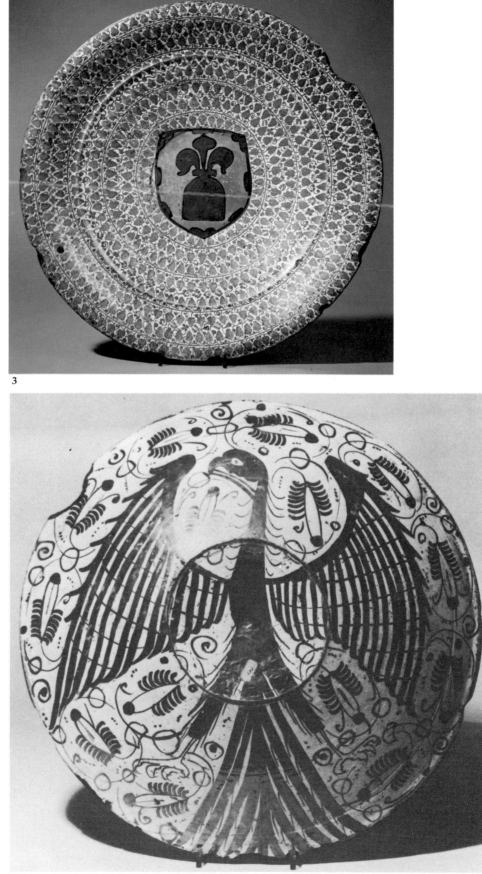

3

3A

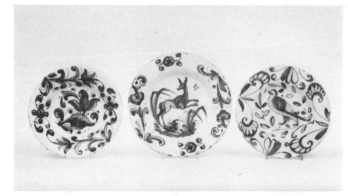

1        2        3

4        5        6

7

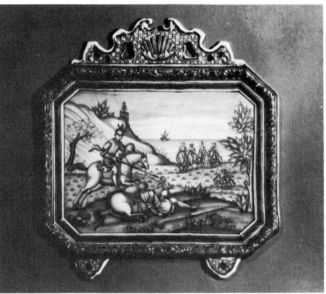

8

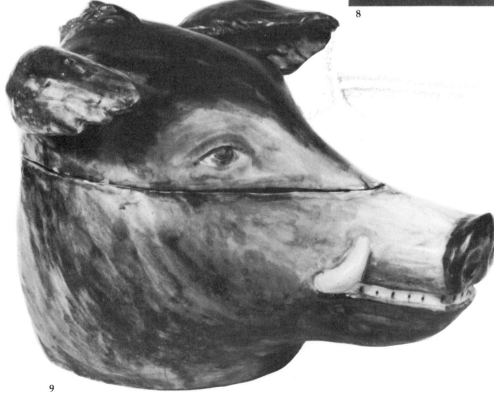

9

**1.** A Puento del Arzobispo plate, circa 1650
22.5 cm. diam.

**2.** A Puento del Arzobispo plate, circa 1650
25 cm. diam.

**3.** A Puento del Arzobispo plate, circa 1650
22 cm. diam.

**4.** A Puento del Arzobispo plate, circa 1650
22 cm. diam.

**5.** A Puento del Arzobispo dish, circa 1650
34.5 cm. diam.

**6.** A Puento del Arzobispo dish, circa 1650
22 cm. diam.

**7.** A Talavera bowl, mid 17th century
54 cm. diam.
The hunting subjects are after engravings from drawings by Johannes Stradanus, published at Antwerp in 1578, entitled *Venationes, Ferarum , Avium, Piscium.*

10

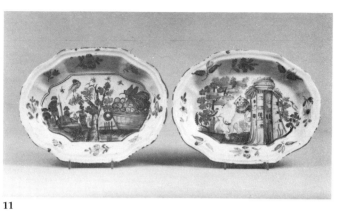

11

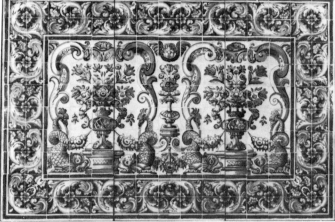

12

13

**8.** An Alcora blue and white plaque, circa 1730
28 cm. x 29 cm.

**9.** A Portuguese (Rato) boar's head tureen and cover, marked F.R. over TB monogram in blue, circa 1770
36 cm. long

**10.** A Talavera armorial plate with the arms of King Philip V of Spain, 18th century
23.5 cm. diam.

**11.** A pair of Spanish shaped oval dishes, circa 1740
23.5 cm. wide

**12.** A Portuguese blue and white tile picture, 18th century
148 cm. x 221 cm. overall

**13.** A Talavera deep circular bowl, 18th century.
39 cm. diam.

**14.** A Rato goose tureen and cover after a Chinese export original, the interior marked FRPB in blue, the base inscribed number 750, circa 1770
37 cm. high

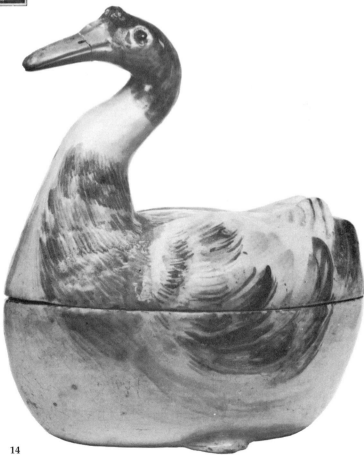

14

**1.** A large Urbino istoriato dish with recessed centre painted by Nicola Pellipario, circa 1528
42 cm. diam.
The subject is derived from the print by Giovanni da Brescia after the Raphael fresco in the Logge

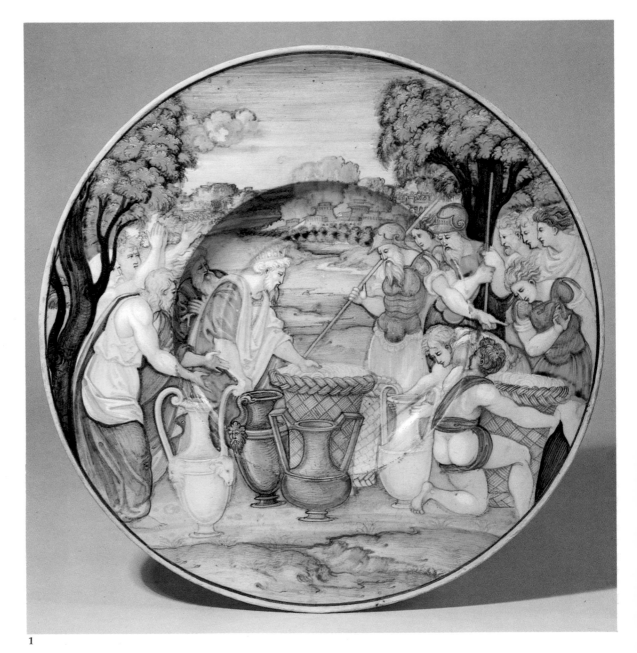

1

# ITALY PRE-1600

The Black Death, which decimated the population of mediaeval Europe in the fifteenth century, had an equally disastrous effect on the pottery of the day. Owing to an unfounded belief that the contagion of the disease was transmitted by the pottery vessels in daily use, these were cast down wells or otherwise destroyed on a massive scale. As a result very little pottery of the period has survived intact, which is probably not such a great loss as it might appear, since the making of pottery as an art-form seems to coincide with the onset of the fifteenth century. This is partly due to social and intellectual factors, which were to combine to produce the early Renaissance, and partly to technical developments that enlarged the range of colours at the potters' command.

The basic colours available were purple and turquoise green, derived from manganese oxide and copper and relatively easily obtainable everywhere. These were used to paint simple stylized motifs on basically useful objects such as jugs and small dishes. Among the centres producing wares of this type were Orvieto, Perugia, and many of the towns of southern Tuscany. In central Tuscany, in the area surrounding Florence itself, cobalt blue was added to the palette by the early 1420s and this factor was to have a dynamic effect on the range of decoration possible. In addition, Florence, the great mercantile centre of Italy, with contacts in Spain, the Low Countries and, via Venice, with the middle and extreme Orient, was open to all sorts of currents of influence both technical and artistic.

Initially the decoration in blue was still enclosed in manganese outlines. However, the Florentine potters developed great skill in a system of double glazes – *doppio ingobbio* or *doppia coperta*. These, while producing a very white ground colour, also enabled the potter to build up thick and rich effects in the coloured blue glaze.

One of the first major exponents of this technique and perhaps the finest was Giunta di Tugio di Giunta. Although his father, Tugio di Giunta, active between 1369 and his death in the summer of 1419, was obviously a successful potter, Giunta is probably the earliest Italian potter to whom we can ascribe existing pieces of maiolica with confidence. In this we are assisted by the wealth of records surviving in Florence and by the emblems and marks on surviving examples. Thus, on 20 July 1431 he is recorded as having supplied vases for the new *farmacia* at the hospital of S. Maria Nuova. There exist several two-handled drug jars with a crutch (the emblem of the hospital) on the handle and an asterisk below and with otherwise classic, but superb, *a zaffera* or raised cobalt decoration. These can be identified with the delivery of vases for the hospital. The asterisk mark below the handle occurs on other pieces of the period, painted with oak-leaves (they are often called "oak-leaf" jars), animals, and heraldic or religious symbols, which can thus be given to the same master.

Not all the potters of the day had the skill of Giunta, nor did the *a zaffera* decoration remain at its best for more than twenty years before it became pale and diluted in its effect. Its demise ushered in the *stile severo* or *stile gotico* which was to dominate the output of the second half of the century. A richer chromatic scale of yellow, blue, green, orange, and purple was deployed on albarelli, waisted cylindrical drug jars, a shape derived from the potters of Islam, and on dishes. Although ostensibly functional objects, these were conceived as works of art and contemporary paintings and prints show maiolica dishes and vases used as objects of display arranged on the tops of chests (*cassoni*) and sideboards in the houses of the prosperous.

The principal decorative elements now included rich stylized foliage scrolls of a Gothic flavour and other formal motifs, many of them inspired by the Hispano-Moresque wares that were being imported by the Medici court. The central fields of the dishes were filled with figure subjects that echoed contemporary developments in painting and wood-cuts. Faenza joined Florence as a major centre and produced, among other motifs, splendid arrangements of peacock feathers in a rich tonality. It is frequently much easier to be precise about the date of pieces of maiolica of this period than to be certain whether they were made in Florence or Faenza. This confusion applies to an even greater extent to the production of maiolica in the sixteenth century. Many potteries now sprang up in Deruta, Siena, Gubbio, throughout the Duchy of Urbino at such places as Urbino, Casteldurante, Rimini, Pesaro and Forli, and at Venice in the north-east. Not merely were their products produced in a similar style, as was natural, but many of the potters and more particularly the decorators were extremely mobile and tended to work at more than one place in the course of their careers. Fortunately we know a great deal about the workings of the Italian potteries at this time because Cipriano Piccolpasso (1524-1579) left us an invaluable record of them in his *Li tre libri dell'arte del vasaio* which he wrote between 1556 and 1559. In it he set out both the techniques and the decorative styles at the command of the members of his craft.

The early sixteenth century saw the emergence of distinct artistic personalities, some of whom signed their work and may be considered major artists. This is partly a

by-product of another development: the tendency to use the whole surface of the maiolica dish, jug, albarello, or vase  (but most particularly the dish) as a "canvas" for a picture. This tradition probably started at the Caffaggiolo pottery, under the patronage of the Medici, just outside Florence. Here the Fattorini family worked and one of their number, Jacopo, was almost certainly responsible for dishes depicting scenes from contemporary life, from papal processsions to the maioloica painter displaying his skill to two visitors in his studio. Caffaggiolo also produced some remarkable blue and white wares, the recessed centres with a ship or other motif and the borders with decorative strapwork and trophies. In these pieces, which are usually fully marked, the rich cream Tuscan *ingobbio* is to be seen at its best. They are among the first reflections in Italian maiolica of the porcelains of the Orient and go a long way towards mimicking their superficial appearance.

Contemporary with Fattorini were Giovanni Maria and Maestro Benedetto, working in Casteldurante and Siena respectively. Giovanni (or Zoan Maria as he signed himself) was another exponent of painted decoration covering the entire surface of the dish, but he specialized in what Piccolpasso calls *a candelieri* decoration, with symmetrical arrangements of caryatids, amorini, and trophies reserved on a blue ground. His masterpiece with the arms of Pope Julius II is signed and dated to the day (12 September 1508). Maestro Benedetto's workshop is known for its albarelli in particular, decorated with grotesques and caryatids in blue and white on orange grounds. Sometimes they have a rather uncomfortable-looking handle set on one side. Drug jars were produced in the same palette but can easily and justifiably be confused with contemporary pieces from Deruta and Montelupo, near Florence.

Giovanni Maria's successor, and probably pupil, was the outstanding maiolica painter of his day, Nicola Pellipario. He was the first and greatest exponent of the "istoriato style" in which the entire surface of the dish was painted with a religious or mythological subject. He painted two large and splendid services for the Ridolfi family and for Isabella d'Este, Duchess of Mantua, and a third series of armorial wares for an as yet unidentified client. His early work has a Renaissance serenity and calm and is frequently combined with skilful use of white enamel on the white ground – bianco-sopra-bianco. Pellipario is also credited with portrait dishes or *coppe amatorie* of great beauty. He did not remain in Casteldurante, but moved in the late 1520s to Urbino where his son, Guido Durantino, had a workshop (*bottega*). It is not clear whether Guido was a painter or merely a potter, but there are pieces signed by Nicola in his son's workshop. The late 1520s and 1530s saw another major artist at work in Urbino, Francesco Xanto Avelli da Rovigo, who must rank next after Pellipario as an istoriato painter. His outstanding achievement was the armorial service he decorated for the Papal Gonfaloniere, Pier Maria Pucci, in 1532.

All istoriato painting derives eventually from engraved originals. Sometimes these are difficult to trace because the scale of the original differs from that of the subject of the maiolica. On other occasions large compositions were created by the maiolica painters using elements from a variety of engraved sources, skilfully adapted and set in a landscape of their own invention.

Guido Durantino's sons, Francesco and Orazio Fontana, maintained a workshop in Urbino until well into the second half of the century. Its most distinguished product was the Punic War service executed between 1565 and 1571 for Guidobaldo II, Duke of Urbino. This service consisted both of istoriato wares of the usual sort and a new development, wares with istoriato panels and borders of *grottesche*. These arabesque and cameo motifs were inspired by Etruscan and Roman wall paintings which were being excavated in holes in the ground or *grotti*. This type of decoration was continued until the end of the century by the Patanazzi family.

The artists named represent, of course, the pinnacles of their craft. Working around them in and around Urbino, at Pesaro and Rimini, Forli, and elsewhere were a large number of maiolica painters of varying standards of competence. Though some of these painters' work may be classed together there are many who, like early

1. An Orvieto moulded jug, first quarter of 15th century
15.2 cm. high

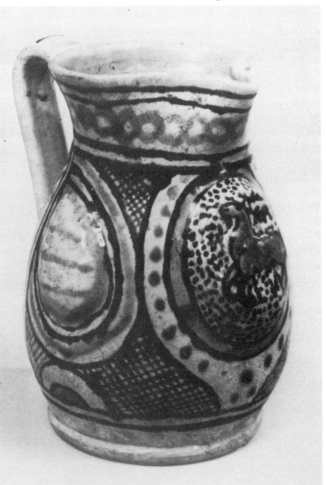

1

Renaissance artists, are described by sobriquets derived from key pieces they produced, such as the Zenobia painter in Pesaro, and "Mazo", a painter who may have worked either in the Urbino area or in Venice. The opinion of scholars is divided.

The istoriato style was not confined to Urbino, for there were also distinguished exponents of the technique elsewhere, notably in Faenza, Venice, and Verona. As a general rule it is much easier to date pieces of this class than to give them a specific place of origin.

At Faenza two types of maiolica were produced, apparently peculiar to the area. The first and most important of these are the wares with pale blue or *berrettino* ground, on which a darker blue predominates with yellow, orange, green, ochre, and white used in the panel subjects. There has been a tendency in the past to ascribe all the wares of this type to a single master, but current scholarship now takes a more cautious view. The major Faenza pieces of this type have splendid decoration on the reverse as well.

The second significant class of Faenza maiolica was ware with *a quartieri* decoration. This emerged around 1535 and continued in production for the next forty years. The principal exponent of this type of decoration seems to have been Virgiliotto Calamelli who operated a workshop from 1531 onwards, though he also produced istoriato wares. Both dishes and drug jars were entirely covered in formal shaped panels reserved in alternating colours. This fashion was to be transferred to Palermo and gave rise to a whole Sicilian tradition of wares in this style.

In southern Umbria, centred on workshops in Gubbio, the third major theme in Italian maiolica had its homeland. Here the influence of the lustre wares of Moorish Spain had its greatest impact. From the beginning of the sixteenth century until 1540 the Deruta potters produced large dishes and vases decorated in a golden lustre and blue with portraits of pretty girls and helmeted men, often with sage mottoes on vertical scrolling ribbons to one side. These chargers, which are thickly potted, have plain lead-glazed backs. The centre subjects include St. Francis of Assisi, St. Thomas, the Madonna and Child, the Angel of the Annunciation, and other religious and mythological themes. Heraldry appears too, both as simple coats of arms and with sphinxes and other beasts. Some of the subjects found in

blue and lustre recur on dishes with polychrome decoration, though generally these are less successful than the lustre ware. The most attractive class of polychrome dish has a turquoise chain-pattern border. Deruta also produced dishes painted with formal patterns which at their most successful were extremely beautiful. At Gubbio a few miles to the north a lustre workshop was set up by Giorgio di Pietro Andreoli under the protection of the Duke of Urbino. Maestro Giorgio and his sons Maestro Cencio and Maestro Ubaldi were to produce a particularly rich ruby lustre which was applied not merely to the wares potted in the town but also to pieces sent in from Urbino and Casteldurante for lustre to be added to polychrome decoration.

The wares of Gubbio are thinly potted, perhaps the most delicate of the period. The majority of them have their decorative elements moulded in relief, a technique otherwise sparsely used in the potteries of the day. The central motif may be religious, amatory, or purely formal: the borders are moulded with scrolls, pine-cones, or other themes.

From the student's point of view, however, the most interesting wares are those decorated elsewhere and then lustred in Gubbio.

These include pieces in which the original polychrome decoration left spaces for the lustre and pieces where the lustre was applied almost at random to the existing polychrome decoration. In many instances the reverse is signed *Mo Go da* (or *in*) *Ugubi* (Gubbio) with the date. Examples exist which are dated to the very day, but these, of course, are rare. The precise dating refers to the original polychrome decoration, be it by Xanto, Pellipario, or from Faenza.

The last major sixteenth-century centre of maiolica production was Venice. A clearly distinguishable production started here around 1540, apart from a whole range of istoriato wares which are hard to distinguish from the lesser ones of the Duchy of Urbino. Peculiar to Venice are pieces decorated in white enamel on blue with fantastic landscapes and, the classic output of the city, gobular jars and cylindrical albarelli painted with portrait heads and full-length figures of saints in yellow medallions on blue grounds reserved with fruiting foliage and scratched with scrolls in white. This type of maiolica was to be extensively imitated throughout Sicily in the following centuries.

1. A tondino fragment from the centre of a Faenza dish, last quarter of 15th century
11.5 cm. diam.

2. A Tuscan famiglia gotica armorial jar for the Neapolitan market, painted with the arms of Alfonso, Duke of Calabria, eldest son of Ferrante I, King of Naples; probably Faenza, circa 1480
30 cm. high
The arms are those of Aragon quartering Jerusalem

3. A Tuscan famiglia gotica portrait jug, circa 1460
34 cm. high

4. A Florentine famiglia gotica two-handled albarello, second half of 15th century
19 cm. high

5. A Faenza famiglia gotica large albarello, circa 1480
34 cm. high

6. A Faenza famiglia gotica albarello, last quarter of 15th century
31 cm. high

7. An early Florentine oak-leaf jar, circa 1435
20.5 cm. high

1

2

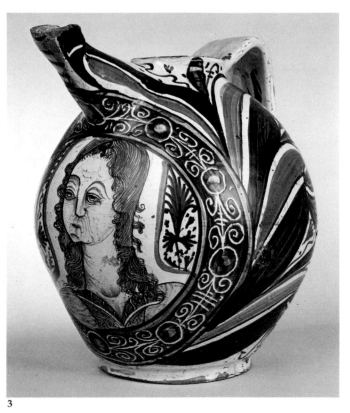

3

4

5 6

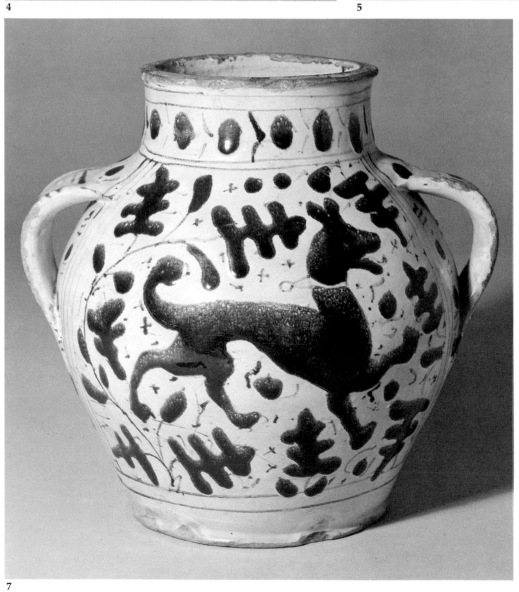

7

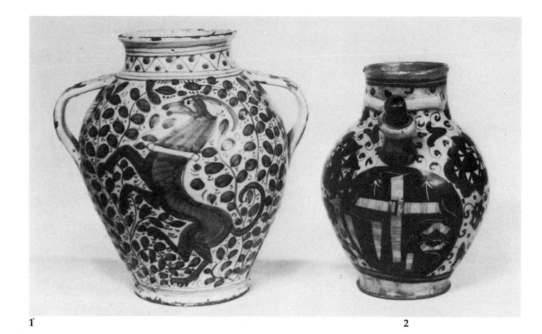

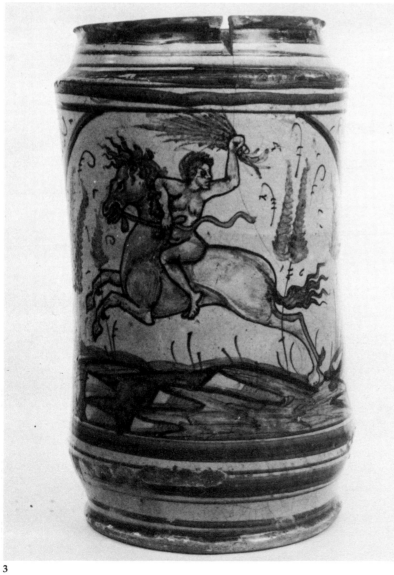

**1.** A Tuscan two-handled oak-leaf jar, the initials TB above the handles, late 15th century
27 cm. high

**2.** A Caffaggiolo wet-drug jar, circa 1550
22.5 cm. high

**3.** A Tuscan large famiglia gotica albarello, circa 1500
35.5 cm. high

**4.** A two-handled scodella, circa 1435, probably Faenza
11.4 cm. diam.

1

2

4

3

5

6

7

8

**5.** A Faenza famiglia gotica
peacock-pattern dish, circa 1480
39 cm. diam.

**6.** A Florentine waisted
albarello, late 15th century
18 cm. high

**7.** A Florentine armorial
albarello, circa 1450
17.5 cm. high

**8.** An early Florentine oak-leaf
jar painted with the emblem of
the city of Florence, circa 1440
24 cm. high

**1.** A documented Florence two-handled jar supplied to the Hospital of Santa Maria Nuova, workshop of Giunta di Tugio, 1431
20 cm. high
The hospital received massive deliveries of maiolica in 1431 from Giunta di Tugio. Though records of the number of pieces delivered survive, there are no further details of the order

**2.** A Faenza famiglia gotica albarello, last quarter of 15th century
30 cm. high

**3.** A Tuscan albarello, last quarter of 15th century
30 cm. high

1

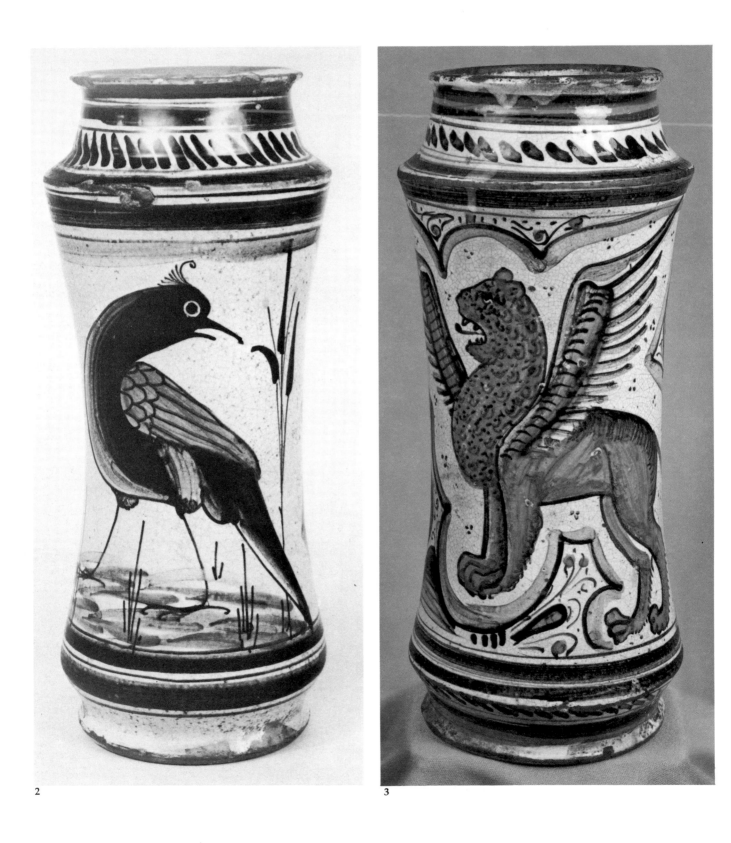

2

3

**1.** A Bologna jug incised with a coat of arms, circa 1500
25 cm. high
Though this jug has many of the characteristics of Pavia wares of this type, the papal connection makes it far more likely to be of Bolognese origin, since Bologna was the centre of the northern papal dominions. The only pope to whom this could refer is Alexander VI (Borgia) who ascended the throne of St. Peter in 1492 and died in 1503, though the arms appear to be those of his successor Julius II (della Rovere)

**2.** An Emilian jug, circa 1500
19 cm. high

**3.** A Bologna jug, circa 1480
21 cm. high

**4.** A jug, perhaps Emilian, 16th century
17 cm. high

**5.** A Bologna flask, 15th century
17 cm. high

**6.** A Bologna albarello, circa 1480
20.5 cm. high

**7.** A pilgrim flask, probably Tuscan, circa 1510
20 cm. high

**8.** A Bologna armorial saucer-dish, circa 1540
38 cm. diam.

**9.** A Tuscan dish, 16th century
26 cm. diam.

**10.** An Emilian dish, 17th century
41.5 cm. diam.

**11.** An Emilian dish, 17th century
44 cm. diam.

**12.** An Emilian dish, first half of 16th century
44 cm. diam.

**13.** An Emilian dish, 17th century
45 cm. diam.

**14.** A Bologna dish, circa 1500
39 cm. diam.

**15.** A Bologna armorial dish, circa 1480
43.5 cm. diam.

**16.** An Umbrian armorial dish, 1520-1530
26 cm. diam.

**17.** A Bologna dish, circa 1500
25 cm. diam.

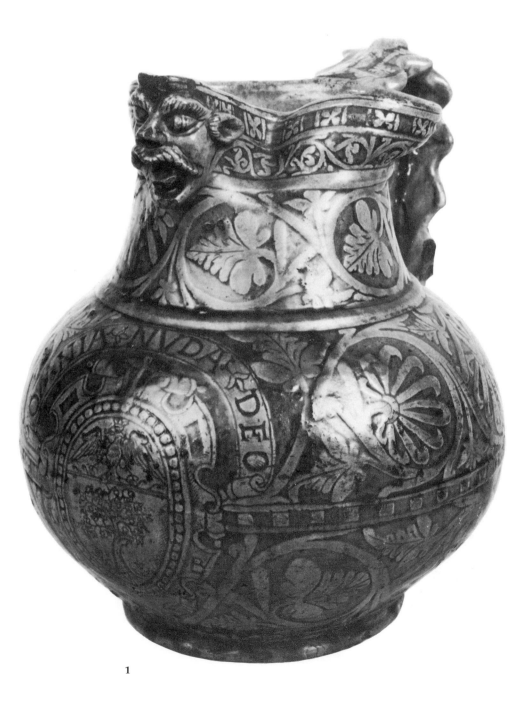

1

2   3   4   5   6   7

8   9

10   11   12   13

14   15   16   17

1

2

3

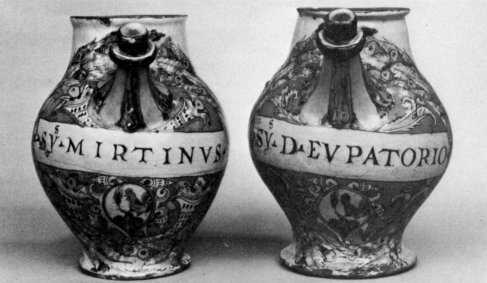

4

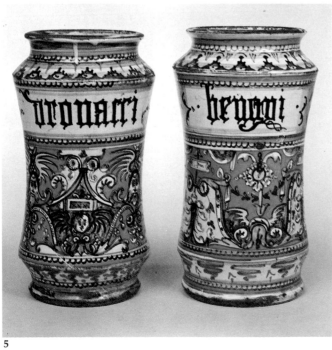

5

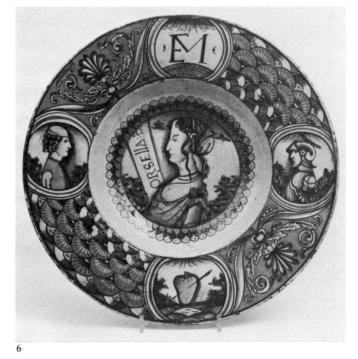

6

**1.** An armorial wet-drug jar, circa 1520
23.5 cm. high

**2.** Two waisted albarelli from the workshop of Maestro Benedetto, circa 1515
21 cm. high

**3.** An armorial wet-drug jar, circa 1520
22.5 cm. high

**4.** A pair of wet-drug jars, 16th century
20.5 cm. high

**5.** Two albarelli painted in the workshop of Maestro Benedetto, circa 1520
24 cm. high

**6.** A coppa amatoria, circa 1505
37.5 cm. diam.

**7.** A large albarello painted by Maestro Benedetto, the reverse with the date 1501 in blue
31 cm. high

7

1

2

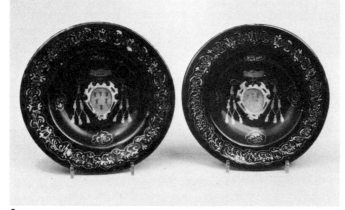

3

4

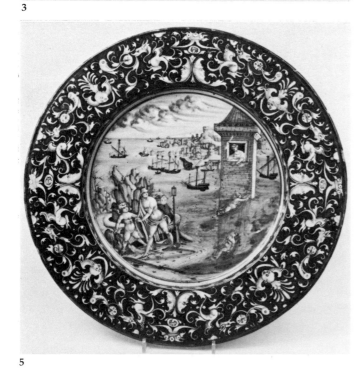

5

6

7

**1.** A berrettino ground istoriato saucer dish, painted by Il Maestro Verde, circa 1520
19.5 cm. diam.

**2.** An albarello, circa 1545
15.5 cm. high

**3.** A pair of berrettino plates, with the arms of Cardinal Farnese, early 17th century, possibly Faenza
23.5 cm. diam.

**4.** An Italian maiolica plaque, possibly Faenza or Caffaggiolo, 1500-1520
42 cm. x 32 cm.

**5.** A large Casa Pirota dish with berrettino ground, the centre painted by Il Maestro Verde, circa 1525
44 cm. diam.

**6.** A plate, circa 1520
24 cm. diam.

**7.** A Casa Pirota berrettino dish, the reverse with blue saltire within a circle, circa 1525
27.5 cm. diam.

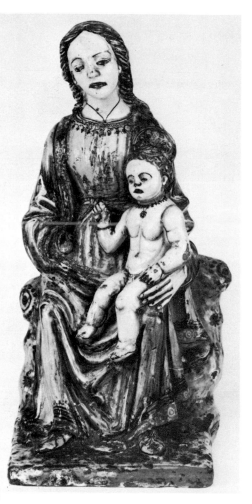

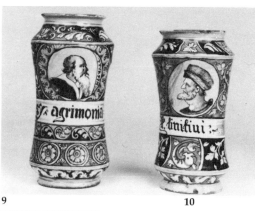

9                          10

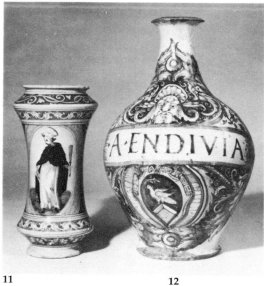

11                          12

13

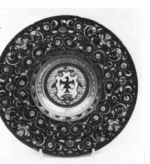

15

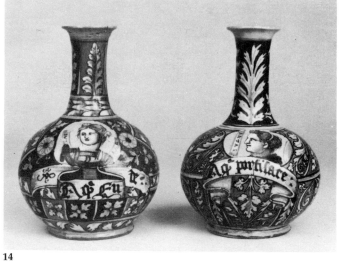

14

8                          11                          12

8.  A group of the Madonna and Child, most probably Faenza, first half of 16th century
40.5 cm. high

9.  An a quartieri albarello, circa 1550
26.5 cm. high

10.  An a quartieri albarello, circa 1550
25.5 cm. high

11.  An albarello, workshop of Virgiliotto Calamelli, circa 1550
29.5 cm. high

12.  An armorial drug jar, early 17th century
42 cm. high

13.  A Casa Pirota dark berrettino ground dish, circa 1530
20 cm. diam.

14.  Two a quartieri pharmacy bottles, circa 1545
23 cm. high

15.  A Casa Pirota armorial berrettino ground dish, circa 1530
25 cm. diam.

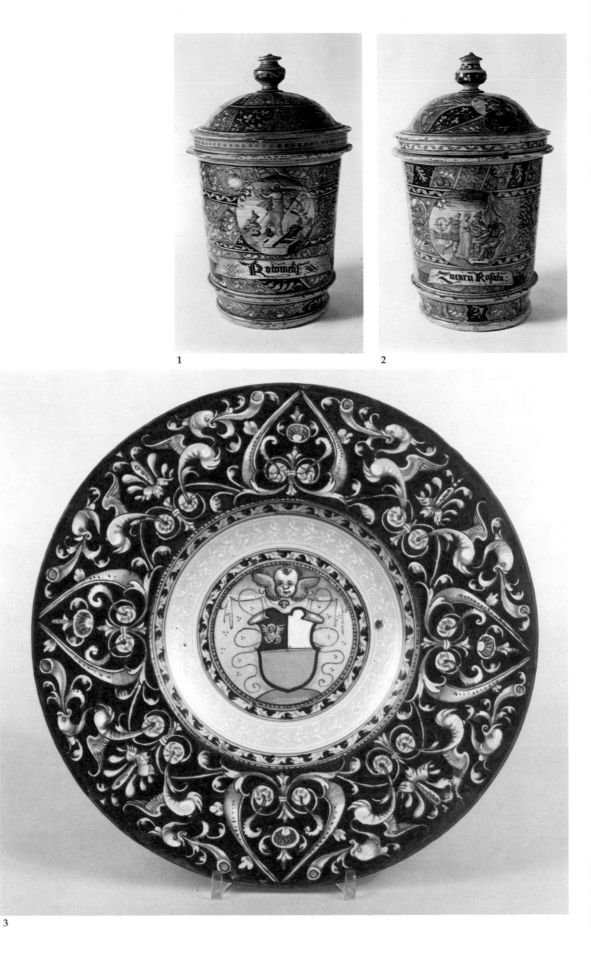

1

2

3

4

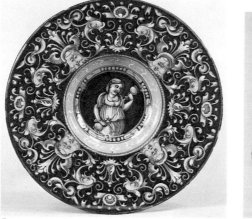

5

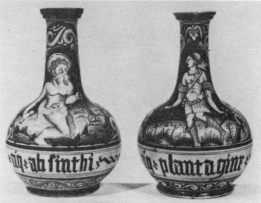

6

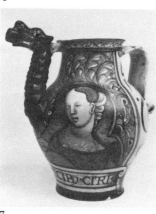

7

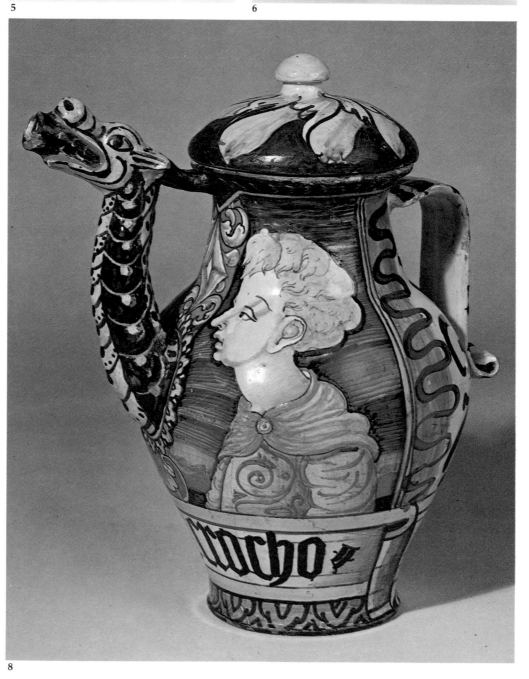

8

**1.** A large a quartieri pharmacy jar and domed cover, the interior of the cover dated 1549, workshop of Virgiliotto Calamelli 61.5 cm. high

**2.** The companion pharmacy jar and domed cover, circa 1550 63 cm. high

**3.** A berrettino armorial dish of Casa Pirota type, mark a circle over a cross, circa 1530 29 cm. diam.

**4.** A portrait albarello, circa 1525 30.5 cm. high

**5.** A berrettino dish, dated 1532 24 cm. diam.

**6.** Two pharmacy bottles of Orsini-Colonna type, circa 1530 40 cm. and 41.5 cm. high

**7.** A wet-drug jar of Orsini-Colonna type, circa 1525 24 cm. high

**8.** A jug and cover of Orsini-Colonna type, circa 1520 27.5 cm. high

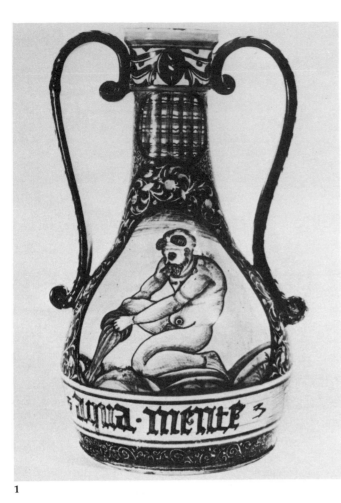

1

1. A two-handled pharmacy bottle of Orsini-Colonna type, circa 1530
43 cm. high

2. A fluted dish, circa 1535
25 cm. diam.

3. A fluted tazza, workshop of Virgiliotto Calamelli, circa 1535
27 cm. diam.

4. An a quartieri fluted dish, circa 1540
24 cm. diam.

5. A pair of oviform drug jars, circa 1525
both about 32 cm. high

6. An a quartieri squat albarello, circa 1540
22.5 cm. high

7. A famiglia gotica albarello, early 16th century
20 cm. high

8. A famiglia gotica albarello, early 16th century
19.5 cm. high

9. A wet-drug jar from the Farmacia Orsini-Colonna, circa 1530
25.5 cm. high

10. A wet-drug jar, from the Farmacia Orsini-Colonna, circa 1525
25.5 cm. high

11. An a quartieri armorial albarello, painted in the workshop of Virgiliotto Calamelli, circa 1550
29 cm. high

12. An albarello dated 1543
22.5 cm. high

13. A Nativity group, last quarter of 15th century
38 cm. x 60 cm.

14. An a quartieri crespina, circa 1545
27.5 cm. diam.

15. An a quartieri crespina, 1535-1540
26.5 cm. diam.

16. A double wall-tile, circa 1475
31.8 x 15.2 cm.

17. A blue and white albarello for Ungto Dalamila, circa 1530
17 cm. high

18. A blue and white albarello, circa 1530
18 cm. high

19. An albarello, circa 1530
17.5 cm. high

20. An albarello, circa 1530
16.5 cm. high

21. A pharmacy bottle, circa 1530
22 cm. high

22. An albarello, circa 1530
17.5 cm. high

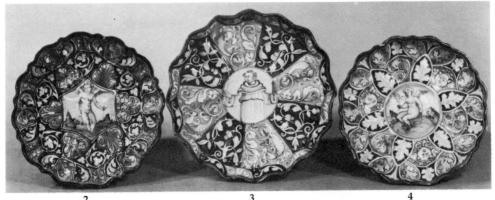

2                    3                    4

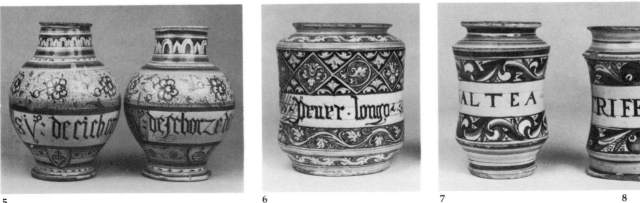

5                    6                    7                    8

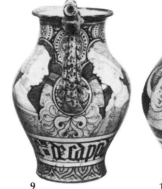

9

10

11

12

14 15

13

16

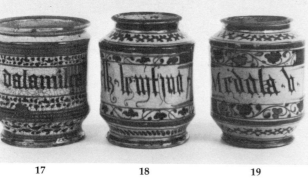

17 18 19

20 21 22

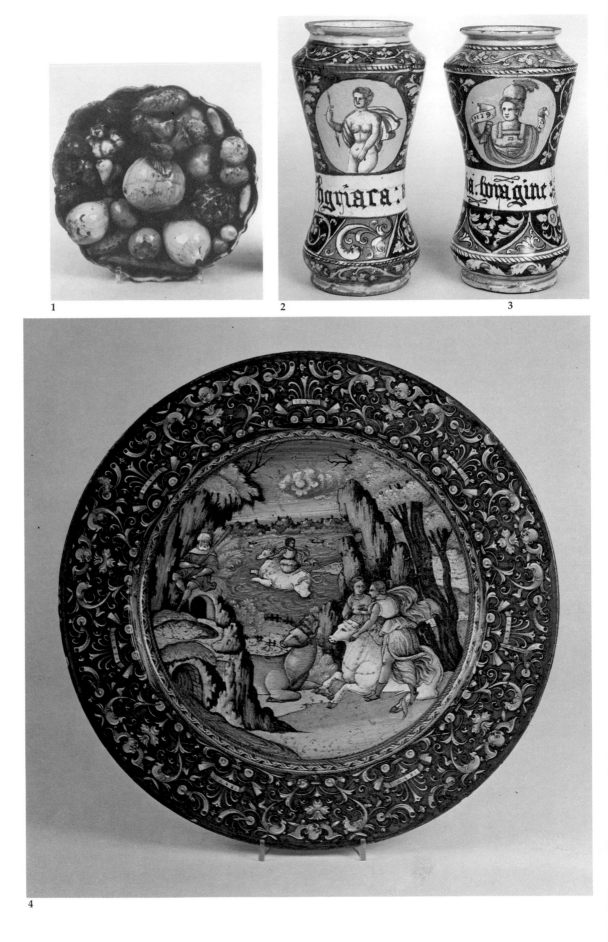

1

2

3

4

1. A fluted crespina, blue AE.V mark beneath an alchemical sign, circa 1550
25 cm. diam.
According to W.B. Honey: *European Ceramic Art*, p. 217, the mark is presumably that of Virgiliotto Calamelli, who died in 1570

2. A waisted albarello, workshop of Virgiliotto Calamelli, circa 1525
44 cm. high

3. Another albarello, workshop of Virgiliotto Calamelli circa 1525
25.5 cm. high

4. A large Casa Pirota istoriato berrettino dish painted by the Master of the Bergantini Bowl, the date 1537 repeated seven times in blue and white enamel, the reverse in blue on blue and yellow with the date 1537
47 cm. diam.

5. An a quartieri crespina, circa 1545
25.5 cm. diam.

6. A tondino of coppa amatoria type, circa 1510
24.5 cm. diam.

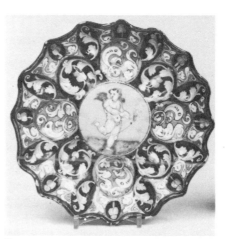

5

6

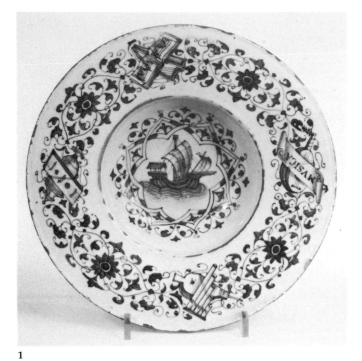

1

2A

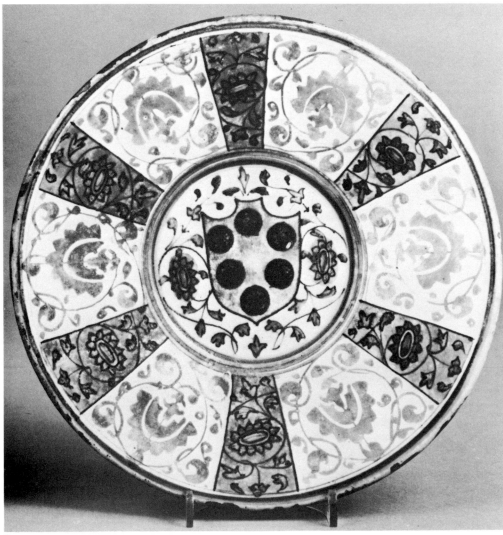

2

1.  A blue and white dish marked jo Chafagguolo in blue, circa 1510
24 cm. diam.

2 and 2A.  A blue and white armorial tondino lustred at Gubbio, the centre with the Medici arms, blue SPF monogram mark, circa 1510
22.5 cm. diam.

3.  A blue and white tondino, blue Jo Chafagguolo mark, circa 1510
24.5 cm. diam.

4.  An armorial two-handled pharmacy ewer painted with a coat of arms and the date 1541
38 cm. high

5.  A waisted albarello, circa 1520
27 cm. high

6.  A small albarello, circa 1525
19 cm. high

7.  An armorial wet-drug jar with the Medici arms, the painter's mark beneath the spout, circa 1525
23.5 cm. high
The arms are either those of Pope Leo X (1514-1521) or his nephew Pope Clement VII (1523-1535) though the latter is more likely

8.  A wet-drug jar, circa 1535
22 cm. high

9.  Two circular pedestal bowls, circa 1530
32 cm. diam.

10.  A drug pot and two albarelli, circa 1530
20.5 cm. and 23 cm. high

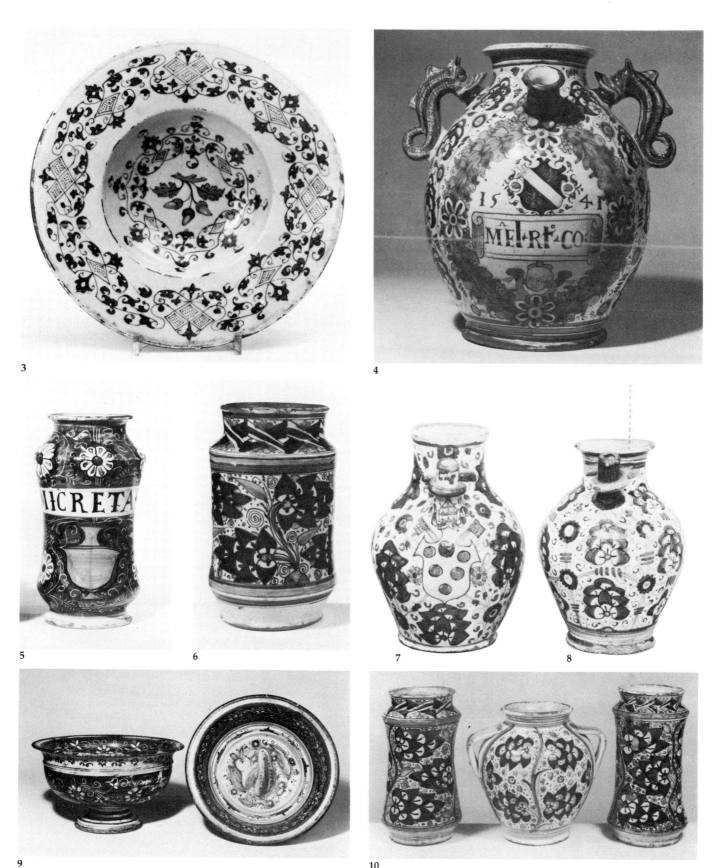

3

4

5

6

7

8

9

10

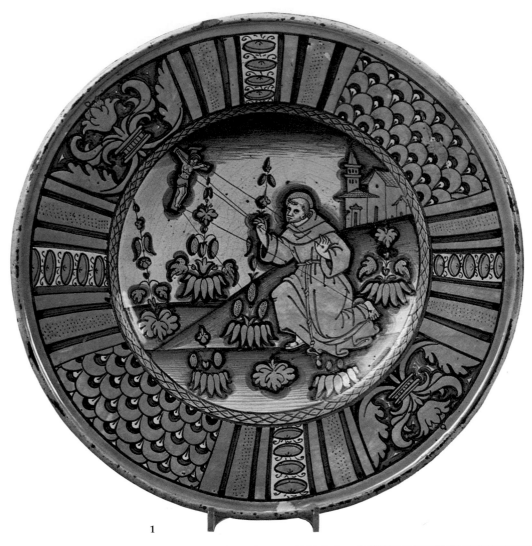

1

2

3

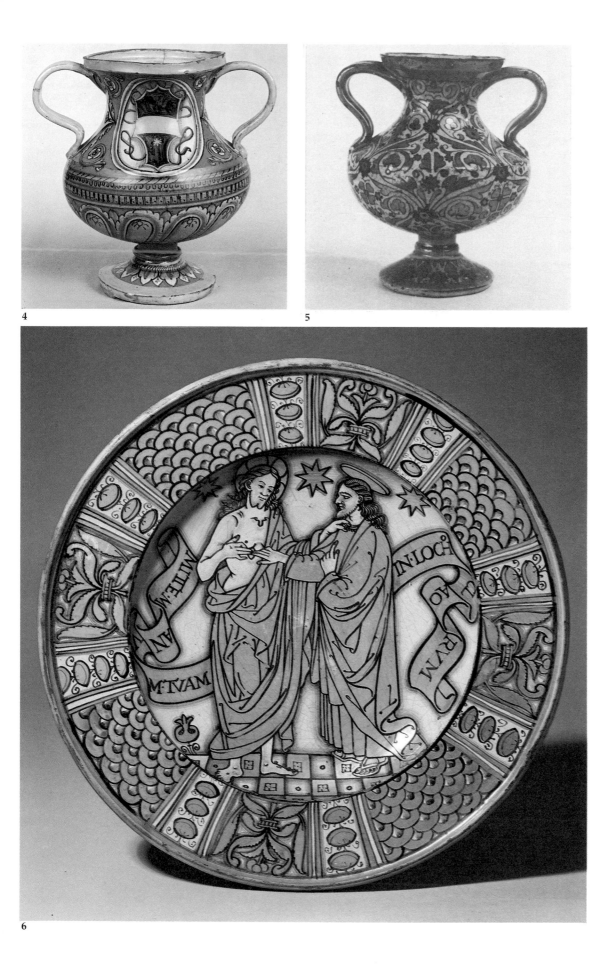

4

5

6

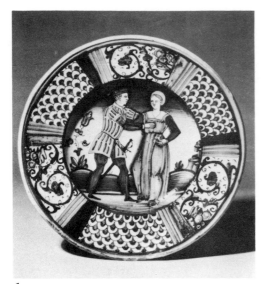

1

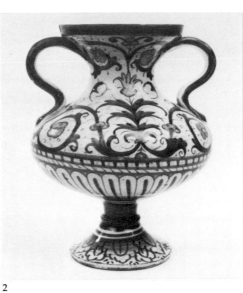

2

1.  A polychrome charger,
1525-1530
40.6 cm. diam.

2.  A polychrome two-handled
baluster vase, circa 1520
24 cm. high

**3 and 3A.**  A circular bowl, the
reverse decorated in blue with a
three-headed monster and the
date ?1514
19 cm. diam.

4.  A large dish, circa 1525
40.5 cm. diam.

5.  A blue and gold lustre dish,
circa 1525
34 cm. diam.

3

3A

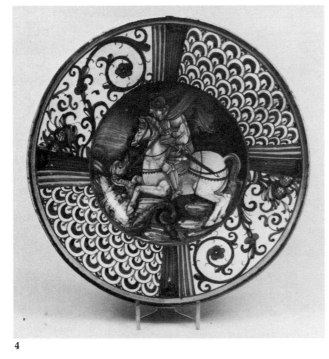

4

5

**6.** A large oviform drug-vase, 16th century
45 cm. high

**7.** A pair of armorial waisted albarelli, circa 1515
20 cm. high

**8.** A circular dish, circa 1520
30.5 cm. diam.

**9.** A portrait tondino, circa 1520
35 cm. diam.

**10.** A blue and gold lustre dish, circa 1520
39 cm. diam.

**11.** A tondino, circa 1525
15.5 cm. diam.

6

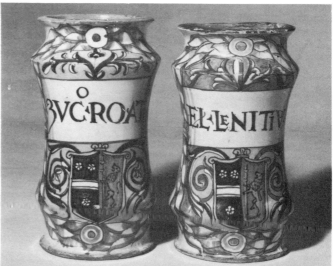

7

8

9

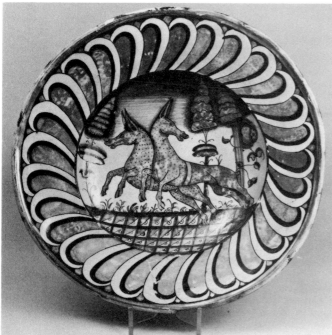

10

11

1A

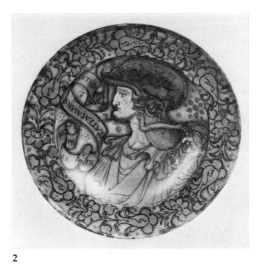

2

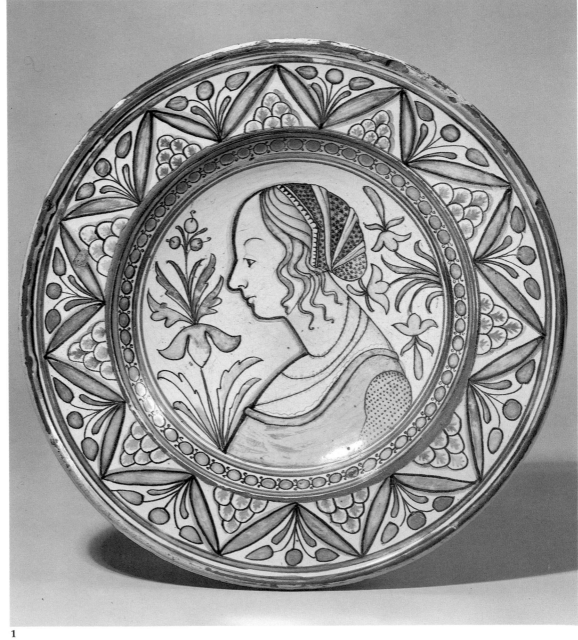

1

**1 and 1A.** A blue, gold and copper lustre coppa amatoria, large blue B mark, circa 1510
36 cm. diam.

**2.** A blue and gold lustre charger, circa 1520
42 cm. diam.

**3.** A blue-ground coppa amatoria, attributed to Francesco Urbini, circa 1525
25 cm. diam.

**4.** A blue and gold lustre charger, circa 1520
43 cm. diam.
The coats of arms are of Medici and another, perhaps del Bene of Verona

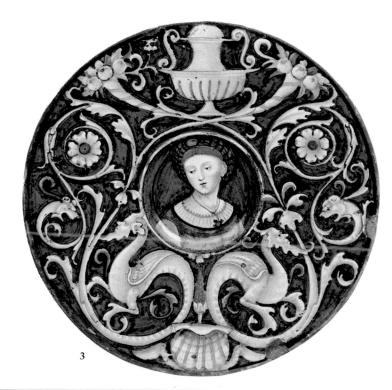

3

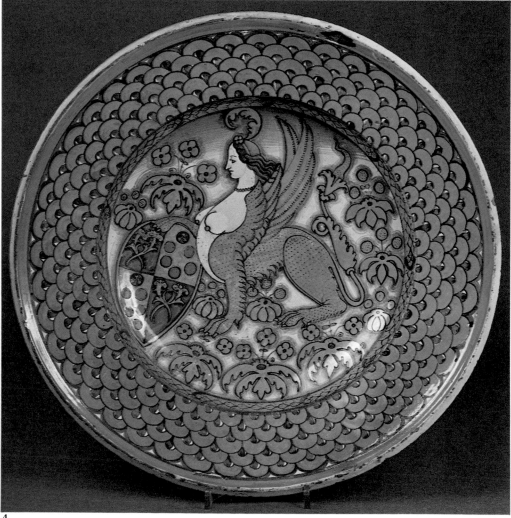

4

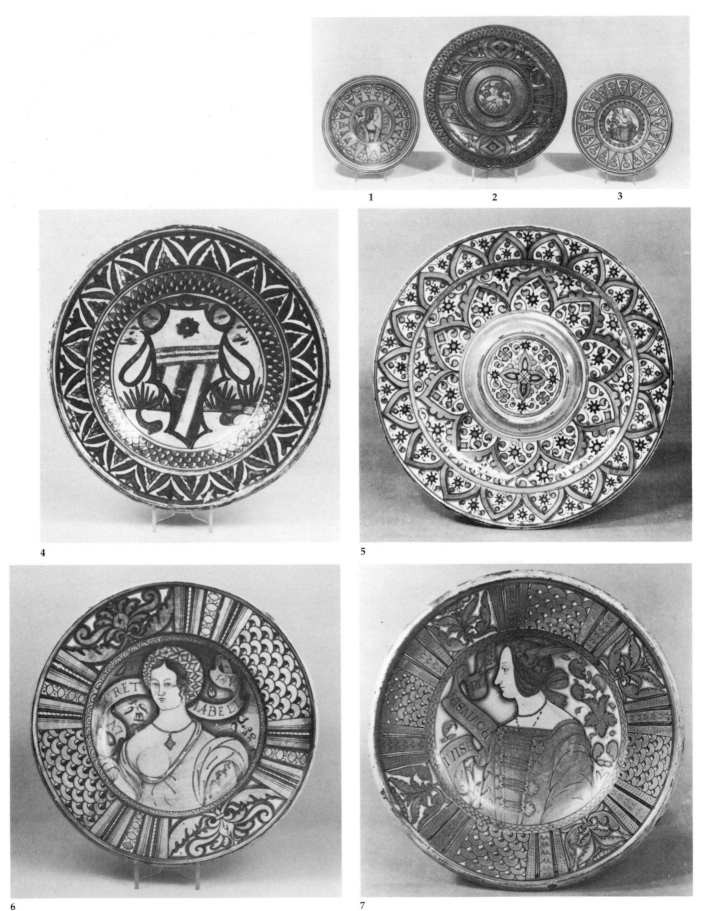

**1.** A circular shallow plate, circa 1520
22 cm. diam.

**2.** A circular saucer-dish, circa 1515
32 cm. diam.

**3.** A circular dish, circa 1515
23 cm. diam.

**4.** An armorial blue, gold and copper lustre dish, circa 1520
42.5 cm. diam.

**5.** A blue and gold lustre tondino, circa 1530
30.5 cm. diam.

**6.** A blue and gold lustre large dish, circa 1520
41 cm. diam.

**7.** A blue and gold lustre charger, circa 1520
42 cm. diam.

**8.** A blue and gold lustre dish, circa 1520
39 cm. diam.

**9.** A blue and gold lustre charger, circa 1520
42 cm. diam.

**10.** A polychrome dish, circa 1520
37.5 cm. diam.

**11.** A polychrome charger, circa 1520
40 cm. diam.

**12.** A polychrome dish, circa 1530
38 cm. diam.

**13.** A gold lustre portrait charger, circa 1520
41.5 cm. diam.

8

9

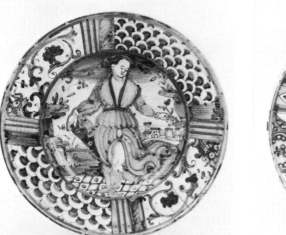

10

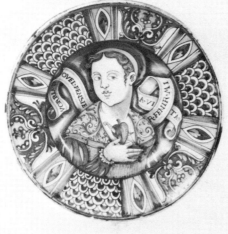

11

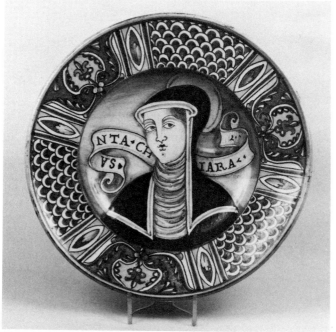

12

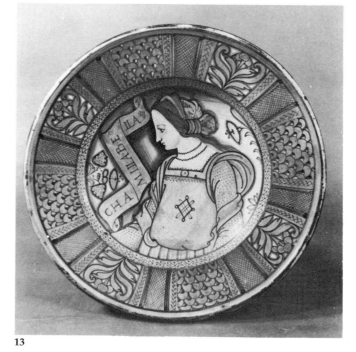

13

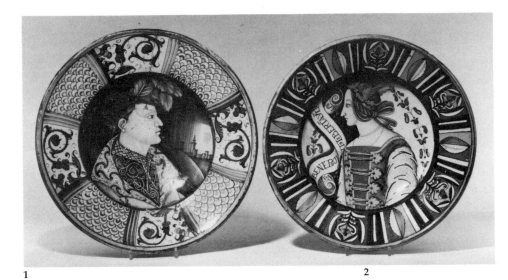

1

2

1. A polychrome charger, circa 1525
41 cm. diam.

2. A polychrome charger, circa 1520
40 cm. diam.

3. A blue, ochre and lustre dish, circa 1515
42 cm. diam.

4. A blue and gold lustre charger, circa 1530
43.2 cm. diam.

5. A blue and gold lustre charger, circa 1530
40 cm. diam.

6. A blue and gold lustre charger, circa 1520
41.5 cm. diam.

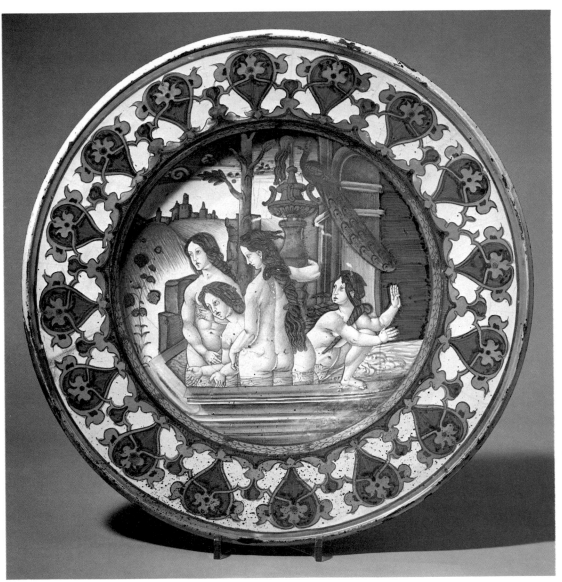

3

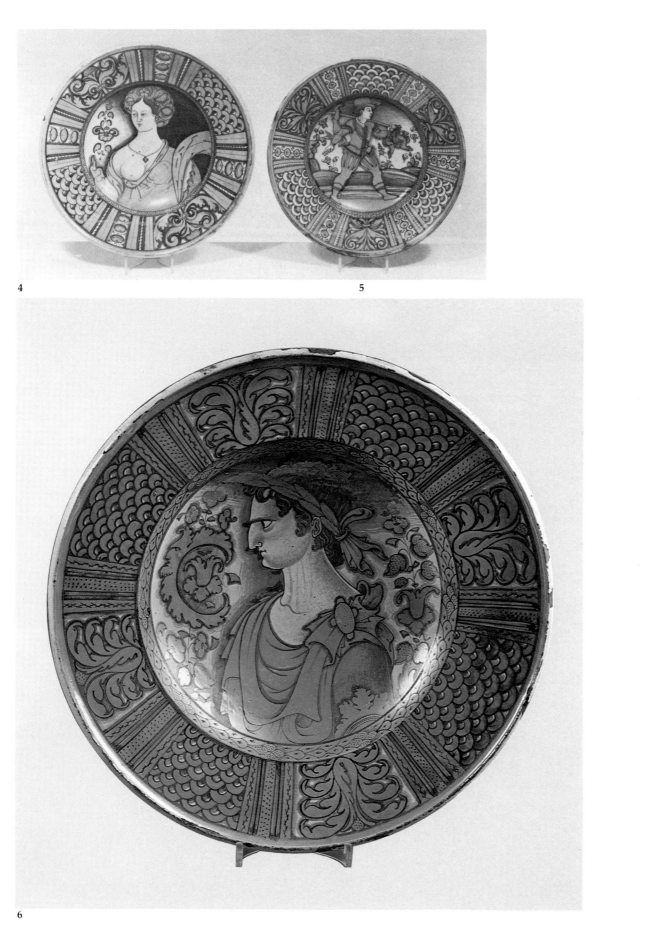

4                                                    5

6

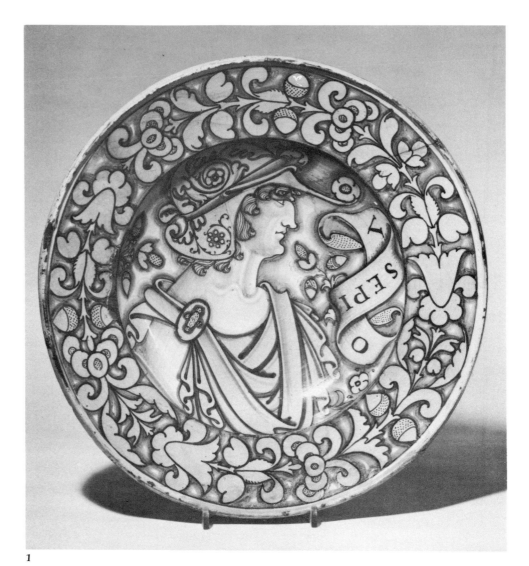

1

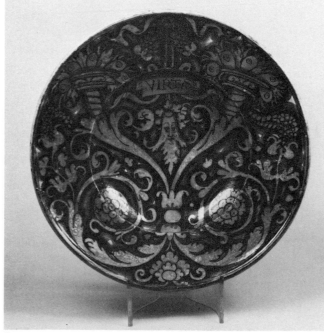

2

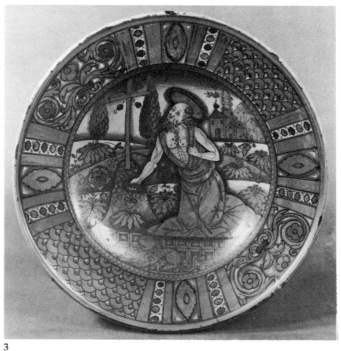

3

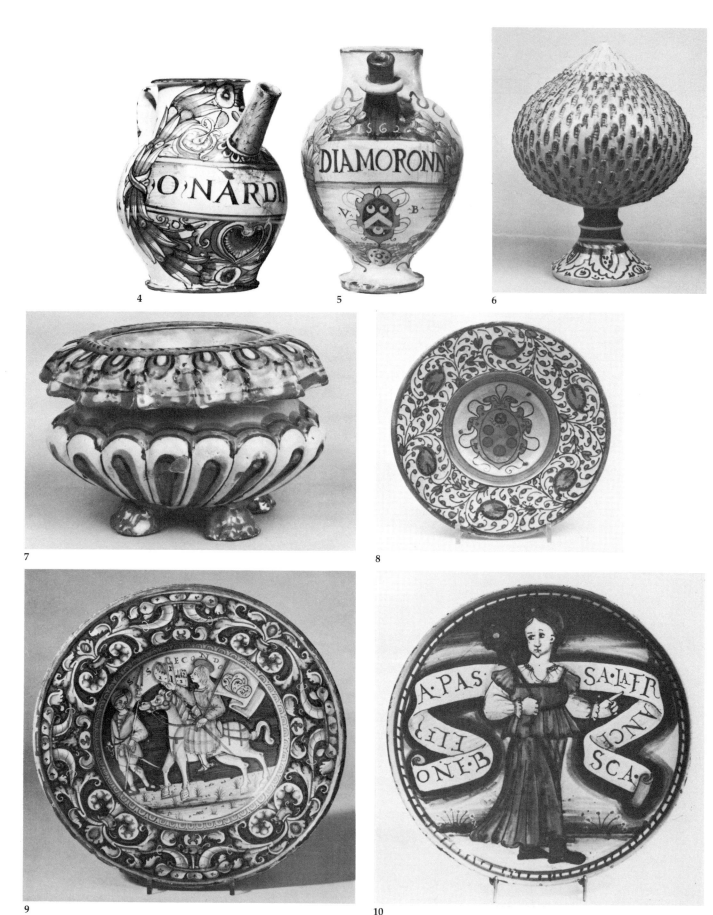

4

5

6

7

8

9

10

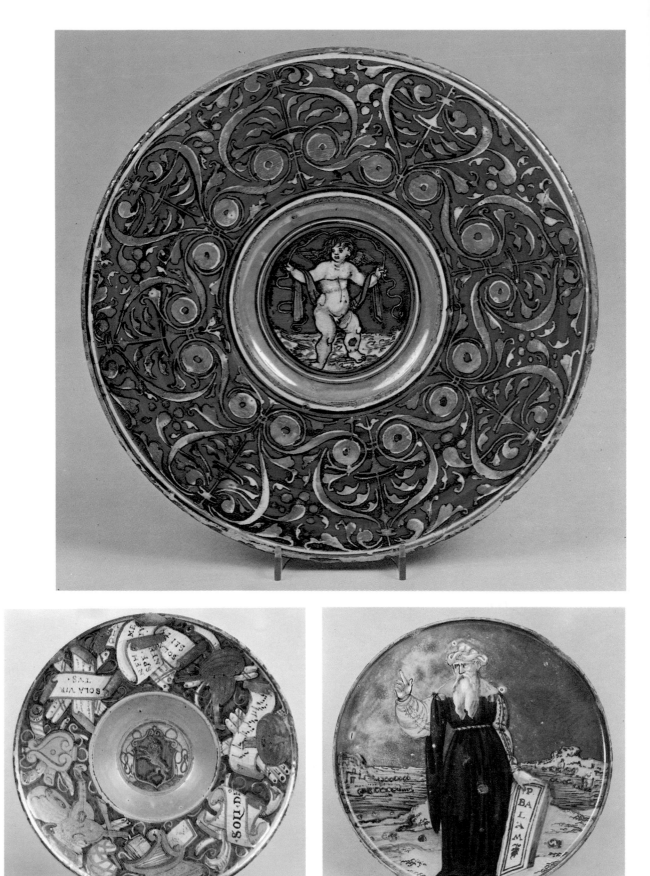

2

3

1.  A Gubbio lustre blue ground tondino, circa 1525
27 cm. diam.

2.  A Gubbio-lustred Casteldurante blue-ground armorial dish, circa 1525
20.5 cm. diam.
The arms are those of Pifati

3.  A Gubbio lustre tazza, by Maestro Giorgio Andreoli, signed and dated in copper lustre MO GO 1534
20.5 cm. diam.

4.  A Gubbio lustre armorial tondino, circa 1525
27 cm. diam.
The arms, Barry, argent and gules, a goat salient sable, surmounted by a cardinal's hat, have been identified as those of Monsignor della Vita

5.  A Casteldurante blue-ground dish lustred at Gubbio by Maestro Giorgio Andreoli, the reverse inscribed in gold lustre 1528 MO GO
28 cm. diam.

6.  A Casteldurante blue-ground tondino enriched in gold and copper lustre at Gubbio by Maestro Giorgio Andreoli, signed and dated in copper lustre: 1528 MO GO daugubi
26 cm. diam.

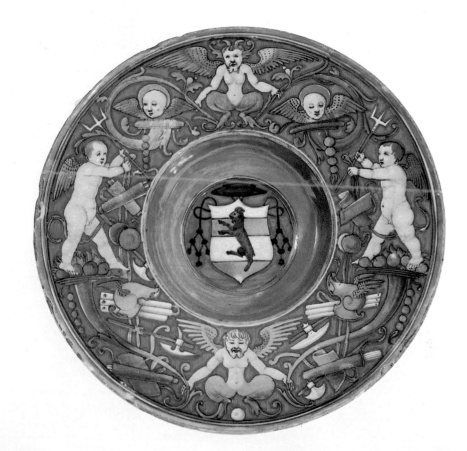

4

5

6

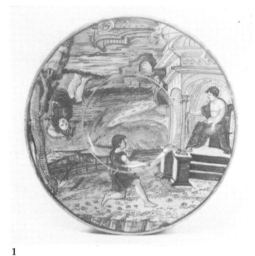

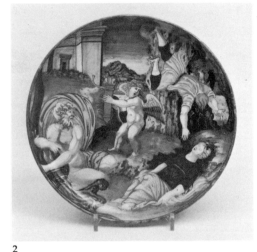

1

2

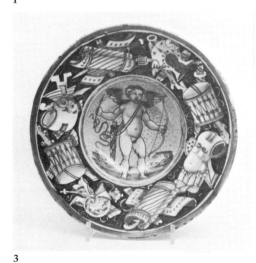

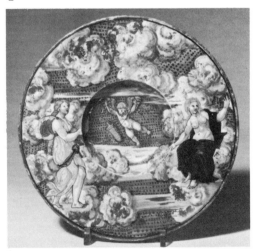

3

4

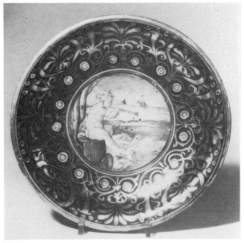

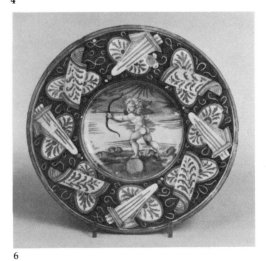

5

6

1. A lustre istoriato dish, dated 1527 and with traces of the signature of Maestro Giorgio Andreoli
23.5 cm. diam.

2. A Gubbio-lustred Urbino tazza, circa 1530
26 cm. diam.

3. A Gubbio-lustred Casteldurante dish, circa 1530
22.5 cm. diam.

4. A Gubbio-lustred Urbino dish, enriched by Maestro Giorgio Andreoli with copper-lustre dots, signed and dated Mo. Go. 1532
22.5 cm. diam.
The polychrome decoration perhaps by Francesco Urbini or Francesco Xanto Avelli. The right-hand figure of Prudentia is derived from an engraving by Marcantonio Raimondi (Bartsch XIV, No. 371)

5. A lustre blue-ground dish, by Maestro Giorgio Andreoli, circa 1530
25 cm. diam.

6. A Casteldurante blue-ground tondino lustred at Gubbio, circa 1525
25.5 cm. diam.

7. A lustre crespina, circa 1525
22.5 cm. diam.

8. An armorial tondino by Maestro Giorgio Andreoli, 1537
22.5 cm. diam.

9. A gold and copper lustre small moulded crespina, circa 1525
20 cm. diam.

10. A blue and copper lustre crespina, circa 1525
24 cm. diam.

11. A Gubbio-lustred Casteldurante rectangular plaque, painted by the Pseudo-Pellipario painter, circa 1530
26 cm. x 20.5 cm.

12. An Urbino istoriato plate lustred at Gubbio in the workshop of Maestro Giorgio Andreoli, the reverse inscribed, circa 1530
23 cm. diam.

13. A lustred confinement bowl cover, the reverse with elaborate signature including the letter M, circa 1535
23 cm. diam.

14. A lustred small istoriato dish, probably painted by Maestro Giorgio Andreoli, the reverse with MA monogram, circa 1530
19 cm. diam.

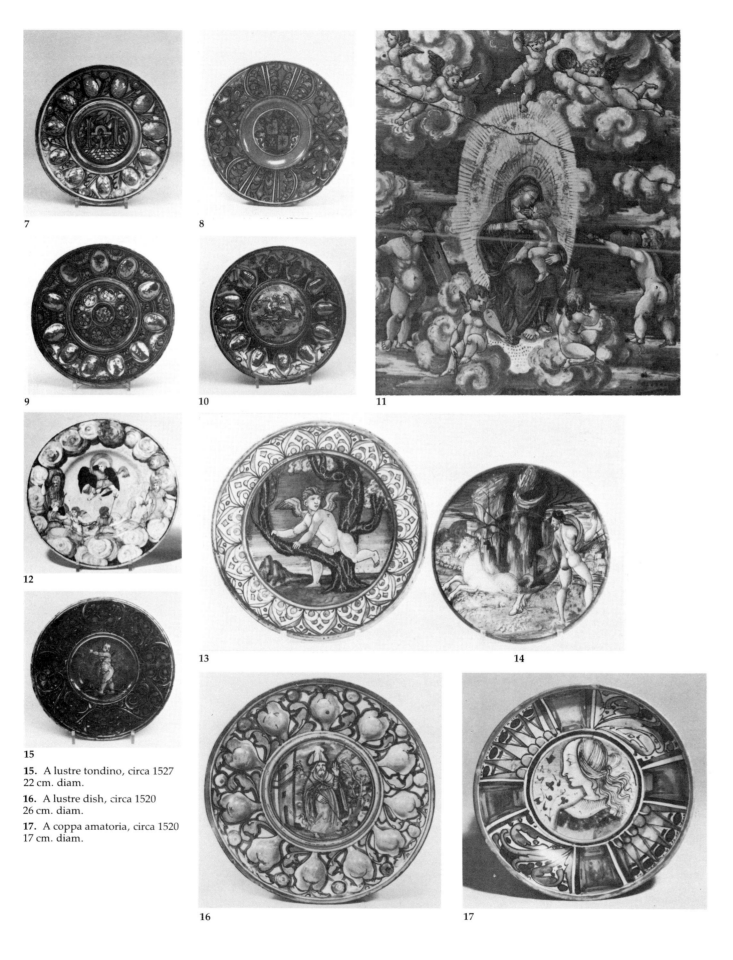

7

8

9

10

11

12

13

14

15

**15.**  A lustre tondino, circa 1527
22 cm. diam.

**16.**  A lustre dish, circa 1520
26 cm. diam.

**17.**  A coppa amatoria, circa 1520
17 cm. diam.

16

17

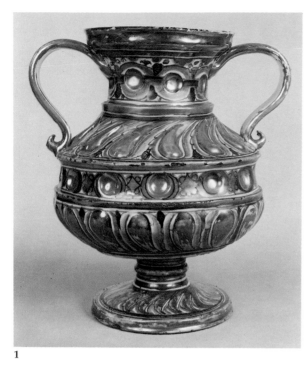

1

2

**1.** A lustre gadrooned two-handled vase, circa 1530
33 cm. high

**2.** A blue, green, copper, and gold lustre moulded tazza, circa 1525
24 cm. diam.

**3.** A crespina, the reverse with gold-lustre scrolls and a date which may read as 1531
25.5 cm. diam.

3

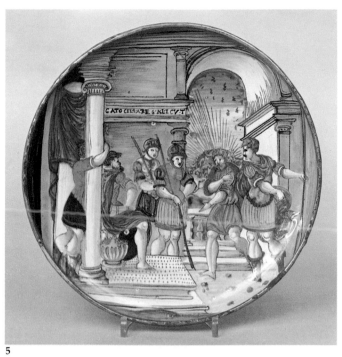

4

5

**4.** A Gubbio-lustred
Casteldurante small tazza,
workshop of Maestro Giorgio
Andreoli, dated 1535 in gold
lustre
19 cm. diam.

**5.** A Gubbio-lustred Urbino
dish, the reverse inscribed in
blue, circa 1530
26 cm. diam.

**6.** A Gubbio-lustred
Casteldurante istoriato tazza
painted by Nicola Pellipario and
lustred by Maestro Giorgio
Andreoli, the reverse inscribed
in copper lustre, 1527, MO GO
da u gubio
33 cm. diam.
The architectural setting is taken
from the Massacre of the
Innocents (Bartsch XIV, 21) after
Baccio Bandinelli, whilst various
other figures are taken from
another print, the Martyrdom of
St. Lawrence, after the same artist
(Bartsch XIV, 104). The original
decoration may be by Francesco
Urbini

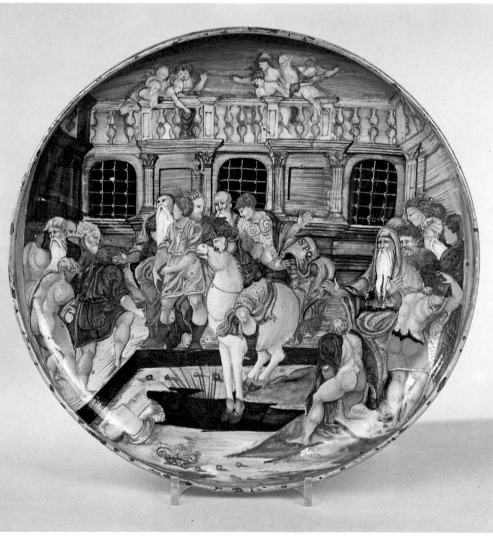

6

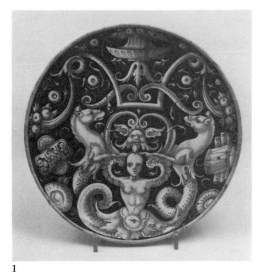

1

2

1. An a candelieri tazza, circa 1535 or later
25 cm. diam.

2. A saucer-dish, circa 1525
25 cm. diam.

3 and 3A. A circular dish, the reverse with the date 1541
19 cm. diam.

4. An istoriato plate, circa 1555
23 cm. diam.

5. An istoriato dish, dated 1544
43 cm. diam.

6 and 6A. A coppa amatoria, dated in blue 1533
22.9 cm. diam.

7. A saucer-dish, circa 1525
23.5 cm. diam.

8. An armorial large dish painted by Nicola Pelliario for an as yet unidentified client, circa 1520
41 cm. diam.

3

3A

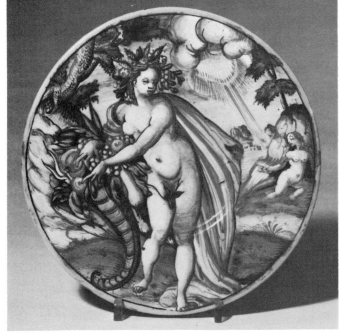

4

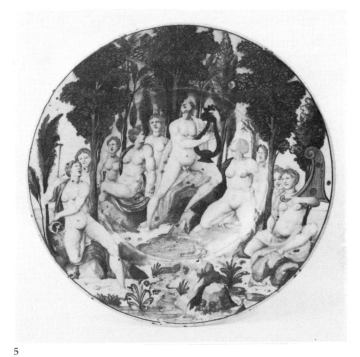

5

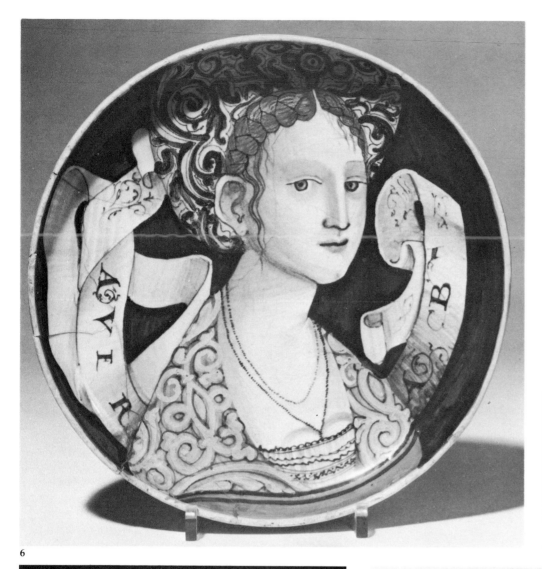

6

6A

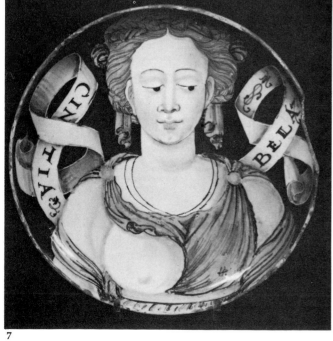

7

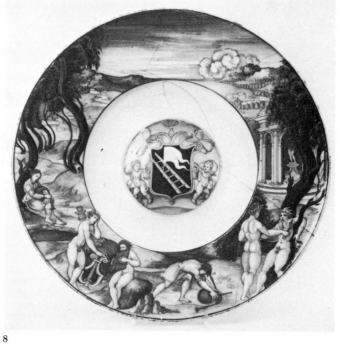

8

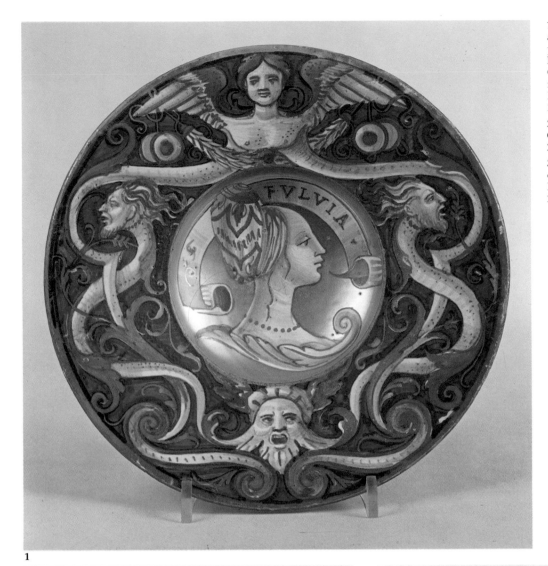

1

2

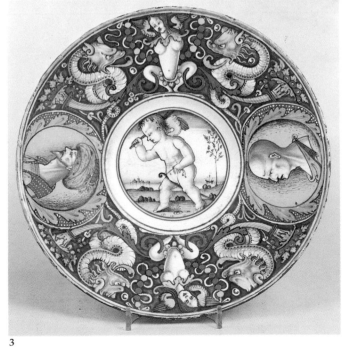

3

**1.** A blue-ground coppa amatoria of a candelieri type painted by Zoan Maria and lustred in Gubbio by Maestro Giorgio Andreoli, the reverse inscribed in copper lustre: 1531 MO GO
23.5 cm. diam.

**2.** An armorial dish lustred at Gubbio, circa 1525
26.5 cm. diam.

**3.** A blue-ground tondino of a candelieri type painted by Zoan Maria, circa 1515
23.5 cm. diam.

**4.** A dated blue and white coppa amatoria of cardinal's hat form and a candelieri type, painted by Zoan Maria, 1521
26 cm. diam.

**5.** An armorial dish from the Gonzaga Este service, painted by Nicola Pellipario, circa 1519
27 cm. diam.
The service was made for Isabella d'Este, wife of Gianfrancesco Gonzaga, Marquis of Mantua

**6.** A blue-ground tondino painted by Zoan Maria, circa 1510
27 cm. diam.

4

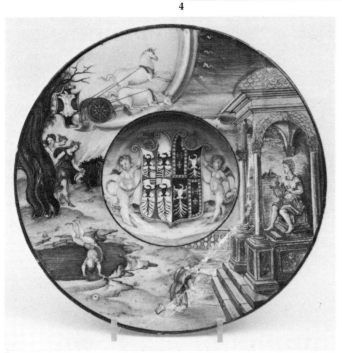

5

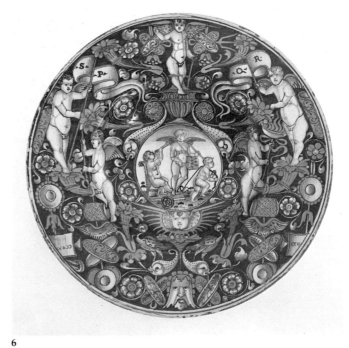

6

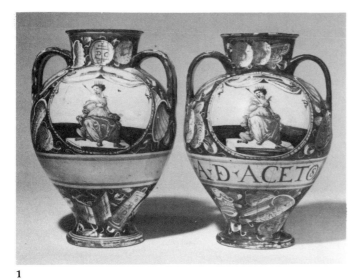

1

1. A pair of two-handled oviform pharmacy jars, with the date 1574
32 cm. high

2. A pair of wet-drug jars, circa 1530
21 cm. high

3. A pair of albarelli, circa 1530
18.5 cm. high

4. A pharmacy bottle, circa 1570
31.5 cm. high

5 and 6. Two small albarelli, circa 1550
14.5 cm. high

7. An albarello, circa 1550
15.6 cm. high

8. A dish attributed to Nicola Pellipario, circa 1535
24 cm. diam.

9. A fluted crespina, Urbino or Casteldurante, circa 1560
21 cm. diam.

10. A dish, circa 1580
22 cm. diam.

11. A coppa amatoria, painted by Nicola Pellipario, circa 1530
25.5 cm. diam.

12. A blue-ground plate, circa 1550
23 cm. diam.

13. A blue-ground dish, circa 1550
23 cm. diam.

2

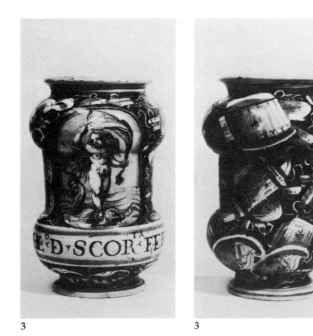

3            3            4

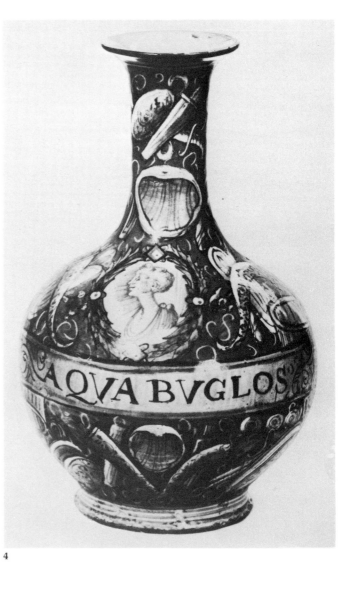

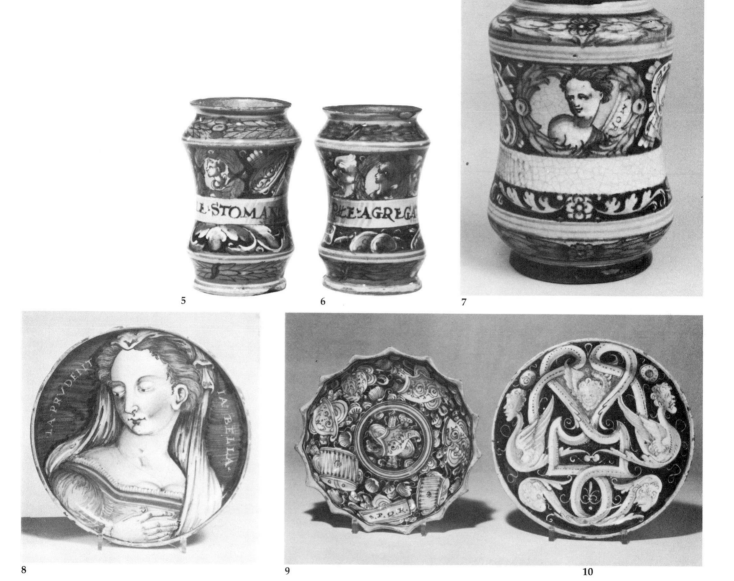

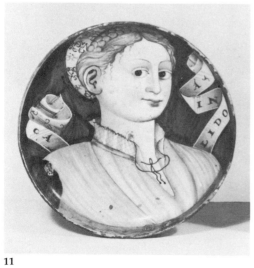

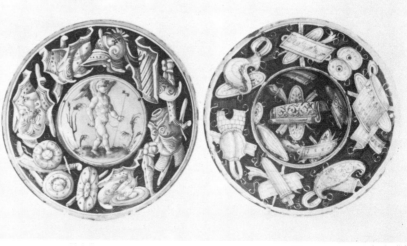

5

6

7

8

9

10

11

12

13

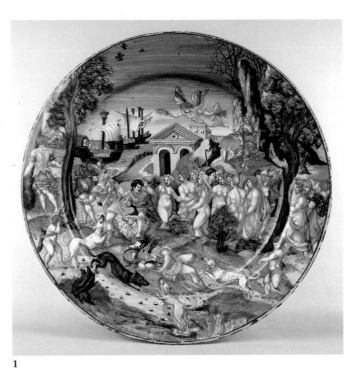

**1**

**1 and 1A.** An istoriato dish by Francesco Xanto Avelli da Rovigo, the reverse inscribed and dated 1534
43.5 cm. diam.

**2 and 2A.** A large incendio istoriato dish painted by Guido Durantino, inscribed and dated 1535 on the reverse in blue
44.4 cm. diam.
Vaguely inspired by the great Raphael fresco in the Vatican, the present dish, probably the largest product of Durantino's workshop extant, is composed of elements derived from several different engraved sources

**3.** An istoriato tondo and separate grisaille border, the tondo painted after a drawing by Taddeo Zuccaro, the tondo 1560-1562, the border perhaps a little earlier
59 cm. diam.
In 1560 Taddeo Zuccaro went to Urbino to execute a series of preparatory drawings for maiolica depicting scenes from the life of Julius Caesar, of which the drawing preserved in the Louvre, No. 185, corresponds precisely to the present dish

**4.** A large circular dish, Patanazzi workshop, circa 1580
42.5 cm. diam.

**5.** A saucer-dish, Patanazzi workshop, circa 1580
27 cm. diam.

**6.** An istoriato armorial 'Piatto di Pompa' from the Pucci service painted by Francesco Xanto Avelli da Rovigo with the arms of Pucci, the reverse inscribed and dated in blue MDXXXII
49 cm. diam.
This is the largest surviving dish from the famous service painted by Xanto for Pier Maria Pucci, Papal Gonfaloniere in 1520

**1A**

**2A**

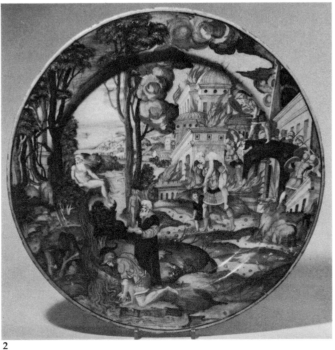

**2**

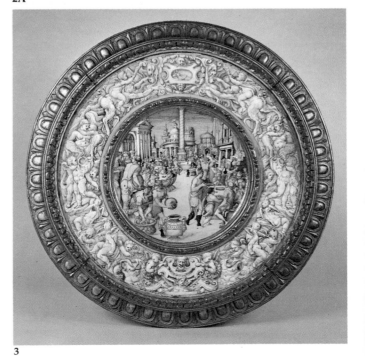

**3**

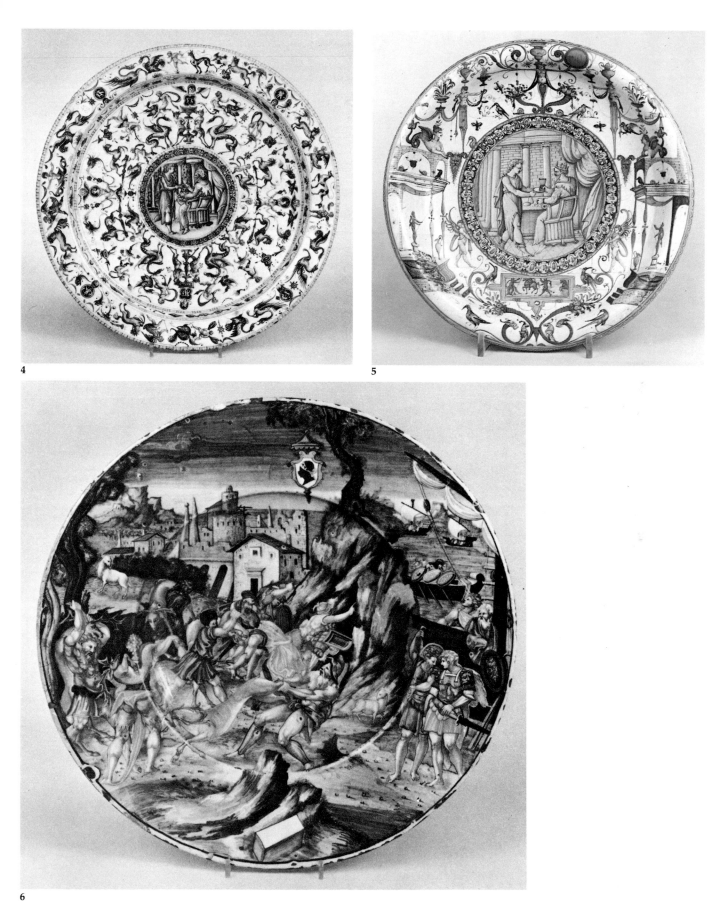

4

5

6

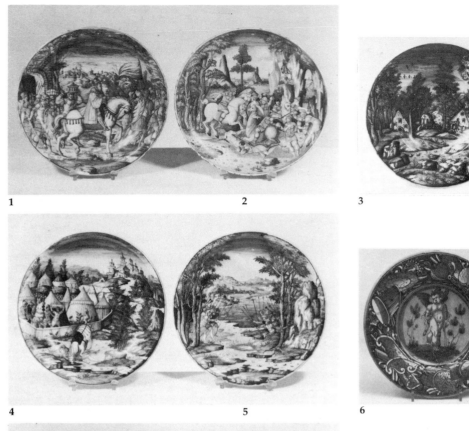

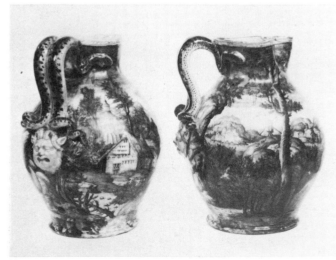

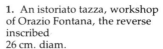

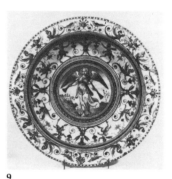

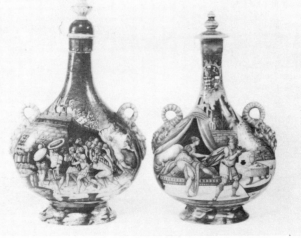

1

2

3

4

5

6

7

8

9

10

11

12

1. An istoriato tazza, workshop of Orazio Fontana, the reverse inscribed
26 cm. diam.
From the service of Guidobaldo II, Duke of Urbino, 1565-71

2. An istoriato circular tazza, the reverse inscribed, from the Guidobaldo service, 1565-71
26 cm. diam.

3. An istoriato dish with the arms of Salviati, circa 1555
27.5 cm. diam.

4. An istoriato dish, the reverse inscribed, no. 89, from the Guidobaldo service, 1565-71
24.1 cm. diam.
From the Second Punic War Series, painted by Orazio Fontana

5. An istoriato dish, from the same series, the reverse inscribed, no. 81
24.1 cm. diam.

6. A dish, circa 1550
28.5 cm. diam.

7. An istoriato dish, the reverse inscribed, no. 106, from the Guidobaldo service, 1565-71
24.1 cm. diam.

8. An istoriato circular dish, from the same series, the reverse inscribed no. 111
24.1 cm. diam.

9. A dish, Patanazzi workshop, circa 1580
45.5 cm. diam.

10. A pair of large istoriato armorial jugs with the arms of Salviati, circa 1555
39 cm. high

11. A pilgrim flask and screw cover, Fontana workshop, circa 1545
40 cm. high

**12.** An armorial pilgrim flask and screw cover, Fontana workshop, circa 1545
38.5 cm. high

**13.** An istoriato dish, Fontana workshop, circa 1550
27 cm. diam.

**14.** A istoriato dish, Fontana workshop, circa 1550
47 cm. diam.

**15.** An istoriato dish, the reverse inscribed, Fontana workshop, circa 1560
32 cm. diam.

**16.** An istoriato large circular dish from the Guidobaldo service Fontana workshop, the reverse inscribed, 1565-71
37.5 cm. diam.

**17.** An istoriato dish painted in the Fontana workshop, circa 1540
54.5 cm. diam.

**18.** An istoriato tazza, from the series, painted by Orazio Fontana, inscribed on the reverse, circa 1565-71
32.5 cm. diam.

**19.** An istoriato plate, probably Fontana workshop, mid-16th century
23.5 cm. diam.

**20.** An istoriato tazza, the reverse with the apparent signature Fa-lay, circa 1535
26 cm. diam.

**21.** An istoriato plaque, painted by Guido Durantino, circa 1540
21 cm. diam.

**22.** A dish painted in the manner of Durantino, circa 1535
47 cm. diam.

**23.** An istoriato dish, School of Durantino, circa 1535
41.8 cm. diam.

**24.** An istoriato dish painted by Guido Merlino, inscribed and signed on the reverse, circa 1540
41.5 cm. diam.

**25.** An istoriato armorial dish, Fontana workshop, the reverse inscribed in blue, circa 1545
27.5 cm. diam.

**26.** An istoriato dish, decorated in the Fontana workshop, the reverse inscribed in blue, circa 1540
44 cm. diam.

**27.** An armorial istoriato dish painted by Orazio Fontana circa 1550
23.5 cm. diam.

13

14

15

16

17

18

19

20

21

22

23

24

25

26

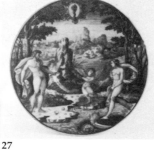

27

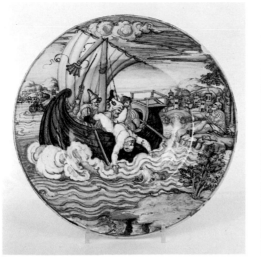

1

2

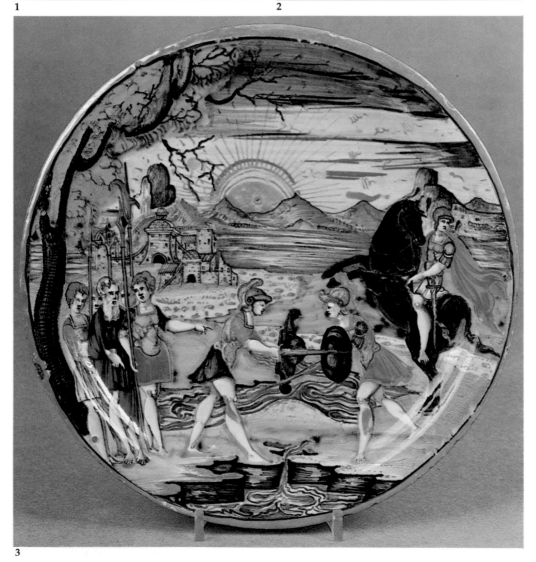

3

**1.** An istoriato dish painted in the workshop of Guido Durantino, the reverse inscribed in blue, circa 1540
27 cm. diam.

**2.** An istoriato dish lustred at Gubbio, painted by Francesco Xanto Avelli da Rovigo, the reverse inscribed L'avara & rea moglier di Amphiarao historia, 1531
29 cm. diam.

**3.** An istoriato dish painted by Francesco Xanto Avelli da Rovigo and lustred at Gubbio by Maestro Giorgio Andreoli, the reverse inscribed and dated 1539
27.5 cm. diam.

**4.** An istoriato shallow tazza, the reverse inscribed in sepia, circa 1535
25 cm. diam.

**5.** An istoriato tondino painted in the workshop of Guido Durantino, the reverse inscribed in blue, fabula di Phe/Bo e Dafne/ nella botega d mo / Guido Durantino / in Urbino / 1535
26 cm. diam.

**6.** An istoriato alzata painted by Francesco Xanto Avelli da Rovigo, 1528-1530
28 cm. diam.
This dish derives its composition ultimately from the lunette by Alessio Baldovinetti in the sacristy of S. Nicolo, Florence, though the direct source is a Florentine engraving by an unknown hand between 1470 and 1490; see Hind, *Early Italian Engravings*, vol. III, pl.186 B 1 14, 11

4

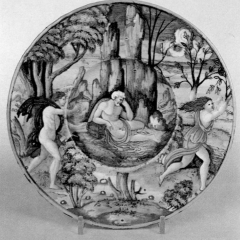

5

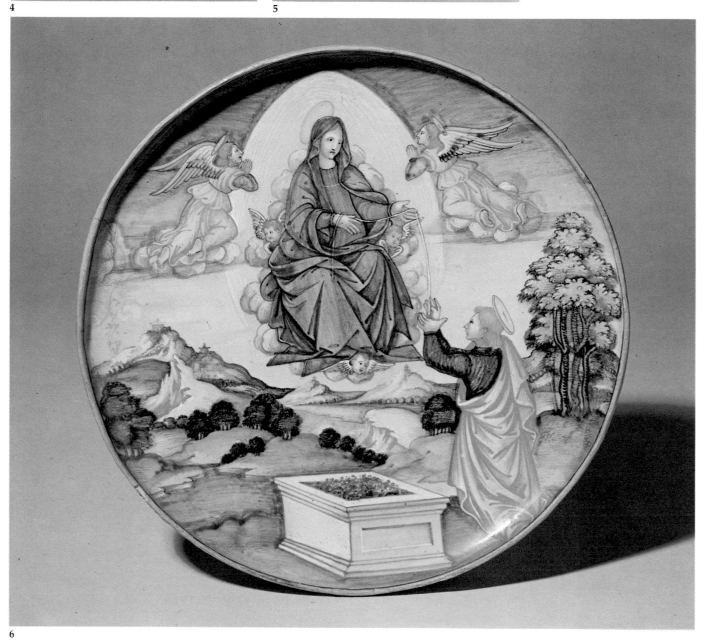

6

1

2

3

4

5

6

7

8

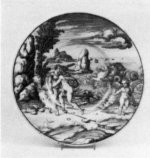

9

10

11

12

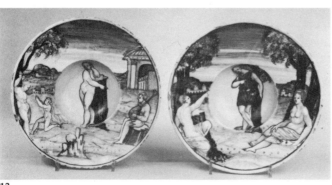

13

1. An istoriato dish, the reverse inscribed, circa 1535
30.5 cm. diam.

2. An istoriato tazza, the reverse inscribed, circa 1545
24 cm. diam.

3. An istoriato dish, circa 1550
28 cm. diam.

4. An istoriato dish, the reverse inscribed, circa 1550
23 cm. diam.

5. An istoriato tazza, circa 1540
26.5 cm. diam.

6. An istoriato dish, the reverse inscribed, circa 1540
26 cm. diam.

7. An istoriato dish, the reverse inscribed, circa 1535
23 cm. diam.

8. An istoriato tondino, the reverse inscribed, circa 1545
24 cm. diam.

9. An istoriato armorial dish, Fontana workshop, the reverse inscribed, circa 1560
24 cm. diam.

10. An istoriato dish, Fontana workshop, the reverse inscribed, circa 1560
24.5 cm. diam.

11. An istoriato dish, Fontana workshop, circa 1550
27 cm. diam.

12. An istoriato dish, the reverse inscribed, circa 1535
27.5 cm. diam.

13. A pair of istoriato dishes, circa 1540
25 cm. diam.

14. An istoriato dish, the reverse inscribed, circa 1540
30 cm. diam.

15. An armorial plate, the reverse inscribed, mid-16th century
21.5 cm. diam.

16. An istoriato circular dish from the Guidobaldo service, painted by Orazio Fontana, the reverse inscribed 1565-71
26.5 cm. diam.

17. An istoriato alzata painted by Francesco Xanto Avelli da Rovigo, the reverse inscribed and dated 1536
25 cm. diam.

18. An istoriato saucer-dish, from the Guidobaldo service, the reverse inscribed, 1565-1571
24.5 cm. diam.

19. An istoriato saucer-dish, circa 1550
28 cm. diam.

14

15

16

17

18

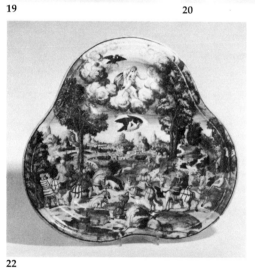

19

20

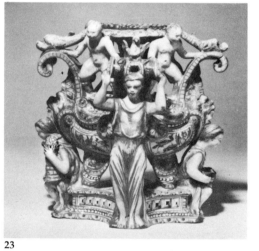

21

**20.** An istoriato dish, circa 1545
26 cm. diam.

**21.** An istoriato dish, the reverse inscribed, circa 1545
30.5 cm. diam.

**22.** An istoriato trefoil dish
46 cm. wide
Perhaps originally part of the service of Guidobaldi II, Duke of Urbino, supplied to him by Orazio Fontana 1565-71

**23.** An armorial boat-shaped salt, Patanazzi workshop, third quarter of 16th century
23 cm. high

**24.** A two-handled vase, circa 1575
51 cm. high

**25.** A wet-drug jar, late 16th century
29 cm. high

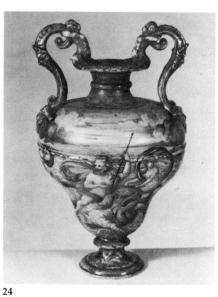

22

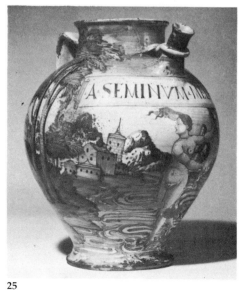

23

24

25

**1.** A large istoriato dish painted by Nicola Pellipario with the rape of Helen, circa 1535
51.5 cm. diam.
The engraved source for this dish is the print attributed to Marcantonio Raimondi (after Raphael Bartsch XIV, 209, and Delaborde: *Pièces douteuses,* 43). It provided the inspiration for many istoriato dishes by Xanto and others

**2.** A group of St. Matthew, circa 1560
23 cm. wide

**3.** A tazza painted by Francesco Xanto Avelli da Rovigo, the reverse inscribed, signed with an X and dated 1541
26.5 cm. diam.
The painting of the Sposalizio (the marriage of the Virgin) is from the engraving by Gian Giacomo Caraio after the drawing by Parmigianino

**4.** A circular plate, circa 1550
26 cm. diam.

**5.** A relief, first half of 17th century
45 cm. x 27.5 cm.

**6.** A dated tazza, painted by Francesco Xanto Avelli da Rovigo, signed XANTUS F., the reverse inscribed and dated 1538
26 cm. diam.

**7.** A large two-handled istoriato vase, workshop of Orazio Fontana, circa 1560
58 cm. high

**8.** An istoriato dish painted in the manner of Pseudo-Pellipario, inscribed on the reverse, circa 1535
27.5 cm. diam.

**9.** A crespina, probably by Guido Durantino, circa 1540
26 cm. diam.

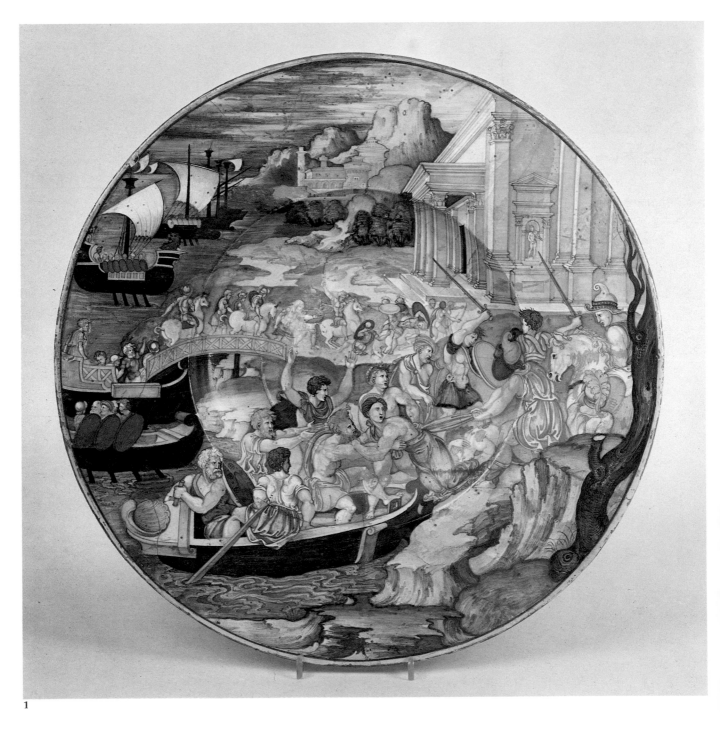

1

2

3

4

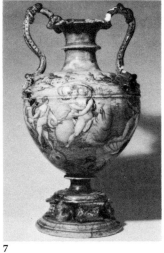

5

6

7

8

9

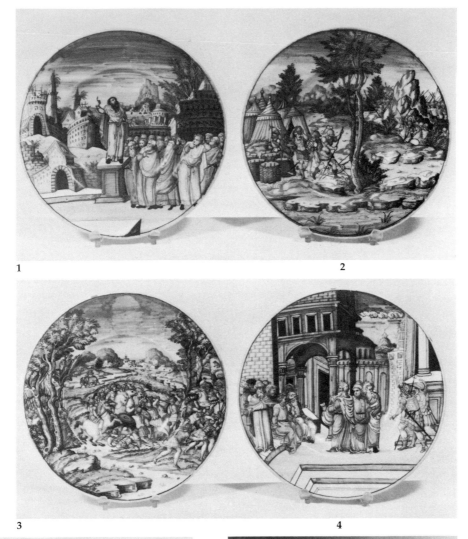

1

2

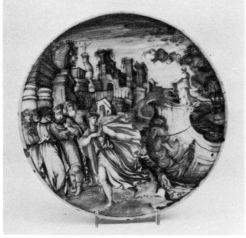

3

4

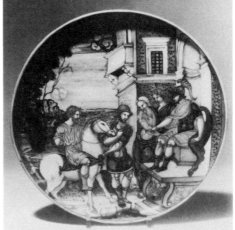

5

6

**1.** An istoriato circular dish, from the Guidobaldo service, 1565-71, the reverse inscribed no. 109
24.1 cm. diam.

**2.** An istoriato circular dish, from the same series, the reverse inscribed, no. 93
24.1 cm. diam.

**3.** An istoriato circular dish, from the same series, the reverse inscribed
27.3 cm. diam.

**4.** An istoriato circular dish, from the same series, the reverse inscribed
27.3 cm. diam.

**5.** An istoriato dish, the reverse inscribed, circa 1550
22 cm. diam.

**6.** An Urbino istoriato alzata painted by Nicola Pellipario, the reverse inscribed in blue, circa 1535
28 cm. diam.

**7.** A pair of istoriato albarelli, mid-16th century
20 cm. high

**8.** An istoriato dish probably painted by Francesco Xanto Avelli da Rovigo, the reverse inscribed and dated 1546
25.5 cm. diam.

**9 and 10.** A pair of waisted pharmacy jugs, circa 1590
19 cm. high

**11.** An istoriato tazza, circa 1545
27 cm. diam.

**12.** An istoriato deep dish, circa 1550
27 cm. diam.

**13.** An istoriato tazza, circa 1540
25.5 cm. diam.

**14.** An istoriato shallow bowl, the reverse inscribed, circa 1560
31 cm. diam.

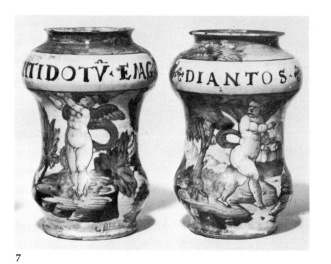

7

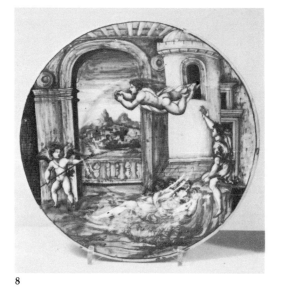

8

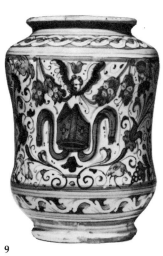

9

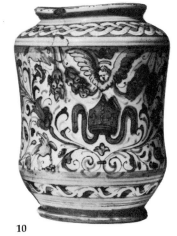

10

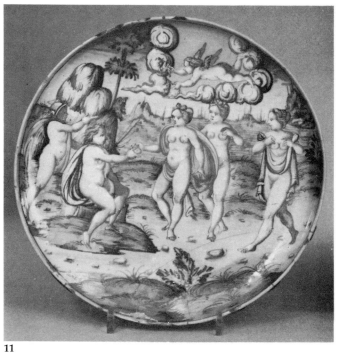

11

12

13

14

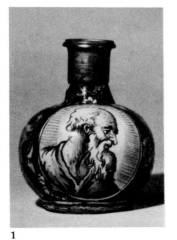

1

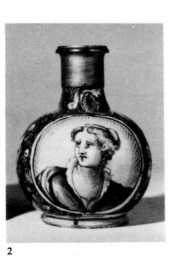

2

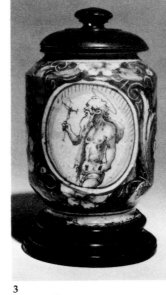

3

**1 and 2.**  Two bottle vases, circa 1600
21.5 cm. high

**3.**  An albarello, circa 1550
17.5 cm. high

**4.**  A vaso a palla, circa 1550
30 cm. high

**5.**  An albarello, circa 1540
31 cm. high

**6.**  An albarello, circa 1570
33 cm. high

**7 and 8.**  A pair of blue and white waisted albarelli, circa 1600
22 cm. high

**9.**  A dish of cardinal's hat form, the workshop of Maestro Lodovico, cross mark, circa 1540
26 cm. diam.

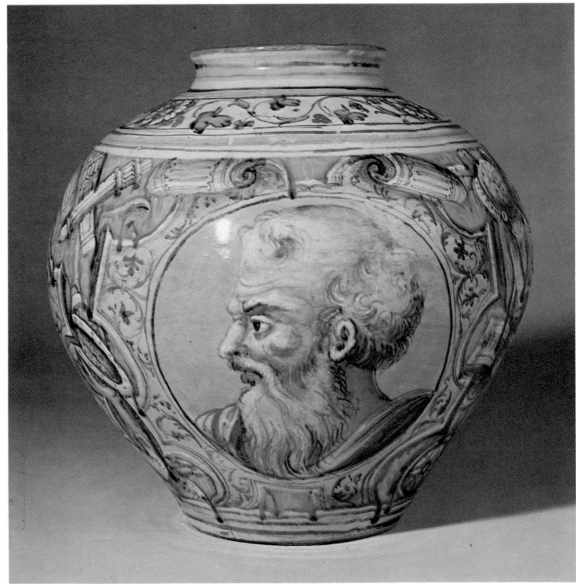

4

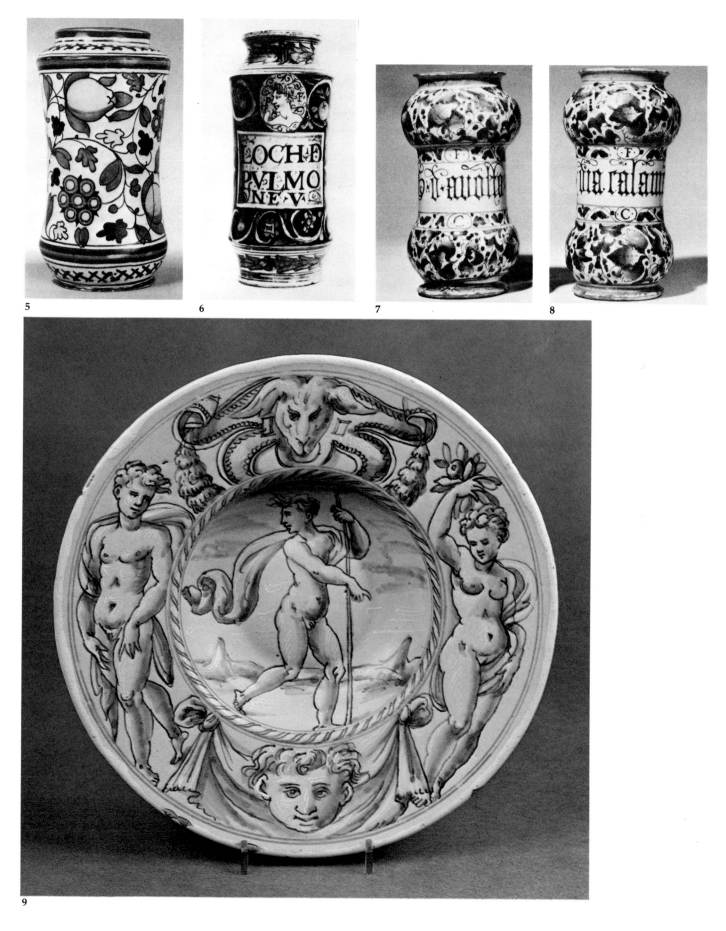

5    6    7    8

9

1.  An istoriato dish, the reverse inscribed in blue, circa 1550
20 cm. diam.

2.  An istoriato dish, circa 1545
26.5 cm. diam.

3.  Three small waisted albarelli, mid-16th century
13.5 cm. high

4.  A pair of two-handled drug jars, circa 1550
37.5 cm. high

5.  A pair of wet-drug jars, circa 1560
22.5 cm. high

6.  A blue and white ewer, workshop of Domenego da Venezia, circa 1555
33 cm. high

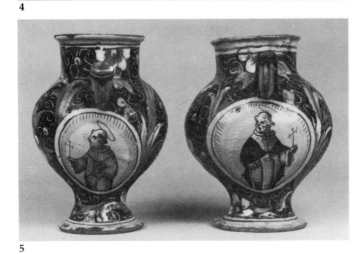

**7.** An istoriato dish, the reverse inscribed, circa 1560
29.5 cm. diam.

**8.** An istoriato tazza, the reverse inscribed, circa 1550
25.5 cm. diam.

**9.** An oviform vaso a palla, last third of 16th century
29 cm. high

**10.** A blue and white armorial oviform jar, circa 1550
24 cm. high

**11.** A berrettino blue and white oviform pharmacy ewer, circa 1580
35.5 cm. diam.

**12.** A pair of vasi a palla, circa 1550
28 cm. high

**13.** Two oviform vases, circa 1550
32 cm. high

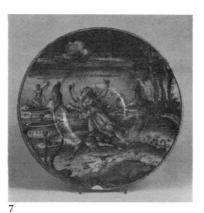

7

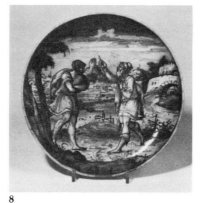

8

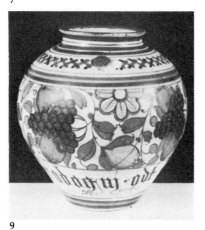

9

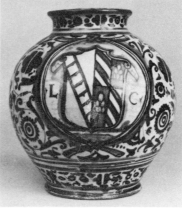

10

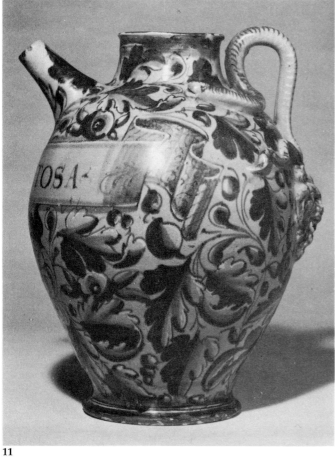

11

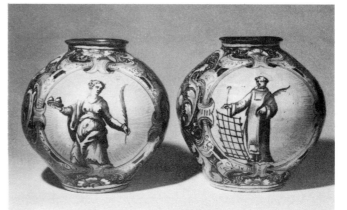

12

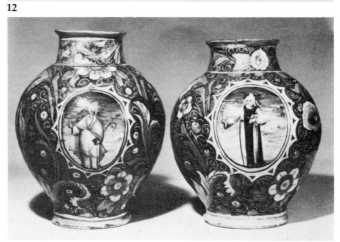

13

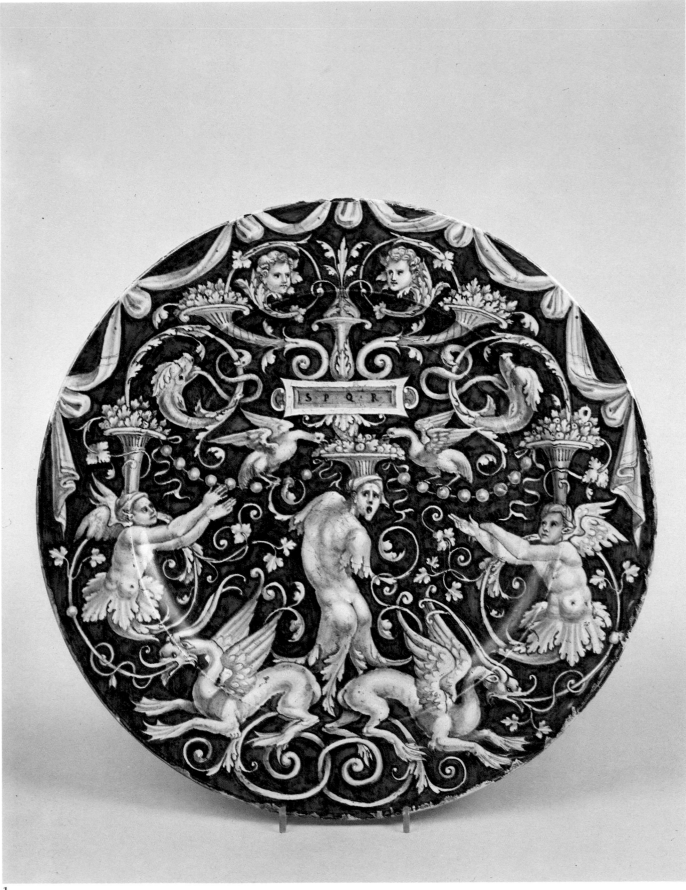

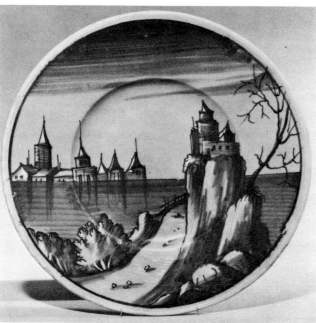

2

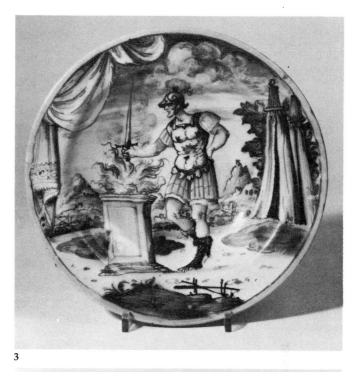

3

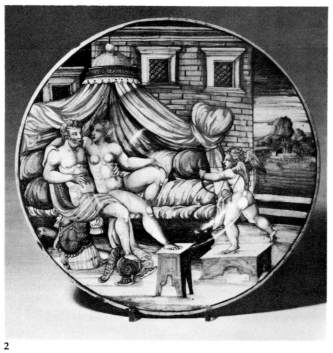

4

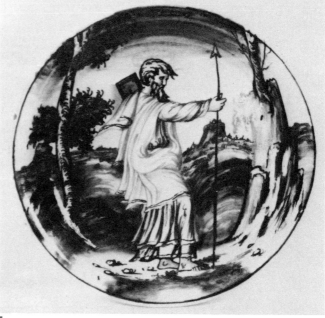

5

**1.** A large blue-ground dish of a candelieri type, circa 1525
48 cm. diam.
One of the largest and most elaborate pieces of this type, this dish is by the same master as the armorial dish with the arms of Imhof and Schlaudersbach, made before 1525 and illustrated by B. Rackham: *Islamic Pottery and Italian Maiolica*, pls. 208, 209, no. 450

**2.** An istoriato dish, the reverse inscribed, circa 1560
30.5 cm. diam.

**3.** An istoriato dish, circa 1560
24 cm. diam.

**4.** A blue and bianco-sopra-bianco tondino from the workshop of Maestro Lodovico, circa 1540
19 cm. diam.

**5.** An istoriato saucer-dish, circa 1545
25 cm. diam.

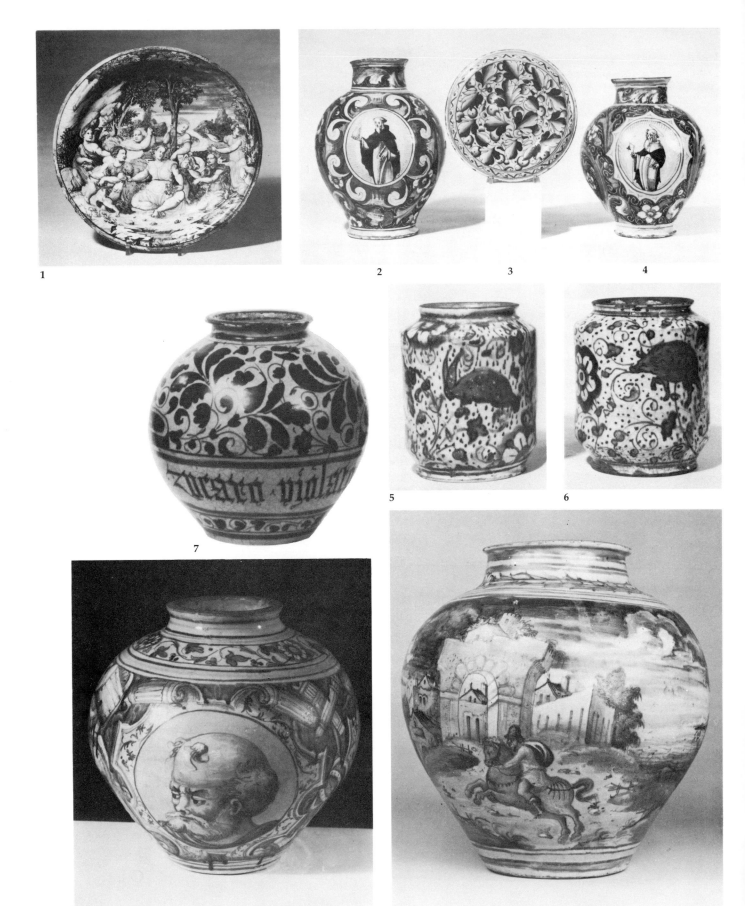

1. An istoriato shallow bowl, the reverse inscribed, circa 1550
30.5 cm. diam.

2. A baluster jar, late 16th century
33 cm. high

3. A berrettino tondino painted by Maestro Domenico, circa 1540
24 cm. diam.

4. A baluster jar, late 16th century
29 cm. high

5 and 6. A pair of albarelli, mid-16th century
15.5 cm. high

7. A blue and white oviform jar, circa 1530
23 cm. high

8. An oviform vaso a palla, signed S.V.P., circa 1540
30.5 cm. high

9. A vaso a palla, early 16th century
35 cm. high

10. A large istoriato dish, Venice or Lyons, circa 1560
36 cm. diam.

11. An istoriato dish, workshop of Maestro Domenico, circa 1545
30 cm. diam.

12. A berrettino dish, circa 1540
31 cm. diam.

13. A berrettino ground plate, circa 1560
21.5 cm. diam.

14. An albarello, circa 1550
40 cm. high

15. A vaso a palla, circa 1550
27 cm. high

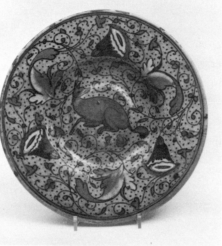

10

11

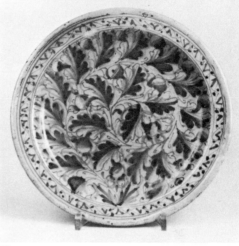

12

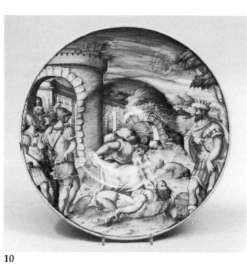

13

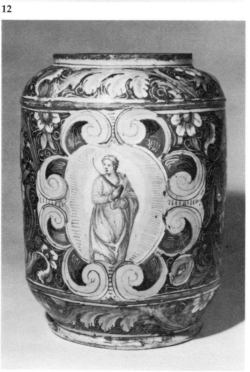

14

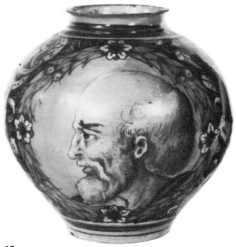

15

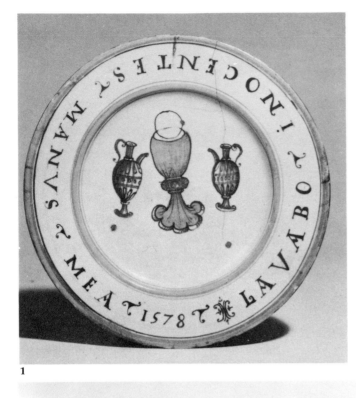

1

2

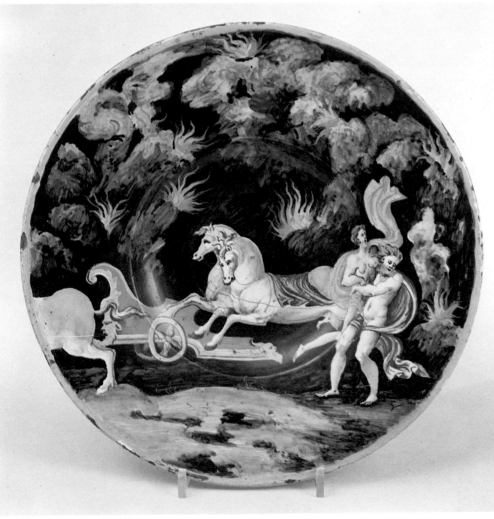

3

**1.** A Montelupo dish, inscribed and dated 1578
24.5 cm. diam.

**2.** A Montelupo dated oval plaque, dated 1587
48 cm. high

**3.** A Rimini istoriato dish, the reverse inscribed in blue Plutone e Preserpina, 1541
31 cm. diam.

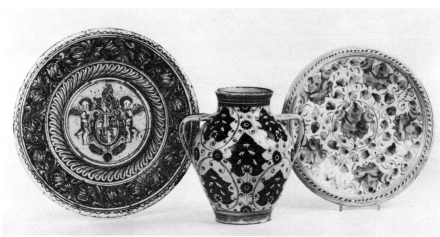

**4**     **5**     **6**     **7**

**4.** A Montelupo armorial dish, with the arms of Visconti quartering another, circa 1660
37 cm. diam.

**5.** A Montelupo two-handled baluster jar, circa 1550
25 cm. high

**6.** A Montelupo circular dish, circa 1660
31.5 cm. diam.

**7.** A small Montelupo albarello, end of 15th century
19 cm. high

**8.** A pair of Montelupo peacock-pattern albarelli, circa 1515
23 cm. high

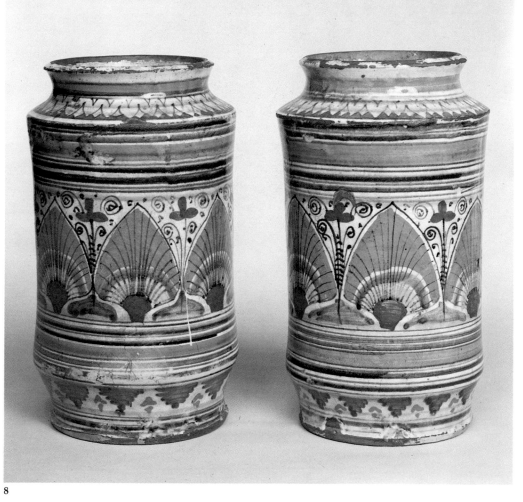

**8**

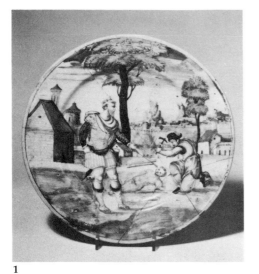

1

1A

1 and 1A.  A dated Pesaro istoriato dish, inscribed on the reverse 'Asa diffa 'Idol bugiardo e. fesso .. 1576 ..S'
24 cm. diam.

2.  A Pesaro istoriato dish, circa 1540
27 cm. diam.

3.  A Montelupo fluted dish, early 17th century
28 cm. diam.

4.  A Rimini istoriato crespina, the reverse inscribed Peperillo, circa 1545
25 cm. diam.

5.  A Rimini istoriato dish, circa 1560
26.5 cm. diam.

6.  A Montelupo dish, blue M monogram, circa 1600
22 cm. diam.

7.  A Montelupo pharmacy ewer, mid-16th century
40 cm. high

8.  A Rimini istoriato dish, inscribed on the reverse, circa 1540
44.5 cm. diam.

9.  A Rimini istoriato dish, circa 1545
28.5 cm. diam.

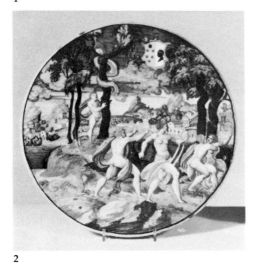

2

3

4

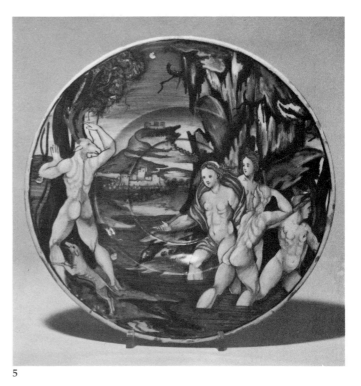

5

6

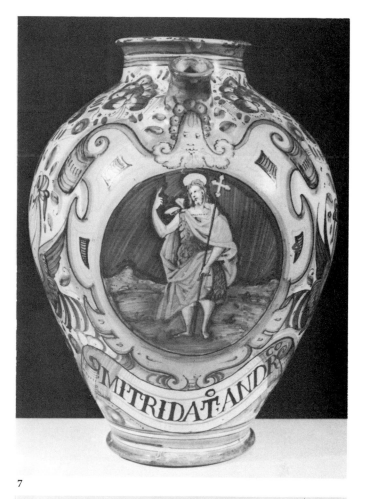

7

8

9

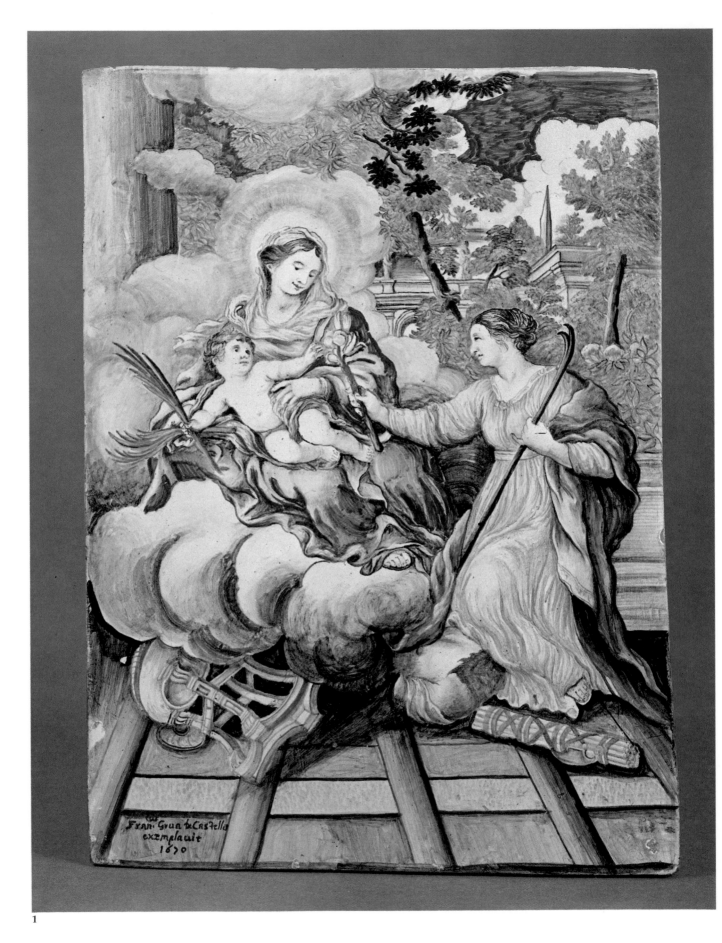

# ITALY POST-1600

Shortly after the middle of the sixteenth century there was a significant change in the nature of the pottery that was produced. For at least another fifty years the prevailing style continued in some areas, but gradually the pottery of Italy became part of a wider spectrum and made its influence felt beyond the fairly limited geographic area it had previously occupied. The established centres of production waned in importance. Florence, responsible for the finest output in the fifteenth century, was by the late sixteenth century a relatively minor centre, though at Montelupo, just outside the city, production of somewhat rustic dishes went on, depicting warriors, horsemen, and occasionally ladies, full length in ochre, green, and blue on rather garish yellow grounds with sketchy landscapes. Casteldurante (by now called Urbania), Deruta, and Urbino all continued to produce debased versions of their earlier wares and only Faenza remained a really significant centre.

Here wares with white grounds started to appear from as early as 1560 and were already well established by 1570. This new style, because of its fairly summary and sketchy type of decoration, was to acquire the name *compendiario*. Its initiator appears to have been Virgiliotto Calamelli. An inventory of his stock-in-trade of 1556 already contains a reference to moulded and basket-work wares in white and to *credenze* or services for display on *cassoni* and other pieces of furniture. The most successful exponent of this style was Leonardo di Ascanio Bettisi, known as Don Pino, to whom Elisabetta delle Palle, widow of Virgiliotto, rented his *bottega* on the latter's death in 1570. Don Pino's masterpiece and the finest example of the compendiario style was the *credenza* of one hundred and twenty pieces executed about 1576 for Elector Albrecht V of Bavaria.

The success of the compendiario style led to its diffusion and imitation throughout Italy and over the Alps into southern Germany and France. The style was so consistent that the products of the various centres are virtually impossible to distinguish.

In Sicily, the *a quartieri* style seen at Faenza continued at Palermo until after the end of the century. Pieces made there can sometimes be identified with certainty owing to the letters SPQP (Senatus Populusque Panormitamus) which are concealed in the decoration. Other centres such as Burgio, Sciacca, and Caltagirone continued to produce progressively debased pieces in this style until

**1.** A Castelli rectangular plaque painted by Francesco Antonio Grue, inscribed and dated 1670
37.5 cm. x 27.5 cm.

**2.** A pair of Naples (Ferdinand IV) creamware vases, late 18th century
46.5 cm. high

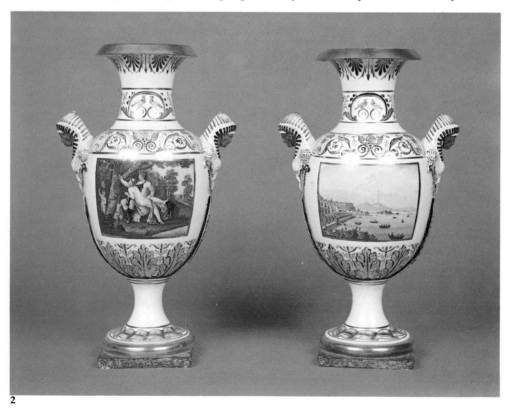

well into the eighteenth century.

Trapani, on the south-west coast of the island, was a centre that produced wares of an individual design. Albarelli of a peculiarly slender type occur, decorated with ribbons and armorial cartouches. In Apulia, at Laterza, not far north of Taranto, a relatively small town of some 3500 inhabitants supported a thriving pottery for the whole of the seventeenth century. Initially the wares were in typical compendiario style, but in the second half of the century the dominant personality of Angelo Antonio di Alessandro asserted itself. The result was a series of large blue and white dishes, their centres painted with naive interpretations of recent masterpieces in a style reminiscent of Paolo Uccello two hundred years earlier. The borders were decorated with scrolls and formal foliage in a strongly Siculo-Arabic vernacular. In the Abruzzo behind Naples was the small and rustic centre of Cerreto Sannita, which operated throughout the late seventeenth and eighteenth centuries and was particularly successful in its output of bénitiers with a dominant feature of a scrolly strap-work surround to the back-plate. Vases and other wares were also enriched in the same way.

North-eastwards in the Abruzzo was Castelli. From 1650 until well into the nineteenth century this was a major centre of production. Like Laterza, Castelli initially produced wares of compendiario type. The majority of these were made by Antonio Lolli who was active at the beginning of the seventeenth century. Like d'Alessandro at Laterza he produced somewhat naive interpretations of contemporary engravings after the masters.

The golden age of maiolica-making at Castelli was established in the third quarter of the seventeenth century by the Grue dynasty, whose style and output was to dominate the factory's output for over a century. The wares produced remained consistent in type and shape throughout the whole period and were principally circular dishes, covered campana-shaped vases, trembleuse beakers, and saucers.

Initially the wares still showed the strong white ground of the compendiario style. By the beginning of the eighteenth century richer tonality was developed by Carlo Antonio Grue, who must also be given credit for the introduction of gilding on Castelli wares. Many signed examples exist by various members of the Grue family and by the Gentile brothers who worked in much the same style. Like the sixteenth-century istoriato painters, the Castelli maiolicari leant heavily on engraved sources for their subject material, using the work of Berchem, Tempesta, Bloemart, Lairesse, and Odoardo Fialetti among others. Francesco Antonio Saverio Grue, like many potters before and since, led a peripatetic existence and, apart from taking a degree at Naples university, worked for a time at the Capodimonte factory and as a potter in both Naples and Bussi.

Easily confused with the wares of Castelli are the pieces made by Bartolomeo Terchi at S. Quirico d'Orcia, near Siena, and at Bassano Romano. Terchi used a very similar palette to the Castelli painters but had an individual and unmistakable way of painting the roots of the trees in his landscapes. For a long time it was thought that he worked at Bassano del Grappa in the Veneto, but the latest research has proved that it was Bassano Romano or Bassano di Sutri.

At Pesaro and Faenza there was an extensive production of faience throughout the latter part of the eighteenth century. This was very much influenced by the wares that were being produced all over France and the German-speaking world, and sometimes the products are hard to distinguish from contemporary pieces from elsewhere. Callegari e Casali at Pesaro and Conte Camillo Ferniani at Faenza were the leading manufacturers. Further north in and around Milan there were more factories making petit-feu wares. Lodi is a few miles from Milan but the products of the Rossetti and Ferretti factories there are almost indistinguishable from those of the Rubati and Clerici factories in the city itself. Here too the styles were within the mainstream of European faience, though Clerici's wares in particular were unusual, both in their very amusing figure decoration and their coloured grounds, which reflect the all-pervasive influence of Sèvres porcelain. The other strong sources of inspiration were the Chinese export wares in the Imari palette or with *famille rose* decoration. The Milan and Lodi factories drew on these sources deeply and almost slavishly: as with the finest Dutch Delft pieces copied from Chinese originals, these Milan imitations are very hard to tell from the originals at a distance of a few feet.

The area surrounding Genoa was a fecund centre of maiolica production throughout the seventeenth and eighteenth centuries, reaching the peak of quality and expression in the third quarter of the seventeenth century. At Savona and Albisola emphasis was laid on the production of pharmacy jars of the most elaborate sort and large dishes for display. The classic Savona wares were finely potted and decorated with figures, generally mythological or religious in tone, in blue and white. Many of them are armorial. There were several factories operating in Savona and Albisola, owned by the Falco, Guidobono, Girodano, and other families, but their styles and products were remarkably homogeneous and unless individual specimens are marked attribution is difficult.

In Piedmont there was a production of maiolica in Turin. Here the dominant influence was the taste of France and much early eighteenth-century Turin faience can easily be confused with the wares of Moustiers and Alcora. This is due not merely to a common source of inspiration in the engravings of Jean Bérain but to the constant exchange of workmen between France and Italy. The leading family in Torinese faience was the Rossettis. Of these the eldest was Giorgio Rossetti di Macello, who was active in Turin around 1725, but the most important was his nephew Giorgio Giacinto Rossetti, who produced and signed pieces both at Lodi, where he was active around 1730, and Turin where he signed work in 1736. Whether he commuted between the two or worked for a period in Lodi before settling down in Turin is by no means clear. The pieces he made in both

places are very similar, evolving gradually from the Bérainesque into formal concentric late baroque designs. By the middle of the century his wares were distinctly rococo in spirit: central landscape and figure subjects were surrounded by asymmetrical scrollwork and the borders decorated with panels of trellis and scrolls. The palette used, of yellow, ochre, manganese, and green, is reminiscent of that already in use at Moustiers and Alcora and reflects the constant links Savoy had with France.

In Venice and the Veneto region the links were with the Near East. These are reflected in the *candiana* wares of Padua, which were produced in the second quarter of the seventeenth century. Very thinly potted and frequently inscribed and dated, they took their inspiration from the wares of Isnik in Turkey. In Venice itself, as well as throughout the Marche and at Faenza, there was a continued production of pharmacy pots and other wares with blue grounds of varying depths of colour. This went on in some centres, such as Gubbio, until well into the eighteenth century. Otherwise not a great deal of maiolica was produced in the city, though large maiolica potiches were made by the Cozzi brothers at their porcelain factory in the 1760s.

In the Veneto, however, there was a lot of activity. The earliest major factory was at Angarano where, during the second half of the seventeenth century, maiolica remarkable both for its sophistication and its almost surreal decoration was made. The wares of Angarano, produced by the Manardi family and their manager Giovanni Antonio Caffa, were more thinly potted than any others. The borders of many of the dishes are treated with repoussé decoration derived from contemporary metalwork. The painted decoration on all the wares of the factory is uncannily spare and restrained: cold tones, such as sepia, grey and blue, predominate and the very landscapes have a lunar quality. The architecture and figures that fill the landscape are reminiscent of the paintings of Monsù Desiderio. The only similar style is to be found in the wares of Holics some forty years earlier.

Also in the Veneto, only a few miles away, was the Bassano factory at Le Nove where in 1728 Giovanni Battista Antonibon established a maiolica factory which has survived to the present day. The initial output was of polychrome wares shaped and decorated in similar fashion to the products of the Rossetti family in Turin. Still-life groups of fruit were a characteristic theme. By 1750 figure subjects are also found, derived from the French engravings which were so popular throughout the potteries and porcelain manufactures of the day. Many of the products of Bassano were tablewares painted with simple designs in a somewhat oriental pattern. Several patterns continued in production for a long period and as a result became automatic and debased in quality. Invention was more prominent in the shapes to which the patterns were applied. Few faience manufacturers can have produced such a compendious range of wares for the table. The success of the porcelain factory set up in the 1760s made large inroads into the market for pottery. As the century drew to its close the factory turned to making large decorative wares including massive vases and mirror frames which were decorated with insipid floral decoration in a palette that included pink. Bassano was the only Italian pottery to display the technical capacity and confidence required for the production of tureens in the shape of animals and vegetables, in the fashion prevailing north of the Alps.

Italy was not immune from the craze for creamware which swept Europe in the wake of Josiah Wedgwood's successful refinement of the material. There were various minor factories in the Veneto producing relatively simple examples of this genre. The most successful centre was Naples, though whether this was a result of her close ties with England is not clear. Some of the creamwares made there by Giustiniani and del Vecchio could very easily be taken for porcelain from the Naples factory, for the quality of the decoration and the sophistication of the shapes echoes rival contemporary porcelain.

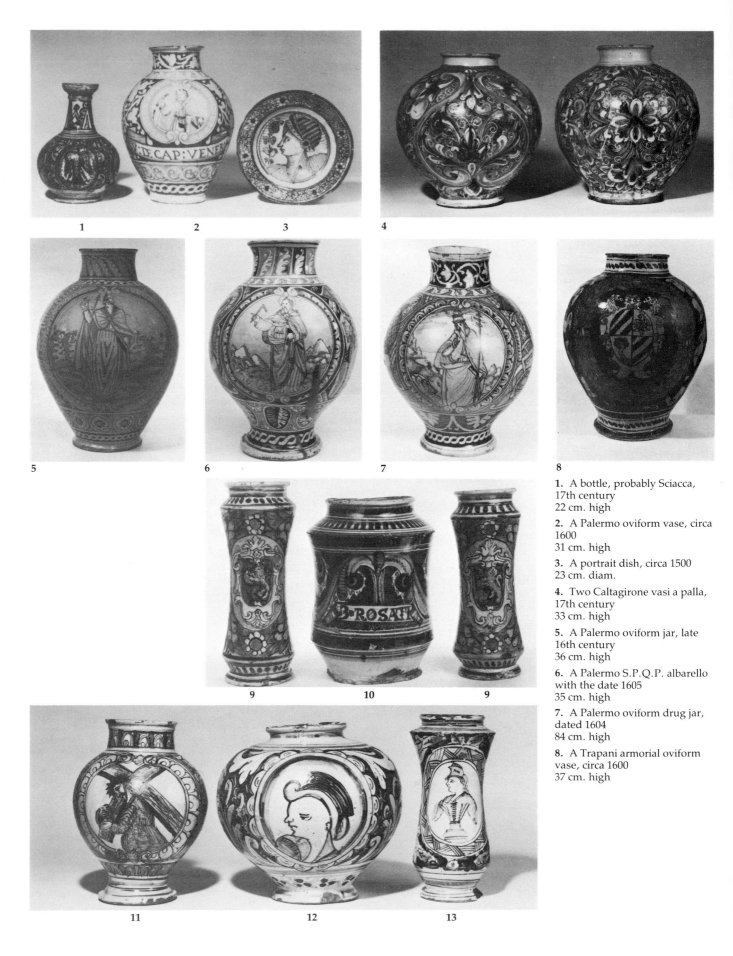

1           2           3           4

5           6           7           8

9           10          9

11          12          13

**1.** A bottle, probably Sciacca, 17th century
22 cm. high

**2.** A Palermo oviform vase, circa 1600
31 cm. high

**3.** A portrait dish, circa 1500
23 cm. diam.

**4.** Two Caltagirone vasi a palla, 17th century
33 cm. high

**5.** A Palermo oviform jar, late 16th century
36 cm. high

**6.** A Palermo S.P.Q.P. albarello with the date 1605
35 cm. high

**7.** A Palermo oviform drug jar, dated 1604
84 cm. high

**8.** A Trapani armorial oviform vase, circa 1600
37 cm. high

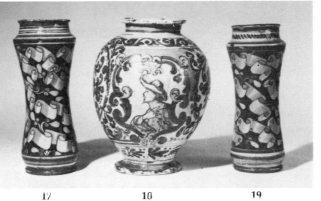

14   15   16    17   10   19

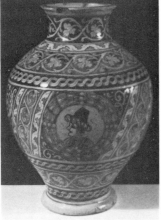

20

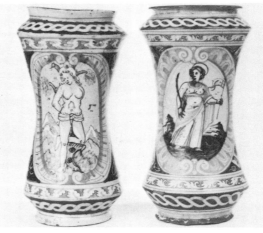

21       22

**9.** Two Trapani albarelli, circa 1600
32 cm. and 30 cm. high

**10.** A Burgio famiglia gotica albarello, circa 1540
29.5 cm. high

**11.** A Sciacca baluster vase, late 17th century
26 cm. high

**12.** A Caltagirone vaso a palla late 17th or early 18th century
25.5 cm. high

**13.** A Sciacca albarello, late 17th century
27 cm. high

**14.** A waisted albarello, late 17th century
31.5 cm. high

**15.** An oviform drug-jar, dated 1685 on the shoulder
32 cm. high

**16.** A waisted albarello, 17th century
31 cm. high

**17.** A Trapani waisted cylindrical albarello, 16th century
32 cm. high

**18.** A Burgio baluster vase, late 17th century
33 cm. high

**19.** A Trapani waisted cylindrical albarello, late 16th century
30 cm. high

**20.** A Palermo baluster vase, circa 1610
34 cm. high

**21.** A famiglia gotica waisted albarello, probably Burgio, circa 1550
29.5 cm. high

**22.** Palermo waisted albarelli, circa 1600
29 cm. high

**23.** A famiglia gotica oviform drug jar, mid-16th century
32 cm. high

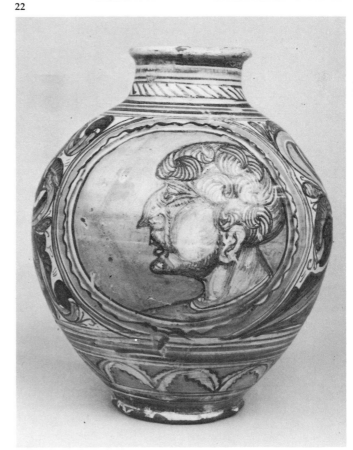

23

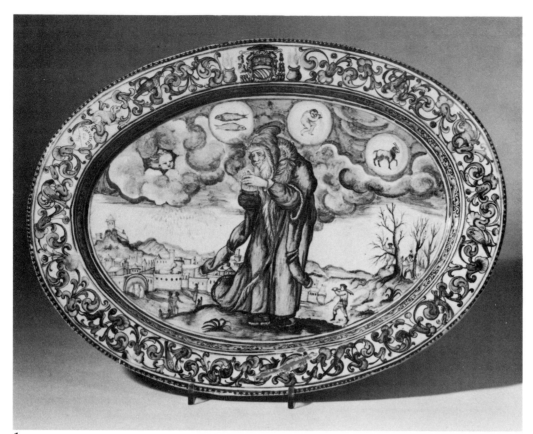

1

**1.** An armorial oval dish painted by Carlo Antonio Grue, circa 1680
46.5 cm. wide

**2.** An oval dish, 1660/1680
46.5 cm. wide

**3.** A circular plate painted by Liborio Grue, circa 1740
17 cm. diam.

**4.** A pair of small circular plates painted in colours enriched with gilding by Aurelio Grue, circa 1750
18.5 cm. diam.

**5.** A circular dish painted by Aurelio Grue, circa 1740
27.5 cm. diam.

**6.** A pair of small circular plates painted in colours enriched with gilding by Francesco Antonio Saverio Grue, circa 1760
18.5 cm. diam.

**7.** A large two-handled jar and cover painted by Antonio Lolli, circa 1680
31.5 cm. high

**8.** A pair of two-handled campana-shaped vases and covers, circa 1750
47 cm. high

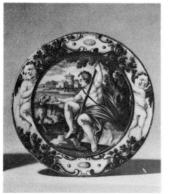

2

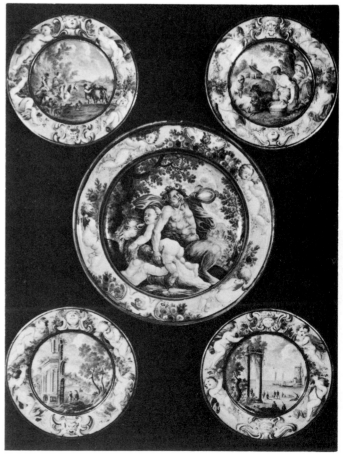

3

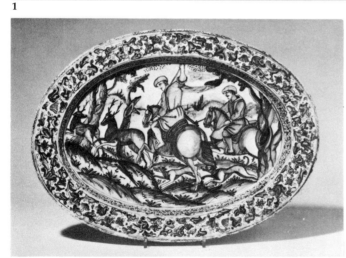

9.  A large waisted albarello, the reverse dated 1697 below the mark of the Carthusian Order of the monastery of San Martino, Naples
32.5 cm. high

10.  A pair of waisted albarelli, blue G.B.C. marks, circa 1680
22.5 cm. high

11.  A tondo painted in the Grue workshop, circa 1750
21.5 cm. diam.

12.  A circular tazza painted by Carlo Antonio Grue, circa 1720
24.5 cm. diam.

13.  A circular dish painted by Saverio Grue, signed S. Grue P, circa 1730
27.5 cm. diam.

14.  A shaped circular dish from the Gentile workshop, circa 1740
25.5 cm. diam.

15.  A tondo, circa 1730
23 cm. diam.

16.  A tondo, circa 1740
19.5 cm. diam.

17.  A pair of armorial wet-drug jars, inscribed and dated 1746
22 cm. high

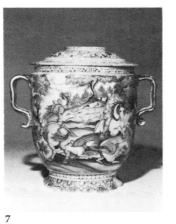

7

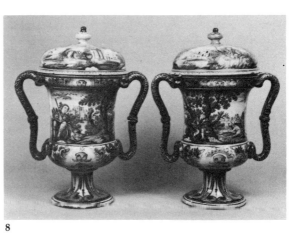

8

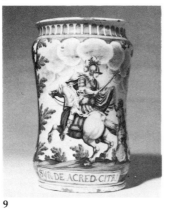

9

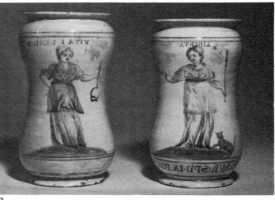

10

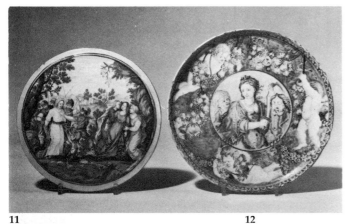

11                           12

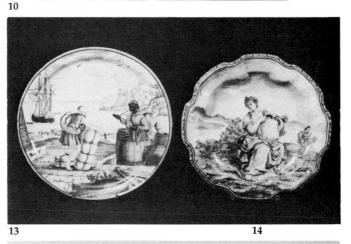

13                                    14

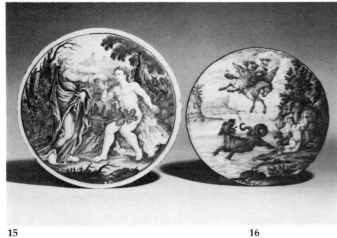

15                           16

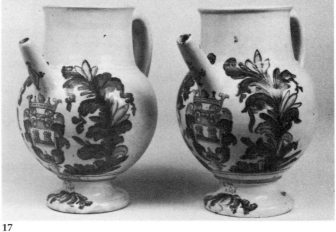

17

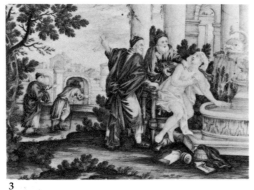

1

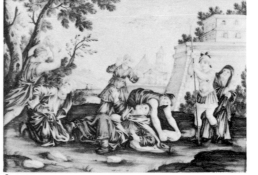

2

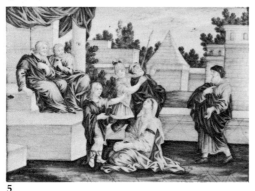

3

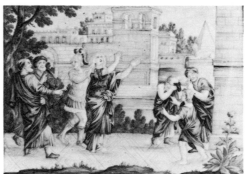

4

5

6

**1 to 6.** A set of six rectangular plaques, workshop of Francesco Grue, early 18th century
33 cm. x 24.5 cm.

**7.** A rectangular plaque painted by Saverio Grue, circa 1720
36 cm. x 28.5 cm.

**8.** A rectangular plaque painted by Francesco Antonio Saverio Grue, circa 1720
35 cm. x 27.5 cm.

**9.** A rectangular plaque painted by Francesco Antonio Saverio Grue, circa 1750
35 cm. x 25 cm.

**10.** A rectangular plaque painted in the Grue workshop, circa 1730
27 cm. long

**11.** A rectangular plaque painted by Aurelio Grue, circa 1740
32 cm. x 25.5 cm.

**12.** A rectangular plaque painted by Aurelio Grue, circa 1720
21 cm. x 27 cm.

**13.** Another rectangular plaque, circa 1720
20.5 cm. x 27 cm.

**14.** A rectangular plaque, circa 1730
26.5 x 19.5 cm.

**15.** A rectangular plaque, circa 1730
27.5 cm. x 21.5 cm.

**16.** A rectangular plaque, circa 1740
23.5 cm. x 18 cm.

**17.** A rectangular plaque, circa 1740
20.5 cm. x 27 cm.

**18.** A rectangular plaque painted by Carlo Antonio Grue, circa 1725
30 cm. wide

7

8

9

10

11

12    13

14    15    16

17    18

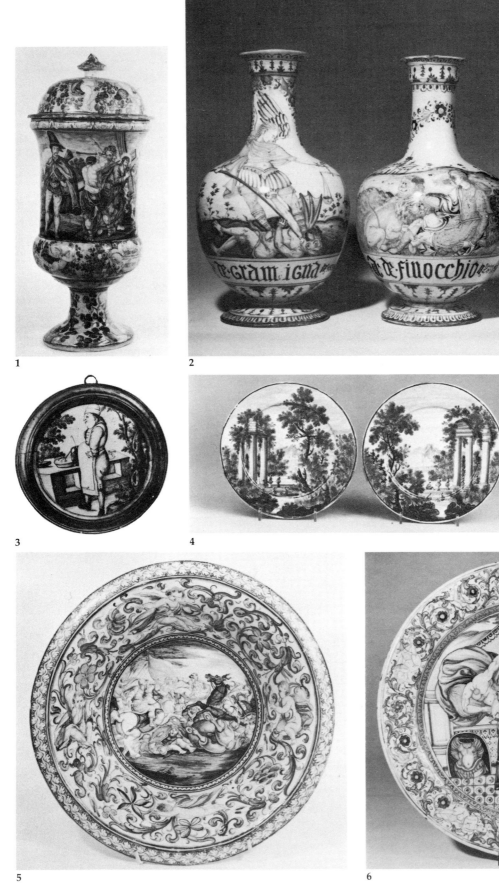

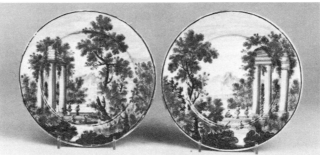

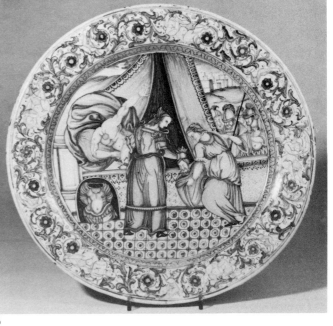

1

2

3

4

5

6

**1.** A vase and cover, circa 1680
61 cm. high

**2.** A pair of pear-shaped
pharmacy vases, circa 1720
42 cm. high

**3.** A tondo painted in the Grue
workshop, circa 1760
23.5 cm. diam.

**4.** A pair of small plates painted
in the Grue workshop, circa 1740
17 cm. diam.

**5.** A circular bowl, painted by
Carlo Antonio Grue, circa 1715
32.5 cm. diam.

**6.** A circular dish, circa 1745
42 cm. diam.

**7.** An oviform pharmacy vase, circa 1750
34 cm. high

**8 and 9.** A pair of rectangular plaques painted by Aurelio Grue, circa 1730
30.5 cm. wide

**10.** A rectangular plaque, circa 1760
25.5 cm. x 19.5 cm.

**11.** A pear-shaped ewer, circa 1730
25 cm. high

**12.** A plate painted by Carlo Antonio Grue, circa 1720
25.5 cm. diam.

**13.** A plaque painted by Carmine Gentile, signed, second quarter of 18th century
28 cm. x 38 cm.

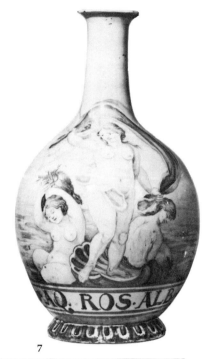

7

8

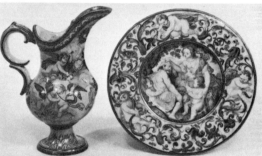

9

10

11                12

13

1

2                                3                                4

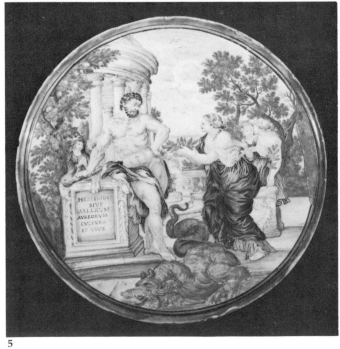

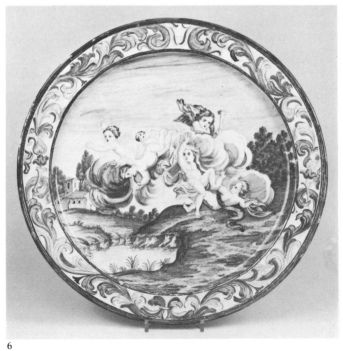

5                                                    6

**7.** A circular dish, circa 1700
24 cm. diam.

**8.** A tondo painted by Francesco Antonio Saverio Grue, circa 1740
22 cm. diam.

**9.** A large circular plate painted by Nicolò Tommaso Grue, circa 1760
42 cm. diam.

**10.** An armorial dish probably painted by Liborio Grue, circa 1740
28.8 cm. diam.

**11.** A tondo painted in the Grue workshop, circa 1740
31.5 cm. diam.

**12.** An armorial dish painted in the Grue workshop, circa 1720
49 cm. diam.

7

8

9

10

11

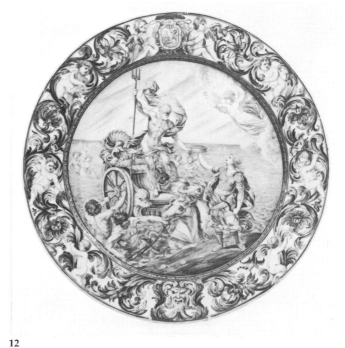

12

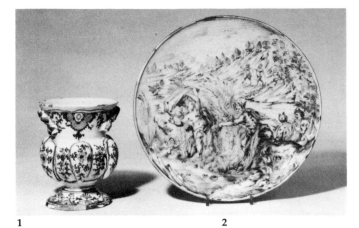

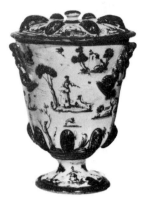

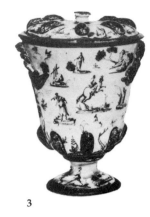

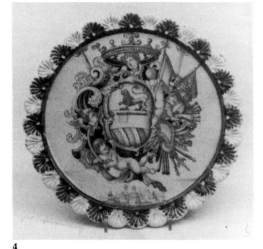

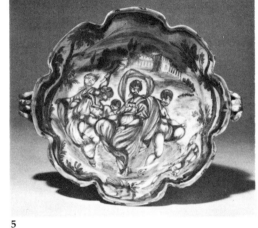

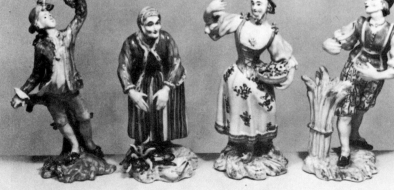

1. A two-handled baluster vase, star mark, first half of 18th century
19 cm. high

2. A blue and white tazza, first quarter of 18th century
33.5 cm. diam.

3. A pair of Albissola vases, manganese J.B. marks, circa 1750
34 cm. high

4. An armorial blue and white tazza, blue S.A.A. mark, circa 1700
32.5 cm. diam.

5. A two-handled blue and white lobed deep dish, circa 1700
30.5 cm. diam.

6. A pair of blue and white wet-drug jars, gb mark in manganese, circa 1680
18 cm. high

7. A blue and white vase, beacon mark, late 17th century
21 cm. high

8. A blue and white waisted albarello, circa 1680
20.5 cm. high

9. A set of four figures, emblematic of the Seasons, Giacomo Boselli factory, circa 1765
30 cm. amd 30.5 cm. high

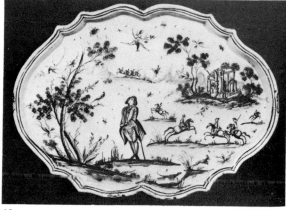

10

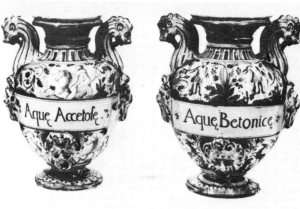

11

**10.** A shaped oval Albissola tray,
Agostino levantino, circa 1760
48.5 cm. wide

**11.** Two blue and white
pharmacy jars, circa 1675
43 cm. high

**12.** A blue and white wet-drug
jar, circa 1680
22 cm. high

**13.** A blue and white pharmacy
jar, second half of 17th century
43.5 cm. high

**14.** A blue and white pharmacy
jar, circa 1670
40 cm. high

**15.** An albarello, dated 1673
18 cm. high

**16.** A pair of blue and white wet-
drug jars, manganese orb marks
and the initial of Agostino
Levantino, circa 1680
18.5 cm. high

**17.** A blue and white waisted
albarello, blue fortress mark,
circa 1680
17.5 cm. high

**18.** An Albissola tazza,
manganese falcon and F mark of
Falco, circa 1760
34.5 cm. diam.

**19.** A two-handled blue and
white drug vase and cover, the
handles formed as camels'
heads, circa 1700
29 cm. high

**20.** A blue and white tazza, blue
crowned arrow mark, late 17th
century
27.5 cm. diam.

12

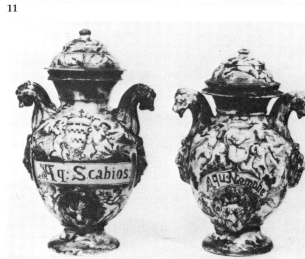

13

14

15

16     17     16

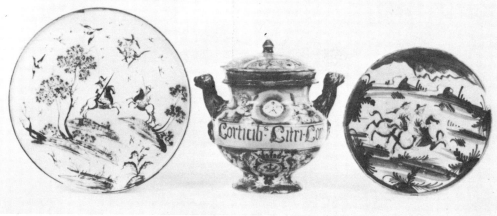

18        19        20

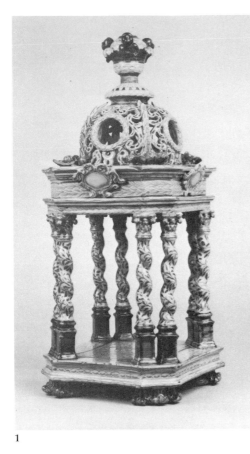

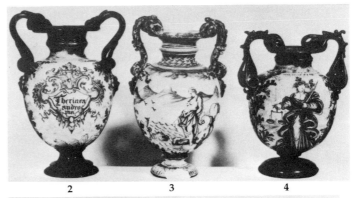

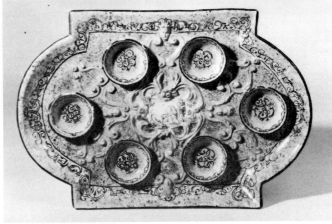

1

5

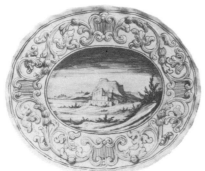

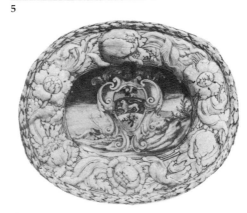

6

7

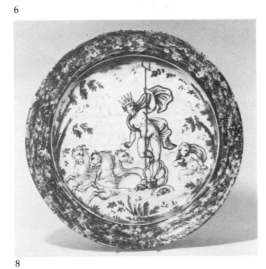

8

9

1. A shaped octagonal baldacchino, circa 1700
56 cm. high

2. A drug vase, late 17th century
49 cm. high

3. A drug vase, dated 1697
48 cm. high

4. A drug vase, circa 1700
44 cm. high

5. A quatrefoil dish, circa 1690
35 cm. wide

6. An oval dish, late 17th century
36 cm. wide

7. An oval dish, crowned manganese AF monogram mark, late 17th century
40 cm. wide

8. A large dish, circa 1700
49 cm. diam.

9. A fluted saucer-dish, possibly Angarano, circa 1700
45 cm. diam.

10                    11

12                              13

**10.** A blue and white manganese tazza, late 17th century
31.5 cm. diam.

**11.** A polychrome plate, late 17th century
37.5 cm. diam.

**12.** A blue and white plate, late 17th century
39.5 cm. diam.

**13.** A plate, late 17th century
47 cm. diam.

**14.** A berrettino oval dish, Manardi's factory, second half of 17th century
26 cm. wide

**15.** A plaque, late 17th century
27.5 cm. wide

**16.** A ewer and shell-shaped dish, perhaps Angarano, circa 1680
the ewer 31.5 cm. high

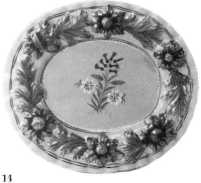

14                    15

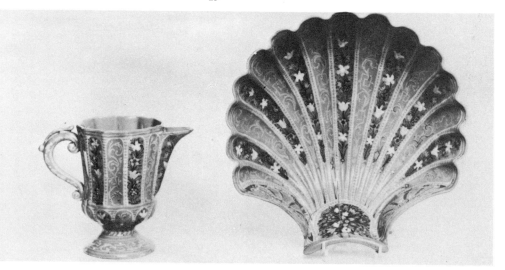

16

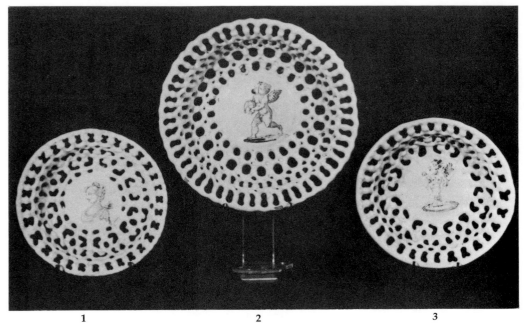

1

2

3

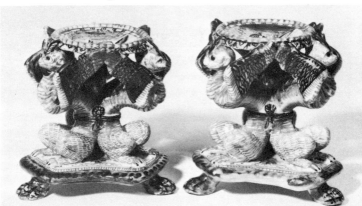

4

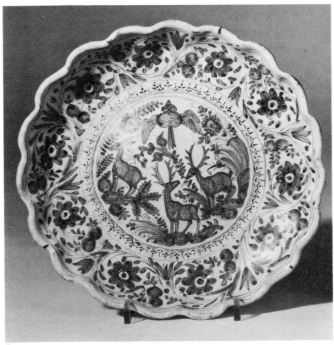

5

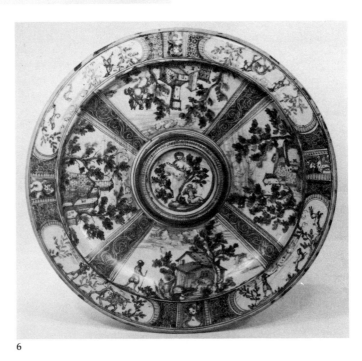

6

1. A Faenza compendiario dish, first half of 17th century
19 cm. diam.

2. A Faenza compendiario dish, first half of 17th century
20 cm. diam.

3. A Faenza compendiario dish, first half of 17th century
19 cm. diam.

4. A pair of Deruta salts, circa 1600
16.5 cm. high

5. A Deruta blue and white fluted crespina, circa 1660
25.5 cm. diam.

6. A Deruta large circular dish, circa 1620
48 cm. diam.

7. A Faenza plate, early 17th century
24 cm. diam.

8. A Faenza armorial plate, dated 1625
25 cm. diam.

9. A Faenza armorial deep dish, late 17th century
39 cm. diam.

10. A Faenza large pear-shaped drug vase, 16th/17th century
41 cm. high

11. A Deruta circular plaque, 17th century
35 cm. diam.

12. A Deruta dish, circa 1610
23 cm. diam.

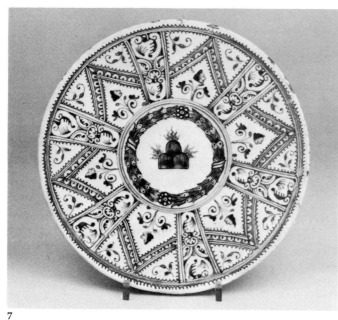

7

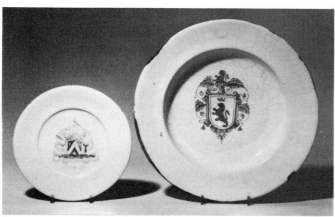

8                              9

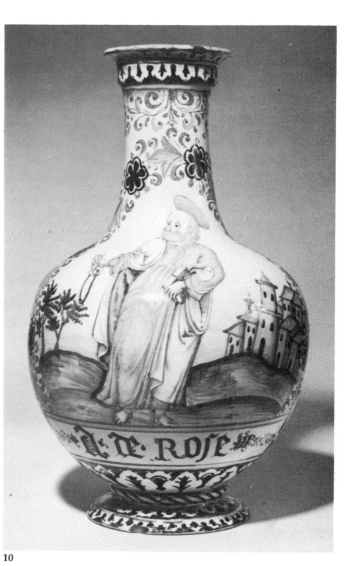

10

11

12

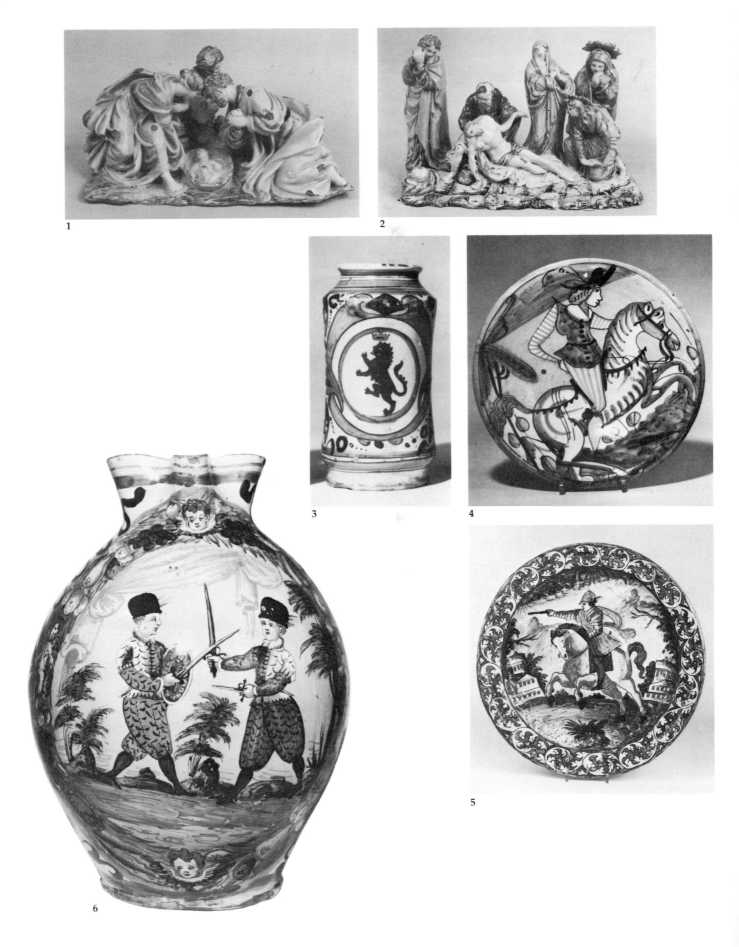

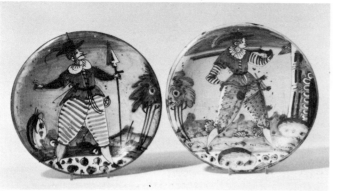

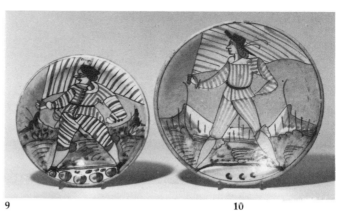

7          8          9          10

**1 and 2.** A pair of groups, circa 1600
about 29 cm. wide

**3.** An armorial waisted albarello, circa 1620
24 cm. high

**4.** A circular dish, circa 1660
30.5 cm. diam.

**5.** A large dish, 17th century
44.5 cm. diam.

**6.** A jug, circa 1610
44.5 cm. high

**7.** A charger, early 17th century
31.5 cm. diam.

**8.** Another charger, early 17th century
32 cm. diam.

**9.** A charger, 17th century
31 cm. diam.

**10.** A dish, early 17th century
24.5 cm. diam.

**11.** A dish, early 17th century
33 cm. diam.

**12.** A crespina, 17th century
25.5 cm. diam.

**13.** A portrait dish, 17th century
31 cm. diam.

**14.** A tazza, 17th century
23 cm. diam.

**15.** A compendiario crespina, perhaps Deruta, circa 1660
33 cm. diam.

**16.** A circular dish, 17th century
32 cm. diam.

**17.** An armorial wet-drug jar, circa 1620
27cm. high

**18.** A Montelupo coppa amatoria, the reverse dated 1563
23.5 cm. diam.

**19.** A Montelupo dish, circa 1600
26 cm. diam.

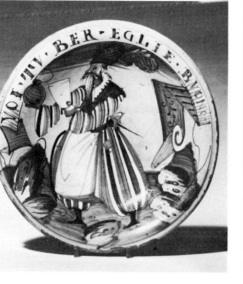

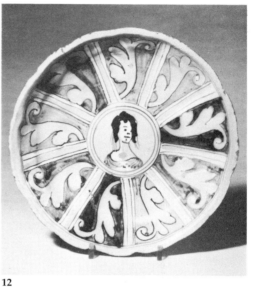

11          12

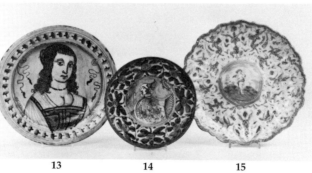

13      14      15      16

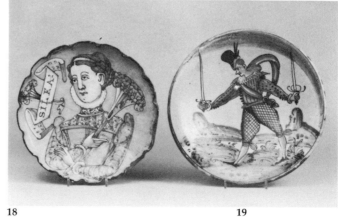

17          18          19

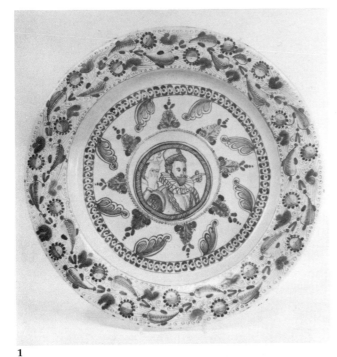

1

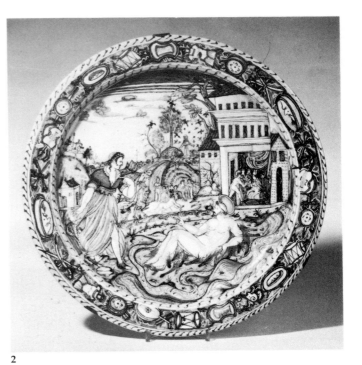

2

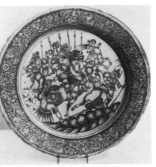

3          4

5

6    7    8    9

10        11        12        13

1. A South Italian circular dish, probably Laterza, mid-17th century
45 cm. diam.

2. A South Italian dish, circa 1650
41 cm. diam.

3 and 4. Two Laterza dishes, early 17th century
47 cm. diam.

5. A South Italian octagonal storage jar and cover, 17th century
38 cm. high

6. A Cerreto Sannita candlestick figure, 18th century
22 cm. high

7. An Apulia candlestick figure, probably Caroline Bonaparte, consort of Joachim Murat, King of Naples, 1808-15
32 cm. high

8. An Apulia candlestick figure, probably Joachim Murat, King of Naples, 1808-15
30 cm. high

9. An Apulia candlestick figure, 18th century
17cm. high

10. A Cerreto Sannita candlestick, 18th century
22 cm. high

11. An Apulia candlestick figure, 17th century
39 cm. high

12. An Apulia candlestick figure, 17th century
31.5 cm. high

13. A South Italian candlestick figure, 18th century
23 cm. high

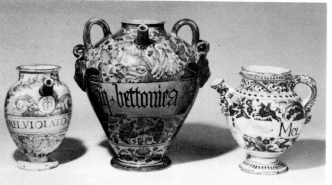

14   15   16

17

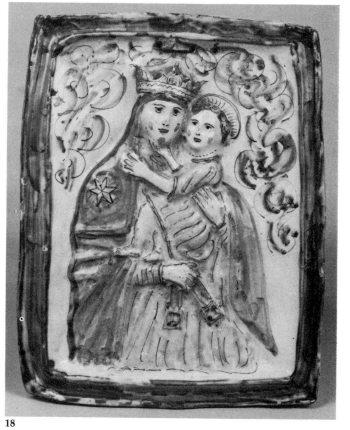

18

**14.** A Deruta wet-drug jar, with the date 1609
22 cm. high

**15.** A Marchigian berrettino two-handled pharmacy ewer, second half of 17th century
33 cm. high

**16.** A Savona blue and white wet-drug jar, mid-17th century
23.5 cm. high

**17.** A Naples armorial waisted albarello, late 17th century
19.5 cm. high

**18.** A Cerreto Sannita rectangular plaque, circa 1650
32 cm. high

**19.** Four Marchigian berrettino albarelli, late 17th century
22 cm. high

**20.** A Marchigian berrettino albarello, late 17th century
22.5 cm. high

**21.** A Savona blue and white wet-drug jar, late 17th century
18 cm. high

**22.** A Marchigian berrettino albarello, late 17th century
21.5 cm. high

**23.** A Marchigian berrettino blue and white wet-drug jar, dated 1702
18.5 cm. high

**24.** A Marchigian berrettino waisted albarello, 17th century
22 cm. high

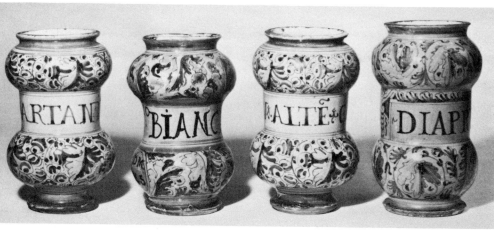

19

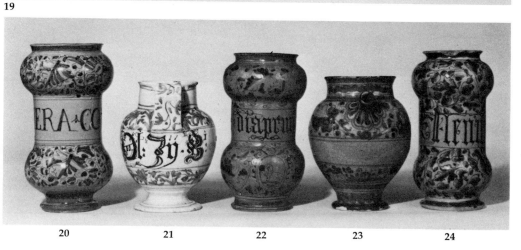

20   21   22   23   24

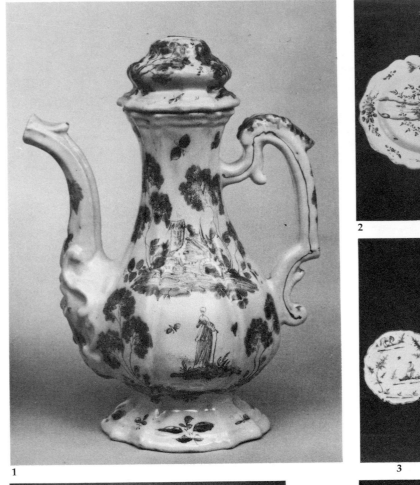

1

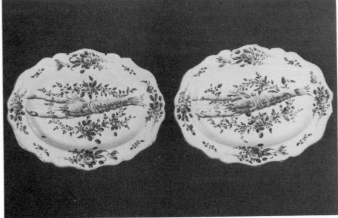

2

3                    4                    5

6          7          6

8              9              10

11

12

**1.** A Lodi octagonal pear-shaped coffee-pot and domed cover, circa 1740
27.5 cm. high

**2.** A pair of Pesaro oval dishes, circa 1765
40 cm. wide

**3.** A Milan (Felice Clerici) polychrome plate, circa 1765
19 cm. diam.

**4.** A Milan (Pasquale Rubati) oval dish, circa 1760
37.5 cm. wide

**5.** A Milan (Pasquale Rubati) plate, circa 1775
23.5 cm. wide

**6.** A pair of Faenza (Ferniani) plates, circa 1760
26.5 cm. diam.

**7.** A Faenza (Ferniani) circular basket, circa 1760
20 cm. diam.

**8.** A Milan (Felice Clerici) plate, circa 1760
23 cm. diam.

**9.** A Lodi (Coppellotti) tureen and cover, circa 1735
23.5 cm. diam.

**10.** A Lodi (Antonio Ferrerri) plate, circa 1765
27 cm. diam.

**11.** A Faenza (Ferniani) soup tureen, cover, and stand, circa 1750
the stand 38.5 cm. wide

**12.** A Lodi oblong octagonal butter-dish, cover, and stand circa 1770
the stand 17.5 cm. wide

**13.** Part of a Milan dinner and dessert service, circa 1770

**14.** Part of a Lodi (Antonio Ferretti) dinner service, circa 1770

**15 and 16.** Part of a Faenza (Ferniani) dinner service, circa 1760

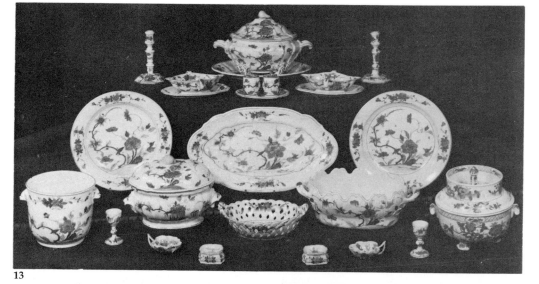

13

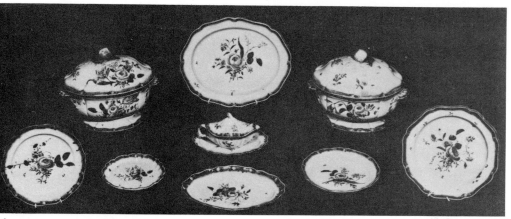

14

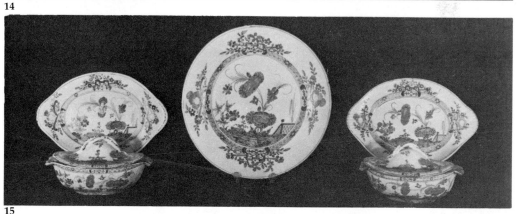

15

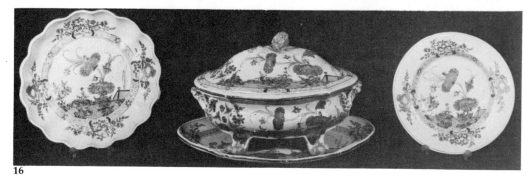

16

1. A pair of Milan (Pasquale Rubati) flower vases, manganese mark, circa 1770
21.5 cm. wide

2. A Milan (Felice Clerici) figure of a magot, circa 1750
34 cm. high

3. A Milan (Pasquale Rubati) flower vase, circa 1765
22 cm. wide

4. A Lodi coffee-pot and cover, second quarter of 18th century
21 cm. high

5. A pair of Milan (Felice Clerici) vases, circa 1760
20.5 cm. high

6. A Milan (Antonio Ferretti) plate, circa 1770
23 cm. diam.

7. A Milan plate, circa 1760
23 cm. diam.

8. A pair of Milan (Pasquale Rubati) oval shell-shaped dishes, circa 1775
24.5 cm. wide

9. A pair of Milan (Pasquale Rubati) hexafoil saucer-dishes, circa 1775
28 cm. diam.

10. A Turin (G.G. Rossetti) octafoil soup plate, circa 1760
25 cm. diam.

11. A Milan (Pasquale Rubati) plate, circa 1770
23 cm. diam.

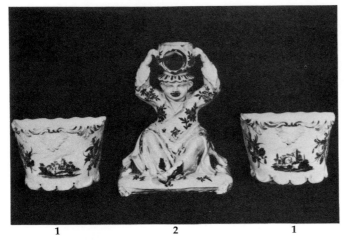

1     2     1

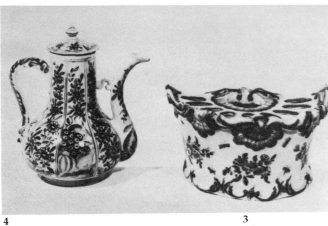

4     3

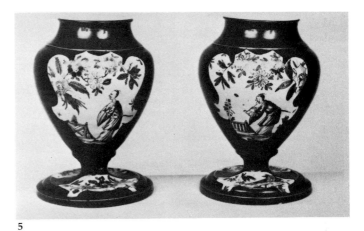

5

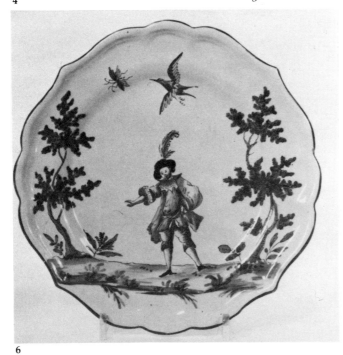

6

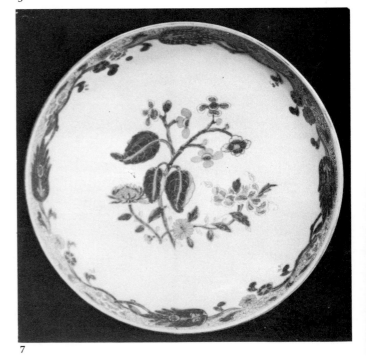

7

8

9                                          10

11

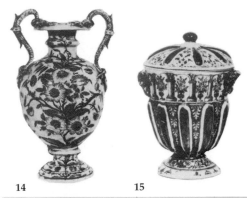

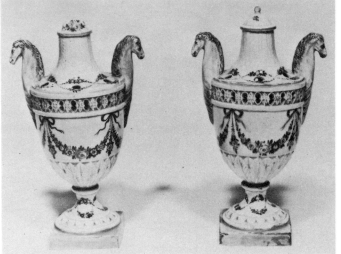

14          15

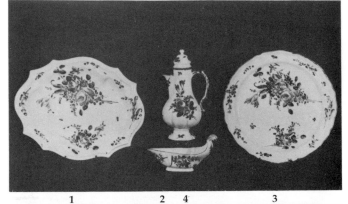

1          2 4          3

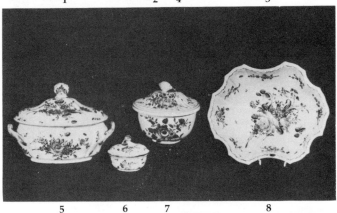

5          6 7          8

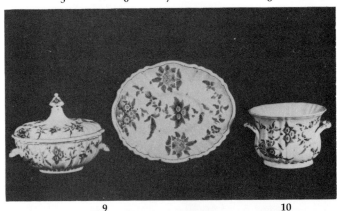

9          10

16

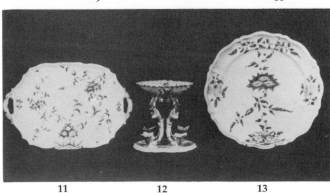

11          12          13

**1.** A Pesaro oval dish, circa 1765
40 cm. wide

**2.** A Pesaro coffee-pot, circa 1765
30 cm. high

**3.** A Pesaro dish, circa 1765
35 cm. diam.

**4.** A Pesaro sauce-boat, circa
1765
21.5 cm. long

**5.** A Pesaro oval soup tureen
and cover, circa 1765
33.5 cm. wide

**6.** A Pesaro sugar-bowl and
cover, circa 1765
11 cm. wide

**7.** A Pesaro oval soup tureen
and cover, circa 1765
22 cm. wide

**8.** A Pesaro oval bowl, circa 1765
37 cm. wide

**9.** A Bassano soup tureen, cover,
and stand, late 18th century
the stand 40 cm. wide

**10.** A Bassano two-handled
seau, late 18th century
26 cm. wide

**11.** A Bassano two-handled oval
tray, late 18th century
44 cm. wide

**12.** A Bassano hors-d'oeuvres
stand, late 18th century
25 cm. high

**13.** A Bassano dish, late 18th
century
39 cm. diam.

**14.** A Milan (Felice Clerici) vase,
circa 1760
52 cm. high

**15.** A blue and white vase, circa
1725, Lodi or Turin
37 cm. high

**16.** A pair of Bassano (Luigi XVI)
vases, blue comet mark, late 17th
century
28 cm. high

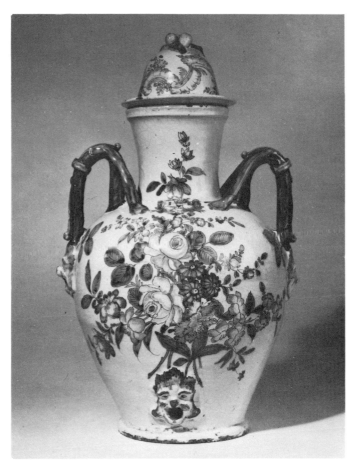

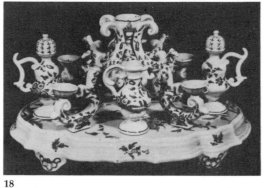

18

19

17

20

21

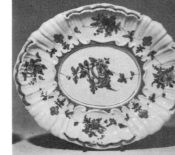

22

24

**17.** A Bassano two-handled oviform wine jar with domed cover, first half of 18th century 55 cm. high

**18.** A Bassano table centre-piece, late 18th century 47 cm. wide

**19.** A Bassano quatrefoil tray, circa 1760 48 cm. wide

**20.** A Lodi cabbage-leaf dish, circa 1770 22.5 cm. wide

**21.** A Bassano cabbage-leaf dish, circa 1760 24.5 cm. wide

**22.** A Bassano oval tureen-stand circa 1760 37 cm. wide

**23.** A Le Nove shaped circular dish, blue star and V mark, circa 1840 59 cm. diam.

**24.** A Le Nove cabbage tureen, cover, and stand, circa 1760 the stand 26 cm. diam.

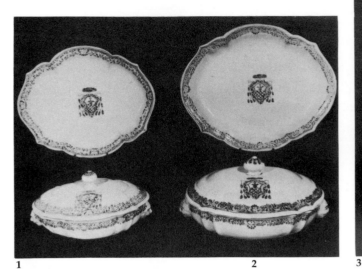

1

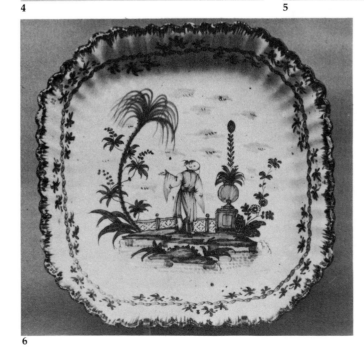

2

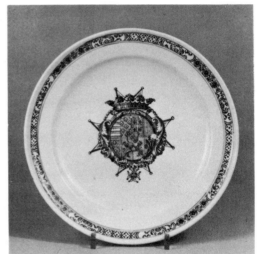

3

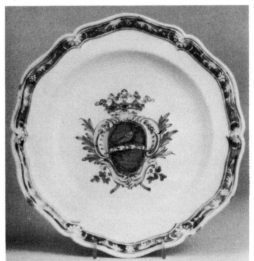

4

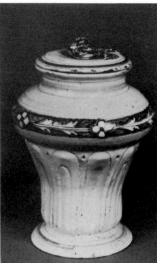

5

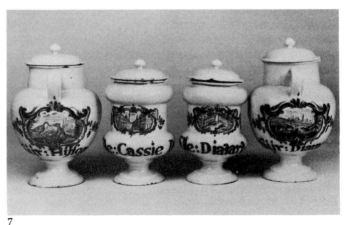

6

7

1. A Turin (G.G. Rossetti) soup tureen, cover, and stand with the family arms of Mossi di Morano, second half of 18th century
the stand 30 cm. wide

2. Another Turin (G.G. Rossetti) soup tureen, cover, and stand, second half of the 18th century
the stand 40 cm. wide

3. A Cerreto Sannita vase and cover, 18th century
26.5 cm. high

4. An armorial plate, perhaps Bassano, circa 1760
24 cm. diam.

5. A Turin blue and white armorial plate, circa 1730
24 cm. diam.

6. A Cerreto Sannita bowl, 18th century
23.5 cm. diam.

7. Two pairs of Veneto drug-jars and covers, late 18th century
24.5 and 21 cm. high

**8.** A Pesaro creamware documentary dated oval two-handled tureen and cover, cover and base inscribed Pesaro, Callegari, Ottobre 1786
29.5 cm. wide

**9.** A Pesaro oval tureen and cover, circa 1760
33.5 cm. wide

**10.** A Bassano fluted two-handled écuelle, cover, and shaped stand, circa 1770
the stand 23 cm. diam.

**11.** A pair of Veneto drug-jars and covers, inscribed in manganese below the foot 10. Mago. 1779 Veno.
26.5 cm. high

**12.** A Bassano pumpkin-tureen, cover and leaf stand, circa 1770
the stand 28 cm. diam.

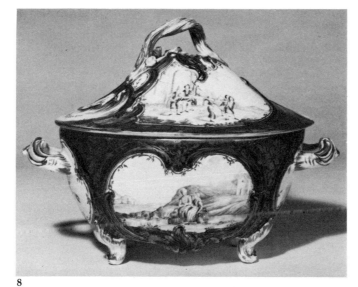

8

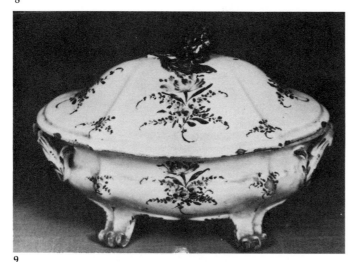

9

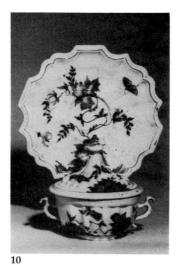

10

12

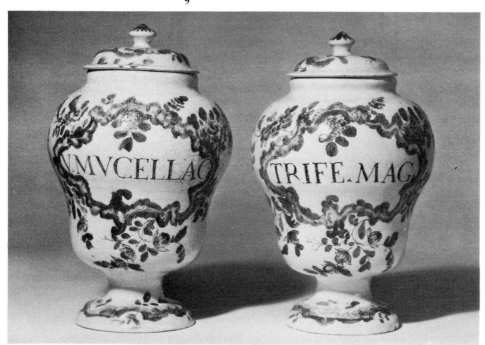

11

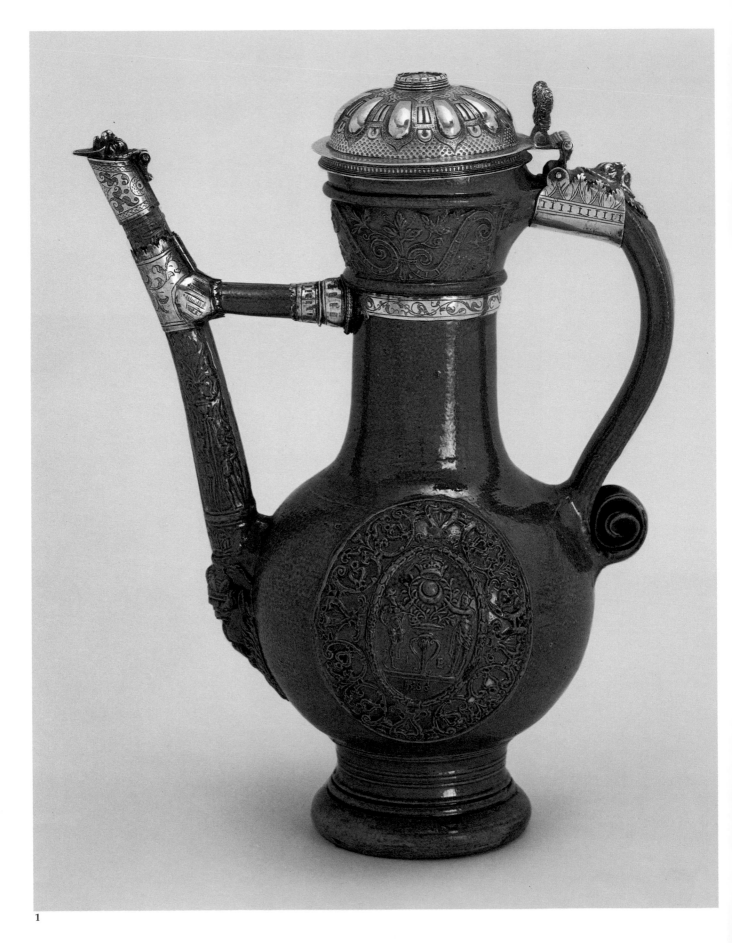

# NORTHERN EUROPE

Unlike their colleagues on the northern shores of the Mediterranean, who derived their tin-glazed pottery from Islam, the potters of the German-speaking world worked initially in stoneware. The use of this material was understood in Roman times. By the early Middle Ages it was widely produced in the Rhine valley and this production spread gradually east across central Germany as far as Bunzlau in present-day Poland. The geographical band in which stoneware was made is quite narrow, with most of the major centres a very small distance north or south of the latitude of Cologne.

The most successful early potteries, whose output was to span three or four centuries, were Siegburg, Frechen, Raeren, and Cologne. Of these Siegburg, where activity is found in the tenth century, produced wonderful wares in a very white body, which acquired a shiny appearance in the firing. The earliest pieces are called Jacoba Kanne, slender pear-shaped jugs with small loop handles and horizontal ribbing. These were succeeded by funnel-necked little jugs, on which we find the first examples of the relief medallions which were to be the hallmark and glory of this centre for the next century. With the Schnelle, a tapering tall tankard, and large wine jugs, this was to be one of the staple forms of Siegburg wares. The potters evolved a technique for applying moulded subjects to the surface of their wares, using clay matrices derived in their turn from white clay master models. The crisp stoneware took the sharp detail from the matrix and kept it clearly defined throughout the firing. The greatest exponents of this technique were Hans Hilgers and

**1A**

**1 and 1A.** A Raeren salt-glazed stoneware Schnabelkanne dated 1583 and with the potter's initials IE for Jan Emens, the contemporary silver mounts bearing the date 1585 and probably Cologne
26.5 cm. high

1                                    2                                    1

Christian Knütgen, both active in the late sixteenth century, who used their wares to display German mannerist allegories enclosed by strapwork. Around 1590, production at Siegburg seemed to die away.

Cologne and Frechen produced the famous honey-coloured bearded mask jugs, which in England have long been called Bellarmines. The attractive colour of the ware was achieved by throwing salt into the kiln and precipitating the glaze. The forms and techniques used here and at Raeren did not differ significantly from those used at Siegburg, though the salt glaze tended to obscure the moulded detail of the surface.

Raeren had used a certain amount of blue glaze, but it was at Westerwald, throughout the seventeenth century and later, that a greyish stoneware was made, picked out in blue. Initially the potters lifted many ideas from the wares of Raeren and Siegburg, in fact, subjects derived from the two earlier potteries are to be found on the same pieces of Westerwald ware. The forms used at this pottery were more complex and varied. As the seventeenth century went by, wares heavily influenced by Siegburg and Raeren were displaced by shapes evolved at the pottery. Moulded figure and armorial subjects in arcaded frames were joined by abstract decoration; initially, the surface was incised as well as decorated with applied relief ornament. In the second

half of the century, manganese joined blue as a decorative colour. The Enghalskrug, a peculiarly German form of ewer, with baluster body and slender neck with scroll handle, made its appearance, as it was soon to do in faience. Flasks were also produced, both square for the storage of wine and spirits and many-sided. Mugs were also made throughout the eighteenth century. These were decorated with formal ornament, incised, applied, and coloured with views of cities, such as Vienna and Frankfurt, with armorials, both civic and personal, and with royal monograms. Teawares, dishes, inkstands, and other useful wares were also made. The output of Westerwald was by far the most compendious of all stoneware-producing centres.

Further east at Kreussen, near Bayreuth, during the first half of the seventeenth century there was an output of dark-brown stonewares, which were enamelled in colours over relief decoration. The majority of the pieces that have survived are Humpen of rather squat proportions. Many have figures of the twelve apostles with armorial and other motifs. These wares are easily and frequently confused with those of Annaberg in Saxony, which are generally half a century later but produced in a very similar technique and style. Other active centres were Altenburg, Bunzlau, and Muskau which, inter alia, used mixed colours of stoneware to

**1.** A pair of Marieberg terrace vases, marked with three crowns, MB monogram and 14.10.74 and 11.1.76, Henri Sten period
28 cm. high

**2.** A Strasbourg polychrome ewer dated 1737, IF mark in sepia
16 cm. high

**3.** A pair of Wiesbaden (Nassau-Usingen) Italian Comedy candlestick figures, blue CU monogram marks, circa 1780
27 cm. high

3

achieve decorative effects. The stoneware tradition in Germany has continued to this day and later examples in traditional style can deceive the unwary or unpractised eye.

Faience came to Germany from the Low Countries. The earliest centres in the Frankfurt area were indeed founded from Holland, and their products are often impossible to distinguish from the contemporary wares of Delft. The pendulum of attribution which once gave much to Frankfurt and Hanau has now swung back and scholars adopt an extremely cautious line when ascribing pieces to this area and period. The first German faience factory in Hanau was founded in the early 1660s by Daniel Behaghel and his son-in-law, Jacobus van der Walle. The majority of the pieces were distinctly Dutch in style, similar to Delft blue and white wares in the oriental tradition. The colour of blue achieved was, however, deeper and more purplish in hue, and there was a less obvious attempt to mimic the surface appearance of oriental porcelain. Local shapes soon emerged, such as the Enghalskrug, already made by the stoneware manufacturers, and a lobed and fluted dish, probably derived from a copper prototype.

In Frankfurt itself, the production of faience started in the year 1661. Here the key figure was Johann Christoph Fehr, who was succeeded on his death in 1693 by his widow and heirs. They remained in charge of the business, albeit a diminished one, till 1722. As in Hanau, blue and white wares of Chinese inspiration were made. The blue of Frankfurt wares is quite distinct from that of Delft or Hanau. It is paler and slightly broken in texture. The principal wares were very simple but splendid in conception: large dishes with raised centres reminiscent in form of Hispano-Moresque ones. Lobed dishes and Enghalskrugs were also made. Some polychrome wares in blue, yellow, and green occur, and occasional examples were produced in manganese monochrome and in manganese and blue.

Further east at Ansbach, Nuremberg, and Bayreuth were three major faience-producing centres. The common factor in all three of them was Johann Caspar Ripp. He was another example of the peripatetic craftsman so often found in the history of pottery. He began his career in Delft and came to Ansbach in 1708 via Frankfurt and Hanau. He was in Ansbach for four years, stayed less than a year at Nuremberg, and spent the next eight at Bayreuth. He was thus involved in the setting-up of all three factories, as he was with Zerbst, shortly after he left Bayreuth in 1720. This led to great similarities of style and decoration throughout.

Ansbach was the first and most remarkable of the three. Its finest products were wares and figures of

oriental inspiration with famille verte decoration. In Nuremberg Christoph Marx and H.G. Hemmon were the first members of a rather fluid partnership that endured to 1770. The early wares were similar in shape and decoration to those of the other German factories of the day. Blue and white predominates and dense overall decoration was a common feature. This included both formal and figure subjects, and there are numerous instances of decoration which is signed. We know the names of some fifteen individual painters in the city.

Bayreuth too was firmly fixed in the Hanau tradition, since, apart from Ripp, decorators trained at Hanau were also employed there. Blue and white decoration, generally of a distinctive cloudy nature, is predominant. The forms adopted were very similar to those employed elsewhere.

Bayreuth was also famous for its stonewares. These were produced with cream or dark brown glazes, decorated in silver lustre. They were thinly potted and rivalled the contemporary porcelain of Meissen.

The faience of Franconia also served as the vehicle for outside decoration or Hausmalerei. These independent painters who stemmed from the tradition of enamellers on glass, silver, and copper, were much more adventurous than those working within the constraints of the factory system and they used muffled colours to enlarge the range of tones available to them. There were distinguished artists of this sort active in Nuremberg, Bayreuth, and Augsburg. Prominent were Faber, Helmhack, and the Seuter family. Frequently the wares they decorated came from other centres.

The factory at Fulda, further north, is linked to Ansbach and Bayreuth by another wandering potter, Adam Friedrich von Löwenfinck. He had been trained at Meissen where, though only eighteen when he left, he had evolved a luxuriant decorative style of oriental inspiration. This he carried on at Fulda. He did not stay long there either and by 1745 was attempting to set up a faience factory at Weissenau. The production of faience continued at Fulda till 1756. Wares were decorated in a peculiar blue and manganese palette, unique to Fulda and producing an effect that has been compared to indelible ink. The outstanding instance of this are the armorial candlesticks and jardinières made for the Prince Abbot of Fulda, the factory's patron.

The next factory with which Löwenfinck was involved was Höchst, where he started in 1746. Owing to a happy combination of personalities and taste, this was to prove one of the most successful and original factories. Its wares were no longer linked to the Chinese tradition, but were expressive of the rococo spirit which was sweeping Germany in the 1740s. Polychrome decoration in a style influenced by the porcelain factory at Meissen was deployed by a team of highly proficient painters, among whom the Hess family and Johannes Zeschinger stand out. The shapes of the wares were vigorously moulded with scrolls and were to have a profound influence on the Baltic potteries and Chinese export wares. The influence of contemporary events at Meissen is also reflected in the splendid coloured figures of birds made around 1750 and

decorated by Zeschinger. The production of faience at Höchst gradually gave way to porcelain by 1758.

Another essentially rococo factory was Schrezheim, founded in 1752 near Ellwangen in Wurttemberg. Plaques and tureens of the highest quality in the form of animals and vegetables, similar in spirit to contemporary porcelain, were made, as were conventional wares of a useful nature, such as those found in most of the minor factories scattered around the middle of Germany.

The Baltic basin was another quite distinct area of faience production. The centres around it, Hamburg, Lesum, Eckernförde, Kiel, Copenhagen, Stockelsdorf, Marieberg, Rorstrand, and Stralsund, all share distinct features arising from their proximity to each other and the type of wares demanded by their clients. Faience table-tops, wares with flowers in coloured relief, and punch bowls of mitre shape, for a drink called a *biskop*, were among the typical products of the area.

In the seventeenth century the Hamburg potters were responsible for an extensive series of jugs decorated in blue and dated. Perhaps because many of these were made for Portuguese ship-captains, there is a school of thought that attributes them all to a Portuguese pottery, though the majority of surviving examples have good German provenances.

Throughout Germany there were also a large number of potteries of various sizes which produced Humpen and table wares, tureens in the form of animals and vegetables, and pastoral figures. Often the attribution of pieces that are not marked and decorated in the prevailing conventional style is a matter of opinion.

At Berlin there was an interesting excursion into lacquered faience which was more remarkable than successful.

Further east in Poland, under the patronage of Stanislas Poniatowski, the Belvedere faience factory in Warsaw made fine wares in the famille verte style for a brief period between 1770 and 1780. The shapes and decoration leant heavily on the wares of the Meissen porcelain factory some thirty years earlier. The manufacture of faience in Poland was continued until the end of the century by Bernardi and Wolff at Bielino.

Hungary was the home of two distinct types of faience. The earlier was made throughout the seventeenth century by the Habaner nomadic anabaptist sect. Many of their pieces were of a commemorative nature and are extensively inscribed and dated. This serves to place them precisely but precludes their having been made with any practical intent.

In the eighteenth century there were two factories at Holics and Tata. The earlier of these, Holics, was started around 1743 under the patronage of Francis of Lorraine, consort of Maria Theresa. The Strasbourg pottery, of course, lay close to his former dominions and this influence is strongly visible in the early wares of the factory, where many ideas from Strasbourg are found expressed in a coarsened provincial manner.

The greatest strength of the factory was in its table ornaments, which were a splendid expression of late

**1.** An Ansbach famille verte two-handled tureen and cover painted with the Karpfenteich pattern by Johann Wolfgang Meyerhöfer, circa 1730
30 cm. high

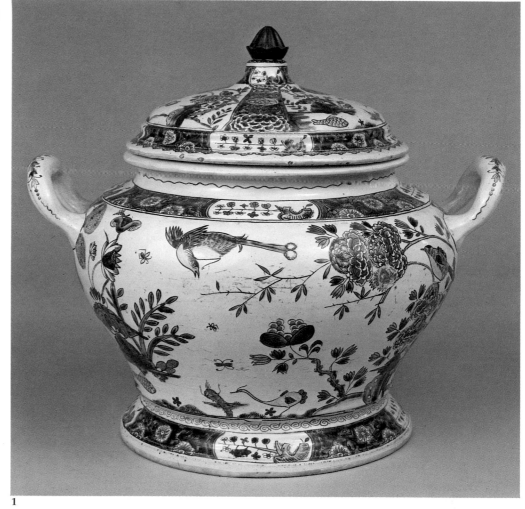

1

baroque and early rococo taste. Through Francis, Holics also had a more specific link with the Castelli factory in Italy, which lay in his domains there. A whole range of wares was made in the 1750s and 1760s with pastoral subjects in a greyish-brown palette, inspired by those of the Grue family. Many Holics tablewares are easily confused with those of Milan and Pesaro of the same date.

The factory continued till almost the end of the century, working in an increasingly neoclassical style. It suffered from the departure of many of its better craftsmen to Tata, founded in 1758 by Count Esterhazy, more famous as Haydn's patron. It took a long time to get the factory going and serious production did not begin until about 1770. The dominant style of its wares was Louis XVI. The most attractive contribution of the factory was the use of green monochrome or camaïeu vert decoration: among its more original products were

miniature pieces of furniture.

Northern Switzerland was another interesting and remarkably independent producer of pottery. Here the earliest success was at Winterthur, where the members of the Pfau family, who were Haffner or stove-makers, made both wares and stove-tiles of beauty and sophistication. Their wares were potted as finely as those of Angarano and the decoration of allegorical figures and groups of fruit echoes the same mannerist spirit.

Elsewhere in Switzerland in the eighteenth century, the successful porcelain factory in Zurich also made figures and wares in faience after the death of Spengler in 1790. At Lenzburg and Bern there were several factories operating in the 1750s and 1760s that produced wares closely related to those of Kunersberg in Germany and Strasbourg. Many examples are unmarked and difficult to distinguish from the wares of other similar and contemporary factories in the German-speaking world.

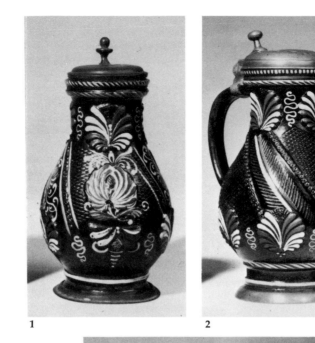

1

2

3

4

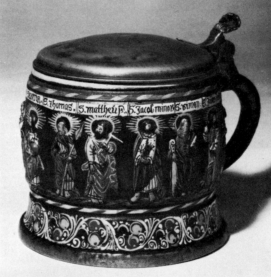

5

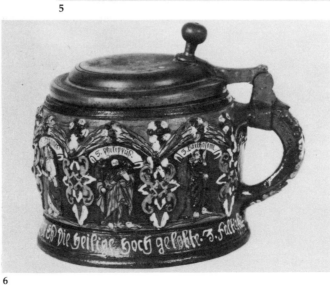

6

**1.** An Annaberg baluster pewter-mounted tankard, the hinged pewter cover inscribed Joh Cristp Seiler Topfin Kreussen 1649
25 cm. high

**2.** An Annaberg pear-shaped portrait tankard, the cover dated 1684, second half of 17th century
23.5 cm. high

**3.** An Annaberg baluster portrait tankard and pewter cover, early 17th century
28 cm. high

**4.** A Kreussen hexagonal oviform bottle, 16th century
22 cm. high

**5.** A Kreussen pewter-mounted Apostle tankard, last quarter of 17th century
13 cm. high

**6.** A Kreussen stoneware Apostle tankard dated 1685
11 cm. high

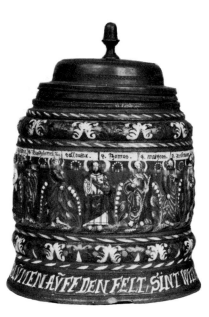

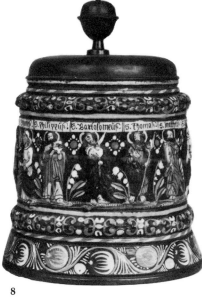

7                                    8

7. A Kreussen pewter-mounted
Apostle tankard, inscribed and
dated 1678
17.5 cm. high

8. A Kreussen pewter-mounted
Apostle tankard, circa 1670
20 cm. high

9. A Kreussen armorial
stoneware Apostle tankard with
the arms of the city of
Nuremberg and dated 1662, the
later silver-gilt cover London
1831 maker's mark SC
23 cm. high

10. A Kreussen stoneware
Apostle tankard dated 1662, the
later silver-gilt cover London
1838, maker's mark RH
21.5 cm. high

11. A Kreussen pewter-mounted
Apostle tankard, dated 1666
15 cm. high

12. A Kreussen armorial pewter-
mounted Apostle tankard with a
central coat of arms and the
name Caspar Gottling, inscribed
and dated 1664
17 cm. high

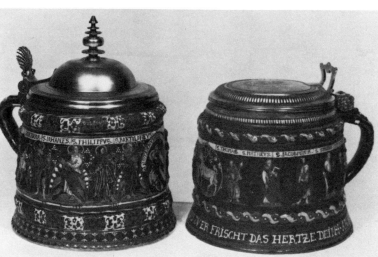

9                                    10

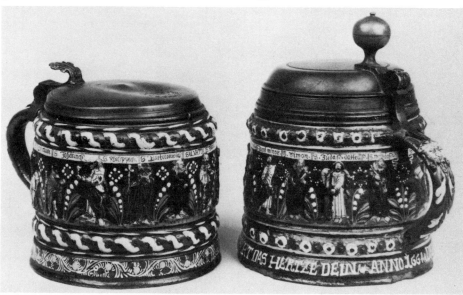

11                                    12

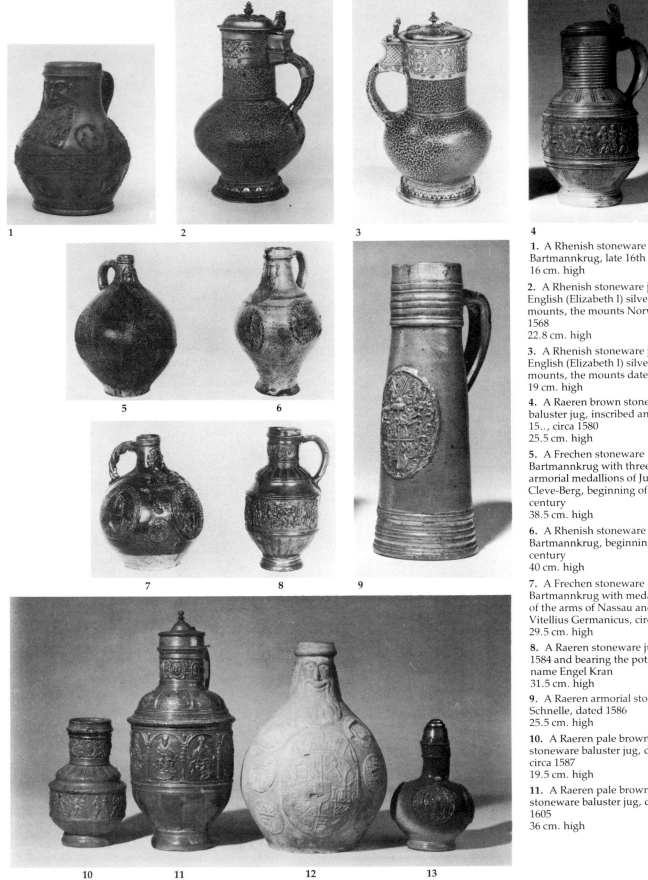

1

2

3

4

5

6

7

8

9

10 11 12 13

**1.** A Rhenish stoneware Bartmannkrug, late 16th century
16 cm. high

**2.** A Rhenish stoneware jug with English (Elizabeth I) silver-gilt mounts, the mounts Norwich 1568
22.8 cm. high

**3.** A Rhenish stoneware jug with English (Elizabeth I) silver-gilt mounts, the mounts dated 1565
19 cm. high

**4.** A Raeren brown stoneware baluster jug, inscribed and dated 15.., circa 1580
25.5 cm. high

**5.** A Frechen stoneware Bartmannkrug with three armorial medallions of Julich-Cleve-Berg, beginning of 17th century
38.5 cm. high

**6.** A Rhenish stoneware Bartmannkrug, beginning of 17th century
40 cm. high

**7.** A Frechen stoneware Bartmannkrug with medallions of the arms of Nassau and Vitellius Germanicus, circa 1600
29.5 cm. high

**8.** A Raeren stoneware jug dated 1584 and bearing the potter's name Engel Kran
31.5 cm. high

**9.** A Raeren armorial stoneware Schnelle, dated 1586
25.5 cm. high

**10.** A Raeren pale brown stoneware baluster jug, dated 87, circa 1587
19.5 cm. high

**11.** A Raeren pale brown stoneware baluster jug, dated 1605
36 cm. high

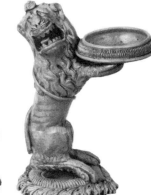

**14**

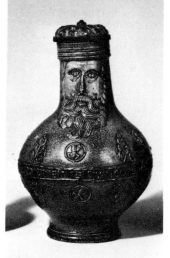

**15**

**12.** A Rhenish armorial unglazed stoneware Bartmannkrug, dated 1652
33 cm. high

**13.** A Rhenish brown stoneware flask, dated 1581
21 cm. high

**14.** A pair of stoneware standing salts, 17th/18th century
17 cm. high

**15.** A Raeren armorial Bartmannkrug, 16th/17th century
41 cm. high

**16.** A Frechen Bartmannkrug, 17th century, with later silver mounts
26.5 cm. high overall

**17.** A Rhenish stoneware Bartmannkrug, 16th century
26.5 cm. high

**18.** A Raeren stoneware cylindrical tankard, with the arms of Austria with the initials K.L.W. and dated '93, circa 1693
29 cm. high

**19.** A Nuremburg (Fleischman) Hafnerware pewter-mounted jug, 19th century
29 cm. high

**20.** A Rhenish stoneware jug, commemorating the accession of King William III in 1689, inscribed Wilhelmus Rex Anglyae 1689
18 cm. high

**21.** A Rhenish stoneware oil and vinegar set, late 17th century
14 cm. wide

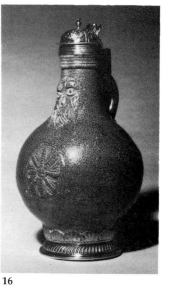

**16**

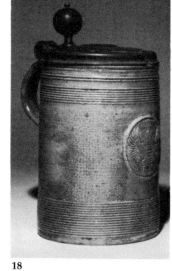

**17**

**18**

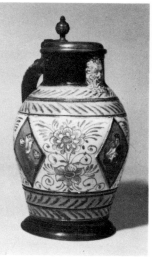

**19**

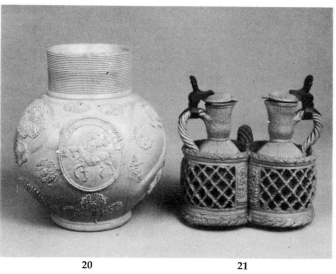

**20**

**21**

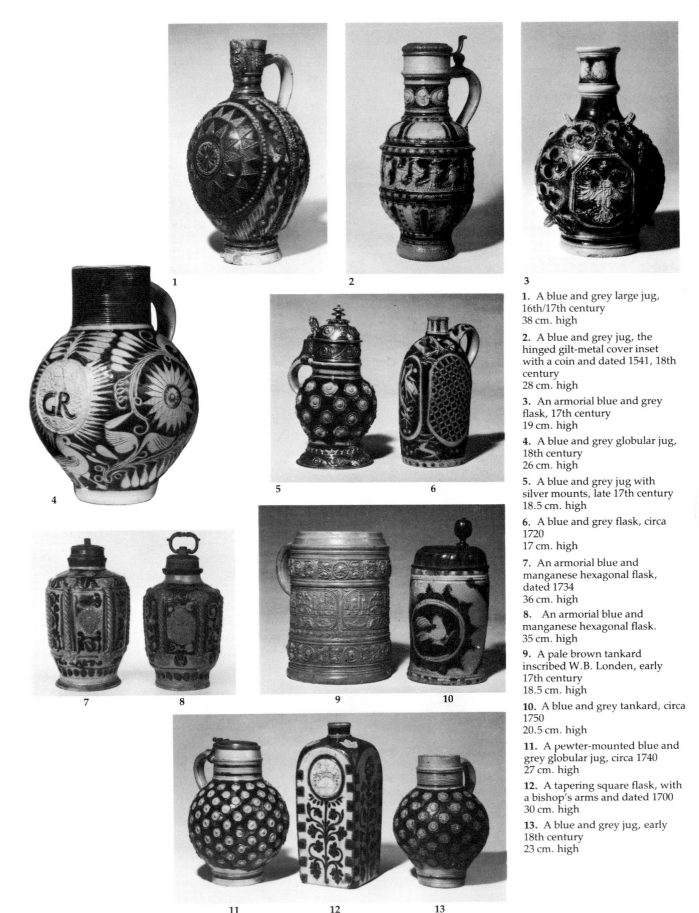

1. A blue and grey large jug, 16th/17th century
38 cm. high

2. A blue and grey jug, the hinged gilt-metal cover inset with a coin and dated 1541, 18th century
28 cm. high

3. An armorial blue and grey flask, 17th century
19 cm. high

4. A blue and grey globular jug, 18th century
26 cm. high

5. A blue and grey jug with silver mounts, late 17th century
18.5 cm. high

6. A blue and grey flask, circa 1720
17 cm. high

7. An armorial blue and manganese hexagonal flask, dated 1734
36 cm. high

8. An armorial blue and manganese hexagonal flask.
35 cm. high

9. A pale brown tankard inscribed W.B. Londen, early 17th century
18.5 cm. high

10. A blue and grey tankard, circa 1750
20.5 cm. high

11. A pewter-mounted blue and grey globular jug, circa 1740
27 cm. high

12. A tapering square flask, with a bishop's arms and dated 1700
30 cm. high

13. A blue and grey jug, early 18th century
23 cm. high

14                          15                          16

**14.** A blue and grey baluster jug, with a bust of Queen Mary II, 1689-93
18 cm. high

**15.** A blue and grey baluster jug, with the Hapsburg arms of Leopold I of Austria, with GR monogram and the date 1688
22 cm. high

**16.** An armorial blue and grey globular jug with William III and Mary seated, inscribed and dated 1691
29 cm. high

**17.** A globular blue and grey jug with William III and Queen Mary seated beneath a crown and with the coat of arms of Orange-Nassau, above a Dutch inscription dated 1691
18 cm. high

**18.** A blue and grey globular jug, circa 1700
21 cm. high

**19.** A blue and grey globular jug, circa 1710
18 cm. high

**20.** A blue and grey armorial jug, with the arms of Amsterdam inscribed Civitas Amsterd with the initials PR on each side and the date 1638 below
27.5 cm. high

**21.** A blue and grey stoneware square flask, circa 1680
25 cm. high

**22.** A blue and grey square flask, circa 1650
18 cm. high

**23.** A blue and grey pewter-mounted stoneware jug with the initials HH for Hans Hilgers, dated 1595
23 cm. high

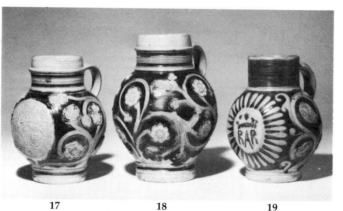

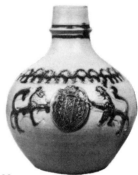

17            18            19            20

21                          22            23

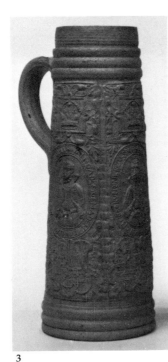

1

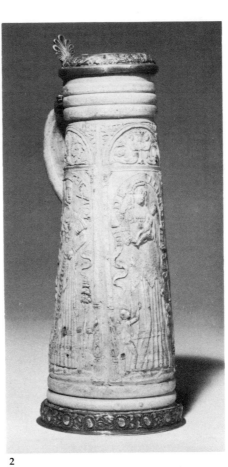

2

1. A Siegburg stoneware silver-mounted baluster jug, the silver mount bearing the date 1624, the stoneware circa 1600
16 cm. high

2. A Siegburg pale grey stoneware Schnelle with later hinged silver cover and footrim inscribed DER GHELOF, HH DE LEIFTDE 157, DE GERICH TIGEIT, Hans Hilgers
circa 1570
27.5 cm. high

3. A Siegburg armorial Schnelle with a bust of a Spanish monarch, late 16th century
23.5 cm. high

4. A Siegburg armorial pewter-mounted pale grey stoneware Schnelle, dated 1576
21 cm. high

5. A Siegburg pewter-mounted pale grey stoneware Schnelle, circa 1590
37 cm. high

6. A Siegburg stoneware jug, inscribed and dated 1594
24 cm. high

7. A Siegburg buff stoneware baluster jug, with a later silver-mounted neck, circa 1680
15 cm. high

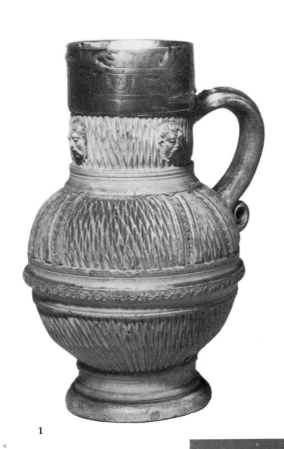

3

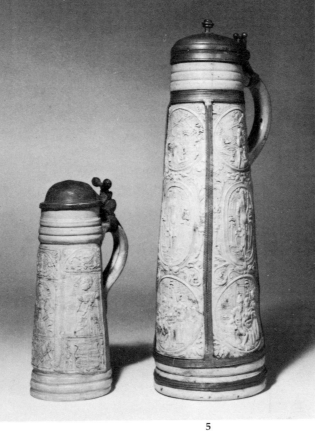

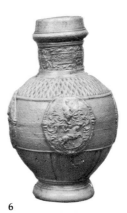

6

4

5

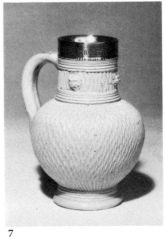

7

**8.** An Altenburg cylindrical pale grey stoneware tankard, circa 1740
26.5 cm. high

**9.** An Altenburg cylindrical pale grey stoneware pewter-mounted tankard with the crowned arms of Augustus III, Elector of Saxony, King of Poland, circa 1750
23 cm. high

**10.** A Muskau slender oviform jug, circa 1800
33 cm. high

**11.** An Altenberg cylindrical stoneware tankard, circa 1720
28 cm. high

**12.** A Muskau dark brown glazed stoneware jug, late 17th century
26 cm. high

**13.** A Bunzlau brown-glazed oviform jug, circa 1700
25 cm. high

**14.** A Bunzlau green-glazed melon-shaped tankard, late 17th century
19 cm. high

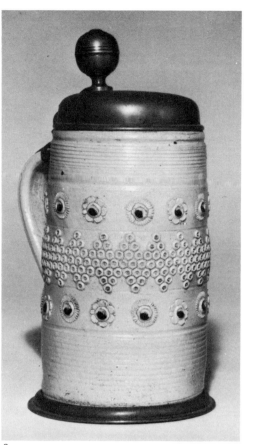

8

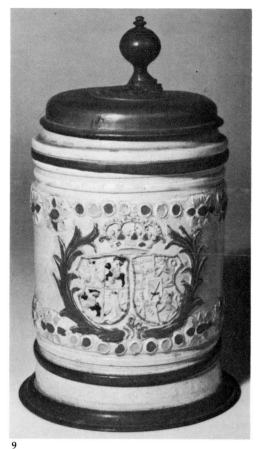

9

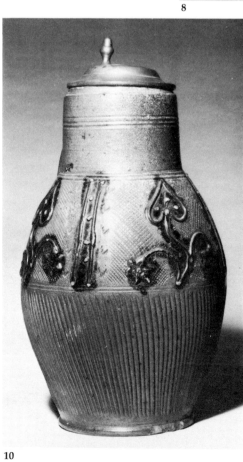

10

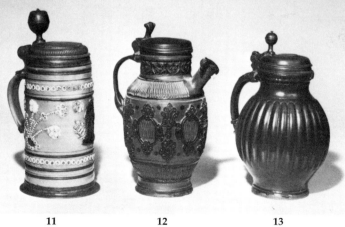

11  12  13

14

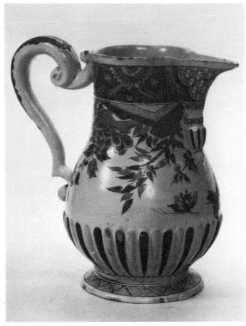

1

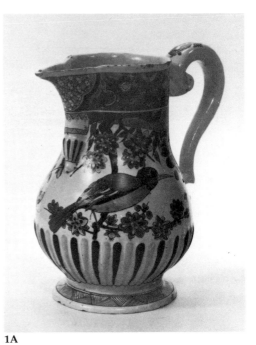

1A

**1 and 1A.** An Ansbach jug painted in a brilliant famille rose palette, circa 1730
16 cm. high

**2.** An Erfurt pewter-mounted tankard, circa 1760
23 cm. high

**3.** A Bayreuth pewter-mounted blue and white tankard, blue B mark, circa 1740
24.5 cm. high

**4.** A Magdeburg blue and manganese pewter-mounted tankard, blue M mark, circa 1760
19 cm. high

**5.** A Brunswick blue and white pewter-mounted tankard, blue VHP mark, circa 1720
15.5 cm. high

**6.** A Hanau blue and manganese pewter-mounted tankard, circa 1700
15.5 cm. high

2                                              3

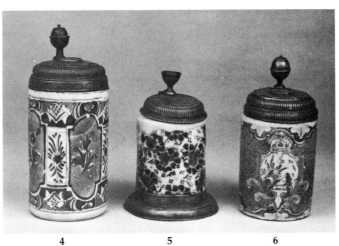

4                    5                    6

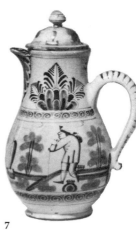

7

8

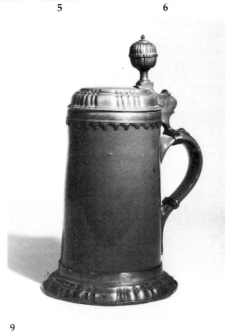

9

**7.** A Bayreuth (Pfeiffer) pear-shaped coffee-pot and cover, BP mark, circa 1765
21.5 cm. high

**8.** A Bayreuth pewter-mounted tankard, early 18th century
20 cm. high

**9.** A Bayreuth pewter-mounted tankard, the cover dated 1756
27.5 cm. high

**10.** A Bayreuth blue and white tankard, blue B.F.S. mark of Frankel and Schreck, 1745-47
26 cm. high

**11.** A Berlin yellow-ground tankard, with a portrait of the King of Prussia, circa 1750
23.5 cm. high

**12.** A Brunswick faience powdered purple-ground tankard, blue interlocked VH/CP mark, circa 1725
21 cm. high

**13.** A Berlin powdered manganese ground pewter-mounted Enghalskrug, circa 1710
31.5 cm. high

**14.** A Berlin pewter-mounted tankard, with St. Peter and the arms of the Archbishop-Elector of Mainz, circa 1760
24.5 cm. high

**15.** A Berlin pewter-mounted tankard, with a crowned monogram of Frederick the Great, blue script F Mark, circa 1750
27 cm. high

**16.** A German Faience cylindrical pewter-mounted blue and white tankard, inscribed J.J.H. 1747
24 cm. high

**17.** A Brunswick powdered purple-ground pewter-mounted tankard, circa 1740
25 cm. high

**18.** A Bayreuth pewter-mounted tankard, blue BP mark, the tankard circa 1761
20 cm. high

**19.** A Bayreuth pewter-mounted tankard, circa 1740
18 cm. high

**20.** A Crailsheim manganese-ground pewter-mounted tankard, circa 1760
25 cm. high

**21.** A Friedburg polychrome armorial jug, blue crowned CB mark, mid-18th century
27 cm. high

**22.** A Gera manganese-ground pewter-mounted tankard, circa 1760
24 cm. high

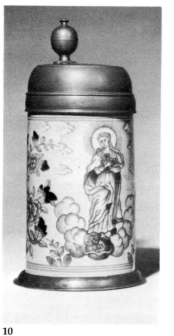
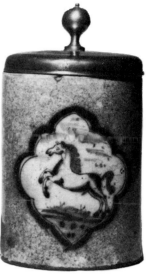
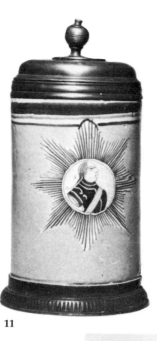

10          11          12

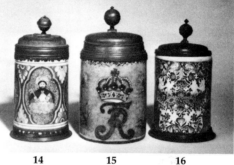

14      15      16

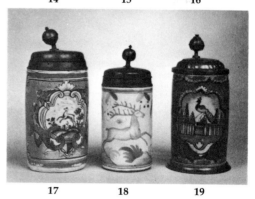

17      18      19

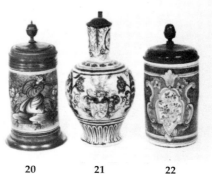

13          20      21      22

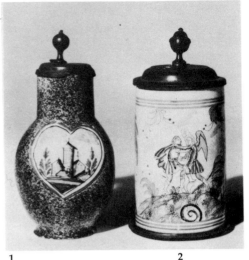

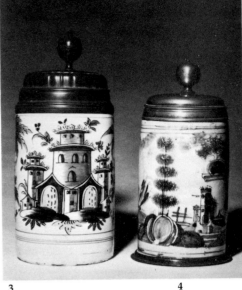

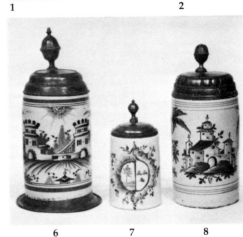

1

2

3

4

5

6

7

8

9

10

11

11

**1.** An Erfurt baluster jug, circa 1760
32 cm. high

**2.** A tankard, circa 1760, probably Crailsheim
23 cm. high

**3.** A Crailsheim tankard, circa 1750
27 cm. high

**4.** A blue and white tankard, probably Bayreuth, mid-18th century
24 cm. high

**5.** A Crailsheim pewter-mounted tankard, circa 1750
23.5 cm. high

**6.** A Kunersberg polychrome pewter-mounted tankard, mid-18th century
27 cm. high

**7.** A Durlach polychrome pewter-mounted tankard, mid-18th century
16.5 cm. high

**8.** A Crailsheim pewter-mounted polychrome tankard, mid-18th century
24 cm. high

**9.** A Donauwörth blue and white tankard painted with the arms of the Weavers' Guild and dated 1781
25 cm. high

**10.** A Thuringian tankard, circa 1760
22.5 cm. high

**11.** A pair of Durlach pewter-mounted Enghalskrugs, mid-18th century
27 cm. high

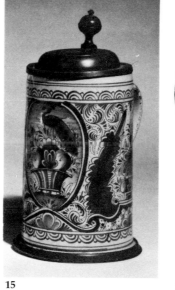
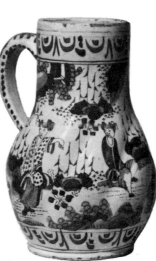

12      13      14      15      16

**12.** An Erfurt tankard, blue E mark, circa 1740
20 cm. high

**13.** A Bayreuth blue and white tankard, circa 1740
28.5 cm. high

**14.** A Crailsheim tankard, circa 1790
17.5 cm. high

**15.** A North German blue and white tankard, circa 1750.
23 cm. high

**16.** A Frankfurt spirally moulded baluster jug, circa 1720
21.5 cm. high

**17.** A Frankfurt blue and white jug, circa 1690
44 cm. high

**18.** A tapering tankard, late 18th century
24 cm. high

**19.** An Erfurt tankard, manganese E mark, late 18th century
25 cm. high

**20.** A Thuringian tankard, late 18th century
26 cm. high

**21.** An Erfurt tankard, circa 1740
26 cm. high

**22.** A German pewter-mounted polychrome tankard, blue A mark, circa 1760
25.5 cm. high

**23.** A Thuringian pewter-mounted tankard, blue V mark, circa 1760
25.5 cm. high

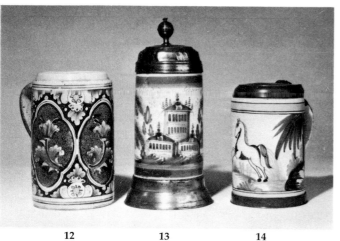

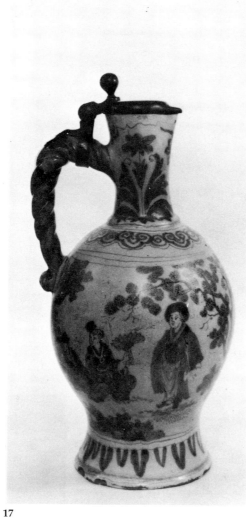

17

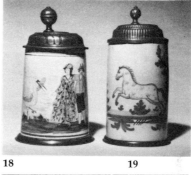

18      19

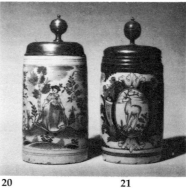

20      21

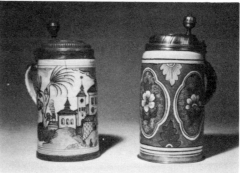

22      23

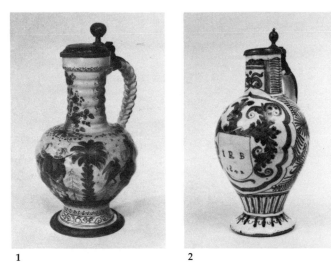

1

2

1. A Franconian pewter-mounted Enghalskrug, SVE monogram mark
28 cm. high
The origin of this piece, which obviously comes from the Nuremberg, Ansbach, or Frankfurt area, is difficult to fix exactly and the monogram mark is equally untraceable

2. A Hamburg blue and white jug dated 1642
27.5 cm. high

3. A Hanau powdered blue ground Enghalskrug, circa 1730
25 cm. high

4. A Hanau blue and white Enghalskrug, circa 1700
30 cm. high

5. A Flörsheim Enghalskrug, FH mark in black, circa 1775
25 cm. high

6. A Nuremburg blue and manganese Enghalskrug, circa 1730
31 cm. high

7. A Hanau octagonal yen-yen vase, circa 1720
45 cm. high

8. A Hamburg blue and yellow jug, circa 1680
22 cm. high

9. A Hamburg blue and white armorial jug, circa 1660
21 cm. high

10. A jug, P mark in black, circa 1730
22.5 cm. high

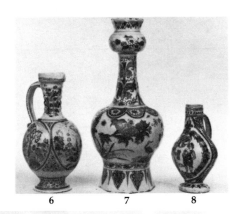

3          4          5

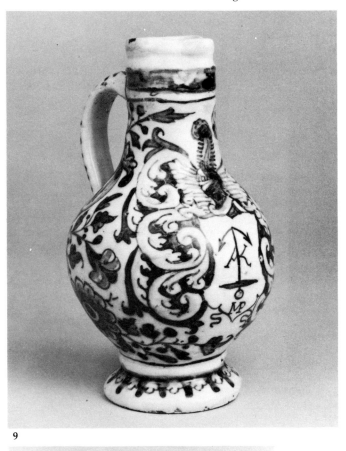

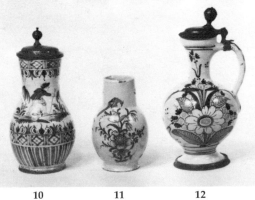

6     7     8     9

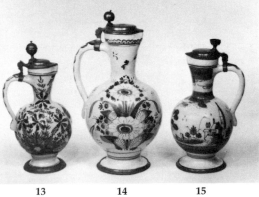

10          11          12

13          14          15

**11.** A small jug, probably Durlach, circa 1775
15 cm. high

**12.** A Hanau Enghalskrug, blue Z mark, circa 1720
29 cm. high

**13.** A Hanau blue and white Enghalskrug circa 1720
29 cm. high

**14.** A Hanau blue and white Enghalskrug, circa 1720
35.5 cm. high

**15.** A Hanau blue and white jug, circa 1720
29 cm. high

**16.** A South German pewter-mounted cylindrical tankard, blue A mark, circa 1780
25.5 cm. high

**17.** A North German tankard, circa 1750
27.5 cm. high

**18.** A Magdeburg tankard, blue M mark, circa 1770
26.5 cm. high

**19.** An Erfurt powdered purple-ground tankard, circa 1750
26.5 cm. high

**20.** A Hannoversch-Münden tankard, manganese three C's mark of von Hanstein, circa 1745
23 cm. high

**21.** A Kunersberg blue and white Enghalskrug, traces of KB marks, circa 1750
36 cm. high

**22.** A Kunersberg blue and white Enghalskrug, script Kunersberg mark, circa 1750
32 cm. high

**23.** A Hanau blue and white small pear-shaped jug, circa 1720
16 cm. high

**24.** An Erfurt polychrome tankard, blue S mark, circa 1735
20 cm. high

**25.** A Kunersberg small Enghalskrug, circa 1750
21 cm. high

**26.** A polychrome tankard, perhaps Erfurt, circa 1750
26 cm. high

**27.** A manganese ground tankard, blue AA monogram mark, circa 1750
22 cm. high

**28.** A Kunersberg polychrome tankard, circa 1750
21.5 cm. high

**29.** An Erfurt tankard, blue A mark, circa 1740
24.5 cm. high

**30.** A Magdeburg tankard, manganese M mark, late 18th century
24.5 cm. high

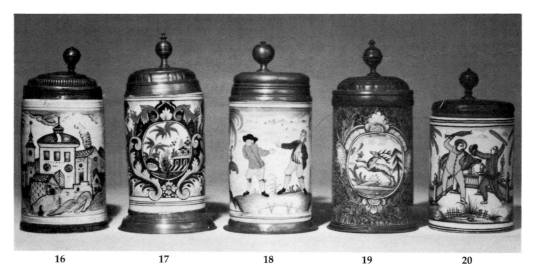

16        17        18        19        20

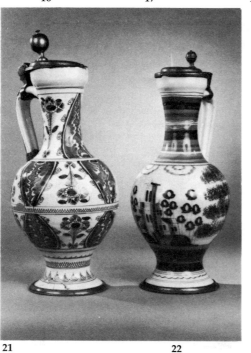

23        24        25

26        27        28

21                22

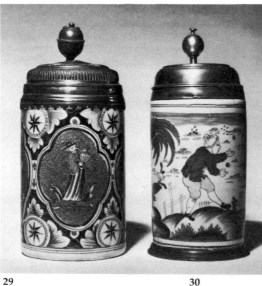

29                30

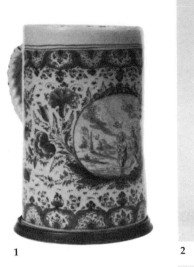

1

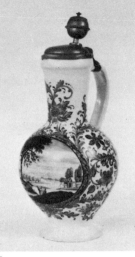

2

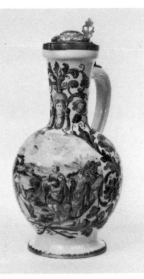

3

4

5

6

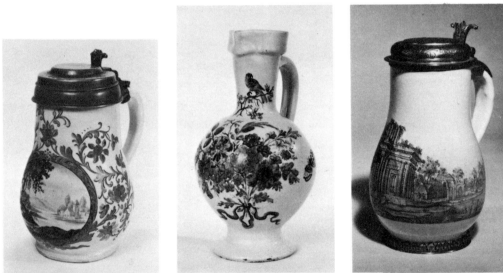

6A

**1.** A documentary Nuremberg blue and white tankard painted by A. Schuster, inscribed Nuremberg 1725 and signed
20 cm. high

**2.** A Nuremberg pewter-mounted Enghalskrug with Hausmalerei decoration, painted in the manner of Helmhack, late 17th century
33 cm. high

**3.** A Nuremberg copper-gilt mounted Enghalskrug painted by Abraham Helmhack, late 17th century
34.5 cm. high overall

**4.** A Nuremberg Hausmalerei tankard painted in the manner of Helmhack, circa 1690
22 cm. high

**5.** A Nuremberg Hausmalerei Enghalskrug painted by Bartholomaus Seuter in Augsburg circa 1730
21.5 cm. high

**6 and 6A.** A Nuremberg baluster tankard possibly painted in Schwarzlot by Johann Schaper, dated 1670
22.5 cm. high

**7.** A Nuremberg blue and white pewter-mounted Enghalskrug, first half of 18th century
26 cm. high

**8 and 8A.** A Nuremberg armorial tankard painted by Georg Friedrich Grebner and with the arms of Barth von Heimating, circa 1730
31 cm. high
Although the piece is unsigned, Grebner was well known as a painter in blue at Nuremberg

**9.** A Nuremberg blue and white tankard, Kordenbusch workshop, circa 1730
17.7 cm. high

**10.** A Hanau Enghalskrug, incised C and manganese painters' marks, circa 1740
23.5 cm. diam.

**11.** A Potsdam powdered manganese ground tankard, mid-18th century
23 cm. high

**12.** A German polychrome tankard, mid-18th century
20 cm. high

**13.** A Crailsheim polychrome tankard, circa 1750
23 cm. high

**14.** A Nuremberg blue and white tankard, circa 1740
19 cm. high

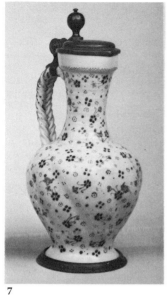

7

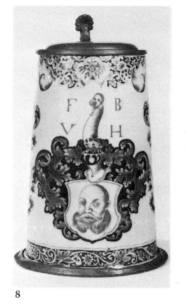

8

9

10

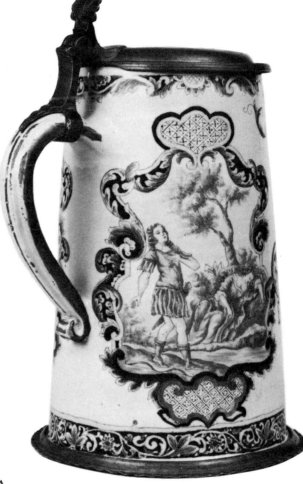

8A

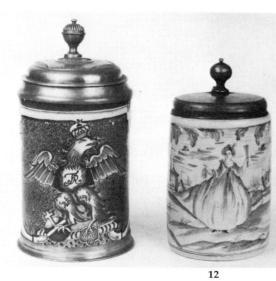

11

12

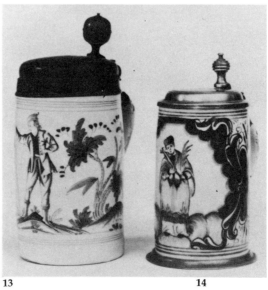

13

14

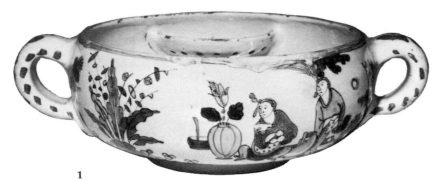

1

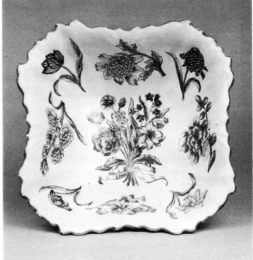

2

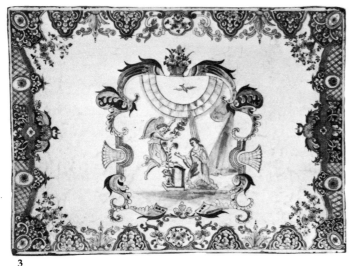

3

6

4                                                    5

7

1. A Frankfurt two-handled shaving-bowl painted in green, manganese, and yellow, manganese S mark to the interior, circa 1700
30.5 cm. wide

2. A German polychrome shaped square bowl, perhaps Ansbach circa 1750
22 cm. wide

3. A blue and white rectangular plaque, mid-18th century, perhaps Schleswig Holstein
42 cm. x 58.5 cm.

4. A German shaped oval dish, black crowned B mark, circa 1760
33.5 cm. wide

5. A Bayreuth (Pfeiffer) shaped oval dish, crowned BP mark in blue, circa 1750
35.5 cm. wide

6. An Ansbach famille verte oblong octagonal dish painted in the manner of Johann Leonhard, UZ, manganese W mark, circa 1730
45 cm. wide

7. A Frankfurt blue and white dish, circa 1700.
33.5 cm. diam.

8. A Frankfurt large dish, inscribed MYAGP, circa 1680
38 cm. diam.

9. A North Bavarian armorial blue and white small dish, dated 1606
20 cm. diam.

10. A Frankfurt blue and white armorial dish, circa 1700
39 cm. diam.

11. A Frankfurt blue and white dish, circa 1700.
47 cm. diam.

12. A Frankfurt blue and white dish, circa 1700
39.5 cm. diam.

13. A Frankfurt blue and white oblong four-handled dated marriage basket, inscribed Anno 1670
30 cm. wide

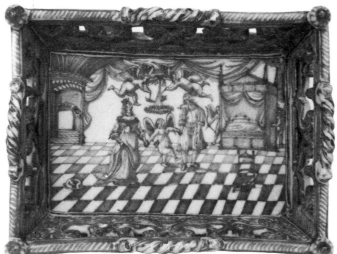

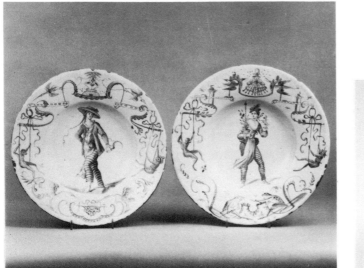

1

3          2          3

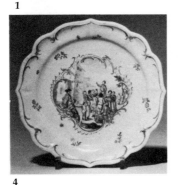

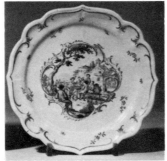

4          4

5

7

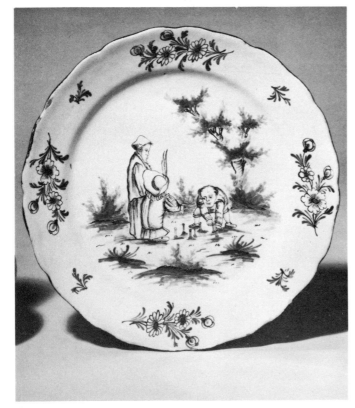

6

**1**. A pair of plates, circa 1735
25 cm. diam.

**2.** A South German armorial dish, circa 1720
30 cm. diam.

**3.** A pair of South German armorial plates, en suite
24 cm. diam.

**4.** A pair of dishes, perhaps Kunersberg, circa 1750
19 cm. diam.

**5.** A Mosbach plate, blue T mark of JSF Tannich, 1774-81
24.5 cm. diam.

**6.** A Hannoversch-Münden plate, script mark Munden, circa 1775
25 cm. diam.

**7.** A Höchst plate, black wheel and painter's mark IZ for Johann Zeschinger, circa 1750
25.5 cm. diam.

**8.** A Frankfurt blue and white dish, first half of 18th century
38 cm. diam.

**9.** A Frankfurt blue and white jug, early 18th century
35 cm. high

**10.** A Hanau blue and white dish, early 18th century
39 cm. diam.

**11.** A Northern rectangular plaque, mid-18th century, Kellinghusen or Lesum
23 cm. x 20 cm.

**12.** A pair of Schrezheim shaped oblong wall plaques from a set of the four seasons, printed in a puce monochrome, circa 1760
38 cm. high

**13.** A Nuremberg armorial plate, circa 1760
25 cm. diam.

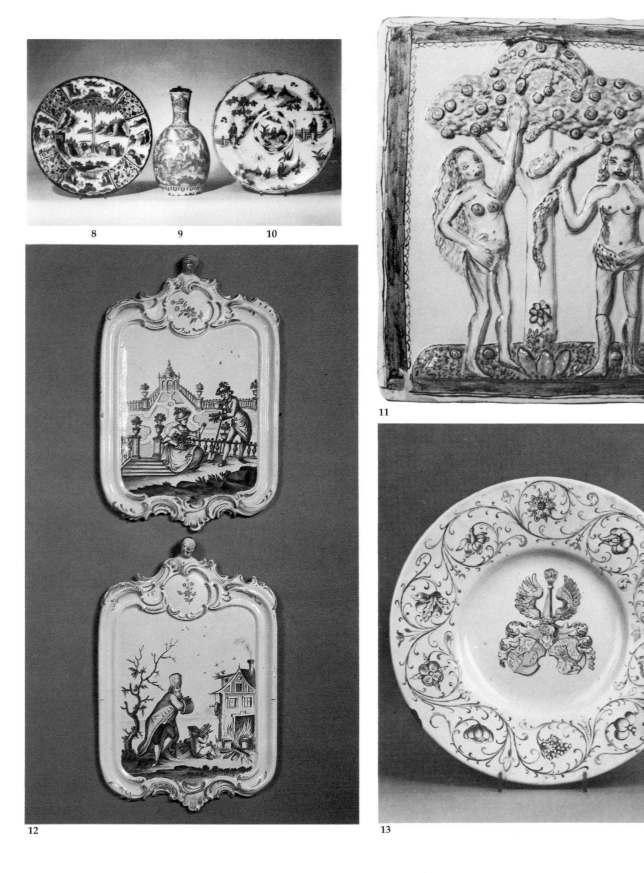

8

9

10

11

12

13

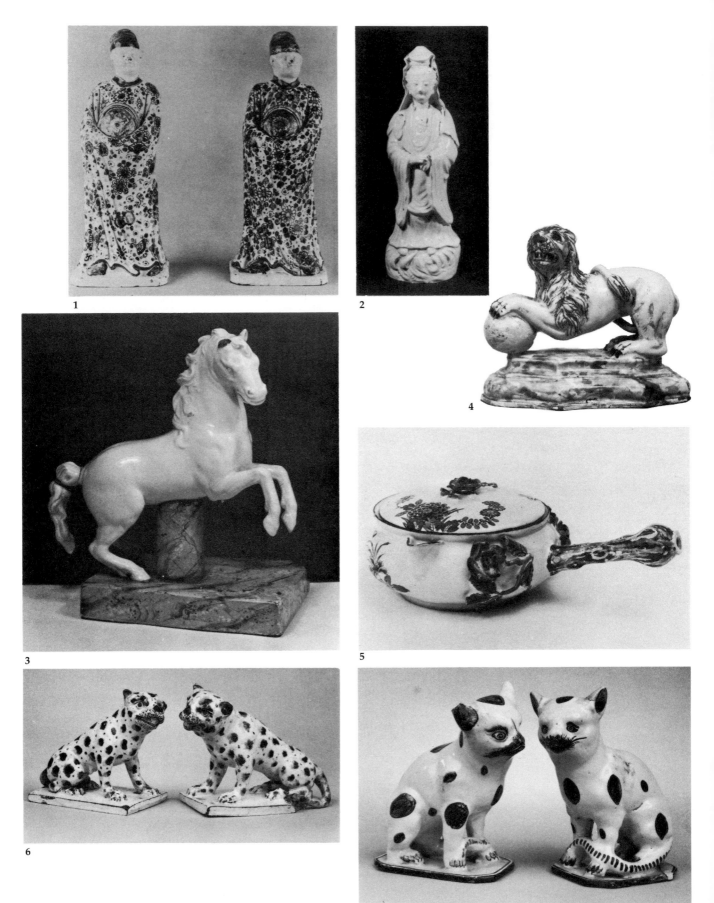

1

2

4

3

5

6

7

1. A pair of figures of Chinese dignitaries, second quarter of 18th century
35 cm. high

2. An Ansbach white figure of Kuan Yin, circa 1725
29 cm. high

3. A German creamware figure of a rearing grey horse, late 18th century
23.5 cm. high

4. A Flörsheim lion, circa 1755
19 cm. long

5. A Höchst circular sauce-pan and cover, puce wheel mark, circa 1740
19 cm. wide

6. A pair of Hannoversch-Munden seated leopards, circa 1760
18 cm. long

7. A pair of Hannoversch-Münden figures of seated cats, three crescent marks in manganese, circa 1760
13 cm. high

8. A Baltic two-handled oval tureen and domed cover, Stralsund or Eckernförde, circa 1770
38 cm. wide

9. A Baltic two-handled rococo tureen and cover, perhaps Stralsund, circa 1760
42 cm. wide

10. A pair of Baltic tureens, covers, and stands, the interiors variously inscribed 2 MW 9 circa 1760
the stands 35 cm. wide

11. A Southern German marrow-tureen and cover, second half of 18th century
18 cm. wide

12. A pair of Erfurt faience boxes and covers, one with manganese i mark, circa 1740
17 cm. wide

13. Two German partridge tureens and covers, 18th century
19.5 cm. high

14. A pair of South German duck tureens and covers, first half of 18th century
32 cm. wide

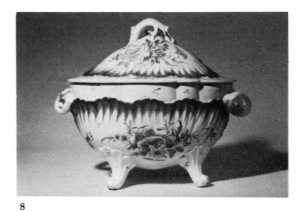

8

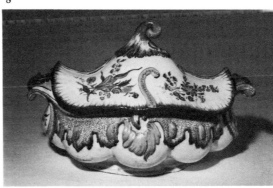

9

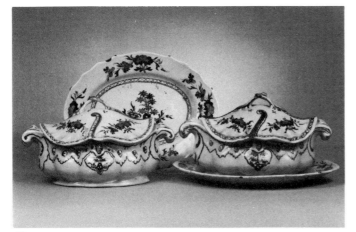

10

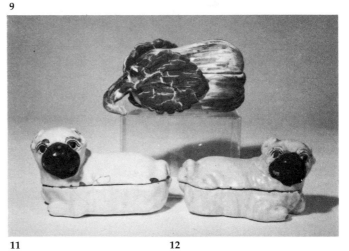

11          12

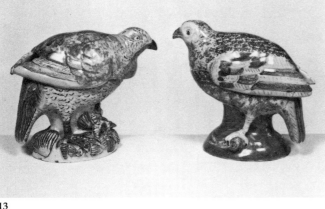

13

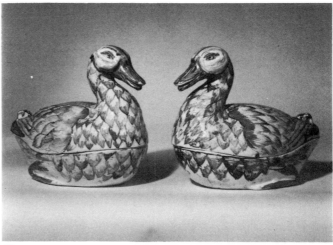

14

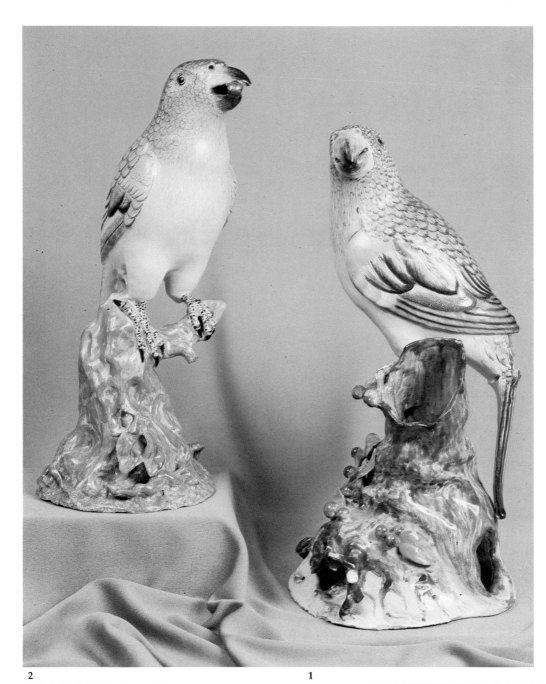

1. A Höchst figure of a parrot painted by Johannes Zeschinger, brown wheel mark and IZ mark of Zeschinger, circa 1750
40 cm. high

2. A Höchst figure of a parrot with a cherry, possibly modelled by J.F. Hess, brown wheel mark and E1 mark, circa 1750
39 cm. high

3. A Flörsheim apple tureen, cover, and fixed stand, the inside cover and the body with manganese W mark, the stand with F mark, circa 1770
18 cm. wide

4. A melon tureen, cover, and fixed stand, blue 3 mark to the inside of the tureen and cover, circa 1755, perhaps Höchst
the stand 24 cm. diam.

5. A melon tureen, cover, and fixed stand, black R mark, probably Höchst, circa 1760
27 cm. wide

6. A Höchst oval tureen and cover, circa 1750
33 cm. wide

7. A Höchst faience melon tureen and cover, black wheel mark, circa 1750
32.5 cm. wide

8. A pair of Kunersberg partridge tureens and covers, circa 1760
31 cm. wide

9. A Magdeburg cabbage tureen, cover, and stand, late 18th century
the stand 29.5 cm. diam.

10. A Höchst partridge tureen and cover, circa 1760
23 cm. wide

11. A German tureen and cover, mid-18th century
40 cm. wide

12. A Höchst vessel modelled as a tortoise, circa 1765
25 cm. long

2            1

3

4

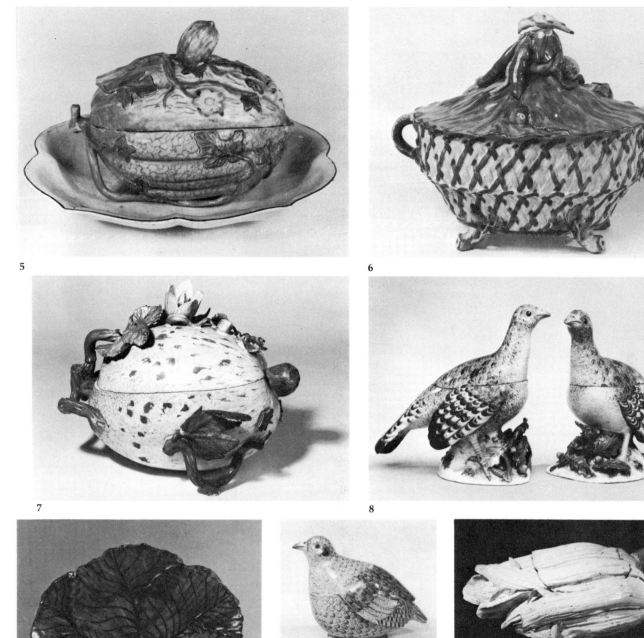

5

6

7

8

10

11

9

12

1

2

3

4

5

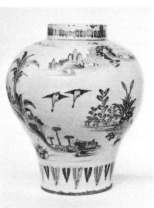

6

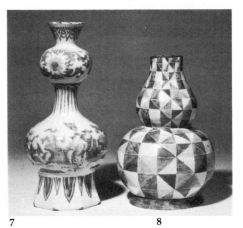

7

8

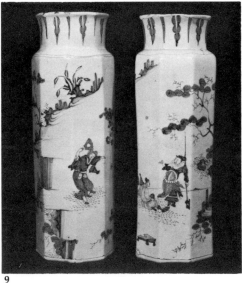

9

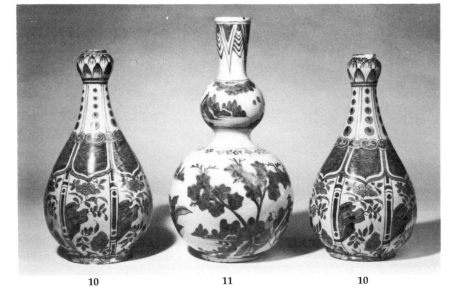

10                    11                    10

1.   A pair of Berlin green lacquer Chinoiserie vases and covers, circa 1720
78.5 cm. high

2.   A pair of Berlin green lacquer Chinoiserie beakers, circa 1720
47 cm. high

3.   A garniture of five Berlin green lacquer Chinoiserie vases, circa 1720
71 to 48 cm. high

4.   A Dorotheenthal manganese ground garniture of five vases, manganese AB/D mark, circa 1725
37-39.5 cm. high

5.   A pair of Berlin polychrome fluted double-gourd vases, iron-red script F marks, circa 1720
29 cm. high

6.   A Hanau baluster vase, circa 1710
28 cm. high

7.   A Hanau blue and white octagonal baluster vase, blue P mark, circa 1720.
29 cm. high

8.   A German double-gourd vase, circa 1730
23.5 cm. high

9.   A pair of Frankfurt octagonal rouleau vases, circa 1700
34 cm. high

10.   A pair of Hanau blue and white bottle vases, circa 1720
31 cm. high

11.   A Frankfurt blue and white double-gourd vase, circa 1690
36.5 cm. high

12.   A German oviform vase, probably Hanau, circa 1690
47 cm. high

13.   A Hanau blue and white vase, circa 1720
95 cm. high

14.   A Hannoversch-Münden baluster vase with reticulated basket-work, manganese CCC/U mark, circa 1780
28 cm. high

15.   A pair of Hanau blue and white globular vases, first half of 18th century
36 cm. high

16.   A garniture of three North German vases and covers, perhaps Kiel, circa 1770
34 to 42 cm. high

17.   A pair of Stralsund baskets of flowers, Stralsund mark in manganese and the letter E, 1766-1770
12.5 cm. wide

18.   A Nuremberg Hausmalerei slender baluster vase, circa 1720, the ormolu later
24 cm. high

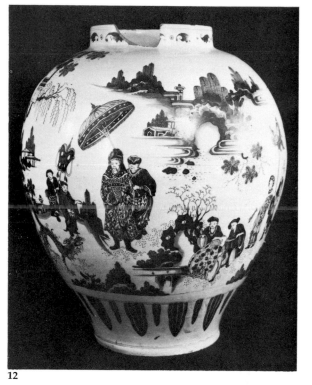

12

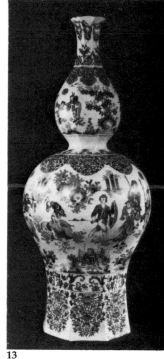

13

14

15

16

17

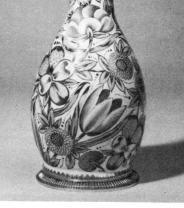

18

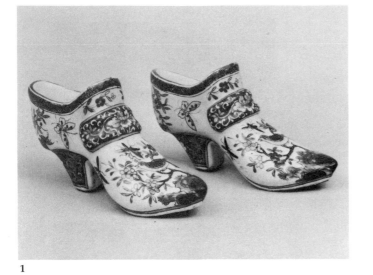

1

2

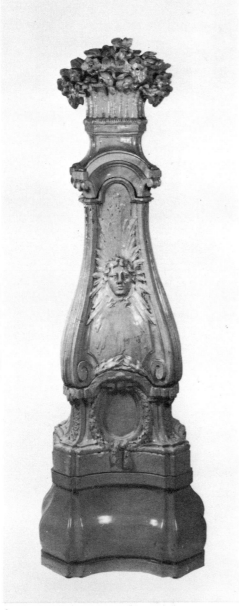

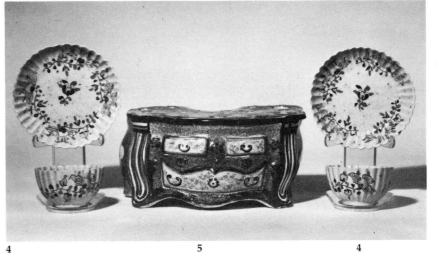

4

5

4

3

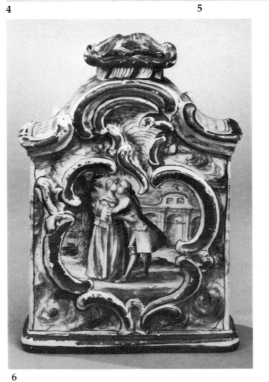

6

1. A pair of Ansbach polychrome shoes, black V marks, circa 1730
16 cm. long

2. A Bayreuth hexagonal salt, circa 1730
9.5 cm. wide

3. A white stove, late 18th century
240 cm. high

4. A pair of German pale blue ground fluted teabowls and saucers, circa 1760

5. A German sponged manganese flower-brick, mid-18th century
24 cm. wide

6. A documentary Hamburg blue and white teacaddy and cover, inscribed Johann Otto Lessel sculpsit et pinxit, Hamburg, Mensis Januarij Anno 1756
17.5 cm. high

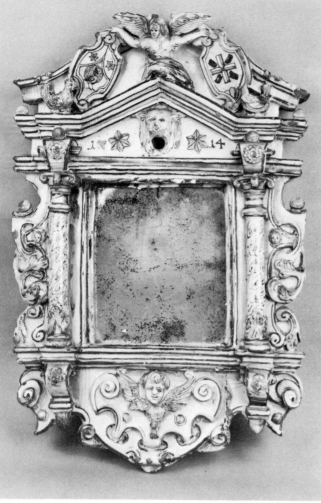

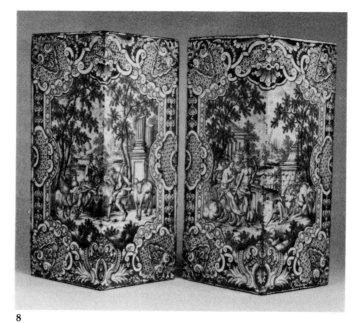

7

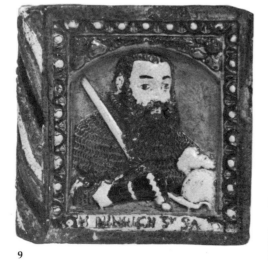

9

9A

**7.** A Habaner dated tabernacle frame, dated 1(7)14
54 cm. high

**8.** A pair of Hamburg blue and white corner stove-tiles, circa 1700
31.5 cm. high

**9. and 9A.** A Nuremberg Hafner-ware stove-tile, with Duke Henry III of Schwabia, circa 1550
18 cm. square
10 cm. deep

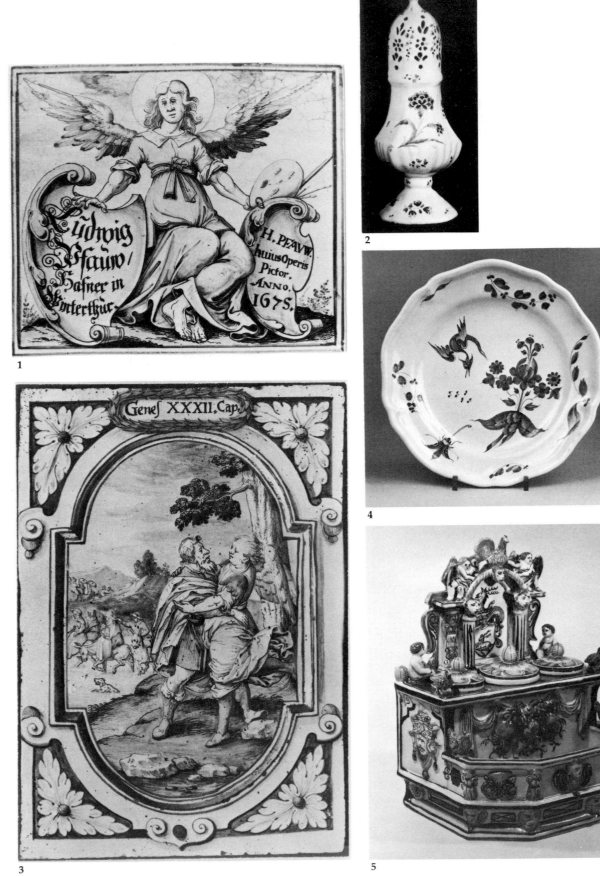

1.  A documentary Winterthur polychrome rectangular tile, signed and dated H. Pfauw, 1675
28 cm x 18 cm

2.  A Lenzburg spirally fluted hexagonal sugar-castor, circa 1765
21.5 cm. high

3.  A Winterthur polychrome stove-tile, painted by H. Pfauw, signed with a monogram and dated 1693
43 cm x 29 cm

4.  A Lenzburg shaped circular plate, 3R marks in manganese, circa 1760
25 cm. diam.

5.  An armorial Winterthur Hafner-ware inkstand, dated 1646
31 cm. high

6.  A Thun baluster vase, circa 1800
31.5 cm. high

7.  A Thun dish, dated 1783
29.5 cm. diam.

8.  A Thun deep dish, circa 1820
27.5 cm. diam.

9.  An Austrian owl jug and cover, 17th century
18 cm. high

10.  A Zurich figure of a boy, incised K4 mark, circa 1775
16.5 cm. high

11  A Zurich baluster sugar-castor painted en grisaille, blue .Z. mark, circa 1800
18 cm. high

6                                    7

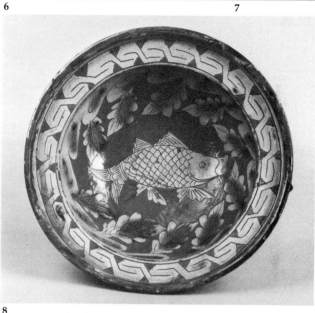

8

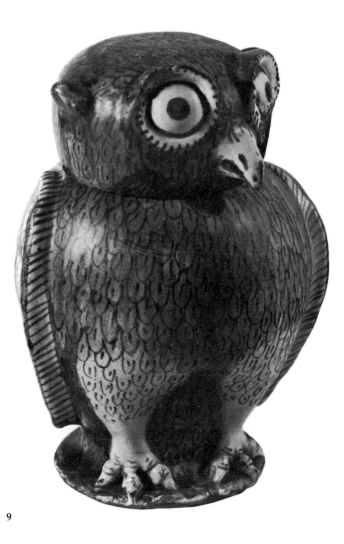

9

10

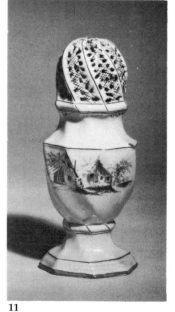

11

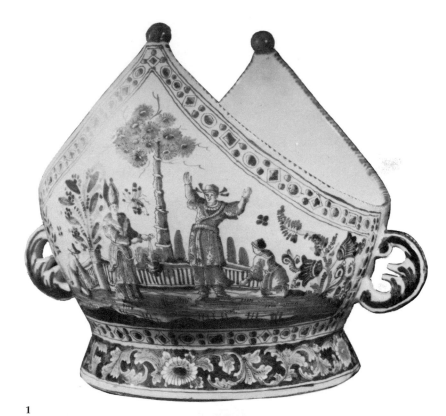

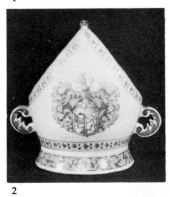

1

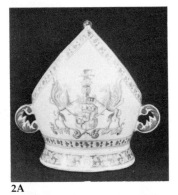

2

2A

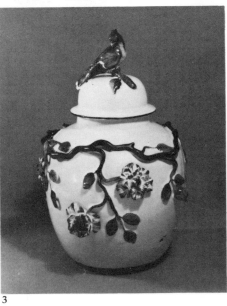

3

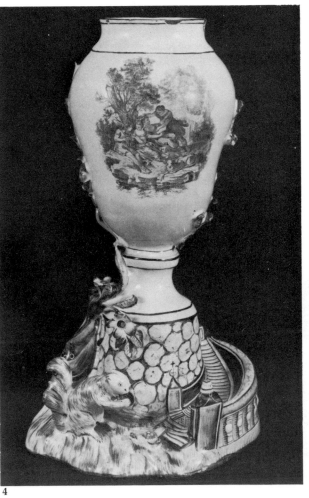

4

1. A Copenhagen blue and white mitre-shaped Chinoiserie punch bowl, Johan Ernst Pfau, St. Kongensgade, traces of blue mark 75, circa 1730
33 cm. wide

2 and 2A. A Copenhagen faience blue and white wine cooler formed as a mitre, circa 1730
30.5 cm. high

3. A Marieberg oviform potiche and cover, blue WW/MB=E mark, circa 1765
36 cm. high

4. A Marieberg terrace vase, decorated en grisaille, blue three crowns and MB-D mark, Berthevin period, 1766-1769
26 cm. high

5. A Stockelsdorf ewer and basin, circa 1760
the base 43 cm. wide

6. A Marieberg white two-handled urn-shaped vase and cover, circa 1785
46 cm. high

7. A Kastrup goose tureen and cover, blue F mark, circa 1760
45 cm. long

8. A Marieberg shaped rococo inkstand, blue three crowns above MB 81 mark, circa 1775
24.5 cm. wide

9. A pair of Rörstrand dishes, mark Rörstrand 26 5 67 in blue and with initial B for either Anders or Henrick Berg, 1767
28.5 cm. high

10. A Rorstrand rococo lobed oval tureen, domed cover and stand, the base of the tureen marked in full and dated 29th September 1771
the stand 48 cm. wide

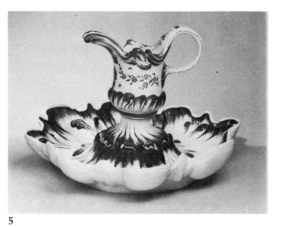
5

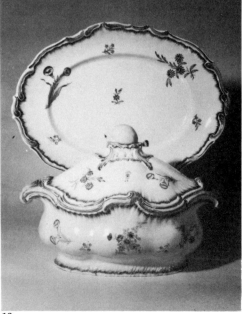
6

7

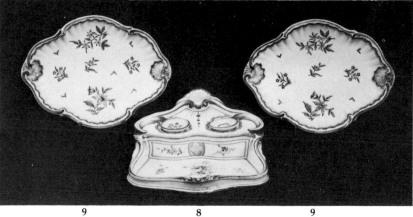
9　　8　　9

10

1

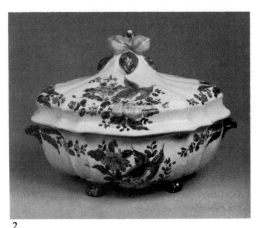

2

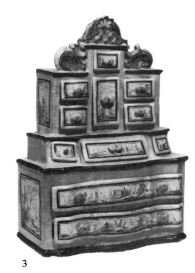

3

4

5

6

7

1. A Holics Memento Mori candelabrum H 2 mark in manganese, incised four, circa 1760
26 cm. wide

2. A Holics two-handled tureen, cover and stand, circa 1770
42 cm. wide

3. A Tata miniature upright secretaire, the fronts to the drawers painted *en camaïeu rose*, circa 1780
38 cm. high

4. A Proskau pierced plate painted in puce, manganese D.P. mark for Dietrichstein, 1770-1783
23.5 cm. diam.

5. A pair of Warsaw (Belvedere) Chinoiserie vases, late 18th century
45 cm. high

6. A pair of Proskau figures of crouching bears, circa 1765
15 cm. long

7. A pair of Proskau jugs, third quarter of 18th century
26.5 cm. high

8. A pair of Holics groups of a shepherd and shepherdess, one with H mark in manganese, circa 1750
22.5 cm. high

9. A Proskau shaped and fluted oval dish, marks in manganese and black, circa 1780
34 cm. wide

10. A Tata two-handled tureen and cover, black F mark, circa 1760
10 cm. wide

11. A Proskau tureen and cover, circa 1780
36 cm. wide

12. A Proskau duck tureen, cover and stand, D.P. mark in manganese, circa 1785
25 cm. wide

13. A Holics pear-shaped coffee-pot and cover, mark in black HH in monogram, circa 1775
22.5 cm. high

14. A Warsaw (Belvedere) plate, 1776
25 cm. diam.
From the service ordered by Stanislas Poniatowski for the Turkish Sultan, Abdul Hamid I

15. A pair of Hungarian duck ewers and stoppers, 18th century
28 cm. wide

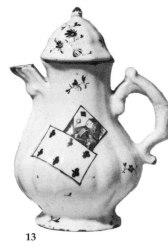

8

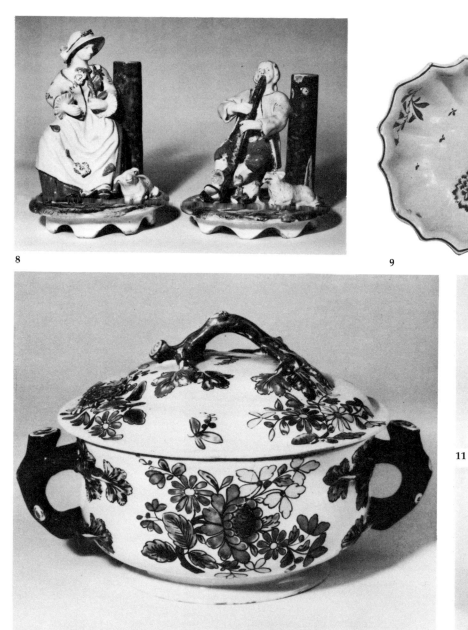

9

11

12

10

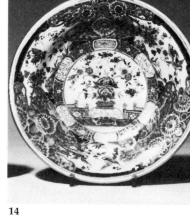

13

14

15

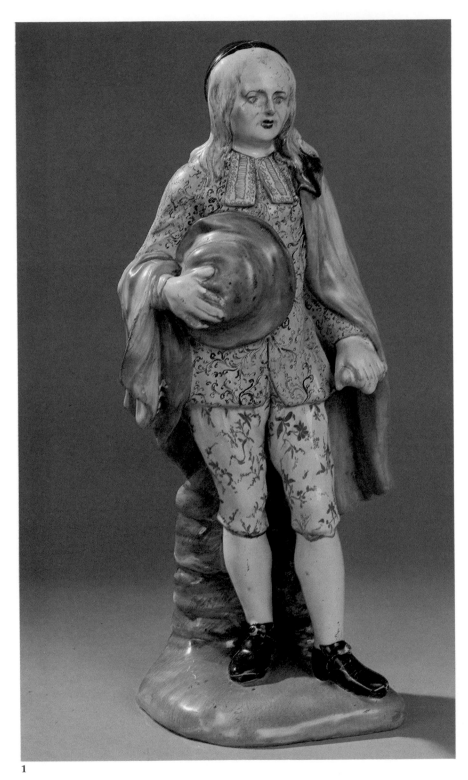

**1.** A Strasbourg figure of
"L'Abbé de Cour" modelled by
Johann Wilhelm Lanz from the
Italian Comedy series, 1745-1748,
Paul-Antoine Hannong
33 cm. high

1

# FRANCE

France stands as a half-way house between the potteries of Italy and those of the German-speaking world.

Initially the dominant influence was that of Italy. An eminent French scholar has even gone so far as to call the whole production of the sixteenth and early seventeenth centuries "pseudo-Italian". It is true that, just as in the glass industry throughout northern Europe, Italians were instrumental in establishing the major early potteries. The earliest of these was almost certainly at Lyons where we know that Sebastiano Griffo from Genoa, Gian Francesco da Pesaro, and two Faentine potters, Gambin and Tardessire, were active in the mid-sixteenth century. Their products tended to run some fifty years behind prevailing fashions in Italy. Thus the earliest established Lyons pieces were of Tuscan inspiration reflecting *oak-leaf* and *famiglia gotica* decoration. This was gradually superseded by *istoriato* wares almost impossible to separate with any certainty from examples made in Italy. Here the situation is complicated by the fact that Italian potters continued to use Italian inscriptions even when they worked in France and their decorative repertoire and source material did not change significantly. There may well be Lyons wares lost among the many pieces given to late sixteenth-century Italy.

At Nîmes a potter called Antoine Syjalon (1524-1590) produced, probably in the last decade of his life, a series of dishes and pilgrim-flasks which have a deep and visible debt to the *a quartieri* wares of Virgiliotto in Faenza. These include the first recorded pots produced for members of the Reformed Church who were assembled in conference in the town in 1581.

A strange byway of French pottery in the sixteenth century led to the wares of Bernard Palissy and his circle. Moulded, pierced, and splashed in aubergine, blue, green, and ochre glazes, these reflected the influence of the goldsmith and the late Renaissance passion for jasper, agate, and similar hard stones. Indeed these wares were styled *façon de jaspe* when they were new. The products of this type are highly restrained. Not so were Palissy's *façon de Saintes* wares, moulded with reptiles and fishes in high relief. An acquired taste, they unfortunately gave rise to numerous nineteenth-century imitations.

The most important of the early factories was Nevers. The first recorded potter there was the same Gambin from Faenza already encountered a few years earlier in Lyons. He was in business with a family called Corrado (in French Conrade) who obtained a *privilège* from Henri IV which gave them the sole right to produce pottery in Nevers for thirty years. The late sixteenth century saw the *istoriato* style in force at Nevers as well, though here it is picked out by a distinctive and unmistakable wave decoration. By the beginning of the seventeenth century the *compendiario* style had arrived and was reflected not merely in white-ground wares (*faience blanche*) but in figures principally devotional, in the same technique. The Corradi did not lose contact with their native land and throughout the century the latest Italian ideas are to be found reflected swiftly in the wares of Nevers. The *berrettino* tradition started in Faenza a century before finds its echo, and is, according to some authorities, excelled in the blue-ground wares of Nevers. The rich blue ground was used as a field for ochre and white enamel formal patterns. In certain instances a yellow ground was used with blue and white enamel decoration.

Nevers was the leading centre of pottery in France throughout the seventeenth century. Like the potters at Delft further north, the *faienciers* felt the influence of Chinese blue and white porcelains. However, they do not seem ever to have sought, and certainly never achieved, the superficial imitation of the Chinese originals that was the hallmark of the finest Delft wares. At Nevers, oriental ideas were used as a source for decorative themes on a purely abstract basis. The resultant pottery, with so-called *à la palette* decoration, combines European forms with decoration which, while using colours lifted from Chinese wares, gives a totally un-Chinese effect. We witness here the birth of Chinoiserie on pottery.

Gradually as the seventeenth century went by, the "Italian" potteries yielded precedence to those of purely French origin. Of these the earliest was at Rouen. Here the first and perhaps most exceptional luminary was Masseot Abaquesne. His activity between 1530 and his death in 1564 was principally devoted to the production of large tile decorations. These were for Anne de Montmorency, Constable of France, in his Château of Ecouen, for his wife at the Château de Fore, and at a variety of other residences of the nobility and churches. He is also on record as the producer of five thousand pharmacy pots for the Rouen pharmacist, Pierre Dubosq, in 1545. The scale and quality of his tile panels, which he would seem to have painted himself, are quite remarkable. His drug jars, which included albarelli and wet-drug jars, echo those made in Italy some half a generation earlier but the shapes he produced are quite distinctive. Their angularity is closer to the (later) wares of Sicily than the High Renaissance pieces he may well have seen. After his death his son Laurent and his widow

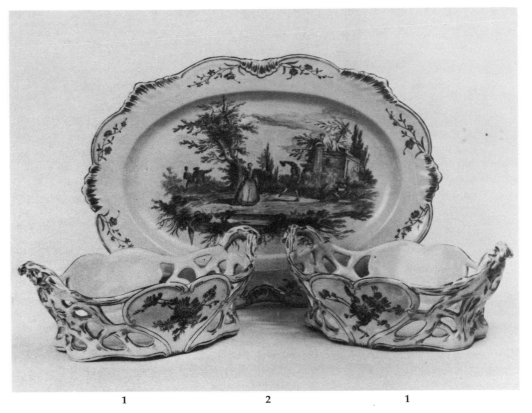

1          2          1

continued working for a period as yet undetermined.

About seventy years then elapsed before documented activity is to be found in the potteries of Rouen. Here Edmé Poterat was responsible for wares in the compendiario style and indeed acted through a *privilège* granted to Nicholas Poirel de Grandval, first gentleman to Anne of Austria, which authorized him to produce "all kinds of tablewares in white faience". Three of his early pieces are inscribed and dated *Rouen 1647*. Without this they could easily be confused with the wares of northern Italy or southern Germany of the same date, such was the uniformity with which the *compendiario* style was used everywhere. Poterat died aged about seventy-five in 1687, having incidentally discovered porcelain. At his death the family empire, which had hitherto had a virtual monopoly of the pottery production in Rouen, was split in two, and, as the eighteenth century went by, was further eroded by factories set up by former employees. The output of Rouen, however, was growing constantly to match this expansion and by the second quarter of the eighteenth century, the apogee of Rouen's success, there were over eight manufactures in operation: by 1786 there were eighteen potteries going, employing twelve hundred work-people. The success of the Rouen potteries lay in two areas: they had access to local clays of the best and more coarse qualities and the massive melting of silver ordered by Louis XIV in 1709 to pay for the catastrophic financial cost of the war of the Spanish succession deprived the nobility of much of their plate. Rouen, with its relative proximity to Paris, was an immediate beneficiary. The wares of the second half of the seventeenth century tended initially to mirror those of Nevers and Italy, but by the end of the century a distinctive local style of great effect emerged. This used as its principal decorative motifs lambrequins, and damask patterns culled originally from the wares of the orient but derived more directly from the graphic work of Daniel Marot and Jean Bérain. The shapes to which this decoration was applied had their origins in the metalwork they were destined to replace.

The initial blue and white decoration was soon joined by red, which the Rouen potters succeeded in firing successfully in the closing years of the seventeenth century. They would appear to have been the first to succeed in firing this very volatile colour with even results by dint of a muffle kiln. This was to give rise to the splendid *style rayonnant*, so called for its rich concentric designs. Initially in red and blue, the finest examples of the late 1720s have the addition of a black *niello* ground which makes them among the grandest pieces produced since the High Renaissance.

Rouen was also deeply influenced by the famille verte wares that were now arriving from China to supplant those in purely blue and white. This palette suited the *faienciers* very well and found perhaps its best expression in the products of J.B. Guillebaud, whose wares were copied by the Chinese potters for export to Europe. The outstanding feature of Rouen faience, the rich and solomn use of formal, floral, and human elements to form a symmetrical pattern, often centred on a coat of arms, endured until almost the middle of the eighteenth century. In no other French factory was pottery imbued with such grandeur. The later years of the century saw a

rather simpler output of which the famous cornucopia pattern is typical.

Close to Rouen and much influenced by it was the Sinceny pottery set up there in 1736. In many ways Sinceny merely takes on where Rouen was beginning to leave off and its products differ little from later Rouen wares.

Apart from Rouen, which was already at a great level of skill by the death of Louis XIV, all the other great French factories date from the reign of his successor, Louis XV. The first of these was at Moustiers in Provence where the Clérissy dynasty, the Olerys-Laugier partnership, and the Ferrat family produced *grand feu* and eventually *petit feu* faience throughout the century. Initially the Clérissys worked in blue and white and produced wares easily confounded with those of Rossetti in Turin, with very delicate decoration in the style of Bérain. By the 1720s, the central medallions had increased in scale and relative importance in the whole design. The classic examples are large dishes decorated with subjects derived from the prints of Tempesta (who played the same role at Laterza). Like the contemporary wares of Rouen, these pieces are grandiose in conception and in actual physical size. By the 1730s this grandeur was diminishing but the decoration was enhanced by the arrival of polychrome colouring, albeit very restrained, in a palette of manganese, sage green, ochre, and blue. Initially the blue was dominant and the other colours served to pick it out: by the middle of the century a balanced palette was worked out. The credit for this is generally given to Joseph Olerys, who, having started out at Moustiers under the Clérissys, took himself off to Marseilles in 1723, and thence to Alcora where he worked for ten years (1727-1737) before returning with his new palette to Moustiers. The scale of his output was altogether simpler and the decoration, in harmony with this fact, was less splendid and more intimate in character. The classic Olerys border was swags of flowers and medallions, generally of mythological subjects, which are surrounded by further garlands. Distinct variations of quality may be found in Moustiers wares of this type, probably owing to the fact that patterns of this sort were produced across the whole spectrum of potteries operating there. Around the middle of the century another decorative style emanated from Olerys' pottery. Here anthropomorphic animals and birds and grotesque zoomorphic figures inspired by the work of Jacques Callot were depicted in schematic landscapes with strange scattered foliage. Apart from the usual wares common to all potteries, Moustiers produced écuelles, powder-boxes, and plaques.

The production of *petit feu* wares at Moustiers came late and was relatively unimportant. This was not at all the case at Marseilles. The production of faience there was started by members of the same Clérissy family who set up Moustiers as a major centre. As the eventual Clérissy heiress Madelaine Héraud was a minor in 1711, the direction of the family pottery was placed in the hands of Joseph Fauchier. His products, without exception in *grand feu*, were technically the leading wares throughout the first half of the century. Particularly strong in the use of manganese, Fauchier also developed a satisfactory yellow ground. His forms were rather heavy and unsophisticated. When he died in 1751 he was suceeded by his nephew, Joseph Fauchier II, who continued in the *grand feu* tradition, producing wares very similar to those of Rossetti in Turin. Occasionally he produced *grand feu* pieces in imitation of the *petit feu* wares of Pierrette Caudelot, better known to students of faience as Veuve Perrin. Taking control of her deceased husband Claude's pottery in 1748, she continued to manage it until her death in 1793. Its output was entirely of *petit feu* wares.

This technique, which admitted of finely potted wares painted in enamel colours combined with gilding, was marvellously suited to the expression in faience of the prevalent rococo style. It was used to produce a wide range of wares in varied and original shapes including tureens with leopard handles and leaping fish finials, vases, wall fountains, and the whole gamut of wares produced in the porcelain factories of the day. Floral decoration played a large part in the pottery's output, as did still-life groups of fish, figures in landscapes, Chinoiseries after Pillement, and patterns imitative of Chinese export wares.

Closely similar to Veuve Perrin's wares were those of Joseph Robert, who also worked purely in *petit feu*. Very little distinguishes the wares of the two potters, though Robert's *à la bergerie* and *à la Saxe* decoration, in which rich gilding encloses figure panels in a brilliant palette to produce some of the richest decoration ever achieved on faience, is perhaps the more successful.

At a time when the economic success of the *faienciers* was threatened both by porcelain and creamware, Antoine Bonnefoy, also working in *petit feu* technique, produced wares remarkable for the sheer technical skill of their execution. Generally his faience was decorated with large central landscape panels of almost monotonous perfection, reflecting the chill neoclassicism of the reign of Louis XVI which was generally not conducive to successful expression in pottery or porcelain.

The *faienciers* of Marseilles, like their colleagues elsewhere, were to suffer greatly at the hands both of the porcelain manufactures and the spread of creamware from England and France itself, and their craft did not survive the Revolution.

In north-eastern France in the regions of Alsace and Lorraine the faience potters were open to currents of influence from Germany just across the Rhine and indeed the technical knowledge used to set up the factories in Hagenau and Strasbourg came from Germany. The key family in the pottery industry were the Hannongs, of Dutch birth but Spanish blood, of whom the first, Charles-François, then aged about forty, settled in Strasbourg in 1709, the very year in which the noblesse of France had seen its plate melted for the war. Although helped initially by a German potter called Wachenfeld, Hannong by 1724 was well established in business both in Strasbourg and in Hagenau where he produced blue and white wares of a fairly simple and

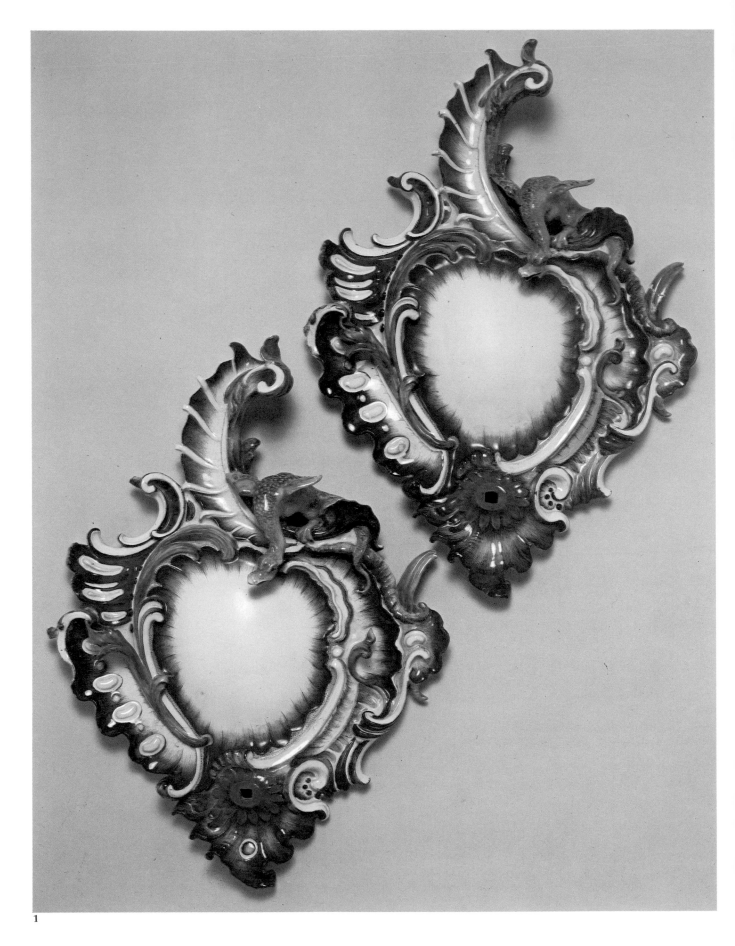

1

**1.** Two Strasbourg rococo appliques, blue P.H. monogram marks of Paul Hannong, circa 1750
45 cm. high

**2.** A pair of Strasbourg figures of musicians, circa 1760
19 cm. long

**3.** A Strasbourg rococo two-handled tureen and cover, circa 1750
32 cm. wide
This model, called a *terrine en baroque* or *terrine à chapeau chinois* and introduced after 1748, was to prove one of the most influential designs of the day. It was copied widely at Sceaux, Niderviller, Höchst, Crailsheim, the Baltic factories, and by the Chinese.

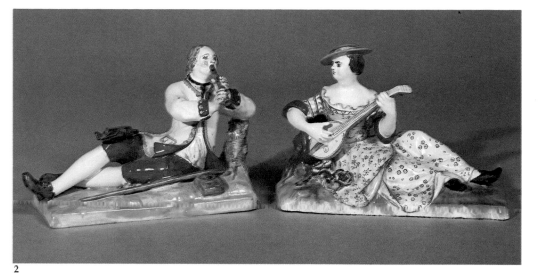

2

unremarkable sort. He continued in this till 1732 when he handed over his affairs to his two sons, Paul-Antoine and Balthazar. The former was to dominate the business for twenty-eight years.

It took some time for Paul-Antoine to evolve a creative style of his own, but when this did come (in 1744) it was to project his factory into new levels of quality and creation. Here he was much helped by the use of muffle colours which derived from the Meissen porcelain factory. At the same time he received help from Germany in the shape of three runaways from Meissen, Adam Friedrich von Löwenfinck, his wife Maria Seraphin, and Johann-Jacob Ringler. Löwenfinck and Ringler were both much-travelled gentlemen. Apart from his youthful years at Meissen, Löwenfinck was also involved in the production of faience at Fulda and Ansbach. His great strength was as a decorator. Ringler, on the other hand, was a technician well versed in the arts of building kilns and firing enamel colours. It is probably thanks to Ringler that Paul-Antoine was able to produce his own porcelain. In the present context this was but a sideline.

The output of this strong team included wares in which floral decoration was applied to shapes derived from contemporary silver. Besides this staple product, some of which was simply executed by filling in previously drawn outlines, Hannong produced fine figures, including Italian comedy subjects, figures emblematic of the seasons, animals, huntsmen, and other themes already to be found in the repertoire of Meissen. A major novelty in the field of ceramics were the trompe l'oeil pieces: here tureens were made in the form of vegetables, fruit, and animals. This was a fashion very much in tune with the prevailing rococo spirit and it was to be taken up throughout the porcelain and pottery factories of Germany and England in the succeeding decades.

The success of Strasbourg and Hagenau continued for some years under Joseph Hannong, Paul-Antoine's younger son. However, family financial complications, a somewhat idealistic nature, and a fundamental preference for porcelain, which he also produced, finally combined to bring down his faience factory in 1779.

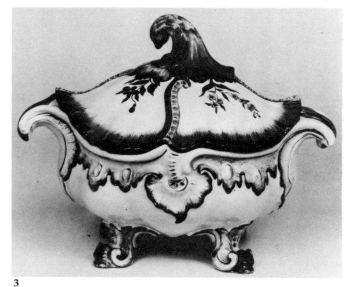

3

There were three factories in Lorraine at Lunéville, Niderviller, and Saint Clément. All three had their best period somewhat later than that of Strasbourg by which they were profoundly influenced. Niderviller produced some splendidly rococo forms around 1760 in the Louis XV taste, and sold wares decorated with *bois simulé* grounds in a technique much used in the porcelain factories of Germany. It never achieved the brilliance and vigour of Strasbourg in either its wares or its decoration.

The example of Strasbourg was also followed by the Sceaux pottery on the outskirts of Paris. Here, when the royal monopoly granted to de L'Isle Adam in 1745 prevented the continued production of porcelain, a successful manufacture of *faience japonnée* was set up. Several of the workmen involved came from Strasbourg and the types of ware produced and the models chosen followed the fashion already laid down by Hannong's pottery. The faience was never as clear and fine. The factory was to survive, producing wares of high quality till its trade was wiped out by the Anglo-French trade agreement in 1786, which was closely followed by the Revolution.

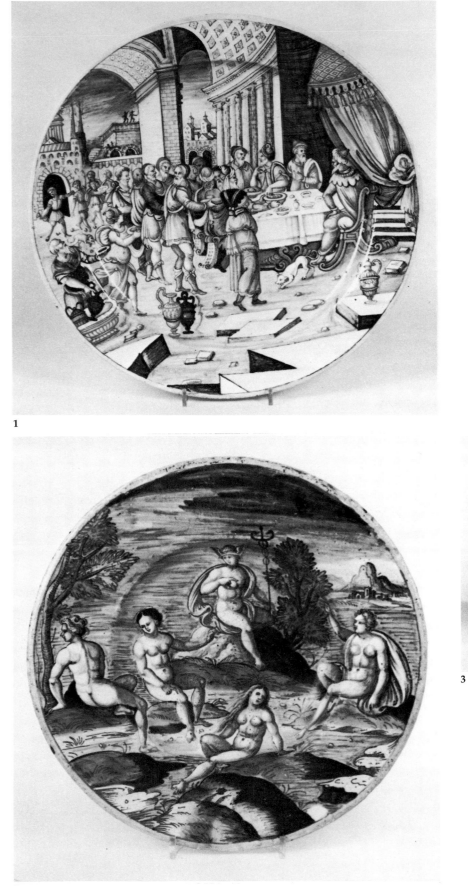

1

2

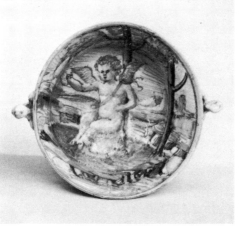

3

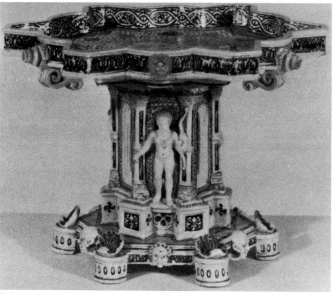

4

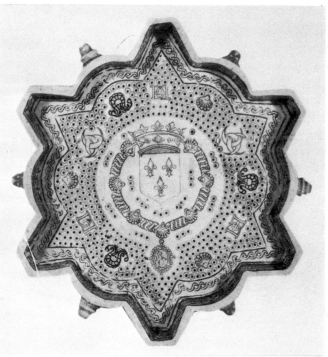

4A

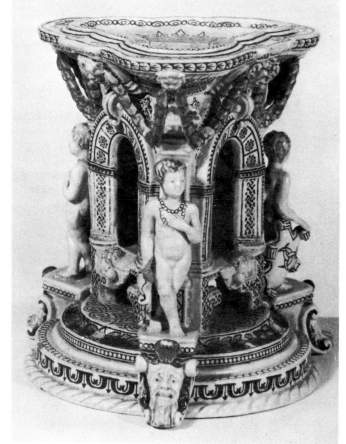

5

**1.** A Lyons istoriato dish, the reverse inscribed Ai genese 63 Cp/ Joseph qui traite /ses frere a la venue/de Beniamin, circa 1570
43 cm. diam.

**2.** A Nevers istoriato dish, the reverse inscribed, late 16th century
34 cm. diam.

**3.** A French maiolica circular two-handled bowl, mark a green cross within flower-heads, circa 1580
21 cm. diam.

**4 and 4A.** A Saint-Porchaire (Henri II) ware tazza, the top pierced and inlaid with the arms of France, second quarter of 16th century
14 cm. high, 19.5 cm. wide

**5.** A Saint-Porchaire (Henri II) ware salt-cellar, the centre painted with the crowned arms of France, 1545-50
15 cm. high

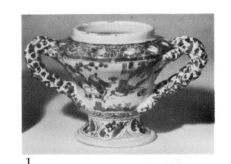

1

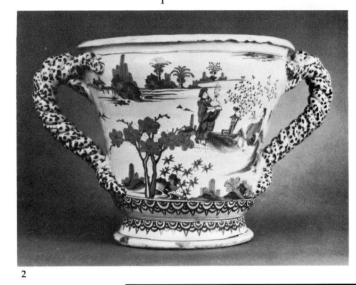

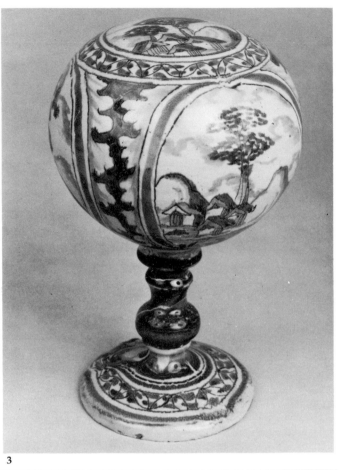

2

3

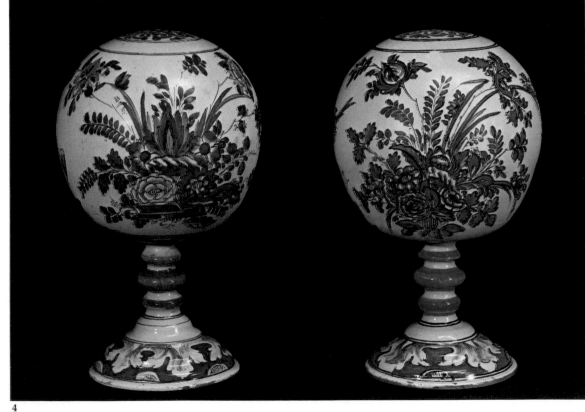

4

**1.** A two-handled pot-pourri vase, second half of 17th century
26 cm. wide

**2.** A blue and white two-handled flaring jardinière, circa 1700
33 cm. high

**3.** A blue and white wig-stand, circa 1700
20 cm. high

**4.** A pair of large wig-stands, circa 1700, perhaps Nevers
30.5 cm. high

**5.** A blue and white shallow bowl, dated 1767 and decorated after a popular print with "L'arbre d'Amours"
31 cm. diam.

**6.** A polychrome shaped shallow dish, dated 1771
34 cm. diam.

**7.** Two *bleu persan* plates, circa 1700
24 cm. diam.

**8.** A blue and white plate, circa 1700
22.5 cm. diam.

**9.** A two-handled rectangular dish, blue I.2 mark, circa 1740
48 cm. wide

5

6

7

8

9

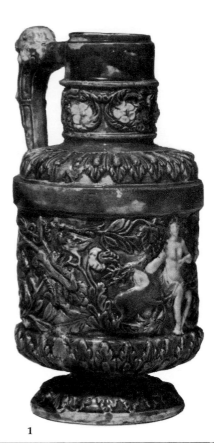

1

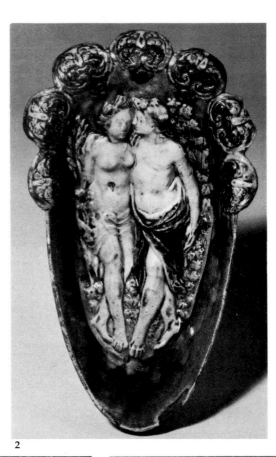

2

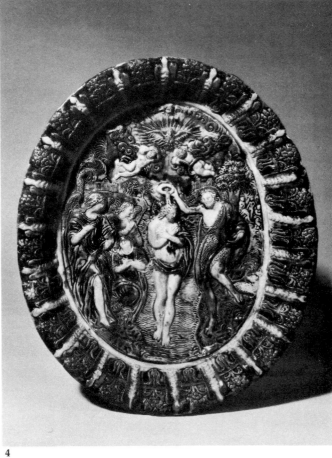

3

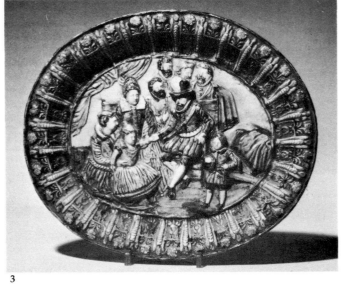

4

**1.** A cylindrical jug, 16th century
18 cm. high

**2.** A small oval dish, 16th century
19 cm. long

**3.** An oval dish, 16th century
31.5 cm. wide

**4.** An oval dish, 16th century
31 cm. high

**5.** A figure of Christ by the well, 16th/17th century
15 cm. high

**6.** An ajouré tazza, late 16th century
22.5 cm. diam.

**7.** A flask and stopper, early 17th century
21 cm. high

**8.** A two-handled pilgrim bottle, 16th century
23.5 cm. high

**9.** A ewer, 16th century
22 cm. high

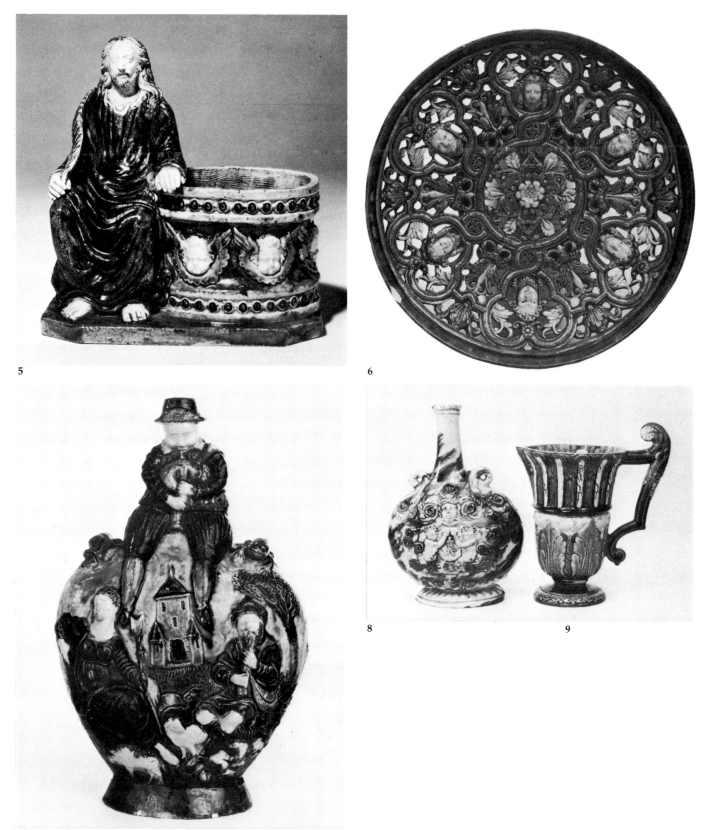

5

6

8

9

7

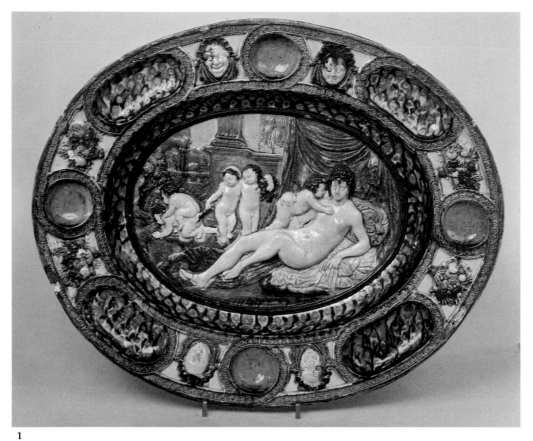

1

1. A Fécondité dish, third quarter of 16th century
48.5 cm. wide

2. A grey-blue ground oval dish, circa 1600
53 cm. wide

3. A tazza, perhaps 16th century
32 cm. wide

4. A large circular dish, circa 1600
51.5 cm. wide

5. A deep blue-ground oval dish, late 16th century
52 cm. wide

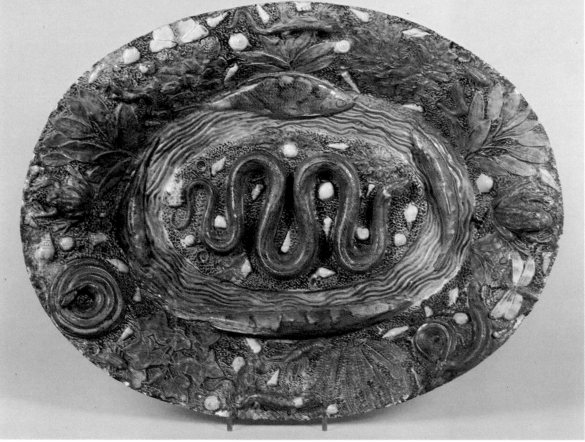

2

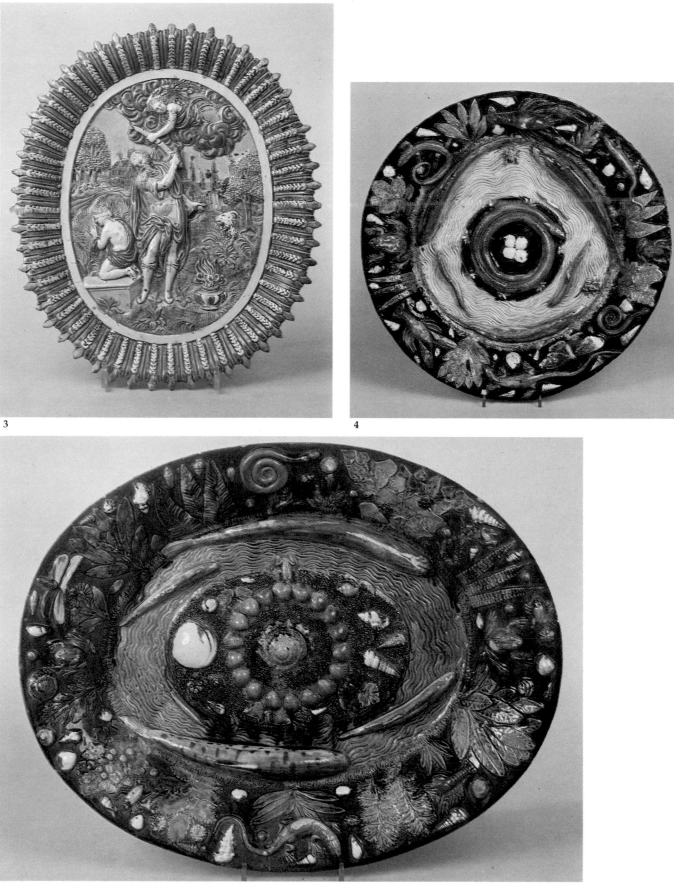

3

4

5

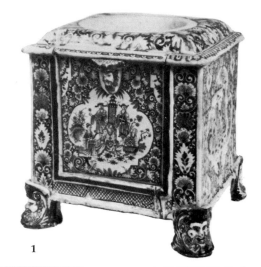

1

1. A Rouen blue and red square travelling water-closet, circa 1700
49 cm. high

2. A Lunéville shaped circular plate, 3R mark in manganese, circa 1760
25 cm. diam.

3. A pair of Lunéville plates, blue marks, circa 1760
23.5 cm. diam.

4. A Lunéville cylindrical two-handled cache-pot, blue marks, circa 1760
12 cm. high

5. A Rouen two-handled écuelle and cover, circa 1720
24 cm. wide

6. A Rouen polychrome two-handled tureen and cover, circa 1750
32 cm. wide

7. A Rouen two-handled oil and vinegar stand, 18th century
23 cm. wide

8. A Rouen polychrome shaped oval dish, iron-red Dieul mark, circa 1770
39 cm. wide

9. A Rouen polychrome shaped octagonal two-handled tureen and cover, iron-red CH mark to cover and green CH mark to tureen, circa 1700
29 cm. wide

10. A Rouen polychrome plate, circa 1780
23.5 cm. diam.

2

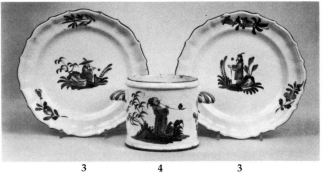

3    4    3

5

6

7

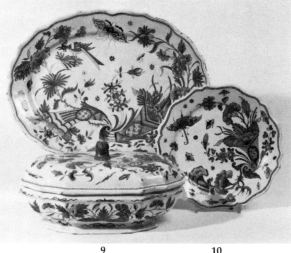

8    9    10

**11 and 11A.** A Lunéville figure of a dwarf probably representing Bébé, the court dwarf of Stanislas Leszczynski, and his pouch with the monogram of Stanislas Leszczynski Rex, signed with the initials "NP fecit de L'annee 1746"
56 cm. high

**12.** A Lunéville recumbent lion, second half of 18th century
46 cm. wide

**13.** A pair of Lunéville turquoise glazed recumbent lions, second half of 18th century
17 cm. long

**14.** A pair of Lunéville figures of recumbent lions, second half of 18th century
45.5 cm. long

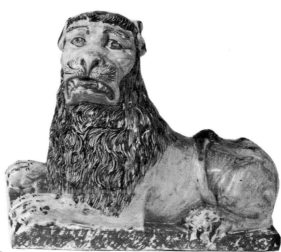

12

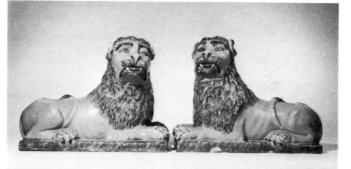

13

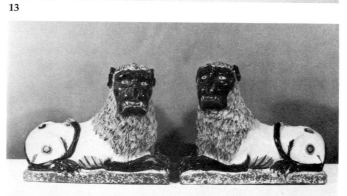

14

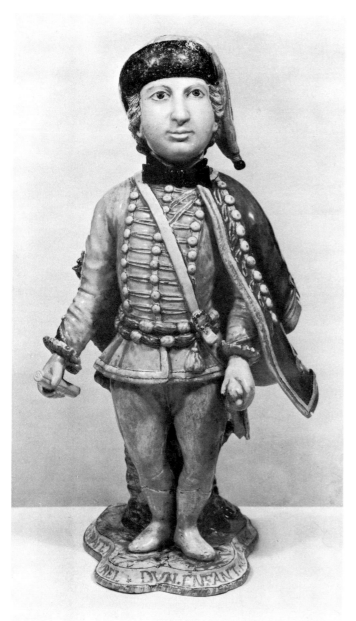

11

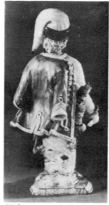

11A

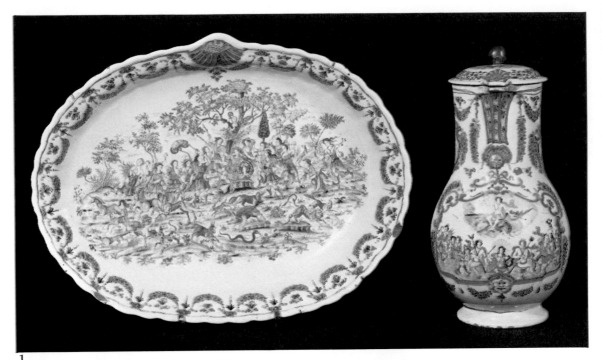

1

2

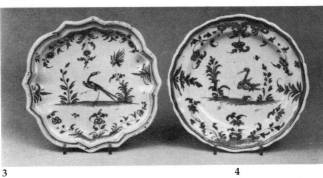

3                                                    4

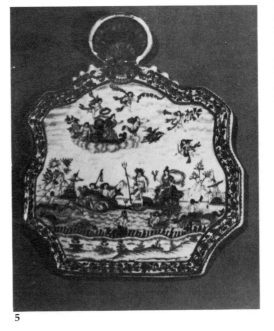

5

**1.** A ewer and basin, circa 1740
the basin 37 cm. wide
the ewer 25 cm. high

**2.** A foliate dish, circa 1760
40.5 cm. diam.

**3.** A Bérain plate, manganese
cross mark, circa 1710
24 cm. diam.

**4.** A Bérain shaped square dish,
blue cross mark, circa 1710
23 cm. wide

**5.** A polychrome plaque, Olerys
factory, circa 1740
23 cm. x 27 cm.

**6.** A plate, circa 1750
25.5 cm. diam.

**7.** An octagonal plate, ochre OL
monogram, cica 1760
25 cm. diam.

**8.** A plate, circa 1750
26 cm. diam.

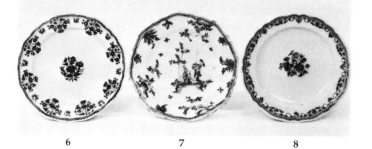

6         7         8

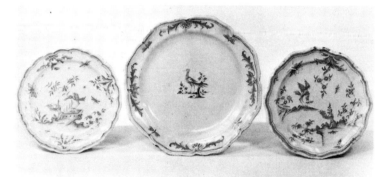

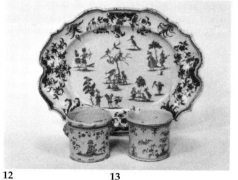

9       10       11       12       13

**9.** A plate, circa 1750
24 cm. diam.

**10.** A hexafoil dish, circa 1750
33 cm. diam.

**11.** A shaped hexafoil plate,
circa 1750
25 cm. diam.

**12.** A shaped oval dish painted
by Fouquet, ochre F and LM
monograms, circa 1750
42.5 cm. wide

**13.** Two two-handled pots-à-
olives, circa 1750
9.5 cm. high

**14.** A waved octafoil dish, circa
1760
24.5 cm. diam.

**15.** A blue and white armorial
dish, with the arms of Madame
de Pompadour, circa 1750
42 cm. wide

**16.** A powder box and cover,
circa 1770
13.5 cm. high

**17.** An oval two-handled tureen,
cover, and stand, circa 1750
the stand 46 cm. wide

**18.** A shaped oval tureen and
cover, circa 1760
37 cm. wide

14

15         16

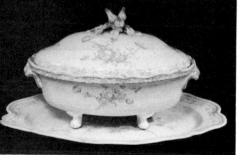

17

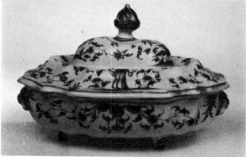

18

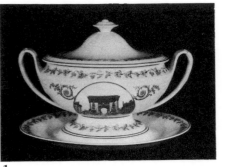

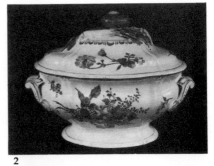

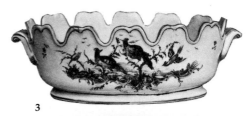

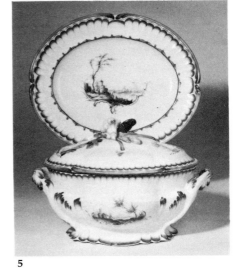

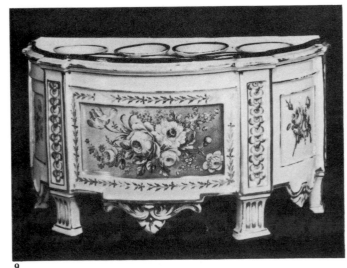

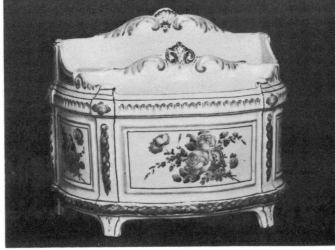

1. A Creil creamware oval tureen, cover, and stand, late 18th century
43 cm.

2. A Niderviller soup-tureen and cover, circa 1770
30 cm. wide

3. An Aprey (Meillonas) shaped oval two-handled seau crénelé, puce AP mark, painter's mark C, circa 1750
35.5 cm. wide

4. Two Sceaux shaped hexafoil plates, circa 1750
23 cm. diam.

5. A Niderviller oval two-handled soup-tureen, cover, and stand circa 1770
the stand 31.5 cm. wide

6. A pair of Niderviller figures of recumbent does, circa 1760
about 22 cm. wide

7. A pair of Strasbourg grape tureens and covers, circa 1765
both about 15 cm. long

8. A Niderviller asparagus tureen and cover, circa 1760
17 cm. long

9. A Saint-Clément Louis XVI tulipière and cover, circa 1780
27 cm. wide

**10.** A Sceaux semi-circular tulipière, R. Glot period, circa 1780
24 cm. wide

**11.** A pair of Sceaux tulipières and covers, circa 1770
14 cm. wide

**12.** A pair of Sceaux semi-circular jardinières, circa 1760
22 cm. wide

**13.** A pair of Eastern French figures of musicians, circa 1770
16 cm. high

**14.** A Niderviller figure of a boy chimney sweep, circa 1775
17 cm. high

**15.** A Sceaux rectangular divided tulipière, pink fleur-de-lys mark circa 1760
21 cm. wide

**16.** A Sceaux duck tureen and cover, yellow fleur-de-lys mark, circa 1760
30.5 cm. wide

**17.** A Niderviller figure of a girl emblematic of spring, circa 1765
20 cm. high

**18.** A figure of a sportsman, probably early Niderviller, circa 1760
20 cm. high

**19.** Two sweetmeat figures, Holics or Niderviller, circa 1765
both about 27 cm. wide

**20.** A Sceaux two-handled bowl, cover, and stand, 1775/1780
the stand 24.5 cm. diam.

**21.** A Saint Clément large coffee-cup and saucer, circa 1770

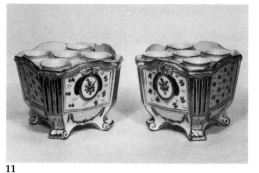
11

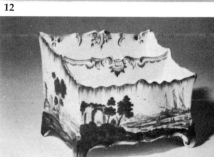
12

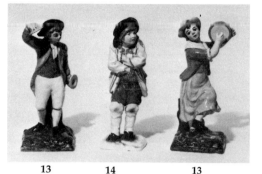
13  14  13

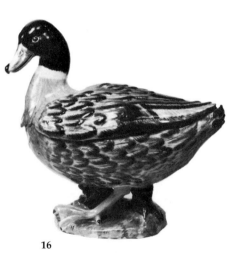
15

16

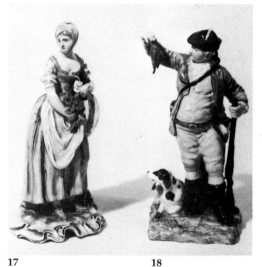
17  18

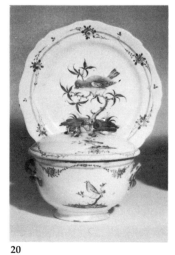
19  20  21

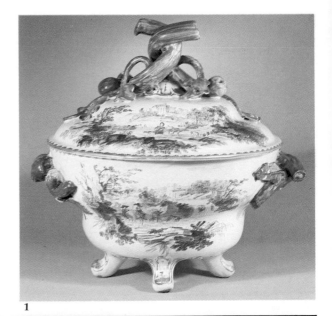

1

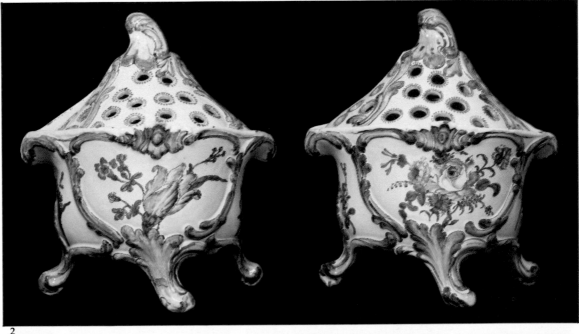

2

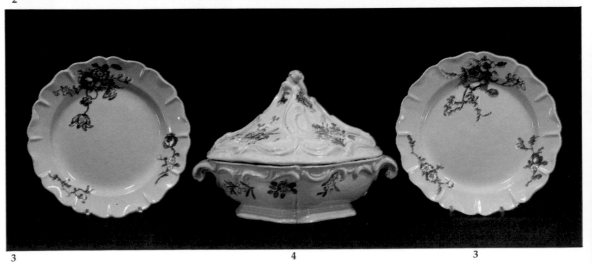

3                                              4                                              3

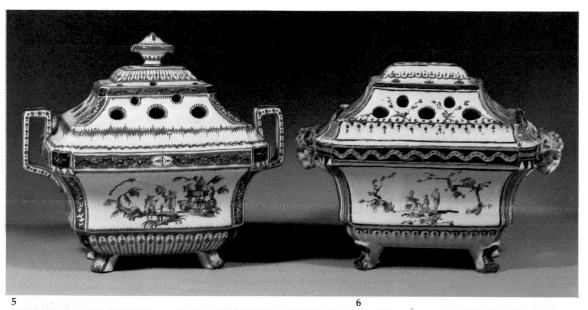

5                                            6

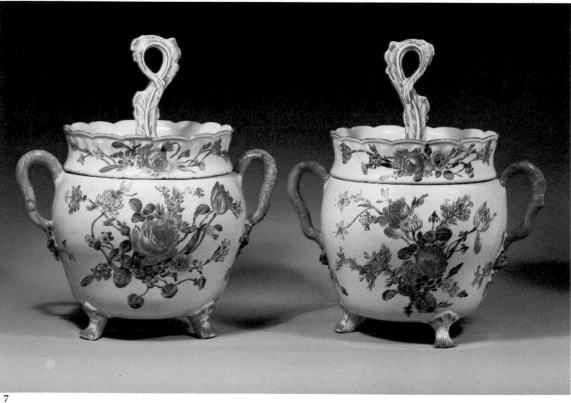

7

**1.** A Veuve Perrin large circular soup-tureen and cover, circa 1765
29 cm. high

**2.** A pair of Louis XV bouquetières and pierced covers, Fauchier II factory, circa 1760
29.5 cm. high

**3.** A pair of yellow-ground plates, Fauchier II factory, circa 1750
24.5 cm. diam.

**4.** A rococo yellow-ground soup-tureen and cover, Fauchier II factory, 1750-1760
33 cm. wide

**5.** A Veuve Perrin jardinière with pierced cover, circa 1770
24 cm. wide

**6.** A Veuve Perrin Louis XVI rectangular jardinière, puce VP marks, circa 1780
26 cm. wide

**7.** A pair of Veuve Perrin ice-pails and covers, circa 1770
31 cm. high

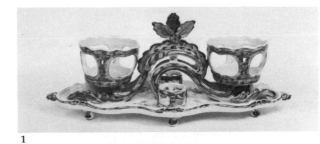

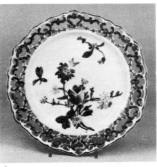

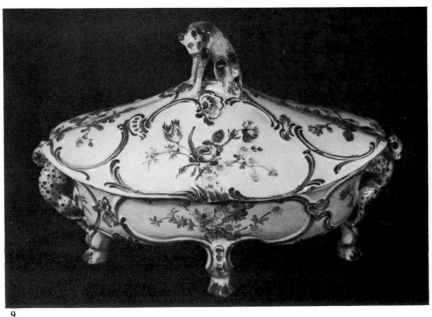

1. A Veuve Perrin shaped oval oil and vinegar stand, circa 1750
34 cm. wide

2. A Veuve Perrin pierced hexagonal plate, black VP mark, circa 1760
24.5 cm. diam.

3. A shaped and pierced oval dish, circa 1760
33 cm. wide

4. A pair of duck tureens and covers, probably Joseph Fauchier II; early 18th century
30.5 cm. wide

5. A pair of Veuve Perrin two-handled baluster pot-pourri vases and covers, circa 1760
19 cm. high

6. A blue and white jug, probably Moustiers, circa 1740
25 cm. high

7. A Veuve Perrin oval two-handled soup-tureen and cover, black VP mark, circa 1760
44 cm. wide

8. A two-handled oblong soup-tureen and cover, puce VP mark, circa 1760
35.5 cm. long

9. A Veuve Perrin oval two-handled tureen and cover, the base and cover with V.P. monograms, circa 1760
37 cm. wide

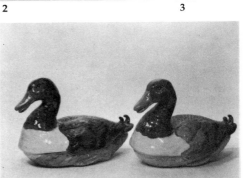

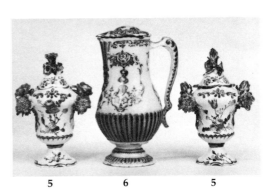

**10.** A pair of Veuve Perrin winged oval bulb-pots, circa 1760
29 cm. wide

**11.** A Veuve Perrin shaped circular two-handled tureen, cover, and stand painted *en camaïeu vert*, circa 1765
30 cm. diam.

**12.** A pair of Veuve Perrin plates, circa 1765
25 cm. diam.

**13.** A Veuve Perrin oval butter-dish and cover, circa 1765
19 cm. wide

**14.** Two rare plates, Robert's factory, circa 1770
25 cm. diam.

**15.** A pair of Veuve Perrin shaped oval dishes, puce VP monograms, circa 1760
33 cm. wide

**16.** A Veuve Perrin two-handled soup-tureen and cover, circa 1760
36 cm. wide

**17.** Part of a Veuve Perrin service, brown VP marks, circa 1760

**18.** Part of a Marseilles Chinoiserie service, painted in the style of Pillement, brown V.P. marks, circa 1760
the seau 21.7 cm. wide

10

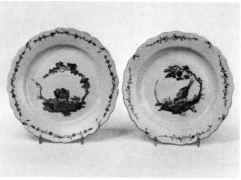

11

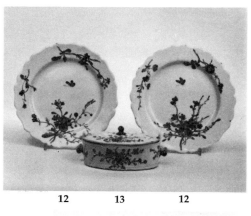

12          13          12

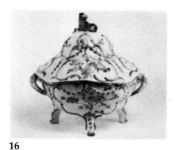

14

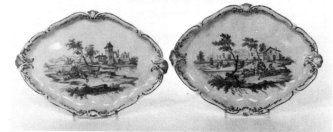

15                              16

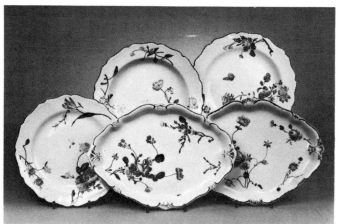

17

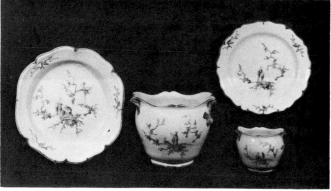

18

1                                                    2

3                                                    4

**1.** A shaped plate, Robert's factory, circa 1765
25 cm. diam.

**2.** A shaped plate, in the Meissen style, Robert's factory, circa 1765
24.5 cm. diam.

**3.** A Veuve Perrin shaped plate, circa 1770
24.5 cm. diam.

**4.** A shaped polychrome plate, Veuve Perrin or Robert's factory, circa 1770
24 cm. diam.

**5**        **6**        **7**

**5.** A Veuve Perrin turquoise-ground ewer and basin, VP mark on ewer, cover, and basin, circa 1760
the basin 38 cm. wide
the ewer 33 cm. high

**6.** A shaped polychrome plate, Robert's factory, circa 1770
25 cm. diam.

**7.** A shaped plate, Robert's factory, circa 1770
24.5 cm. diam.

**1.** A pair of Chinoiserie figures,
Paul Hannong, circa 1745
14 cm. wide

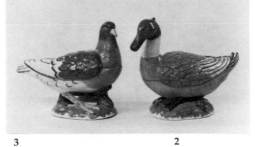

**2.** A duck tureen and cover, Paul
Hannong, circa 1760
34.5 cm. wide

**1**

**3**                                    **2**

**3.** A pigeon tureen and cover,
Paul Hannong, circa 1760
30.5 cm. wide

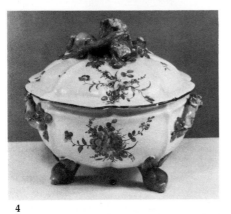

**4.** A tureen and cover, possibly
Strasbourg or Niderviller, circa
1765
21 cm. wide

**5.** A cauliflower tureen, cover,
and pierced stand, Joseph
Hannong, circa 1765
34 cm. diam.

**6.** A Saint-Clément figure of a
girl with a birdcage, circa 1770
18.5 cm. high

**7.** A figure of a boar modelled by
J.W. Lanz, Paul Hannong, circa
1750
13 cm. wide

**4**                        **5**

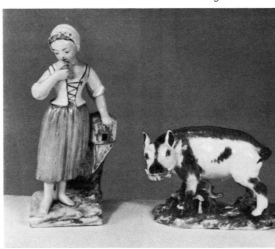

**6**                    **7**

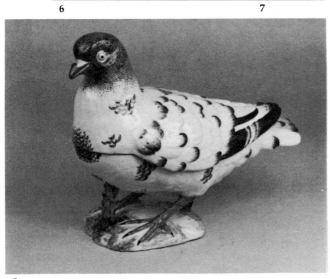

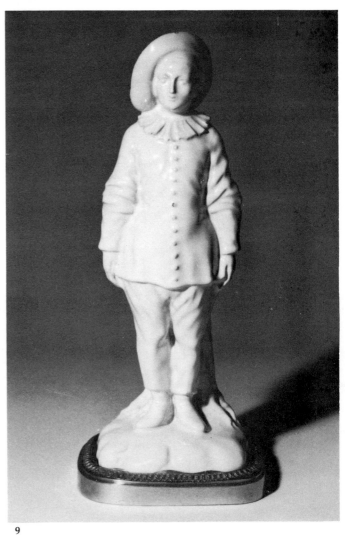

**8**                                    **9**

**8.** A pigeon tureen and cover, modelled by J.W. Lanz, Paul Hannong, circa 1760
34 cm. long

**9.** A white figure of Gilles, after Watteau, Paul Hannong, circa 1750
30.5 cm. high overall

**10 and 11.** Six shaped circular plates, blue H/39 marks, Joseph Hannong, circa 1765
25 cm. diam.

**12.** A figure of Harlequin, circa 1750
37.5 cm. high

**13.** A large circular dish, blue 26 H mark, Joseph Hannong, circa 1765
44.5 cm. diam.

**14.** An oblong dish, Joseph Hannong, circa 1765
41.5 cm. wide

10

11

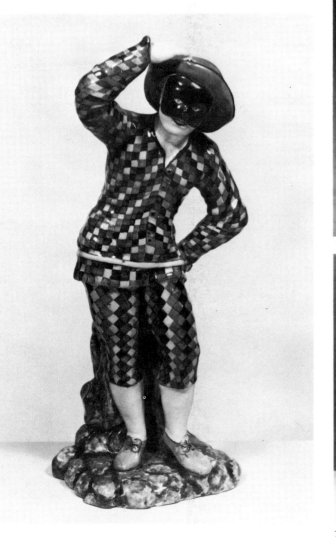

12

13

14

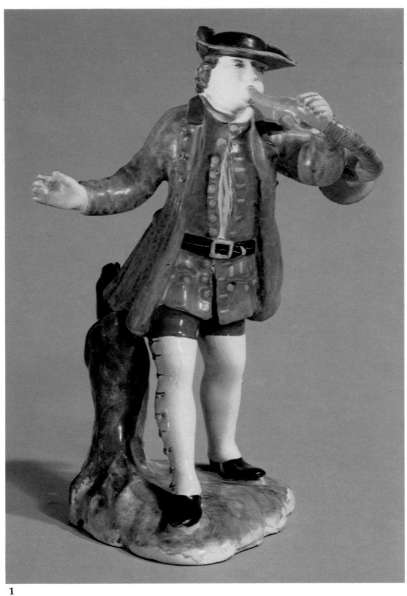

1

1. A figure of a huntsman blowing a horn modelled by J.W. Lanz, Paul Hannong, 1750-54
20 cm. high

2. A figure of a running dog modelled by J.W. Lanz, Paul Hannong, circa 1750
19 cm. long

3. A figure of a wild boar modelled by J.W. Lanz, Paul Hannong, circa 1750
24 cm. long

4. A pair of two-handled double-lipped sauce boats, Joseph Hannong, blue H. 480 marks, circa 1765
21 cm. wide

5. An octagonal plate, H 23 mark in blue and 42 in puce, Joseph Hannong, circa 1770
24.5 cm. diam.

6. A pair of octafoil plates, H 23 marks in blue, Joseph Hannong, circa 1770
24 cm. diam.

7. An oval basin, Paul Hannong, circa 1760
32 cm. wide

8. A pair of plates, blue H 39 marks, Joseph Hannong, circa 1770
24.5 cm. diam.

9. A hexafoil plate, blue PH monogram above a painter's mark in sepia, Paul Hannong, circa 1750
24.5 cm. diam.

10. A pair of partridge tureens and covers, Paul Hannong, circa 1760
20 cm. wide

2                                3

4

5 6 6

7 8 9 8

10

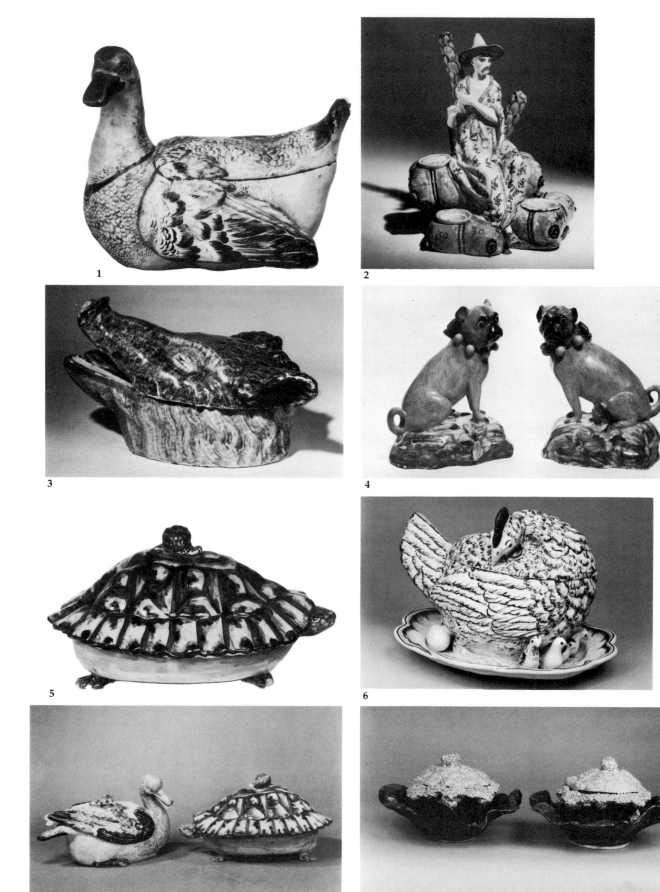

**1.** A Brussels duck tureen and cover, black I mark, circa 1760
15 cm. wide

**2.** A Brussels Chinoiserie inkwell, Rue de la Montagne factory, circa 1785
24.5 cm. high

**3.** A Brussels boar's-head tureen and cover, Rue de Laecken factory, circa 1740
45 cm. wide

**4.** A pair of Tournai pug-dogs after Meissen originals, circa 1760
15 cm. high

**5.** A Brussels tortoise tureen and cover, second half of 18th century
31 cm. wide

**6.** A Brussels hen tureen, cover, and fixed stand, circa 1775
the stand 39 cm. wide

**7.** A Brussels duck tureen and cover, second half of 18th century
30.5 cm. wide

**8.** A Brussels tortoise tureen and cover, second half of 18th century
32 cm. wide

**9.** A pair of Brussels cauliflower tureens, covers, and stands, circa 1765
36 cm. diam.

**10.** A Brussels tureen and cover, formed as a cow, second half of 18th century
20 cm. wide

**11.** A Frisian blue and white circular dish, circa 1720
48.5 cm. diam.

**12.** A Brussels turkey tureen and cover, circa 1775
20 cm. wide

**13.** A Frisian blue-dash charger painted with a portrait of Katherine of Braganza, 17th century
40 cm. diam.

**14.** A Frisian blue and white large dish, early 18th century
43 cm. diam.

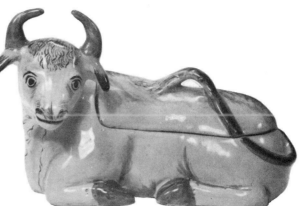

10

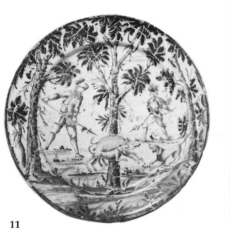

11

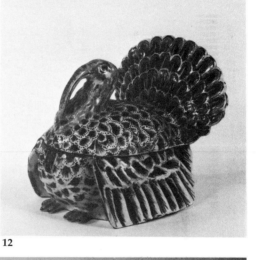

12

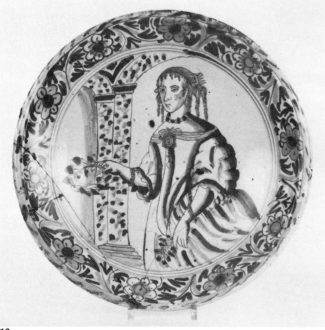

13

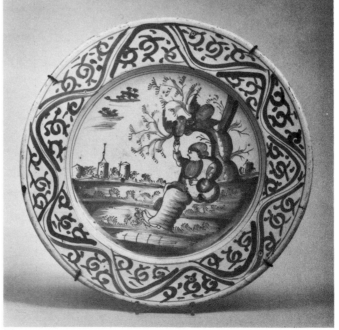

14

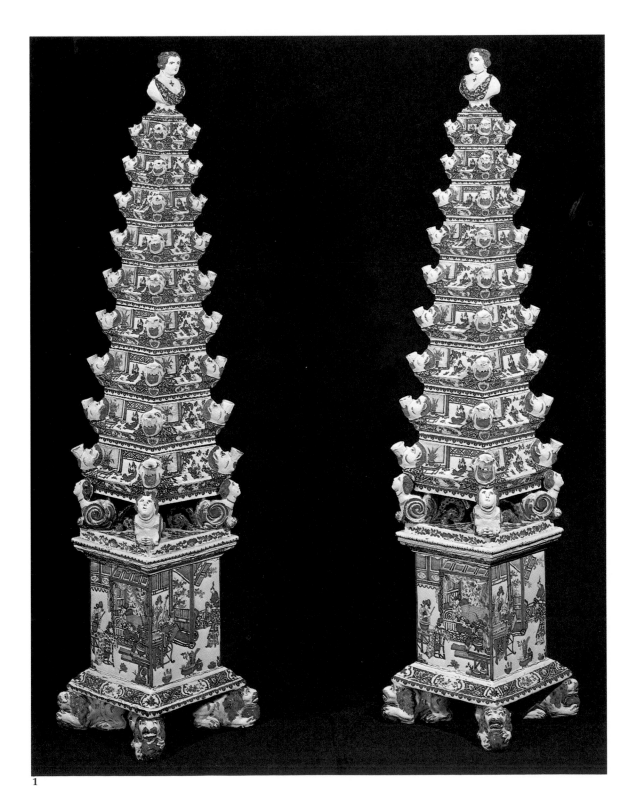

**1**

# THE NETHERLANDS

In the Low Countries, as elsewhere in Europe, the initial inspiration for the production of art pottery came from Italy. From the beginning of the sixteenth century a thriving production of Netherlandish maiolica was established in the area of Antwerp, whilst further north a more rustic ware was produced in Friesland. The tin-glazed earthenware of Flanders, frequently hard to distinguish from the products of north Italy of the same date, was virtually extinguished by political events. In 1585, as a result of the emergent Dutch republic, the city of Antwerp fell into Spanish hands and this provoked a general migration northwards of the potters who formed the backbone of the industry. By the early seventeenth century, potteries were well established in Rotterdam, Haarlem, the Hague, and Delft, though it was Delft, with its strong political ties throughout the seventeenth century, that was shortly to dominate the industry and stamp its influence on subsequent developments in the western part of Germany and England.

The wares of Rotterdam stand at a stylistic crossroads. Their colours are still redolent of the products of the Italian potters, whilst the patterns they used show the growing influence of the Chinese porcelain that was being imported to Europe in ever-increasing quantities. Owing to the trading of the Dutch East India Company, there was a particularly large influx of ware to Holland. This was to provoke a strong and positive reaction among the potters of Holland.

The town of Delft was almost totally destroyed by an explosion of gunpowder in 1654. The rebuilt city had a lot of available sites left vacant by the decline of brewing in the town. Many of these became potteries, but kept their original brewery names; it is for this reason that the various potteries have names more appropriate to taverns, such as "The Three Bells" (De Drie Klokken), "The Metal Pot" (De Metalen Pot), and "The Young Moor's Head" (Het Jonge Moriaenshooft). The large number of potteries that sprang up were generally owned by the prosperous merchants of the city, though the actual day-to-day conduct of them was usually left in the hands of a professional potter. There were two reasons for this: the potters did not generally have sufficient funds to acquire their own ventures, whilst the merchants were debarred by the Guild of St. Luke, which administered the trade, from the actual management of the enterprises.

Initially the major sources of inspiration for the potters in Delft were the Chinese wares. At the start Delft was produced predominantly in blue and white and copied Chinese originals amazingly closely. Both the shapes of the wares and the decoration were faithfully imitated from Chinese prototypes to the extent that they were vitually indistinguishable from them when seen at a distance. Despite the fact that they were working in pottery whilst the Chinese originals were of translucent porcelain, the Delft potters were successful in matching

**1.** A pair of Delft blue and white nine-tiered tulip vases, circa 1690 160 cm. high overall
The portrait bust finials, which would appear to depict Queen Mary, and the exceptional proportions and quality of this pair of tulip vases lend support to the supposition that these were made for William III or his entourage

**2 and 2A.** A Delft armorial octagonal teacaddy painted with a double portrait of Princess Anna and Prince William IV, dated 1747
10.5 cm. high

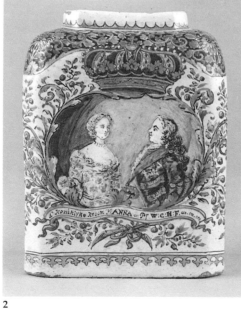

2

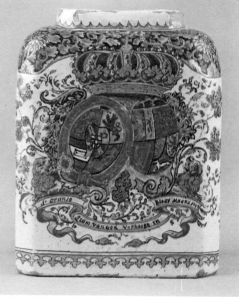

2A

the brilliant surface of the Oriental ware. Indeed their products were frequently described as "Porceleyn". Many types of imitation of Chinese export blue and white wares were produced, mimicking both the Wan-Li wares of the previous generation, which were known as "Kraak porseleynen" and, as the century went by, the more sophisticated wares produced under the new Qing dynasty Emperor Kangxi. Initially the shapes used were frankly derived from the Chinese wares, but were of course gradually modified to suit local requirements. There resulted a strange marriage between overtly European shapes and decorative motifs which were still clearly Chinese in inspiration. Typical of this phenomenon are the splendid tiered tulip vases produced from around 1685, in which a purely European shape, for a purpose required only by the Dutch nobility, is found combined with decoration of Chinese inspiration. The majority of the tulip vases recorded, among the most complex and ambitious creations in the whole history of European pottery, were produced for William and Mary and their immediate entourage. Many were brought to England and are still to be found at Hampton Court or in the houses of descendants of their Dutch courtiers. The majority of the pieces of this class appear to have come from De Grieksche A factory, though other potteries would have been quick to imitate such a successful model. The exact maner in which these vases were used is unclear: surprisingly, there are no contemporary representations of them. It is probable that tulip bulbs were put in the various tiers and induced to flower through the apertures at the corners.

Parallel to blue and white wares of Oriental origin there was an output of pieces with European subjects. Many of these dealt with religious themes or even depicted religious texts, as one would expect of a Calvinist society. A wide range of useful wares was also produced. Pharmacy jars for both wet and dry drugs, which were generally named on the exterior, were made in quantity. The cartouches enclosing the names were generally a confection of strapwork, cherubs, peacocks, and baskets. This motif, unfortunately, acquired a fairly international currency and is to be found on German and English as well as Dutch wares. Separating the Dutch wares from the English can prove an exacting task, though Dutch Delft ware is generally greyer and more gritty and the blue less intense.

Unique to the Delft potteries is the snuff-jar. These, which were oviform containers with brass covers, were

**1.** A Rotterdam maiolica dish, circa 1640
27.5 cm. diam.

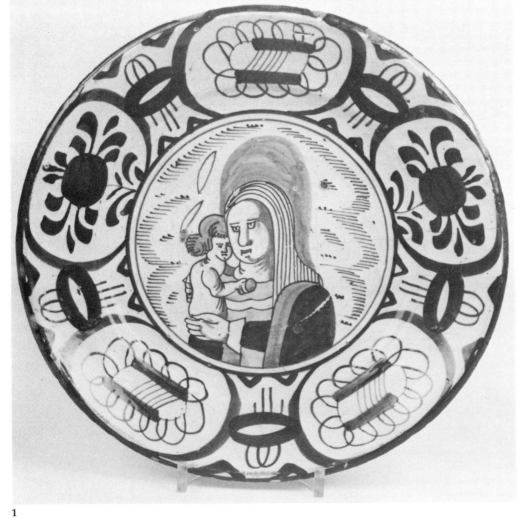

1

generally painted, like pharmacy jars, with the name of their intended contents. This was enclosed in a cartouche of one of a varying succession of patterns. These ranged from relatively simple scroll surrounds to a splendid scene of a feathered "Indian" seated by a vase (inscribed with the name of the contents) overlooking a bay with ships at anchor. Armorial jars with royal or provincial arms are to be found. Spittoons, pierced cress dishes and stands, and elaborate baskets inspired by contemporary silver were also made.

As the end of the century approached the influence of Oriental polychrome wares in the *famille verte* palette then current in China began to make itself felt. Here, as in the blue and white wares, there is a curious mixture between superficially Chinese decorative motifs and fundamentally European shapes. By the 1720s we find a further class of product inspired by Japanese wares exported from the port of Imari and decorated in red, blue, and gold. These pieces, which are known as *Delft doré* wares, are probably the first instance of the use of gilding on *grand feu* pottery in Europe. As in contemporary polychrome wares they display a curious mixture of European themes, such as armorials, with Chinese formal motifs such as lappets and lambrequins.

A technical achievement of importance was the development of a black enamel. This was most difficult to fire successfully and pieces with this decoration are rare. Naturally this has led to many imitations and all black-ground wares have therefore to be viewed with caution.

In the eighteenth century the blue and white wares underwent a gradual decline in quality. The actual material used was relatively coarse and thickly potted and the decoration much less sophisticated than hitherto. Most interesting are sets of plates depicting the months of the year and whaling subjects, though they have rarely survived complete.

The wares of the eighteenth century had to compete with the porcelain that was being produced in ever-increasing quantities throughout the period. Perhaps owing to the skill of the Delft potteries, Holland was a relatively late starter in the field of porcelain. However, the shapes and decoration of the wares were immensely influenced by what the porcelain manufactures were doing. Thus from about 1740 onwards there were produced quite large numbers of tureens and covered bowls either moulded as fruit and vegetables or with their covers formed as figure subjects. Sometimes these figures are offered for sale on their own, but they are in

**2.** A Netherlandish maiolica dish, probably Antwerp, 16th century
24.5 cm. diam.

2

fact incomplete in this state. The introduction of *petit feu* technique at Delft made possible a far wider range of enamel colours and gave rise to an extensive output of wares in the Meissen style. Here the very thinly potted ware imitates the porcelain original closely and the decorative treatment is almost slavishly similar. The necessity of imitating porcelain betrays the essential weakness of the Delft potters in the mid-eighteenth century. The quality of their product had fallen seriously and with it the motive force to produce new ideas. The ever-increasing flow of porcelain from across the German frontier was one problem: another was the development of refined creamware in England and, subsequently, the Low Countries. Much English creamware was in fact shipped to Holland in the white, by William Turner, and decorated there with subjects suited to the Dutch market. The result was that Delftware, like all faience throughout Europe, was squeezed out of the market by other commodities, one more expensive but more durable, the other considerably cheaper.

Though ceramic wall-coverings have been produced in the Middle East from the thirteenth century, and subsequently in Spain and Italy, it was in the Netherlands that they were to achieve their greatest success. The earliest production of glazed tiles was most probably in Antwerp. Workmen from the Italian colony there produced tile panels virtually indistinguishable from those their cousins were still making in Italy. The palette they used was the same as that in use by the potters in Italy and even the technique of *coperta* or *ingobbio* was employed in the same way. However, the balance of the tones is quite different and ochre dominates the palette in a peculiarly Flemish manner. Apart from formal designs, the potters at Antwerp also produced whole wall-panels and house signs. The duration of the tile industry in Flanders was relatively short: it started in the mid-sixteenth century and was extinguished by 1625.

Further North, however, the production of tiles in Rotterdam, Delft, and at Makkum in Friesland was to assume massive proportions and endure to this day. Much of this success was based on standard, almost industrial, methods of production and the fact that the basic unit size was standardized. This made individual tiles easily interchangeable and thus vastly enlarged the decorative permutations available. Some early tiles were produced in groups of four, thus forming star and other formal patterns; in other cases two or four were required to create a complete image. Many types of tile were created with a conventional framework, often in blue, enclosing different flowers, birds, and other animals. Rarer examples depict portraits, ships and shipbuilding,

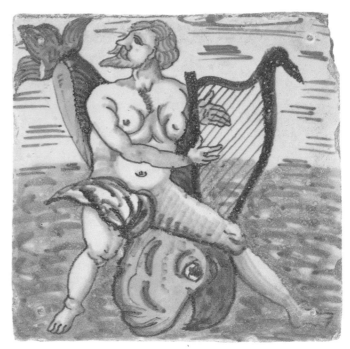

1

soldiers, mythological figures, and birds perched on nails in an almost trompe l'oeil effect.

The greatest displays of the Dutch tile-makers' art were the decorations produced for specific buildings such as the Amalienburg at Nymphenburg near Munich, where thousands of polychrome tiles went to decorate the interior.

Tile pictures, as distinct from whole interior decorative schemes, were also a major area of output. These were composed from four or more tiles. Apart from the Delft and Makkum factories, one of the leading manufacturers was the Aelmis factory in Rotterdam, established in 1752 and active until well into the nineteenth century. Tile pictures, being entities in themselves, are naturally much more portable than fixed tile decorations and are of course not subject to the constraints of a particular location.

Allied to tiles and pictures formed from them are plaques, which the Dutch potteries produced in quantity. The finest, and earliest, of these were painted in blue and white by Frederik van Frijtom (1632-1702). He also painted jugs and plates, but he really used the surface of the Delftware purely as a support for his painting which was of a quality that could well have been deployed in oil on canvas. Generally, however, the decoration on plaques follows that to be found on the other wares of the same date.

**1.** A Rotterdam polychrome tile
first quarter of 17th century
133 mm x 132 mm

**2.** A Dutch Delft blue and white
ewer, probably Adriaen Kocks,
De Grieksche A, circa 1690
68 cm. high

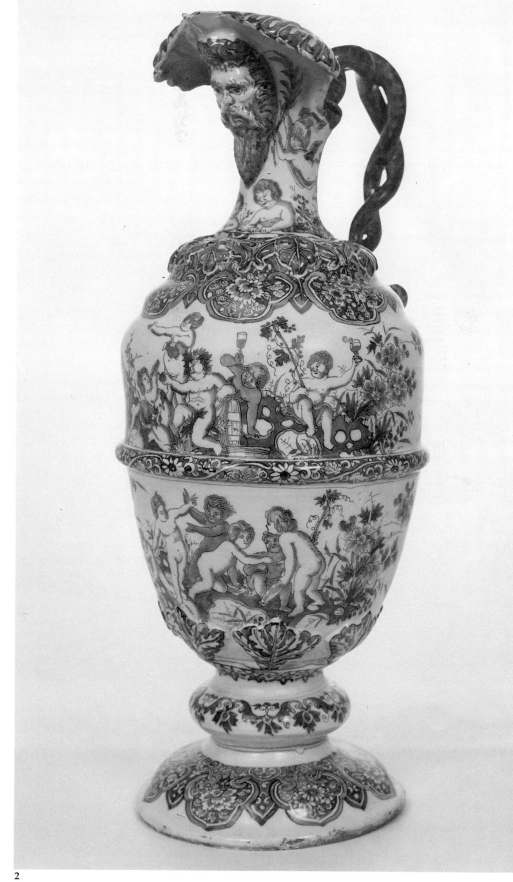

2

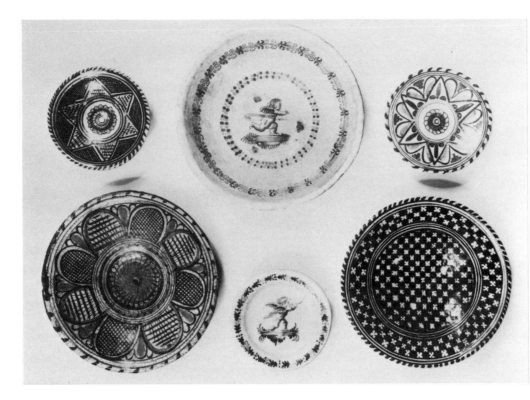

1. A Delft maiolica small dish, first half of 17th century
19 cm. diam.

2. An Amsterdam maiolica dish, first half of 17th century, perhaps Haarlem
33 cm. diam.

3. An Amsterdam maiolica small dish, first half of 17th century, perhaps Haarlem
20 cm. diam.

4. A maiolica dish, first half of 17th century, perhaps Amsterdam
32 cm. diam.

5. An Amsterdam maiolica small dish, first half of 17th century, perhaps Haarlem
18 cm. diam.

6. A maiolica dish, first half of 17th century, perhaps Utrecht
30.5 cm. diam.

7. A Delft blue and white royalist charger, late 17th century
35 cm. diam.

8. A maiolica dish, circa 1640
34 cm. diam.

9. A Delft royalist charger, late 17th century
35 cm. diam.

10. A fluted dish, first quarter of 18th century

11. A maiolica dish, 17th century
38 cm. diam.

12. A maiolica dish, second half of the 16th century

13. A blue-dash charger, the reverse inscribed Crie, early 17th century
32 cm. diam.

14. An Antwerp albarello, early 17th century
20 cm. diam.

15. An Antwerp albarello, 17th century
13 cm. high

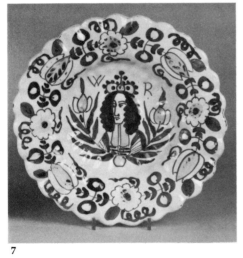

7

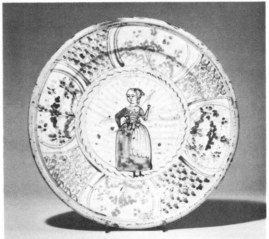

8

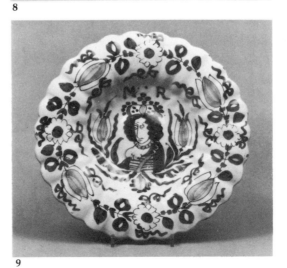

9

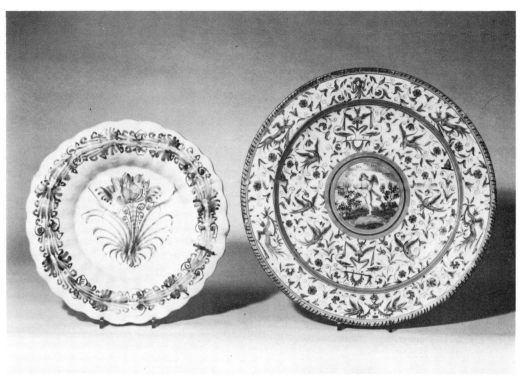

10

11

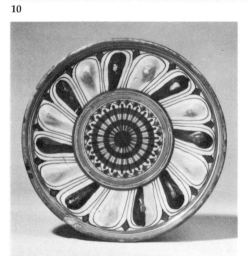

12

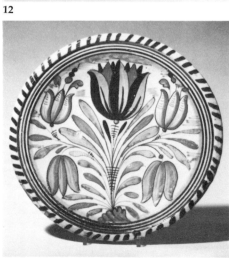

13

14

15

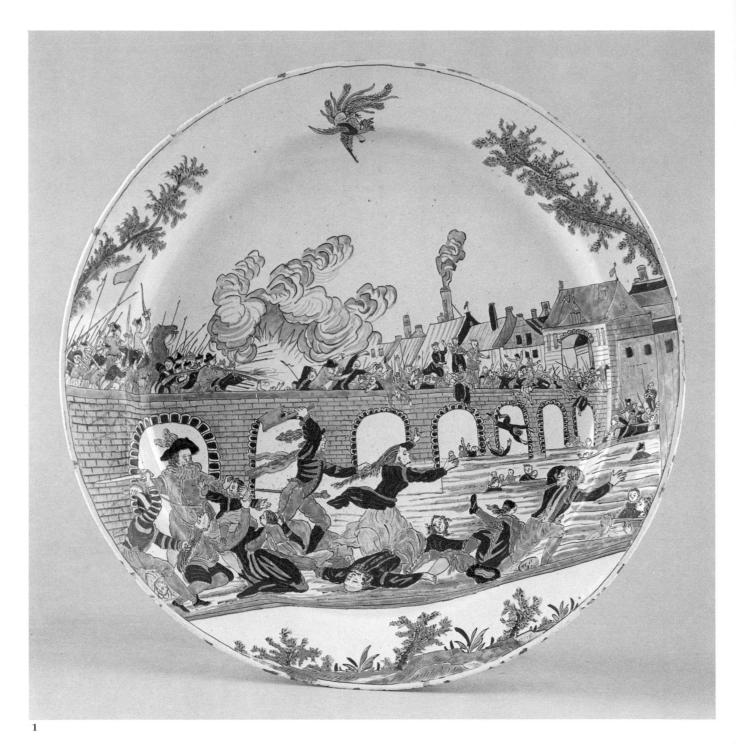

1

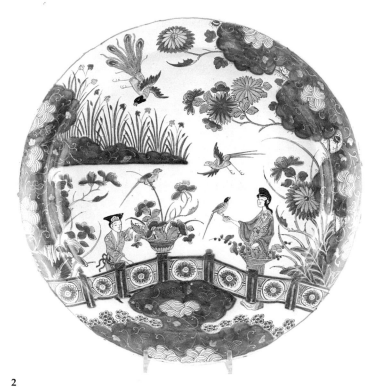

**1.** A dish depicting the Storming of Maastricht by the Prince of Parma on 29 July 1619, after a print by Jan Luyken, second quarter of 18th century
35.5 cm. diam.

**2.** A dish, PAK monogram of Pieter Adriaensz Kocks, circa 1700
38 cm. diam.

**3.** A barrel-shaped mustard pot in the Meissen style, the interior to the cover marked 3, the base 4, circa 1750
8 cm. high

**4.** An ink-stand, circa 1750
24 cm. long

**5.** An oval tub in the Meissen style marked with a V and on the bottom 3, circa 1750
12.5 cm. long

**6.** A butter-tub and cover in the Meissen style marked with a V on the inside of the cover and on the bottom, circa 1750
11.5 cm. diam.

**7.** An octagonal butter-tub, cover, and stand in the Meissen style, marked with an F and a 7 on the inside of the cover and 19 on the bottom, circa 1750
the stand 15.5 cm. diam.

**8.** A round butter-tub and cover, the inside of the cover marked 25 and the bottom 10, second quarter of 18th century
11.5 cm. diam.

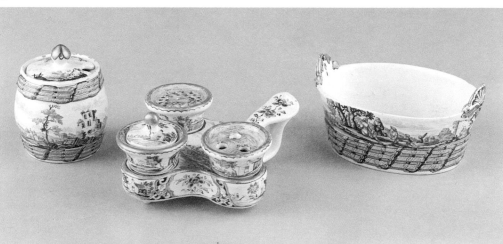

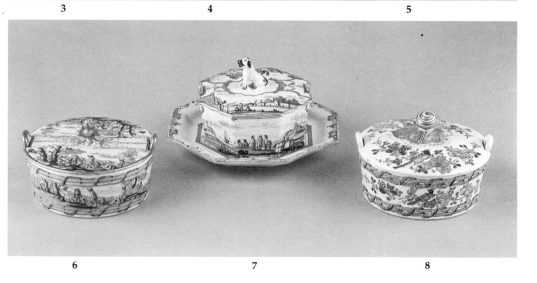

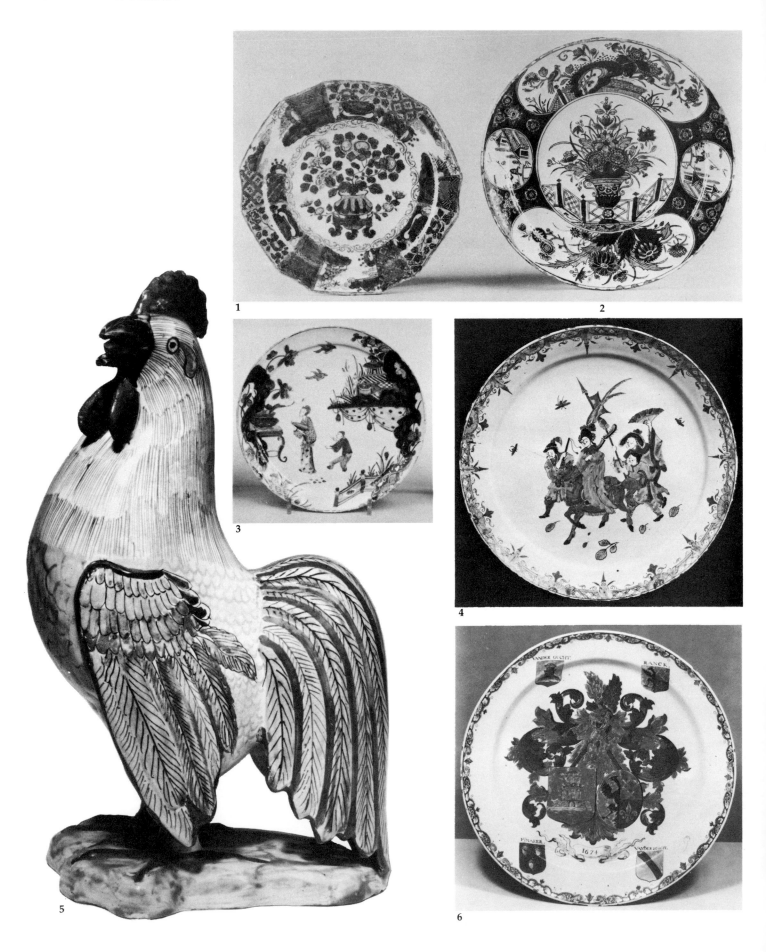

1

2

3

4

5

6

7

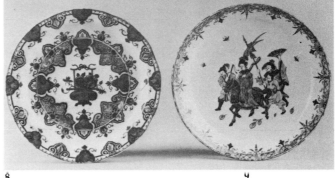

8                                    9

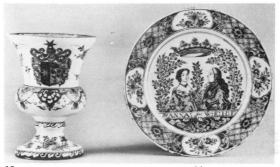

10                                   11

12                                   13

14

**1.** An Imari pancake plate, circa 1700
22 cm. diam.

**2.** An Imari pancake plate, first quarter of 18th century
26 cm. diam.

**3.** A Chinoiserie plate, iron-red APK mark, of Adrianus and Pieter Kocks, mid-18th century
22 cm. diam.

**4.** A Chinoiserie plate, iron-red AR monogram mark, circa 1720
23 cm. diam.

**5.** A polychrome cockerel after a Japanese model, circa 1725
22 cm. high

**6.** An armorial dish, dated 1674
35.5 cm. diam.
Probably made to commemorate a marriage. The lesser shields are those of families prominent in Delft

**7.** A large dish, monogram mark of AR for Ary Rijsselberg, De 3 Vergulde Astonnekens factory, circa 1730
38.7 cm. diam.

**8.** An Imari plate, mark of Pieter Adriaensz. Kocks in De Grieksche A factory, beginning of 18th century
21.5 cm. diam.

**9.** A pancake plate with famille verte decoration, mark of Ary Rijsselberg in De 3 Vergulde Astonnekens factory, circa 1725
23 cm. diam.

**10.** An armorial vase, middle of 18th century
18 cm. high

**11.** An armorial plate painted with Princess Anna and Prince William IV and dated 1749
22.5 cm. diam.

**12.** An Imari pancake plate, mark of Pieter Adriaensz. Kocks in De Grieksche A factory, beginning of 18th century
22 cm. diam.

**13.** An Imari pancake plate, mark of Pieter Adriaensz. Kocks in De Grieksche A factory, beginning of 18th century
22 cm. diam.

**14.** An Imari dish, mark of Pieter Adriaensz. Kocks in De Grieksche A factory, beginning of 18th century
34 cm. diam.

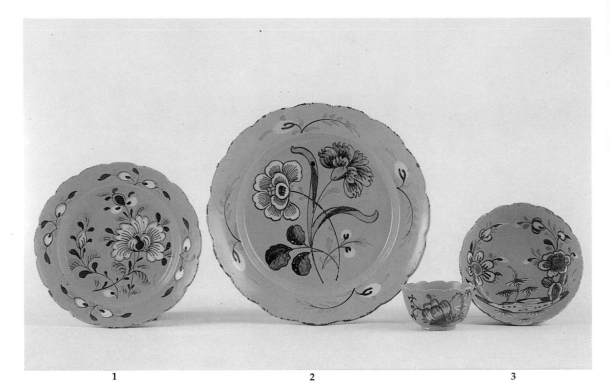

1      2      3

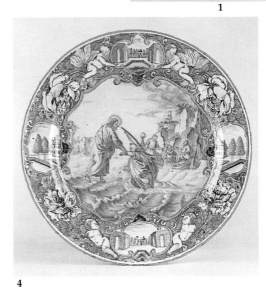

4

5

6

**1.** A turquoise ground dish, second half of 18th century 16.5 cm. diam.

**2.** A turquoise ground dish, second half of 18th century 22.5 cm. diam.

**3.** A turquoise ground cup and saucer, second half of 18th century the saucer 12.5 cm. diam.

**4.** A Bible dish depicting Matthew 14 v. 25, beginning of 18th century 36 cm. diam.

**5.** A dish, second quarter of 18th century 34.5 cm. diam.

**6.** A dish, first half of 18th century 35 cm. diam.

**7.** Part of an armorial service made for an Ulster baronet and with the arms of Webster, of Battle Abbey, blue D/12 mark, circa 1760

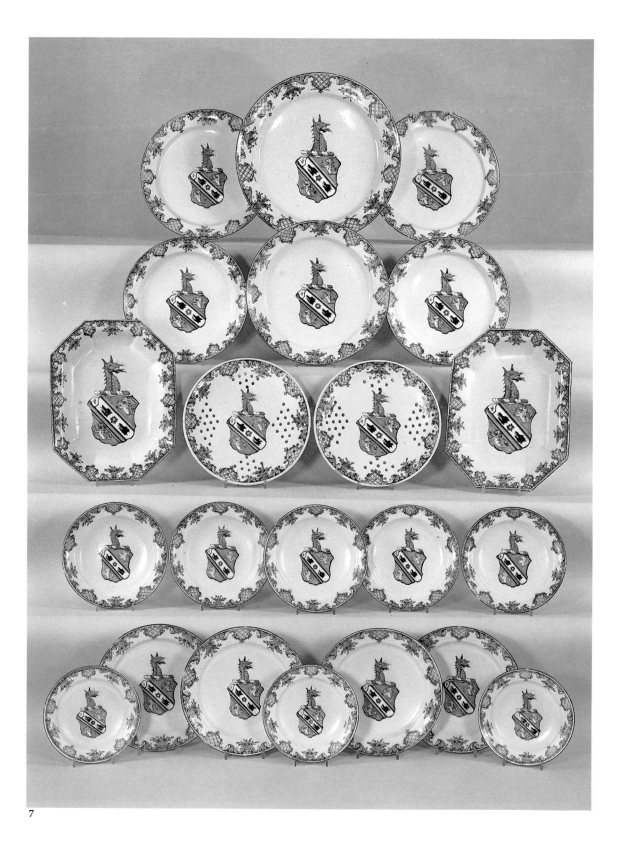

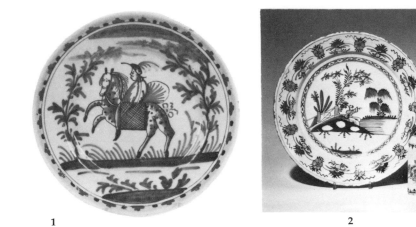

**1.** A plate, first quarter of 18th century
23 cm. diam.

**2.** A polychrome dish, circa 1740
35 cm. diam.

**3.** A rectangular caddy painted in the famille verte manner, JVOH mark probably for Jan van Hagen, circa 1750
14.5 cm. high

**4.** A polychrome dish, circa 1760
34.5 cm. diam.

**5.** A plate of almonds, blue 9 mark, first quarter of 18th century
20 cm. diam.

**6.** A dish, first half of 18th century
34 cm. diam.

**7.** A plate, first quarter of 18th century
23 cm. diam.

**8.** A garniture de cheminée by Lambertus van Eenhoorn, circa 1710
59 cm. to 81 cm. high

**9.** An octagonal double-gourd vase, manganese interlaced SVE mark for S. van Eenhoorn and VIIII mark, 1678-1687
26.5 cm. high

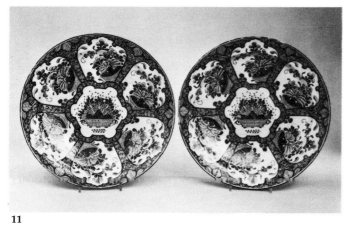

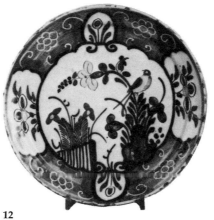

11

12

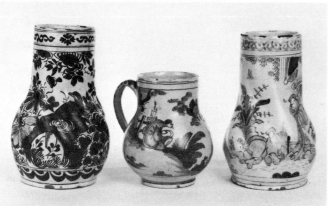

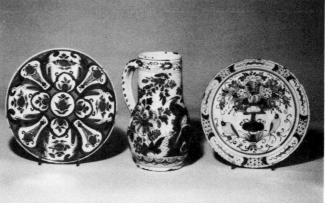

13            14            15            16            17            18

**10.** A fluted bowl, circa 1700, on later Chinese gilt metal stand
30.5 cm. diam.

**11.** A pair of dishes, blue D/7 mark, circa 1720
34.5 cm. diam.

**12.** A pancake plate, circa 1725
22.5 cm. diam.

**13.** A jug, circa 1720
23 cm. high

**14.** A blue and white jug, Dutch or German, circa 1730
16.5 cm. high

**15.** A German jug, circa 1730
22.5 cm. high

**16.** A pancake plate, mark of De Paeuw, early 18th century
22.5 cm. wide

**17.** A jug, first quarter of 18th century
22 cm. high

**18.** A pancake plate, early 18th century
22 cm. diam.

**19 and 19A.** An oval two-handled wine cistern, blue APK monogram for Pieter Adriensz Kocks at De Grieksche A factory, 1701-1722
50 cm. wide

**20.** A vase, De Roos factory, circa 1725
58.5 cm. high

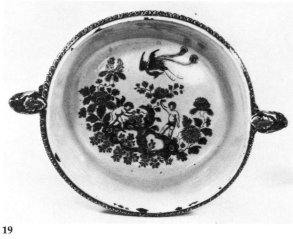

19

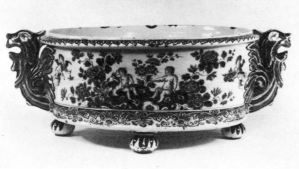

19A

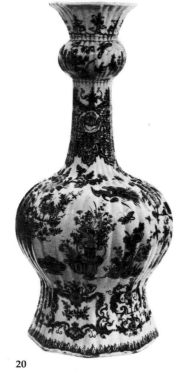

20

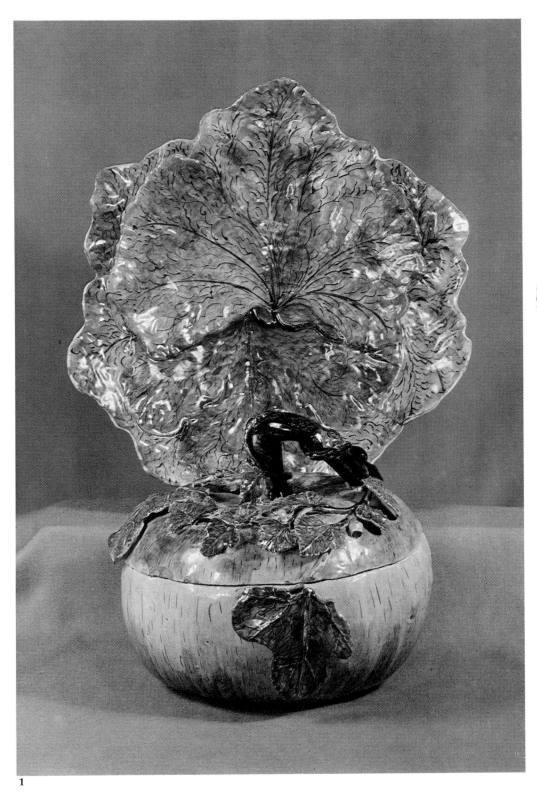

1

2

1. A pumpkin tureen, cover, and leaf stand, the stand with blue GVS mark for Het Oude Moriaenshooft factory, circa 1765
the stand 38 cm. wide

2. A pear-shaped *bleu persan* jug with silver cover, mark of De Paeuw 2 factory, first quarter of 18th century
24 cm. high

3. A puzzle jug dated 1754
21.5 cm. high

4. A tulip vase marked with LVE and IVK monograms of Louwijs Victorsz of De Dobbelde Schenkkan factory and of Lambert van Meerten of De Metalen Pot factory, circa 1700
34 cm. wide

5. An oval dish with fluted sides, mark of Lambertus van Eenhoorn and 10 in De Metalen Pot factory, end of 17th century
40.5 cm. long

6. A pair of baluster vases and covers with *bleu persan* grounds, beginning of 18th century
30 cm. high

3

4

5

6

**1.** A Makkum blue and white cottage, late 18th century
16.5 cm. long

**2.** A pair of polychrome sweetmeat figures, circa 1750
18.5 cm. wide

**3.** Four polychrome shoes, mid-18th century
about 15 cm. long

**4.** A pair of polychrome oval bowls and covers, the covers with the mark of De Porceleyne Lampetkan factory, mid-18th century
14.5 cm. wide

**5.** A polychrome tureen, blue GVS mark for Het Oude Moriaenshooft factory, mid-18th century
11 cm. diam.

**6.** A polychrome bowl and cover, mid-18th century
16.5 cm. high

**7.** A polychrome tureen and cover, blue axe mark for De Drye Porceleyne Flesschen factory, mid-18th century
12 cm. wide

**8.** A pair of white figures of horses painted in cold colours, the pottery circa 1725
19 cm. long

**9.** A pair of polychrome high-heeled shoes, mid-18th century
15.5 cm. long

**10.** A figure of a child in a walking chair, blue Z mark, circa 1720
13.5 cm. high

8        9        8        10

12

11

11. A pair of coloured busts of Herod and Salome, early 18th century
26 cm. high

12. A blue and white bird-cage, 18th century
29 cm. high

13. A polychrome figure of a horse, mid-18th century
22 cm. wide

13

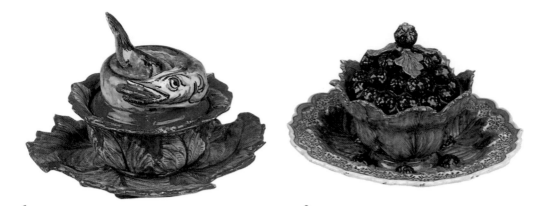

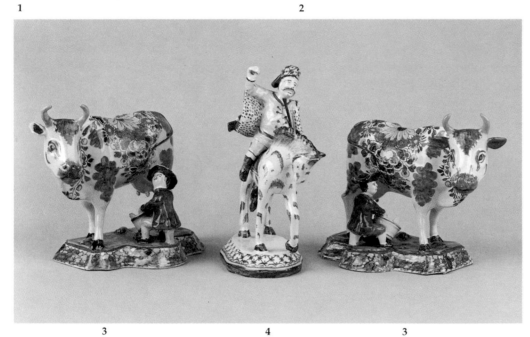

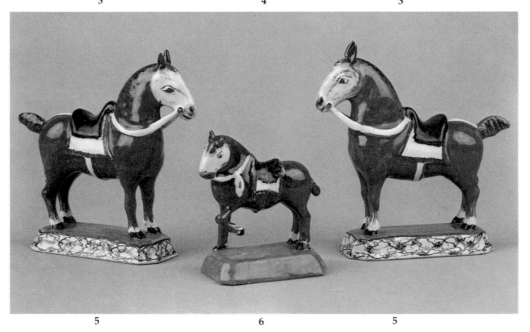

**1.** A polychrome sauce-tureen, cover, and stand, third quarter of 18th century
the stand 20 cm. diam.

**2.** A polychrome confiturier, cover, and stand, third quarter of 18th century
the stand 19 cm. diam.

**3.** A pair of polychrome milking groups, mark of Van Duyn from De Porceleyne Schotel factory, last quarter of 18th century
22 cm. long

**4.** A polychrome equestrian figure of a Hussar in Austrian uniform, third quarter of 18th century
22 cm. high

**5.** A pair of dun horses, mark of De Porceleyne Bijl factory, circa 1765
15.5 cm. long

**6.** A dun horse, mark of De Porceleyne Bijl factory, circa 1765
10.5 cm. long

**7.** A pair of polychrome recumbent cows, second half of 18th century
16 cm. long

**8.** A polychrome parrot, second half of 18th century
18.5 cm. high

**9.** A pair of polychrome shoes, middle of 18th century
13.5 cm. long

**10.** A pair of polychrome slippers, second half of 18th century
11 cm. long

**11.** A pair of polychrome shoes purple B mark on the side and blue B on the front of the heel, third quarter of 18th century
13.5 cm. long

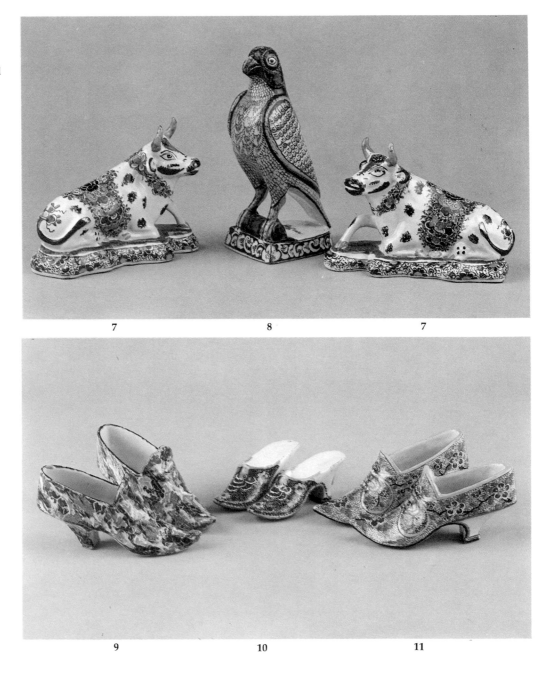

7          8          7

9          10          11

1

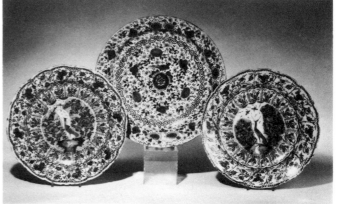

2    3    2

4    5    6

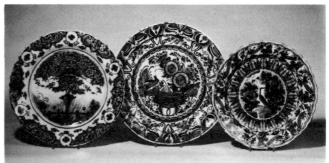

7    8    9

10    11

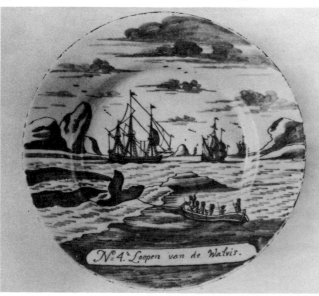

12

**1.** A large dish, late 17th/early 18th century
40 cm. diam.

**2.** Two dishes, blue mark of the De Porceleyne Bijl factory, circa 1700
35 cm. diam.

**3.** A dish, circa 1720
39.5 cm. diam.

**4.** A dish, circa 1730
31 cm. diam.

**5.** A dish, blue interlaced DB monogram and star mark, circa 1720
25 cm. diam.

**6.** A dish, blue mark of De Porceleyne Claeuw factory and 200, circa 1720
31 cm. diam.

**7.** A dish, blue mark of De Porceleyne Claeuw factory, and various numerals, circa 1725
35 cm. diam.

**8.** A dish, blue 24 mark, first half of 18th century
39 cm. diam.

**9.** A dish, blue LP Kan mark, first half of 18th century
34.5 diam.

**10.** A plate, R mark, circa 1730
22 cm. diam.

**11.** A polychrome dish, blue PL mark, circa 1720
22 cm. diam.

**12.** A whaling plate from a set of twelve, mark of De Porceleyne Bijl factory, second half of 18th century
22.5 cm. diam.

**13.** A pancake plate, 6 mark, circa 1720
23 cm. diam.

**14.** A fluted dish, circa 1700
24.5 cm. diam.

**15.** A plate, first quarter of 18th century
23 cm. diam.

**16.** A large dish, 1720-50
47 cm. diam.

**17.** A dish, blue PK monogram mark, circa 1700
34.5 cm. diam.

**18.** An orange and yellow dish, orange Z mark, circa 1740
34.5 cm. diam.

**19.** A dish, with VDuyn mark, circa 1720
35 cm. diam.

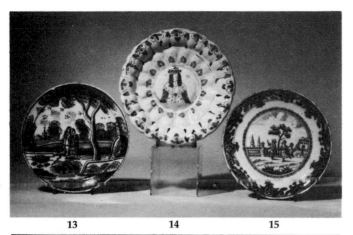
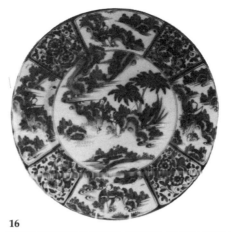

13    14    15    16

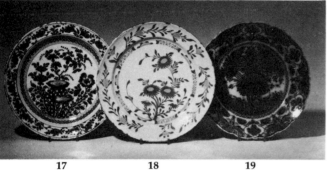
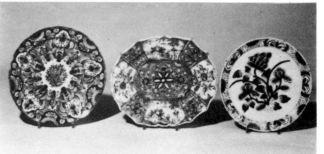

17    18    19    20    21    22

**20.** A plate, second quarter of 18th century
22.5 cm. diam.

**21.** A shaped oval dish, 136 star mark, second quarter of 18th century
26 cm. wide

**22.** A pancake plate, circa 1725
22.5 cm. diam.

**23.** Two from a set of twelve pancake plates, the De Roos factory, first half of 18th century
22 cm. diam.

**24.** A liturgical dish, 1700-1720
41 cm. diam.

**25.** A pair of month plates, mark of De Porceleyne Bijl factory, mid-18th century
23 cm. diam.

**26.** A ewer, late 17th century
22 cm. high

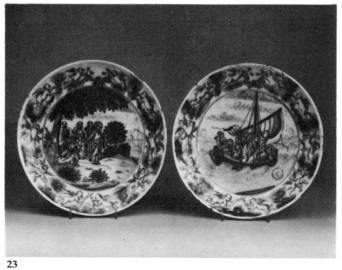

23

24

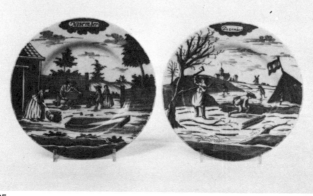

25

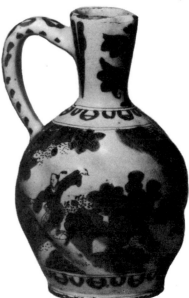

26

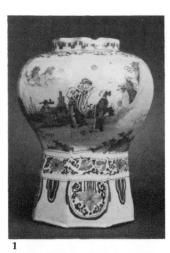

1

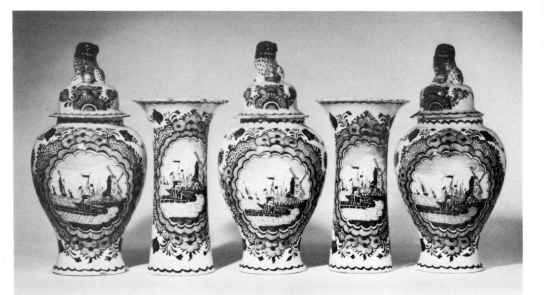

2

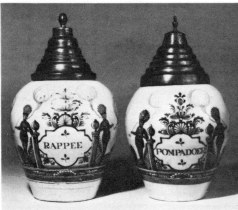

3

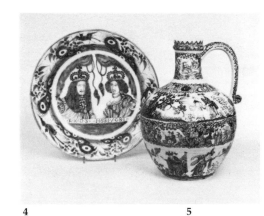

4          5

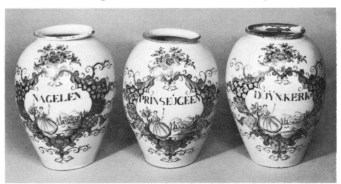

6

7

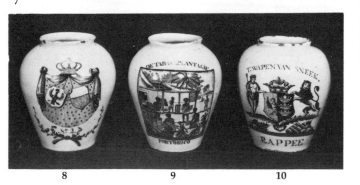

8          9          10

**1.** An octagonal baluster vase, circa 1700
33 cm. high

**2.** A garniture of five vases, mid-18th century
29 cm. and 40 cm. high

**3.** Two oviform tobacco jars, blue MQ VI marks, circa 1700
25.5 cm. high

**4.** A royalist charger, late 17th century
38 cm. diam.

**5.** A large jug, mark of De Porceleyne Claeuw factory, perhaps early 18th century
34 cm. high

**6.** An oviform jar, first half of 18th century
28 cm. high
A close imitation of Chinese porcelain of the previous generation

**7.** A set of three tobacco jars, blue JS marks, mid-18th century
38 cm. high

**8.** An oviform armorial jar, three triangle mark in blue, mid-18th century
26.5 cm. high

**9.** An oviform jar, three triangle mark in blue, mid-18th century
26.5 cm. high

**10.** An oviform armorial snuff jar the work of De Drie Klokken factory in blue, mid-18th century
26.5 cm. high

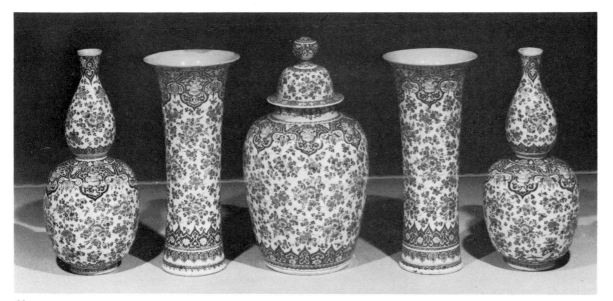

**11**

**11.** A garniture de cheminée, the centre vase with a monogram of Lambertus van Eenhoorn/25/O/DW, circa 1690
50 cm. high

**12.** Three bottle-shaped drug jars, circa 1690
all about 28.5 cm. high

**13.** A pair of oval two-handled butter-dishes and covers, blue mark of De Porceleyne Bijl factory, mid-18th century
14 cm. wide

**14.** An armorial baluster tobacco jar with the royal arms of Holland, mark of De Drie Klokken factory, 18th century
27 cm. high

**15.** A pancake plate, monogram of Pieter Adriaensz Kocks, 1720-1750
26 cm. diam.

**16.** A plate, first half of 18th century
26 cm. diam.

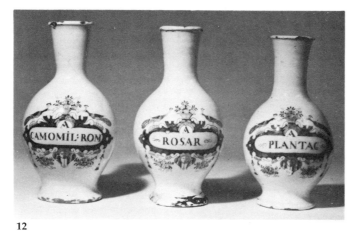

**12**

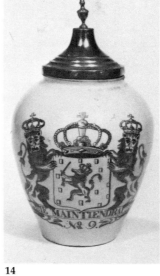

**14**

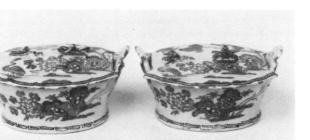

**13**

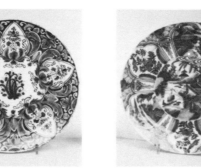

**15**

**16**

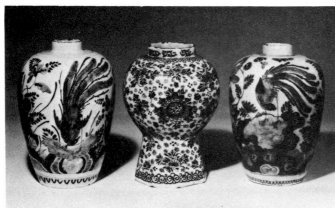

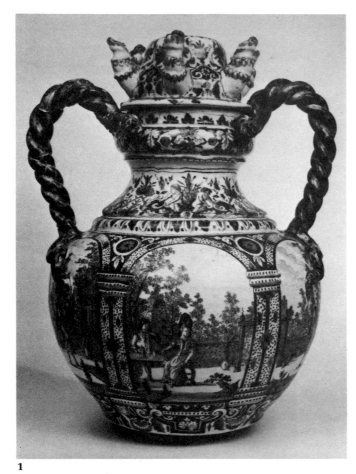

**1.** A two-handled tulip vase and domed cover, AK monogram of Adriaen Kocks, circa 1690
55 cm. high

**2.** A pair of potiches, blue PK monogram of Pieter Adriaensz Kocks, circa 1700
54.5 cm. high

**3.** A garniture, blue mark of De Drie Klokken factory, circa 1750 all about 36 cm. high

**4.** An oviform vase, blue 21 mark, circa 1700
25 cm. high

**5.** An octagonal baluster vase, early 18th century
23.5 cm. high

**6.** An oviform vase, blue 23 mark, circa 1700
25 cm. high

**7.** A two-handled posset-pot and domed cover, circa 1720
24 cm. wide

**8.** An oviform drug jar, circa 1680
33 cm. high

**9.** An oviform vase and cover, circa 1700
30.5 cm. high

**10.** An octagonal baluster vase, circa 1720
26 cm. high

**11.** A garniture of five vases, blue interlaced CK and 24 marks of perhaps Nicolaes Cornelisz Keyser, circa 1680
37 cm. and 43 cm. high

**12.** A garniture of five vases, first half of 18th century
26 cm. and 37 cm. high

**13.** A pair of polychrome six-tier obelisk tulip vases, blue star marks, first quarter of 18th century
71 cm. high

**14.** A posset-pot, circa 1700
20.5 cm. wide

**15.** A two-handled openwork basket, marked in red De Grieksche A of Jacobus Adriaensz Halder, 18th century
32.7 cm. long

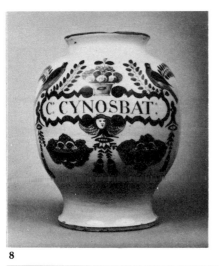

8

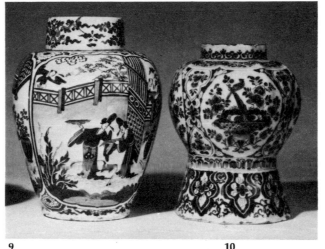

9

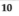

10

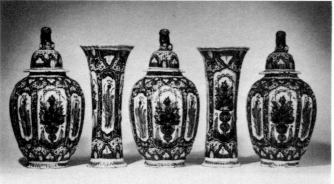

11

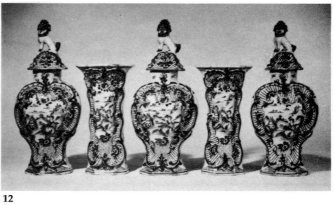

12

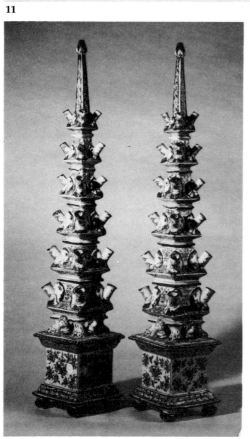

13

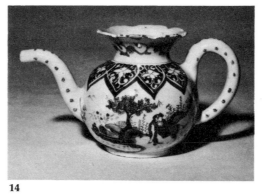

14

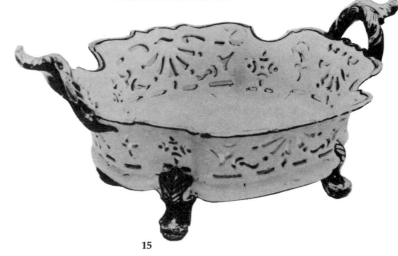

15

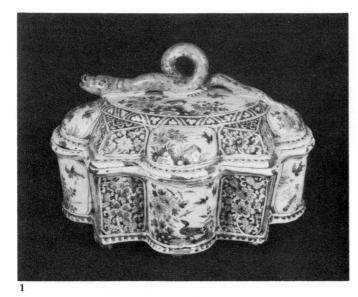

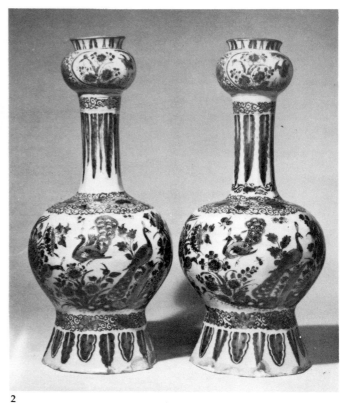

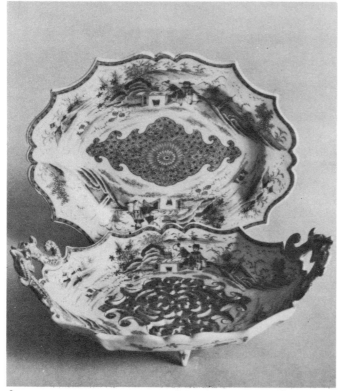

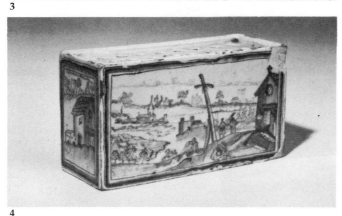

**1.** A spice box and cover, AK marks of Adriaensz. Kocks, circa 1675
26.5 cm. wide

**2.** A pair of vases, marks in blue apparently of Lambert van Eenhoorn, circa 1700
55 cm. high

**3.** A two-handled cress dish and stand, mark of De Porceleyne Bijl factory, mid-18th century
28.5 cm. wide

**4.** A rectangular flower brick, circa 1700
16.5 cm. wide

**5, 6, and 8.** A set of nine tobacco jars, mark of De Drie Klokken factory, first half of 18th century
33 cm. high

**7.** A pair of tulip vases with two-tiered covers and detachable stands, circa 1690
105 cm. high

**9.** A dated marriage plate
30.5 cm. diam.

**10.** A dated betrothal plate, blue AC mark
22 cm. diam.

**11.** A pair of peacock pattern dishes, first half of 18th century
35 cm. diam.

**12.** A blue and white and polychrome plate, circa 1720
23 cm. diam.

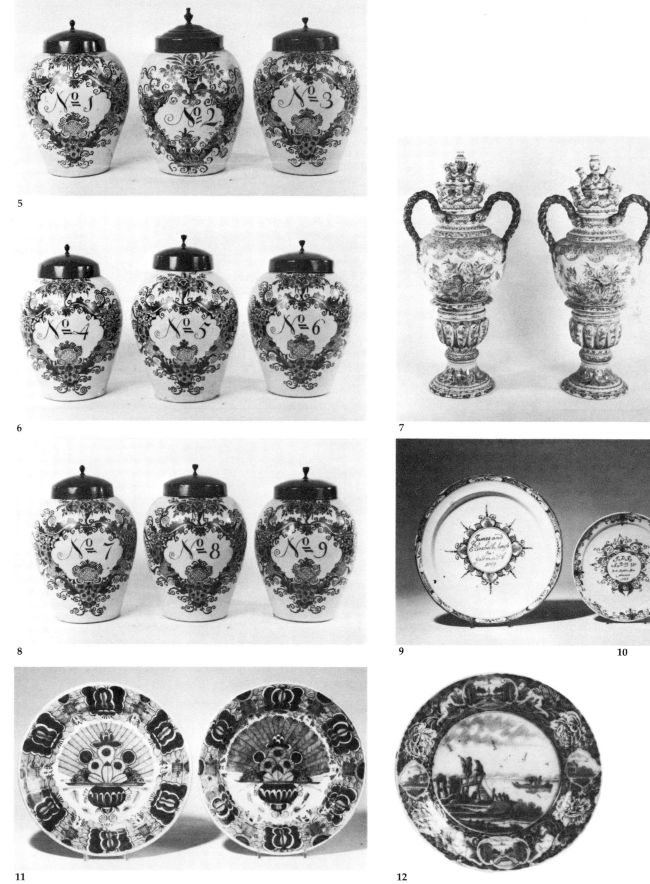

5

6

7

8

9          10

11          12

1

2                                3

4

5

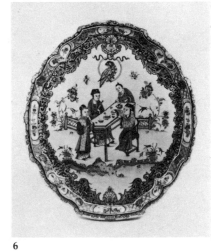

6                                7

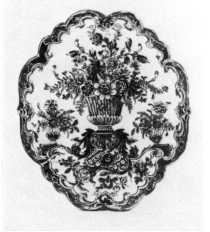

**1.** A Delft polychrome shaped plaque, first quarter of 18th century
38.5 cm. wide

**2.** A Delft blue and white octagonal stand, circa 1735
26 cm. wide

**3.** A Delft blue and white shaped octagonal plaque, the reverse dated 1724
27 cm. wide

**4, 5.** A pair of Dutch framed tile pictures, circa 1750
each about 39 cm. high

**6.** A Delft polychrome wall plaque, circa 1730
42 cm. high

**7.** A Delft polychrome shaped oval wall plaque, circa 1730
32 cm. high

**8, 9.** A pair of Dutch royalist tile portraits, first quarter of 18th century
37.5 cm. x 25 cm.

**10.** A Delft blue and white rectangular plaque painted in the manner of Frederick van Frijtom, circa 1700
32 cm. x 38 cm.

**11.** A Rotterdam (Aelmis) tile picture, second half of 18th century
131.5 cm. x 38.5 cm.

**12.** A Dutch polychrome tile picture, first half of 18th century
53 cm. x 40 cm.

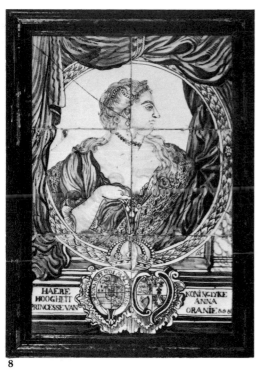

8

9

10

11

12

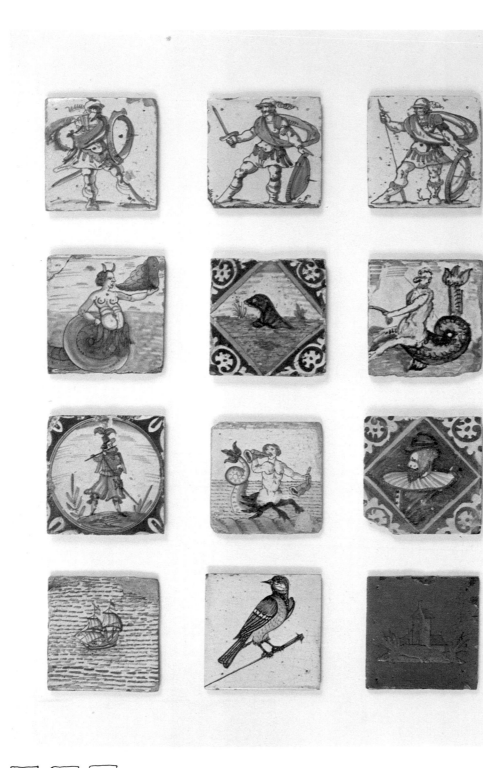

1. A Rotterdam polychrome tile, first half of 17th century

2. A Rotterdam polychrome tile, first half of 17th century

3. A Delft polychrome tile, beginning of 17th century

4. A polychrome tile, first half of 17th century, probably Rotterdam

5. A Rotterdam polychrome tile, first half of 17th century

6. A Delft polychrome tile, first quarter of 17th century

7. A polychrome tile, first half of 17th century, probably Hoorn

8. A Gouda nail tile, first half of 17th century

9. A Rotterdam polychrome tile, first half of 17th century

10. A Rotterdam polychrome tile, first half of 17th century

11. A polychrome portrait tile, circa 1600

12. A polychrome tile, 17th century, probably Rotterdam

13. A Delft polychrome tile, first half of 17th century

14. A Delft polychrome tile, first half of 17th century

15. A Delft polychrome tile, first half of 17th century

16. A Delft polychrome tile, circa 1600

17. A Delft polychrome tile, first half of 17th century

18. A Delft polychrome tile, circa 1600

19. A Delft polychrome tile, end of 16th century

20. A Delft two-colour tile, first half of 17th century

21. A Delft polychrome tile, first half of 17th century 11 cm. x 11 cm.

22. A Delft polychrome tile, circa 1600

23. A Gouda polychrome nail tile, first half of 17th century

24. A Delft polychrome tile, first quarter of 17th century

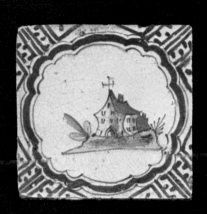
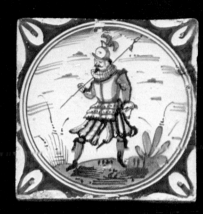
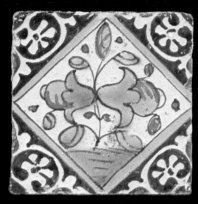
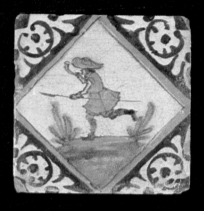
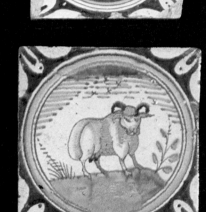

1

2

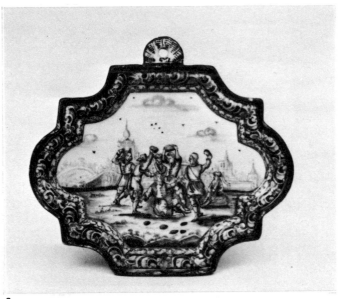

3

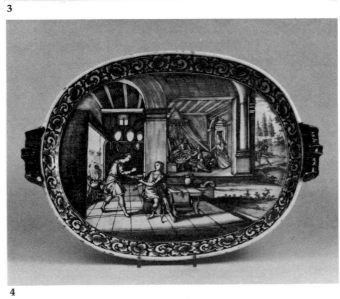

4

5

6

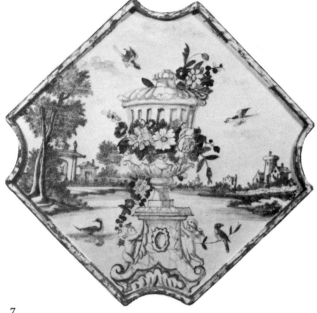

7

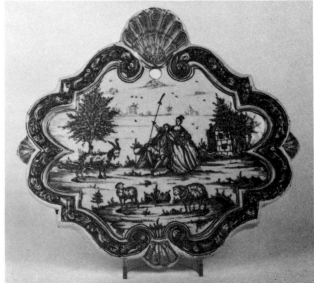

8

1. A Delft polychrome tile picture, first quarter of 18th century
31 cm. wide

2. A Delft blue and white plaque, early 18th century
32.5 cm. wide

3. A Delft blue and white shaped quatrefoil wall plaque, mid-18th century
25 cm. wide

4. A Delft blue and white two-handled oval tray, blue LPK mark, circa 1740
43 cm. wide

5,6. A pair of Makkum rectangular polychrome plaques, late 18th century
43.5 cm. wide

7. A Delft lozenge-shaped polychrome plaque, circa 1750
41 cm. wide

8. A Delft shaped oval blue and white plaque, first half of the 18th century
25 cm. wide

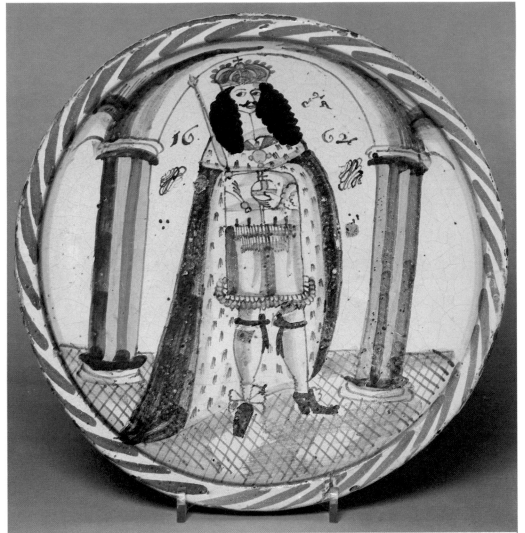

**1.** A Lambeth Charles II blue-dash charger, inscribed CIIR 1662
30.5 cm. diam.

**2.** A London blue and white royalist portrait plate with half-portraits of William III and Queen Mary inscribed above WMR and below MW 1691
21.5 cm. diam.

**3.** A Bristol grace plate inscribed in blue 2/Give thanks/before thou eat/(1746) and F/RE/1746
17.5 cm. diam.

**4.** A Liverpool blue and white ship plate inscribed *Diadem*, the reverse inscribed Francis Gott 1752
22 cm. diam.

**1**

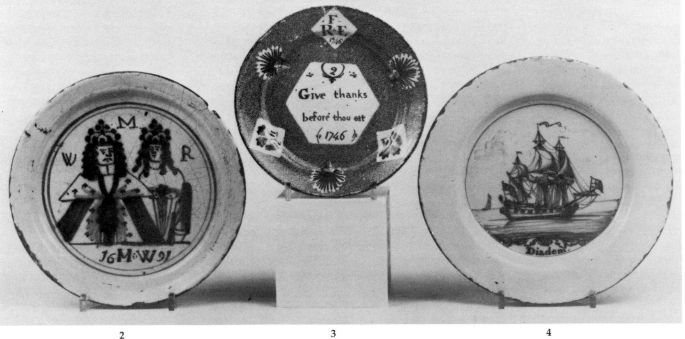

**2**                    **3**                    **4**

# ENGLAND: DELFT

Pottery in England has its roots in a medieval craft. The simple output of this trade produced massively potted and plainly glazed wares which continued well into the seventeenth century. Then there followed two strands of development which lasted for the next century and a half. Of these the first was the production of slipwares, which evolved from the medieval and indigenous potteries; the second was the production of tin-glazed earthenware or delft which, as its name implies, was imported as a craft from Holland.

The delft industry seems to have started in London around the turn of the seventeenth century. For long Lambeth was regarded as the principal centre of production, but research over the last twenty years has established that there were other and earlier potteries producing "gallyware" (tin-glazed as opposed to plain earthenware). Of these the earliest was probably run by Jacob Johnson or Jansen in Aldgate: the most important, however, was in the parish of Southwark. Here Christian Wilhelm, a man of Dutch origin but born and bred in the realm of the Elector Palatine, started producing gallyware in 1618. Within a decade he acquired the style of gallipot-maker to the King and a monopoly of the production of the material. His wares are principally blue and white in Chinese style: his shapes are derived from contemporary metalwork. Wilhelm died in the 1640s and his dominant position in Southwark would seem to have fallen to William Bellamy. Delftware continued to be made in the Southwark district till well into the eighteenth century.

At Lambeth, further up the river, production of gallyware does not seem to have started till well after the Restoration in 1660: but it was then to continue uninterrupted till almost the end of the eighteenth century.

The other major centres were Bristol, Wincanton, Liverpool, Glasgow, and Dublin. Though documentary evidence exists for a massive production of wares from the Delftfield factory in Glasgow (sixty to eighty thousand pieces were exported per annum) and though the factory operated for a long time, from 1748 till 1810, identifiable wares are few. The Wincanton pottery ran for only about twenty years, from the mid-1700s to the 1750s. Here, though the output was never great, there are at least six marked and dated specimens, plus a good number of kiln-wasters, found on the site of the pottery, all of which help towards specific identification.

Bristol was perhaps the largest producer of delftwares. The earliest gallipots were not actually produced in the city itself but at Brislington a couple of miles outside it.

Here John Bissicke and Robert Bennett, both Southwark men, set up a factory of which the first dated product that has come down to us was made in 1649. The first delftware pottery in the city itself was founded by a Brislington man, Edward Ward, who purchased a site in Temple Backs from Anna Jordan in 1683. His descendants operated a successful business there till the 1740s, when it would seem to have changed hands. The pottery continued making delftwares till close to the end of the century. These were never, however, its sole product, as stonewares and earthenwares were also made and continued long after the production of delft had stopped. Other pottery manufacturers making delft were the Franks family at Redcliffe Backs, and the Limekiln Lane pottery, which operated under various managements for the first half of the eighteenth century.

Liverpool was a slightly later starter than Bristol or London. Its earliest delftware potteries date from around 1710 when, once again, men from Southwark were imported to the city. There were by 1730 at least four delftware potteries in the city, and the industry survived there till about 1785, when it was wiped out by the advent of Josiah Wedgwood's creamwares.

The products of the major English delftware manufactures had much more in common than points of difference. Initially the wares produced in London were loosely derived, like the wares of the Dutch, from Chinese porcelains. At the same time, however, there was a production of jugs and pharmacy pots in which a creamy-white glaze was used to offset simple inscriptions such as "CLARET 1646" in blue. The Restoration ushered in the blue-dash charger, a type of dish also made in the Frisian potteries, which was to endure well into the reign of George II. Initially the royal portraits were quite clear and charming but, with the passage of time, the formula became debased and the sovereigns depicted were visual ciphers: the same degeneration also occurred with another popular subject, the Adam and Eve dish. This too was introduced late in the Commonwealth era but was to continue well into the eighteenth century. Other subjects were oak leaves and arrangements of tulips. These dishes were produced in both London and Bristol and are to be found with both dash and sponged borders. Also from the late seventeenth century onwards come sets of six Merry Man plates, the inscriptions on which combine to form a rhyme. These have very rarely survived complete.

Armorial wares, initially most frequently produced for corporate clients, such as guilds, occur regularly across the whole period of production and in all the centres.

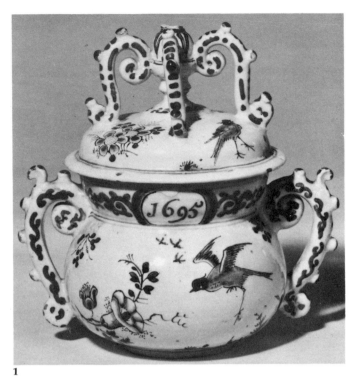

1

1. A London delft blue and white two-handled bowl and cover dated 1695 and with the initials R.F.
15.5 cm. wide

2. A Liverpool polychrome ship bowl inscribed Success to the Owners of the Love of Whit Haven Joseph Haile Master, circa 1750
23.5 cm. diam.

3. A London blue and white wet-drug jar with the initials IR and date 1677
19.5 cm. high

4. A London blue and white drug-jar with the initials IF and date 1677
19.5 cm. high

5. A London blue and white drug-jar with the initials TG and date 1683
18 cm. high

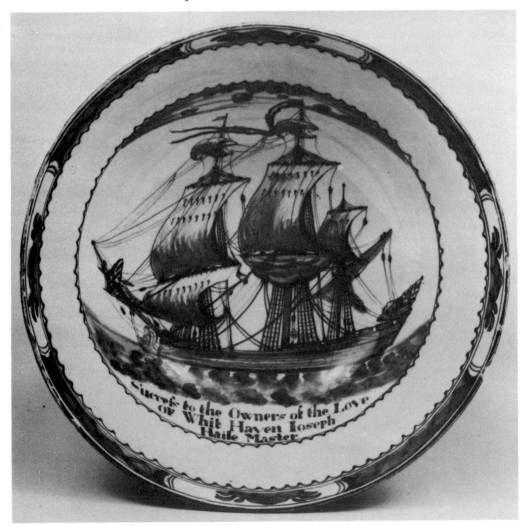

2

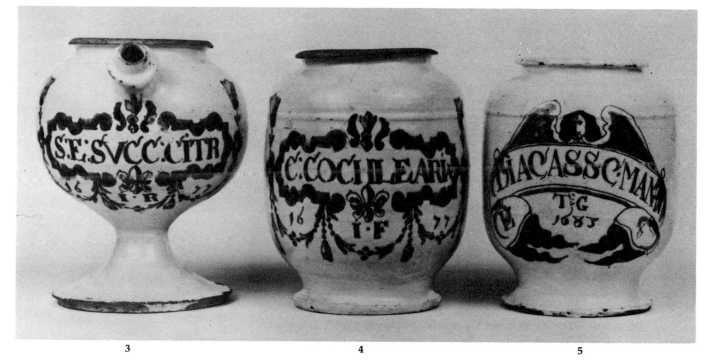

3          4          5

Armorial plates are among the few pieces that can with certainty be ascribed to the Glasgow factory. As in every field, they are to be found in both blue and white and polychrome. Of comparable human interest and equally helpful to the student are wares with inscriptions and/or dates, which again are evenly spread throughout the development of English delft and help to date and to clarify similar undated pieces. The most splendid examples of inscribed delftware are the large bowls which were made at Bristol and particularly at Liverpool, where ship-masters were ready clients for "ship-bowls".

Many of the items made by the English "gallipotters" were no different to those made by their European cousins. However, there is a whole range of English delftware pieces peculiar to the requirements of the local market. Pill-slabs painted with the arms of the Apothecaries' Company and other corporate bodies such as the Barber-Surgeons, flower-bricks and inkwells, double-lipped sauce-boats, wall-pockets, pear-shaped bottles, char-dishes (from Liverpool) and colander-bowls are among the pieces without parallel in other lands.

Much of the decoration follows the norms established elsewhere. There is, however, no English equivalent of Delft doré, and the palettes used at the various factories are generally softer than those used by continental potteries. The Bristol factories were particularly strong in the use of sponged decoration and Bristol and Wincanton were indistinguishably skilled in the production of powdered manganese grounds reserved with numerous panels in blue and white. The most exciting decoration common to the major English potteries is *bianco-sopra-bianco*. This technique of painting white enamel on a white ground had been employed with skill at Casteldurante in the sixteenth century as an ancillary element on *istoriato* dishes. In England it was used to give a rich border to dishes and occasionally bowls in blue and white and polychrome. At Liverpool it is to be found with that city's major contribution to English delftware, so-called Fazackerley flowers. These, painted in lemon-yellow, orange-yellow, sage-green, pale manganese, French blue, and outlined in black, derive their name from a pair of mugs made for a couple of that name. However, so strong were the links between Bristol and Liverpool that the same colour combinations also occur there. In fact much English and Irish delftware is simple to date but hard to attribute to a specific factory.

The production of delftware in the British Isles was finally snuffed out around 1790 by the commercial and technical success of Josiah Wedgwood's creamwares.

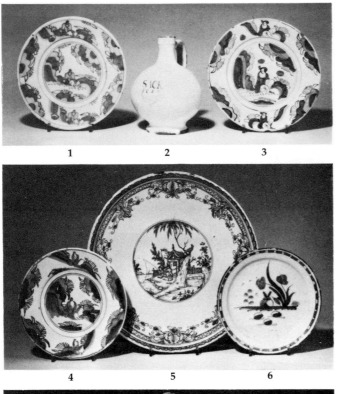

1. A London blue and white plate, circa 1685
21.5 cm. diam.

2. A London white sack bottle, inscribed 'SACK 1649'
18 cm. high

3. A London blue and white plate, circa 1685
21.5 cm. diam.

4. A London blue and white plate, circa 1685
21.5 cm. diam.

5. A Liverpool blue and white three-footed tazza, circa 1760
36 cm. diam.

6. A Bristol blue and white plate, circa 1730
21.5 cm. diam.

11

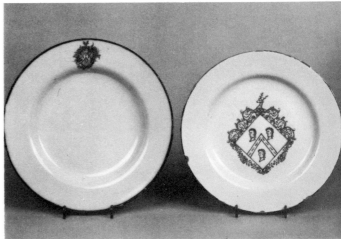

12

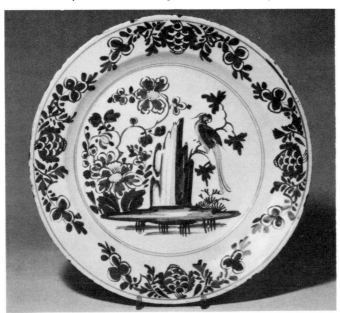

10

13                                              14

**7.** A London dated plate, with the initials ILM and 1688
21 cm. diam.

**8.** A Lambeth delft blue and white ballooning bowl, circa 1784
22 cm. high

**9.** A Bristol delft blue and white dated plate, with the initials IPA and the date 1725
22.5 cm. diam.

**10.** A Lambeth polychrome dish, circa 1760
34 cm. diam.

**11.** A pair of Liverpool blue and white plates inscribed B.T.M. and dated 1766
22 cm. wide

**12.** A pair of dated Liverpool blue and white plates, with the initials HRS, 1756
23 cm. high

**13.** A delft blue and white armorial plate, possibly Dublin, circa 1760
23.5 cm. high

**14.** A delft blue and white armorial plate, possibly Dublin, circa 1760
21.5 cm. diam.

**15.** A Glasgow (Delftfield) armorial polychrome dish, circa 1760
29 cm. wide
The arms are those of Murray of Polmaise

**16.** A Bristol powdered manganese plate, circa 1740
30 cm. diam.

**17.** A Dublin manganese and white lobed oval large dish, 2 marks in manganese, circa 1755
54.5 cm. wide
Attributed to Henry Delamain's factory

**18.** A Bristol blue and white dish painted in the manner of John Bowen, circa 1760
30.5 cm. diam.

**19.** An blue and white dish, Bristol or Liverpool, circa 1760
36.5 cm. diam.

**20.** A blue-dash tulip charger, Lambeth or Bristol, circa 1700
35 cm. diam.

**21.** A Bristol polychrome blue-dash oak-leaf charger, circa 1680
33 cm. diam.

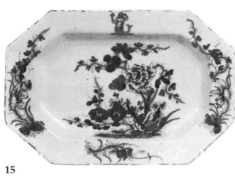

15

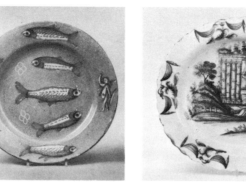

16       17

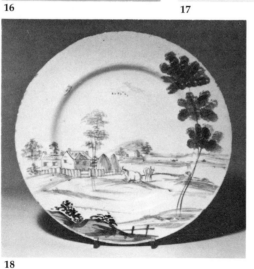

18

19

20

21

1

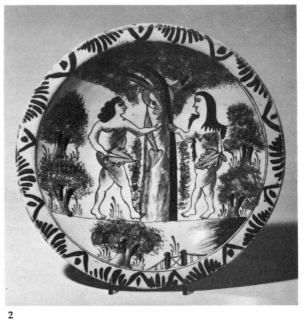

2

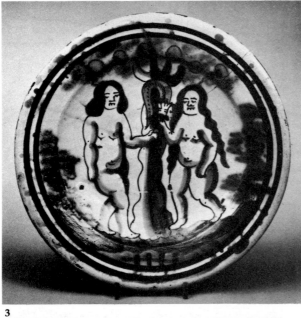

3

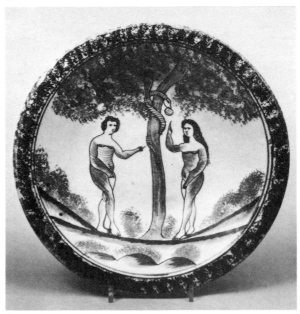

4

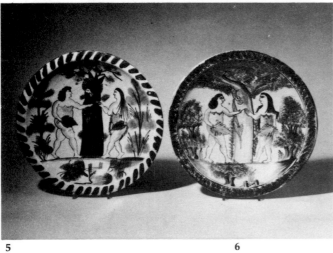

5                              6

**1.** A Bristol polychrome Adam and Eve charger, circa 1730
33 cm. diam.

**2.** A Bristol polychrome Adam and Eve charger, circa 1730
34 cm. wide

**3.** A London polychrome Adam and Eve charger, circa 1700
34 cm. diam.

**4.** A Bristol polychrome Adam and Eve charger, circa 1730
32.5 cm. diam.

**5.** A Bristol polychrome blue-dash Adam and Eve charger, circa 1710
34 cm. diam.

**6.** A Bristol Adam and Eve polychrome charger, circa 1730
34 cm. diam.

**7.** A Brislington blue and manganese charger, dated 1685
33.5 cm. diam.

**8.** A Bristol polychrome dish, circa 1710
28.5 cm. diam.

**9.** A London blue-dash royal portrait charger showing William III, circa 1690
33.5 cm. diam.

**10.** A Bristol blue-dash oak-leaf charger, circa 1730
34 cm. diam.

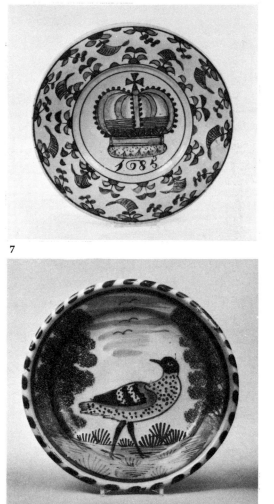

7

8

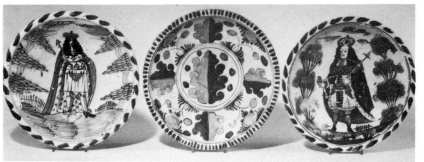

9　　　　　10　　　　　11

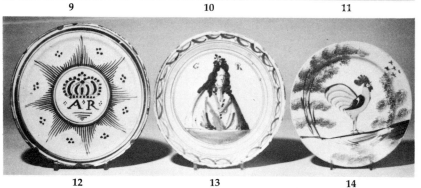

12　　　　　13　　　　　14

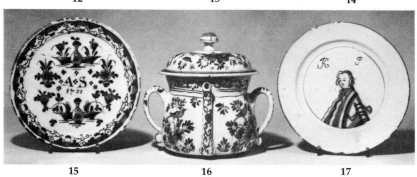

15　　　　　16　　　　　17

**11.** A London blue-dash royal portrait charger showing George I, circa 1715
33 cm. diam.

**12.** A blue and white plate, probably Bristol, circa 1710
22.5 cm. diam.

**13.** A Lambeth polychrome royalist plate, circa 1714
21.5 cm. diam.

**14.** A Bristol polychrome plate, circa 1750
20 cm. diam.

**15.** A London blue and white plate with the date 1722
22.5 cm. diam.

**16.** A Bristol blue and white baluster posset-pot and domed cover, circa 1725
22.5 cm. wide

**17.** A Bristol blue and white portrait plate of the King of Prussia, circa 1760
22 cm. diam.

**18.** A Bristol blue and white oblong octagonal dish, inscribed E.S. and dated 1730
43 cm. wide

**19.** A Bristol blue and white plate, inscribed and dated with the initials HL and the date 1727
21 cm. diam.

**20.** A Lambeth plate, circa 1740
21.5 cm. diam.

**21.** A Lambeth armorial plate, circa 1740
23 cm. diam.

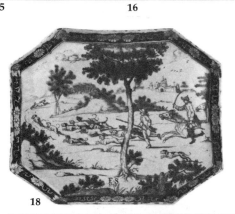

18

19

20　　　　　21

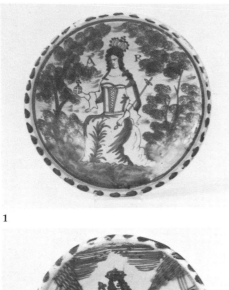

1

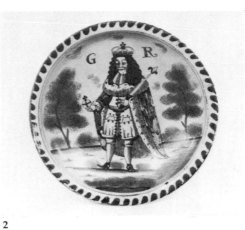

2

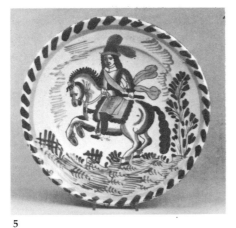

3

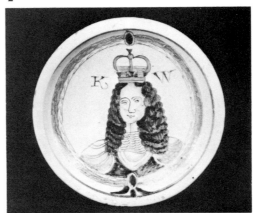

4

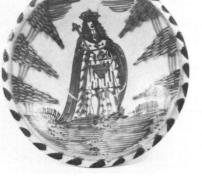

5

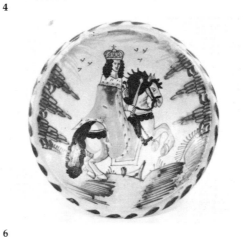

6

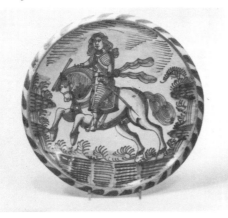

7

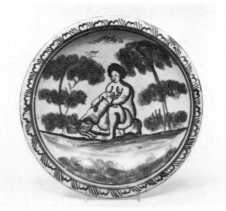

8

1. A Bristol portrait charger of Queen Anne, circa 1702
34.5 cm. diam.

2. An English portrait charger of George I, possibly Bristol, circa 1714
34 cm. diam.

3. A London charger with a standing crowned monarch representing either Charles II or William III, circa 1685
35.5 cm. diam.

4. A Brislington portrait charger of William III, circa 1689
34 cm. diam.

5. A London polychrome equestrian charger, circa 1700
32.5 cm. diam.

6. A London equestrian portrait charger of William III, circa 1685
34 cm. diam.

7. A London blue-dash equestrian portrait charger, circa 1720
33.5 cm. diam.

8. A Bristol charger, circa 1720
32.5 diam.

**9.** A London blue-dash oak-leaf charger, circa 1690
30 cm. diam.

**10.** A Bristol blue-dash charger, circa 1700
33.5 cm. diam.

**11.** An English portrait charger of William III and Queen Mary, circa 1690
34 cm. diam.

**12.** A Bristol portrait charger of Prince Eugene, circa 1730
35 cm. diam.

**13.** A Bristol portrait charger of the Duke of Marlborough, circa 1730
30.5 cm. diam.

**14.** A Bristol portrait charger of Prince George of Denmark, circa 1700
35.5 cm. diam.

**15.** An English portrait charger of William III, circa 1690
33.5 cm. diam.

**16.** A London charger, second half of 17th century
32.5 cm. diam.

**17.** A Lambeth Fećondité dish, dated 1638?
46 cm. wide

9

10

16

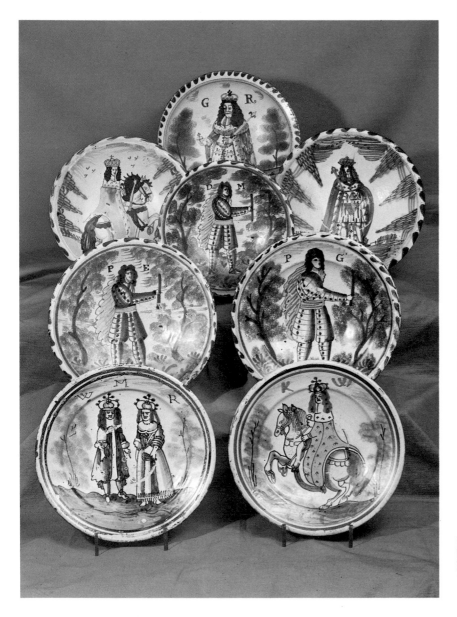

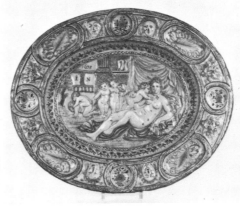

17

1

2

3

4

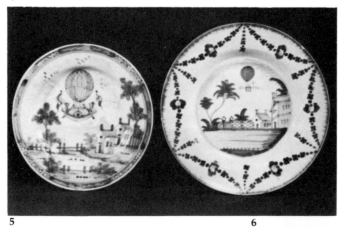

5                                          6

7

1. A pair of Dublin manganese and white plates, circa 1755
25 cm. diam.
Attributed to Henry Delamain's factory

2. An English polychrome armorial plate, circa 1740
21.5 cm. diam.
The arms of those of de Cardonnel of Bedhampton Park

3. A pair of Bristol blue and white plates, circa 1760
22 cm. diam.

4. A Dublin blue and white oblong octagonal dish, 6 mark in blue, circa 1760
50.5 cm. long

5. A Lambeth blue and white ballooning plate, circa 1785
19.5 cm. diam.

6. A Lambeth polychrome ballooning plate, circa 1785
23 cm. diam.
These plates commemorate Lunardi's ascent from Vauxhall in 1784

7. A pair of English powdered manganese ground plates, blue P/6 marks, Wincanton or Bristol, circa 1745
29 cm. diam.

8. A Bristol polychrome dish, circa 1740
30 cm. diam.

9. A Bristol polychrome dish, circa 1755
22 cm. diam.

10. A Bristol blue and white stand, circa 1760
22 cm. diam.

11. A Liverpool dish, circa 1760
35 cm. diam.

12. A Bristol blue and white and bianco-sopra-bianco dish, circa 1760
33.5 cm. diam.

13. A Bristol powder-blue ground plate, circa 1750
23 cm. diam.

14. A Bristol blue and white dish, circa 1760
36 cm. diam.

15. A Bristol polychrome dish, circa 1730
32.5 cm. diam.

16. A pair of Glasgow (Delftfield) plates, circa 1760
23 cm. diam.
The arms are those of Murray of Polmaise

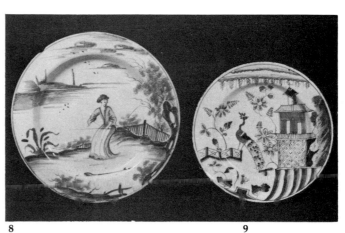

8 9

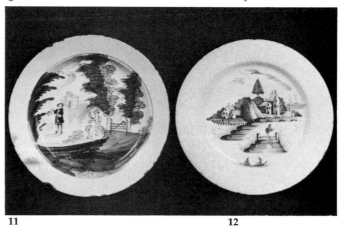

11 12

10

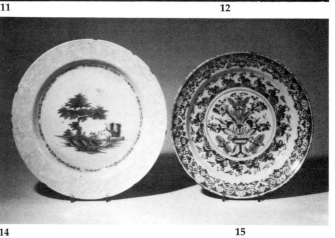

14 15

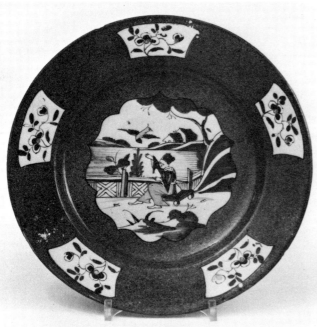

13

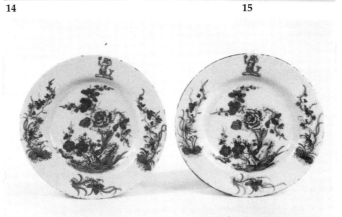

16

1A

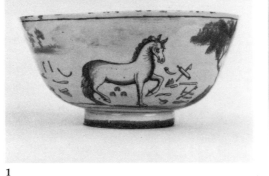

1

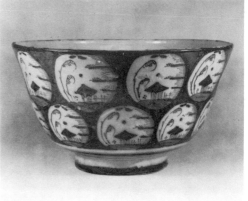

2

3A

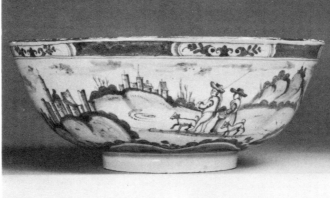

3

**1 and 1A.** A Bristol blue and white dated punch bowl, inscribed Thomas Nowell, 1742
30 cm. diam.

**2.** A Bristol blue and white deep bowl, circa 1720
28 cm. diam.

**3 and 3A.** An English blue and white deep bowl, with the inscription The Gift of Benjamin Richards to Thomas Gwynn Esq.r. 1729, probably Bristol
37 cm. diam.

**4 and 4A.** A Liverpool blue and white bowl painted with A Midnight Modern Conversation after William Hogarth, circa 1750
26 cm. diam.

**5 and 5A.** A Bristol blue and white punch bowl, circa 1750
36 cm. diam.

**6.** A Liverpool blue and white sweetmeat dish, circa 1750
22 cm. diam.

**7 and 7A.** An English polychrome and bianco-sopra-bianco Success to the British Arms punch bowl, circa 1760
26 cm. diam.

4A

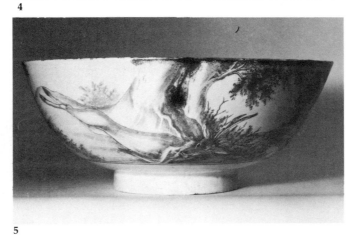

4

5A

5

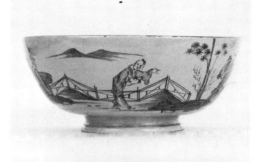

6

7

7A

**8.** A Lambeth blue and white inscribed shallow bowl, circa 1780
18 cm. diam.

**9.** A Liverpool inscribed lawyer's bowl, circa 1750/60
30.5 cm. diam.
The inscribed volume *Coke upon Littleton*, refers to Sir Edward Coke's treatise *Institutes*, published in 1628. Coke's commentary on Sir Thomas de Littleton's text long remained the principal authority on English real property law

**10.** A Bristol blue and white dated bowl, the base with the initials W.P. 1750
25.5 cm. diam.

**11.** A Bristol blue and white royal portrait plate, with Queen Anne, blue 2 mark, circa 1702
22.5 cm. diam.

**12.** A Lambeth polychrome bowl, circa 1770
27 cm. wide

**13.** A Bristol blue and white bowl inscribed and dated John Atwood 1731
27.5 cm. diam.

**14.** A Bristol polychrome bowl, circa 1750
27.5 cm. diam.

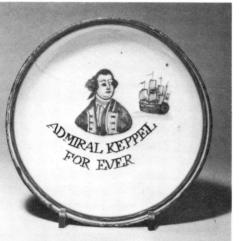

8

9

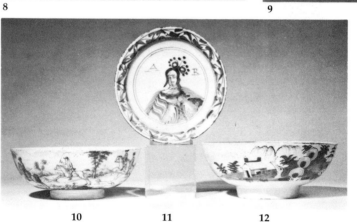

10          11          12

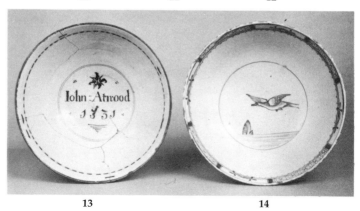

13          14

1

2

3

4

5

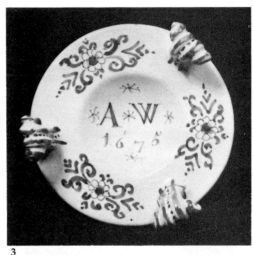

6

**1.** A London blue and manganese polychrome flower-vase formed as the head of a child, the base inscribed TCE 1685
16.5 cm. high

**2.** A London white bleeding bowl, circa 1690
18 cm. wide

**3.** A London blue and white standing salt, inscribed AW 1675
12.5 cm. diam.

**4.** A London blue and white dated hand-warmer, inscribed I.D. 1659
13 cm. high

**5.** A London vase in the form of a seated cat, circa 1675
16 cm. high

**6.** A London blue and white figure of a seated cat, circa 1680
11.5 cm. high

**7.** A Lambeth polychrome wine taster of Ann Gomm type, circa 1790
14 cm. wide
The decoration is similar to that of a Lambeth plate inscribed Ann Gomm

**8.** A London white fuddling-cup, circa 1690
8 cm. high

**9 and 9A.** A Lambeth wine cup with powdered manganese ground, inscribed Thomas Hunt of Eden 1635
10 cm. high

**10.** A Lambeth mug inscribed and dated 1660
9 cm. high

**11 and 11A.** A documentary English blue and white bleeding bowl, dated 1727
12.5 cm. wide

**12.** A London tin-glazed earthenware group of a court lady and gentleman, circa 1670
12 cm. high
Excavated in Greek Street, London, in May 1929

7

8

9

9A

10

11

11A

12

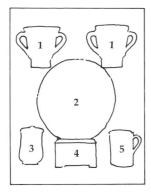

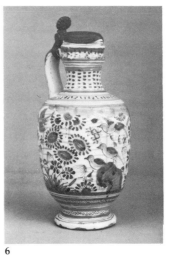

6

7

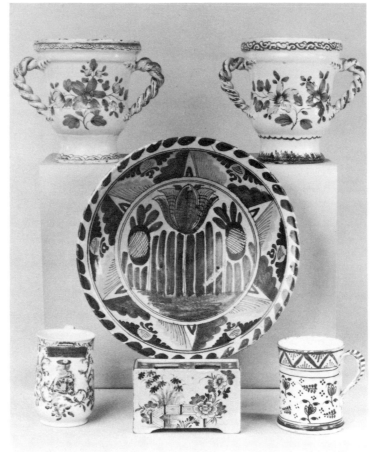

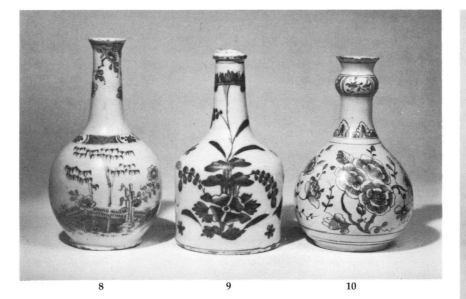

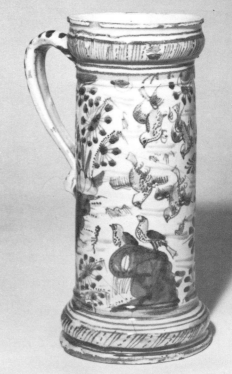

8          9          10

11

1. Two Bristol polychrome campana vases painted in the Fazackerly palette, circa 1760 about 19.5 cm. high

2. A Bristol blue-dash tulip charger, circa 1720 33 cm. diam.

3. A Staffordshire salt-glaze Jacobite mug with a half-length portrait of the Young Pretender, circa 1745 13 cm. high

4. A Bristol polychrome flower brick, painted in the Fazackerly palette, circa 1750 15 cm. high

5. An English polychrome flared cylindrical mug, London or Bristol, circa 1730 12 cm. high

6. A London blue and white oviform jug, 1630-40 23.5 cm. high

7. A Lambeth delft blue and white cylindrical mug, circa 1780 18.5 cm. high

8. A Liverpool blue and white globular bottle, circa 1770 23 cm. high

9. A Bristol blue and white mallet-shaped bottle, circa 1770 22.5 cm. high

10. A Bristol blue and white globular bottle, circa 1770 22 cm. high

11. A dated blue and white cylindrical tankard, probably Southwark, 1630 25 cm. high

12 and 12A. A Lambeth blue and white two-handled dated cup, the base inscribed I.H.F. 1715 25 cm. wide

13. A Liverpool blue and white shell-moulded sauceboat, circa 1760

14. A Lambeth blue and white cylindrical posset-pot and shallow domed cover, circa 1685 23.5 cm. wide

15, 15A and B. A Bristol blue and white jug inscribed and dated 1730 23.5 cm. high

12A

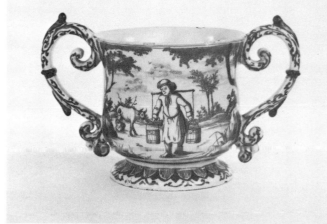

12

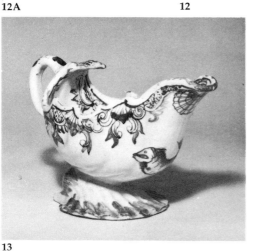

13

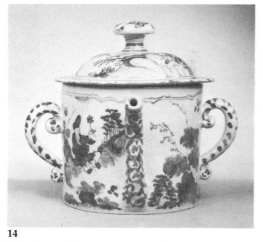

14

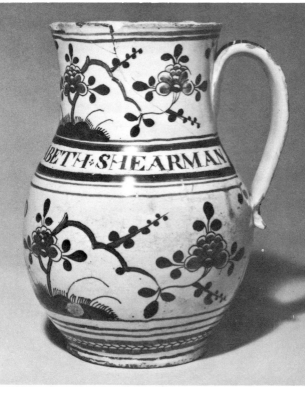

15

15A

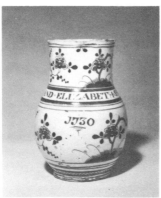

15B

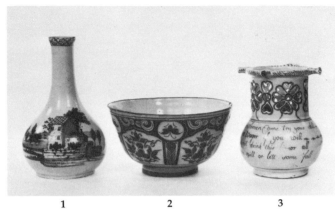

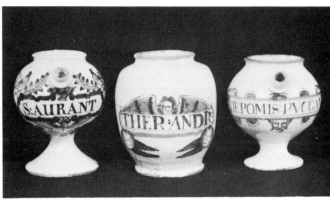

1. A Liverpool blue and white pear-shaped bottle, circa 1760
23.5 cm. high

2. A Bristol polychrome bowl, circa 1730
22.5 cm. diam.

3. A Liverpool blue and white inscribed puzzle-jug, circa 1760
18 cm. high

4. Three Lambeth blue and white drug jars, 1690-1700
All about 18 cm. high

5. A Lambeth white wine-jug inscribed and dated 1651
15 cm. high

6. A London blue and white tankard, inscribed and dated 1663
13.5 cm. high

7. A London blue and white inscribed royalist mug, circa 1685
9 cm. high

8. A Lambeth blue and white wet-drug jar, circa 1720
21 cm. high

9. A blue and white bottle, Liverpool or Dublin, circa 1755
25.5 cm. high

10. A Lambeth polychrome oviform drug jar, with the initials IP 1723
18 cm. high

11. A pair of Liverpool blue and white wall-pockets, circa 1760
23 cm. high

12. A pair of Lambeth blue and white wall-pockets, circa 1700
20.5 cm. high

13. A Lambeth blue and white flower-brick, circa 1760
15 cm. wide

14. A Lambeth blue and white flower-brick, circa 1760
19.5 cm. wide

15. A pair of Bristol blue and white flower-bricks, circa 1760
15 cm. long

16. A Liverpool polychrome spirally moulded wall-pocket, circa 1760
21 cm. high

17. A Liverpool blue and white spirally moulded wall-pocket, circa 1770
23.5 cm. high

18. Part of a Liverpool blue and white miniature tea-service, circa 1760

19. A Bristol blue and white octagonal tea-caddy, circa 1760
10.5 cm. high

20. A Bristol blue and white fluted bough-pot, circa 1760
20.5 cm. wide

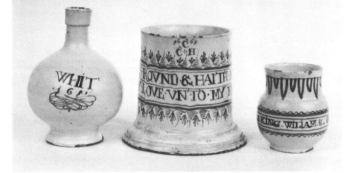

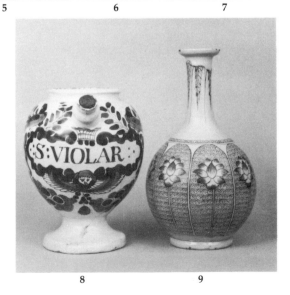

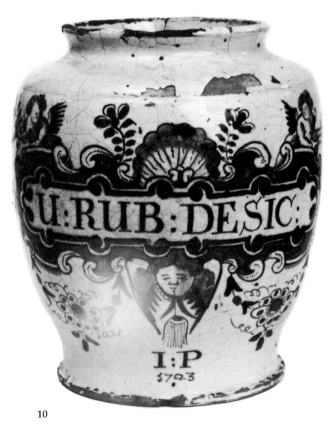

11

12

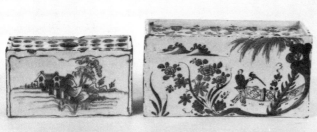

13                    14

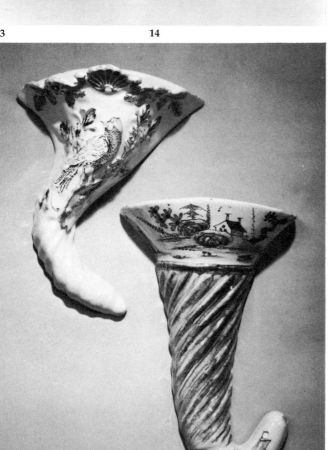

16                    17

15

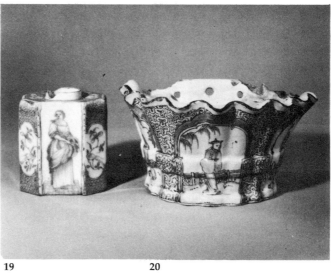

18

19                    20

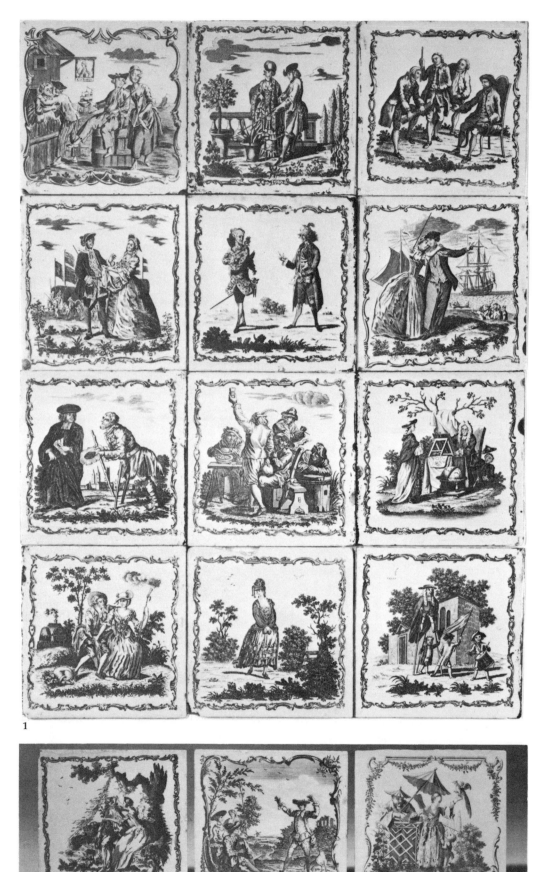

**1.** A collection of Liverpool tiles transfer-printed by John Sadler in red-brown, 1756-1775 each approximately 12.5 cm. square
Sadler is believed to have been the inventor of transfer-printing on pottery and porcelain about 1750. Records dated 1756 show that by then he and his partner Guy Green had printed large quantities of earthenware tiles in Liverpool. Later on he decorated pottery for Wedgwood

**2.** A Liverpool tile transfer-printed in black by John Sadler, signed Sadler Liverp.l, circa 1760
12.5 cm. square

**3.** A Liverpool tile transfer-printed in black by John Sadler, signed J. Sadler, Liverpool, circa 1760
12.5 cm. wide

**4.** A Liverpool tile transfer-printed in black by John Sadler, circa 1760
12.5 cm. wide

**5.** Two Liverpool tiles printed in iron-red by John Sadler, 1758-1775
12.5 cm. square

**6.** Two Liverpool tiles, printed in iron-red by John Sadler, 1758-1775
12.5 cm. square

**7.** Two Liverpool tiles printed in black by John Sadler, 1758-1775
12.5 cm. square

**8.** Six Liverpool theatrical tiles, circa 1775
each 12.5 cm. square

1    2    3

| 4 | 5 | 4 |
| 6 | 6 | 7 |
| 8 | 9 | 8 |
| 10 | 11 | 12 |

13

**8.** A pair of Bristol polychrome tiles, circa 1760
13 cm. square

**9.** A Liverpool blue and white tile, 7 mark, circa 1760
12.5 cm. square

**10.** A Bristol powder-blue ground tile, circa 1730
12.5 cm. square

**11.** A Liverpool blue and white tile, circa 1760
12.5 cm. square

**12.** A Liverpool tile, circa 1756
12.5 cm. square

**13.** A Bristol polychrome tile painted in the Fazackerly palette, circa 1760
13 cm. square

**14.** A Liverpool blue and white pill-slab with the arms of the Apothecaries' Company, circa 1760
27.5 cm. wide

**15.** A Liverpool blue and white pill-slab, with the arms of the Apothecaries' Company, circa 1760
27.5 cm. high

**16.** A Liverpool tile transfer printed in red by John Sadler, with A Macaroni at a Sale of Pictures, circa 1775
12.5 cm.

**17.** A Lambeth blue and white oval pill-slab, with the arms of the Apothecaries' Company and the initials and date DA 1687
30 cm. high

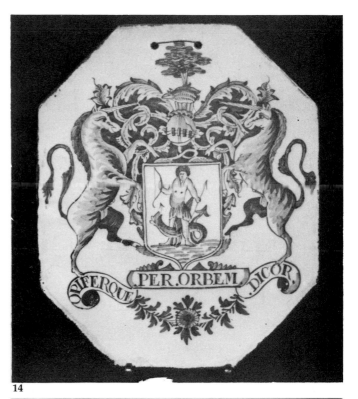

14

15

16

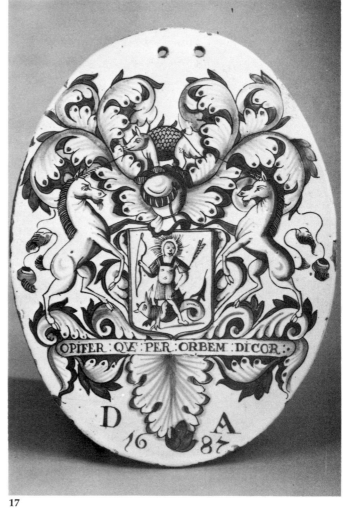

17

**1.** A Staffordshire salt-glaze owl
jug and cover, circa 1720
19 cm. high

# ENGLAND: POTTERY

Slipware techniques are of great antiquity. The practice of decorating redwares with areas of glaze to form formal patterns reaches back to Roman times. At its most sophisticated, where the body was cut away to hold the slip or glaze, as used on tiles and wares in Norman times, it was an extremely skilled craft. Its greatest period of expression was, however, in the sixteenth and seventeenth centuries in Staffordshire and at Wrotham in Kent. Many of the slipwares that have survived are domestic wares of a basically functional sort which, like many useful objects, did not change much from one generation to the next. Though progress is more marked in metropolitan centres which were open to influences from other parts of the world, the process of change in provincial backwaters is immensely slow and it is always prudent in the case of useful wares to assume that they are of more recent manufacture than may at first appear. Fortunately, there is a whole class of slipwares which can be easily placed because they are generally inscribed and/or dated. Of these, the most important group are those made in the Burslem area by Thomas Toft, his brother Ralph, and his sons Thomas Toft II and James.

Thomas Toft was by general consent the greatest master of slipware this country produced. Born around 1640, he died in 1689. His output must have been fairly prolific, as almost forty pieces attributable to him have survived. His motifs included the royal coat of arms, crests and other emblems, Charles II hiding in the Boscobel oak, obviously of special appeal to royalists, Adam and Eve, and figures of royalty. These themes were also echoed by other members of his family and by his contemporaries, of whom the leaders were Ralph Simpson and William and George Talor.

The hollow slipwares made in Staffordshire at this time were relatively few. At Wrotham in Kent, where at least five potters produced slipwares in the seventeenth century, hollow wares predominate, particularly a many-handled cup called a tyg. Activity at Wrotham is recorded between 1612 and 1739. The decoration used, which obviously entered Kent through the Channel ports, was of the "sprigged" sort already practised by the stoneware potters in Germany.

At the beginning of the eighteenth century a new group of wares emerged. The principal creator of these, which were press-moulded, was Samuel Malkin who, like the Tofts, worked in Burslem. He was one of many potters working in this technique and indeed, not the only one with the initials S.M. Here, as in so many other areas of the potters' art, plagiarism and imitation greatly confuse the subject. The patterns employed were often

the same as the ones used in earlier times. Charles II in the Boscobel oak recurs, clock faces and hunting subjects, birds and octagonal dishes with concentric patterns are all classic types.

Apart from the pieces which are signed and/or dated, there was a large output of useful wares with more or less simple decorations created from marble slip, trailed and feather decoration, and other simple patterns in trailed slip. These pieces were extremely practical and robust objects, produced in a number of potteries. Both their origin and their dating are very hard to establish unless they are associated with a kiln site or have a documented provenance. Their practical simplicity and the problems surrounding their precise dating and origin have perhaps combined to give them less respect than they warrant. Their production continued in rural areas until well into the nineteenth century.

The English potteries of the eighteenth century were almost without exception in Staffordshire. Starting from very simple beginnings and plain redwares at its outset they had, by the end of the century, entirely revolutionized their craft, transformed it into an industry of worldwide importance, and in the process swept aside the faience makers of Europe.

The redwares which initiated this process were inspired by the Yixing pots that were imported in large quantities from China for the consumption of tea. The men responsible for bringing the production of the material to Staffordshire were two Germans, Johann Philipp and David Elers. They apparently started life in Cologne, but made a stay in London in the 1690s, where they were in some trouble over the infringement of patents, before eventually settling in Bradwell Wood near Burslem well before 1700. Thus the basis of the Staffordshire potteries' success was a combination of oriental example and German skill, based on techniques the two brothers had acquired in their original calling of silversmiths.

Initially the Elers managed to keep the secret of their skill to themselves. However, the local potters seem gradually to have discovered their methods and they became absorbed into the mainstream of potting in Staffordshire. Few potters specialized in one area of production and redwares were produced by potters who also worked in the other staple material of the 1720s to 1750s, salt-glazed stoneware. This too was a material with a long ancestry: it had been imported to Britain from the Rhine valley since at least 1550. The use to which it had hitherto been put, the storage of wine and spirits and the manufacture of tankards, required a relatively coarse

and robust material, but in eighteenth-century Staffordshire the key demand was for tea-wares. Traditionally these had been of a very delicate material and the salt-glazed wares of Staffordshire were to follow this pattern. Though at the outset they were thrown on the wheel in the usual way, various moulding and slip-casting techniques, derived from both Germany and France, were soon brought in. These were part of the process of industrialization of the potteries that was to continue throughout the century. Decoration was "sprigged" or luted on to wares, both salt-glaze and red, from small intaglio-cut moulds probably derived from the Elers' experience as silversmiths. Press-moulding of plates, a process also developed at Meissen in the production of porcelain, was also practised. Hitherto the porosity of the ware had made it necessary to glaze the interior of vessels, but a subtle change in firing techniques removed this necessity.

As the middle of the century approached, the use of coloured lead glazes, probably developed by Thomas Whieldon, added a new dimension to the craft. Like Astbury and Thomas Wedgwood, who were prominent in the industry at the time, he was but one of the most successful of many potters producing good wares in Staffordshire. His kilns at Fenton Low have been excavated and provide us with an accurate picture of what he produced.

Much of what was potted was a gradual refinement of the various strands of tradition that were available to the potters. Redwares were turned on the lathe, the agate wares originally used by the indigenous slipware potters were adapted to make attractive teawares. The majority of the wares produced in this form were in simple colours, either those created by the pottery itself or those produced by applied varied slips on a dark surface. Whieldon's lead glaze produced results in two distinct veins: the first of these may be called splashed wares in which yellow, green, manganese, and blue glazes were applied, achieving a tortoiseshell effect and imitating the splashed wares of Kangxi. The second, which was also of oriental inspiration, deployed the famille rose palette on the plain salt-glaze ground. Sometimes the patterns and subjects painted were overtly Chinese in derivation. On other occasions the subjects were purely European, commemorating the '45 rebellion, Frederick the Great, and other personalities and events. Enamelled salt-glaze wares were to remain in production until Josiah Wedgwood's creamware, and similar wares produced at Liverpool and Leeds, took over the whole area of the market occupied by salt-glaze.

Salt-glaze was also the vehicle for the production of figures and groups. Of these the most famous are the Pew groups of the 1740s, made in two tones of ware. Astbury also produced figures in lead-glazed earthenware, using a two-tone process. The great and attractive simplicity of these figures has been somewhat tarnished by the numerous spurious examples that were produced between the World Wars. The splashed technique was employed on animals and groups too, both of oriental and European subjects.

In 1754 Whieldon took Josiah Wedgwood into partnership. This combination was to have a massive influence on the destiny of the potteries. After six years in partnership with Thomas Whieldon, Josiah Wedgwood set up on his own at the Ivy House, Burslem, in 1758. Here he began the series of refinements of the craft that was to revolutionize the manufacture of pottery in England and make the potteries of Staffordshire the centre of the industry throughout the western world.

Josiah's first step was the refinement of the basic material. The tortoiseshell wares of his youth were to be superseded by a siliceous white earthenware. This material, which is generally called creamware, or faience fine, has a transparent glaze, is highly fired, and therefore stronger than all preceding forms of pottery. It was also cheaper. Josiah, who did not remain alone in the field for long (he soon had competitors at Leeds, Cockpit Hill near Derby, and in Liverpool) was also a man of great business acumen. With intelligence, he called his ware "Queensware" after his patron, Queen Charlotte. Though this did not improve the physical nature of his product, it certainly enhanced its saleability. Within twenty years the sales of queensware were seriously damaging the fortunes of the delft-ware manufacturers and causing cries of outrage all over the continent.

The majority of the pieces produced in queensware are of limited appeal. It was, however, the vehicle for decoration executed by David Rhodes, a painter of originality and fantasy. Many of the table wares Josiah sold were, like the majority of neoclassical table services, plain to the point of being boring, though the service he presented to Catherine the Great of Russia was a splendid tour-de-force of decoration. It must be remembered that Josiah regarded his queensware as his bread-and-butter, whereas his upmarket products were jasperware and basaltes, as he himself described it.

These were the result of a meeting between Wedgwood and Thomas Bentley at Liverpool (where Sadler was printing his creamwares) in 1762. They went into partnership to pursue another area of pottery where Josiah's refining zeal was on the alert. In 1768 they opened a factory which they called Etruria, for Thomas Bentley was an antiquarian. Their professed aim, painted on their initial products, was that the arts of Etruria should be reborn (Artes Etruriae renascuntur). The shapes they were to produce were distinctly classical in feeling: indeed they were the epitome of the neoclassical spirit that was sweeping Britain and the rest of Europe in the last quarter of the eighteenth century. The material they used, the black stoneware that was called basalt, and its white companion, jasper, were by no means new. Since Roman times tiles had been made in a coarse version of the former, whilst the latter was a purified stoneware which Wedgwood had discovered by dipping in the colour he wanted. Both materials were very hard (Josiah described basalts as "equal in hardness to agate or porphyry") and both could be turned on the lathe or polished on the wheel.

These were no wares for hoi polloi but quite unashamedly products for the Palladian and Adam

**1.** A Wedgwood transfer-printed creamware punch-pot and cover, impressed mark, circa 1770 32 cm. wide

houses of the rich and powerful. Flaxman and Hackwood were employed to design the shapes, just as the Sèvres porcelain factory used leading artists to conceive its shapes and decorate its wares. Like the contemporary porcelain factories, the Wedgwood & Bentley partnership issued an annual catalogue of its wares. Apart from vases and tewares, in both basalt, agateware, and, after 1776, jasper, they sold portrait medallions, of historical figures, the twelve Caesars, the Popes, the Kings of England and of France and of illustrious moderns divided as to their vocations. Initially these were made in basalt, but the development of jasper gave added scope to this side of their activity, bringing with it the virtue of colour, albeit of a cold neoclassical tonality. The applied white with its variations of thickness and translucency offered much greater possibilities for the portraitist than had been afforded in basalts.

Thomas Bentley did not long enjoy the benefits of the invention of jasper. He died in 1780 and his widow and Josiah dissolved the partnership. The Wedgwood & Bentley mark was now replaced by the word Wedgwood for almost a century. Josiah experimented with combined colours of jasper, both on teawares and on the vast number of small bottles and seals or plaques that he produced right up to the end of the century. These were often made for the jewellery trade and are to be found with contemporary mounts in cut steel and gold.

Josiah's most famous product of the period is the only one not to bear his mark. This, the Portland vase, copied from the Roman glass original now in the British Museum, was produced on a limited edition basis only, but such were the technical difficulties encountered that many of them are blemished in one way or another. Only in later versions of this model is the Wedgwood mark to be found.

Josiah had many local imitators in the production of basalts, prominent among them Spode, Turner, Adams, and Mayer. Two of these, Adams and Turner, also made jasperwares. Turner's greatest claim to fame lies, however, in the enamelling shop he operated in Holland, where creamwares from a variety of factories were decorated.

Naturally Wedgwood's products did not constitute the entire output of the potteries. He was not strong on the production of figures, though marked specimens by him do exist. Here the dominant manufacturers were the Wood family of Burslem and Felix Pratt of Fenton.

The Woods, father and son, both called Ralph, specialized in figures which were thinly potted and splashed in pale manganese, green, brown, and blue glazes. The subject-matter varied from pastoral themes of shepherds and shepherdesses to mythological figures such as Neptune and Apollo, and an equestrian figure of Hudibras. They also produced Toby jugs; these beer jugs in human form were initially finely made and skilfully potted. With the passage of time they became coarser and much of the fine detail was lost. The same fate overcame many of their figures. Early Ralph Wood pieces occasionally have the Wood rebus mark, a tree in relief on the side of the base.

The figures and wares of Pratt and his many imitators were decorated in a sponged technique in which blue, ochre, orange, and manganese predominate. They were not as thinly potted or finely detailed as the wares of the Wood family.

The production of creamware was not confined to Wedgwood or indeed to the potteries. It might even be said that his industrialized perfection of the material effectively destroyed it from an artistic point of view.

In many ways the products of the Leeds factory, where a technique of perforation was developed, are superior to those of Wedgwood. Here the wares were basically simple, with all the decorative force concentrated on handles, which were frequently entwined with floral terminals, spouts, and finials. Occasionally at Leeds, massive centrepieces of great complexity were produced as displays of virtuosity in the perforated technique.

Creamwares of a rather poorer quality were made at Cockpit Hill, near Derby, whilst in Liverpool, Sadler & Green applied printed decoration to wares produced locally and from other major centres of production.

Creamware from England killed off the production of faience throughout Europe by the end of the eighteenth century. As a result of Josiah Wedgwood's industrial techniques, it very early ceased to be a craft product and became the vehicle for endless repetition.

It was succeeded by pearlware, an inferior commodity dressed up as an improvement, and by a wide range of printed earthenware in blue and white.

The impact of the industrial revolution on the potteries was to enrich the master potters and impoverish the quality of their wares, effectively closing the story of pottery as a craft.

**1.** A Staffordshire slipware two-handled bragget-pot with the initials DS, circa 1695
23 cm. wide

**2.** A Wrotham slipware tyg inscribed and dated by Henry Ifield with the initials HI and the date 1644
13 cm. high
This seems to be the earliest recorded example made by Henry Ifield

1

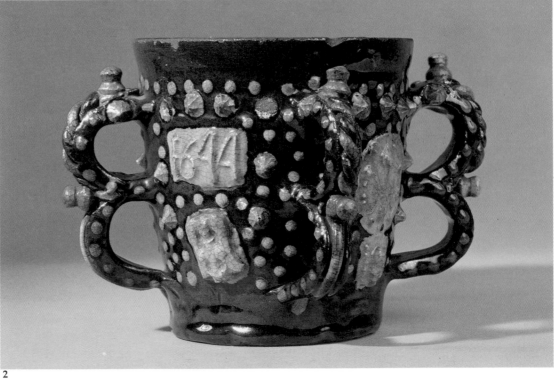

2

**3.** A Thomas Toft slipware dish, 17th century
45.5 cm. diam.

**4.** A slipware dish, late 17th century
33 cm. diam.

**5.** A documentary slipware press-moulded dish by Samuel Malkin, inscribed on either side of the hand Samuel Malkin the Maker in Burslam (sic) 17
36 cm. diam.
The number 17 in a box immediately below the hand pointing to XII indicates the date 1712

3

4

5

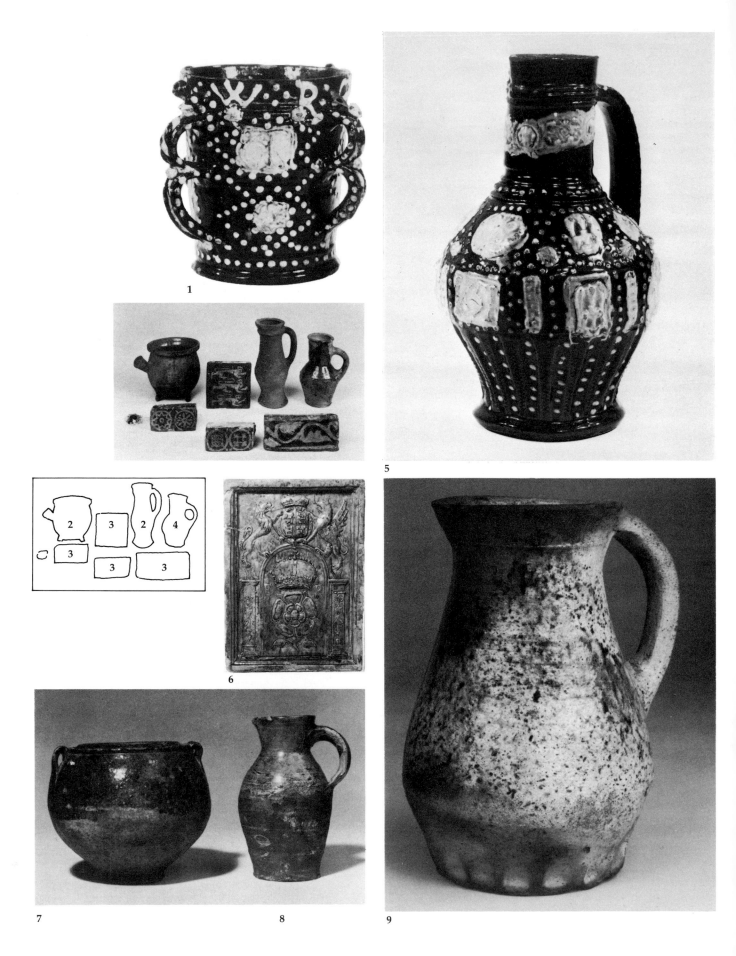

1. A Wrotham slipware tyg, by George Richardson, inscribed Wrotham, signed GR and dated 165(9)
16 cm. high

2. A medieval tapering jug and a globular cooking vessel, both late 14th century
19 cm. high and 13 cm. diam.

3. A medieval floor tile; a rectangular border-tile; and two rectangular border-tiles, 15th century
10 cm. square, 14.5 cm. long, 9.5 cm. long

4. A medieval jug, late 14th century
15.5 cm. high

5. A Wrotham slipware jug, by George Richardson, signed GR and dated 1651
24.5 cm. high

6. An Elizabethan green-glazed stove-tile
35 cm. x 25.5 cm.

7. A medieval oviform jar, late 15th century
16 cm. wide

8. A medieval tapering oviform jug, probably English, 15th century
16.5 cm. high

9. A medieval baluster jug, late 14th century
19 cm. high

10. A Queen Mary pottery jug with silver-gilt mounts, circa 1555
15.5 cm. high

11. A slipware piggin, with the inscription Mary Burgh: 1699
11.5 cm. diam.

12. A Toft dated slipware two-handled bragget-pot with the inscription "The best is not too good for you 1697 ED" and with the initials WD and RD to the sides
32 cm. wide

13. A Staffordshire inscribed posset-pot dated 1671 and with the initials RF, the reverse with the initials E
            IW
24.5 cm. wide
The initials RF probably refer to the Burslem potting family of Fletcher

14. A Staffordshire slipware inscribed and dated bragget-pot with the initials BB and RF, the border with the inscription "The best is not too good for you, 1697"
32.5 cm. wide

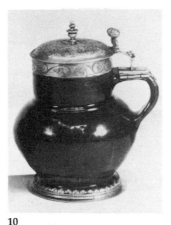

10

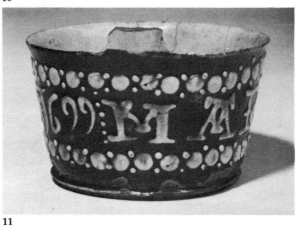

11

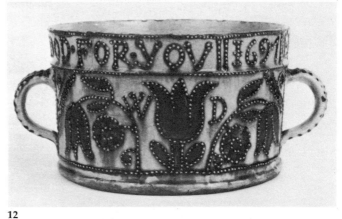

12

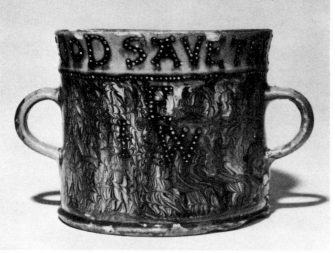

13

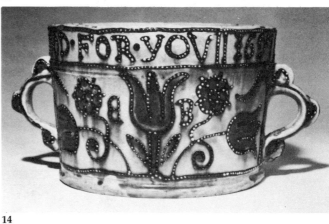

14

1

2

3

4

1.  An early slipware charger, late 17th century
34 cm. diam.

2.  An early slipware dish, late 17th century
40.5 cm. diam.

3.  A Staffordshire slipware dish, by William Simpson, with the initials WS, circa 1700
34 cm. diam.

4.  A Staffordshire slipware dish, circa 1740
35.5 cm. diam.

5.  A Staffordshire slipware dish, with the date 1784
35 cm. diam.

6.  A Staffordshire slipware charger, by John Osland, the border with the initials I : O, circa 1720
45.5 cm. diam.

7.  A Barnstaple slipware oviform jug, late 18th century
22 cm. high

8.  A Wrotham two-handled tyg, dated 1711 and with the initials IE and EH between the loop handles
17.5 cm. high
The initials IE are probably for John Eaglestone, the successor to George Richardson

9.  A Staffordshire slipware cradle by Ralph Simpson, circa 1700
21.5 cm. wide

5

6

7

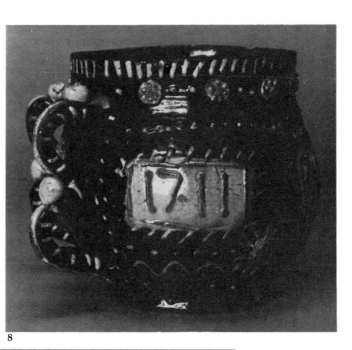

8

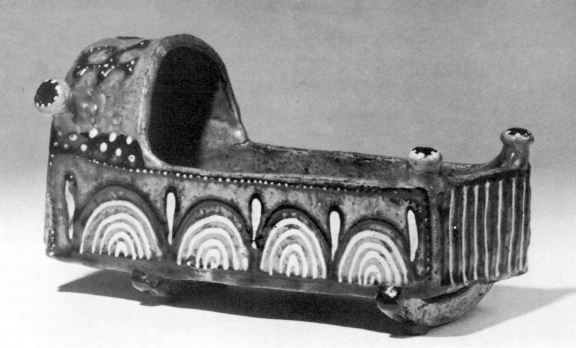

9

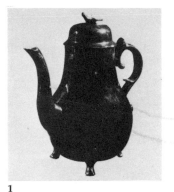

1

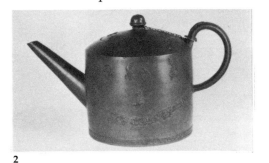

2

3

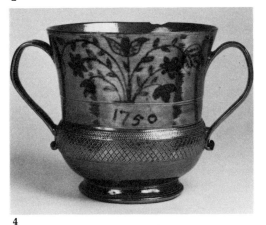

4

5

6

7

1. A Staffordshire black-glazed coffee-pot and cover, circa 1760
23 cm. high

2. A red stoneware punch-pot and cover, circa 1760
33 cm. wide

3. An Astbury glazed redware Portobello mug with sprigged decoration, dated Nov. 22, 1739
16 cm. high

4. A Nottingham salt-glaze stoneware thistle-shaped two-handled cup, dated 1750
31 cm. wide

5. A brown-glazed redware double-spouted posset-pot incised SS M7 IS and the date 1731, probably West Country
25 cm. diam.

6. A brown-glazed stoneware globular jug, the base inscribed Mr. and Mrs. Sivepson, January 3, 1822
18.5 cm. high

7. A Nottingham salt-glaze stoneware dated cylindrical mug, with the inscription Joseph Harrison, 1769
17.5 cm. high

8. A Staffordshire pottery black-glazed Jacobite tankard, circa 1780
14.5 cm. high

9. A Fulham salt-glaze stoneware dated cylindrical mug, inscribed "Danll Cok att Dyashall 17=38"
22 cm. high

10. A Nottingham salt-glaze stoneware thistle-shaped cup, inscribed Henry & Sarah Howard, Sep.r.23 1793
22.5 cm. high

11. A dated salt-glaze stoneware mug with portrait medallions of King William, Queen Anne, and Charles I and incised with initials JS and the date 1726
18.5 cm. high

12. A Nottingham salt-glaze stoneware charger, circa 1750
41.5 cm. diam.

13. A Whieldon square tea-caddy, circa 1760
12.5 cm. high

14. A Staffordshire redware coffee-cup and saucer, the cup with impressed seal mark, circa 1760

8

9

10

11

12

13

14

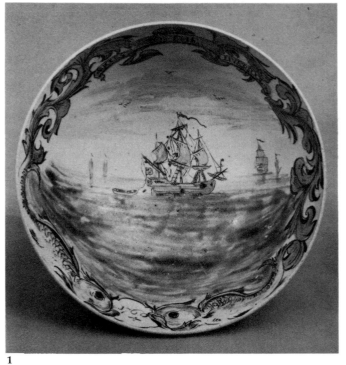

1

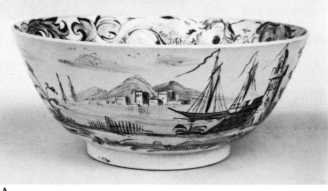

1A

2

3

4

**1 and 1A.** A dated ship bowl, inscribed 1760
19 cm. diam.

**2.** A pew group, circa 1740
19 cm. wide

**3.** A figure of the Taoist immortal Chung-Li Ch'uan, circa 1750
18.5 cm. high

**4.** A bear-jug and cover, circa 1740
21.5 cm. high

**5.** A cylindrical mug, circa 1760
9.5 cm. high

**6.** A coloured figure of Harlequin after the Meissen model by J. J. Kändler, circa 1755
12 cm. high

**7.** A figure of an athlete, circa 1760
10.5 cm. wide

**8.** A commemorative baluster mug, moulded with the inscriptions "The British Glory Reviv;d/Admiral Vernon/He took Portobello with six ships only Nov.: ye 22: 1739', circa 1740
12 cm. high
It is interesting to compare this mug with the redware example, number 3 on page 268

**9.** An arbour group, circa 1740
18 cm. high

**10.** A coloured figure of Mezzetin from the Meissen model by J.J. Kändler and P. Reinicke, circa 1755
12 cm. high

5

6

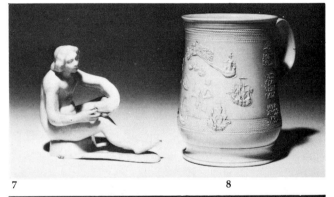

7

8

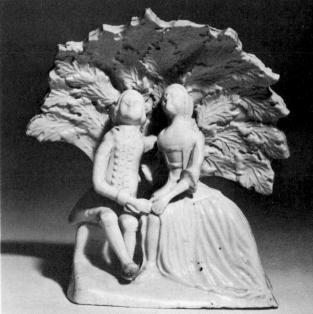

9

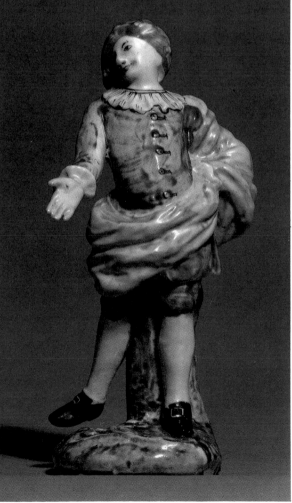

10

1                                    2

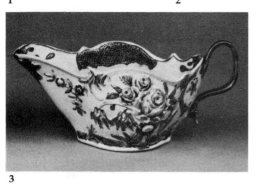

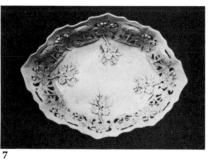

3                                    4

5

6

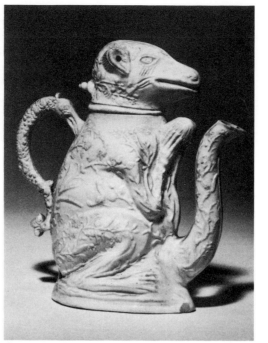

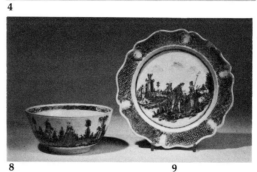

7                          8                    9

1.  An agateware figure of a seated cat, circa 1755
12 cm. high

2.  An agateware figure of a seated cat, circa 1755
8.5 cm. high

3.  A lobed oval sauceboat, circa 1760.
16.5 cm. wide

4.  A teapot and cover, circa 1755
15.5 cm. high

5.  A pair of wall-pockets, circa 1760
26.5 cm. high

6.  A King of Prussia commemorative dish, circa 1760
36.5 cm. diam.

7.  A pierced oval basket, circa 1760
32 cm. wide

8.  A bowl, circa 1755
16 cm. diam.

9.  A plate painted with The Fortune Teller, circa 1755
22.5 cm. diam.

10.  A polychrome tankard, circa 1755
16 cm. high

11.  A lobed oval two-handled tureen and cover, circa 1760
27 cm. high

12.  A pair of polychrome campana vases, circa 1760
15 cm. high

13.  A bottle, circa 1750
22.5 cm. high

14.  A polychrome teapot and cover, circa 1755
15.5 cm. wide

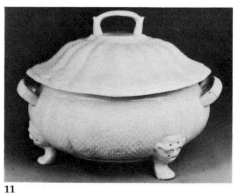

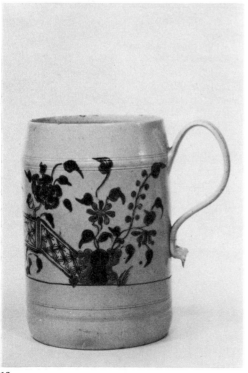

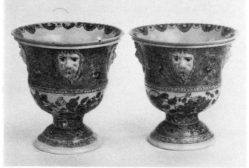

10                         11

12

**13**

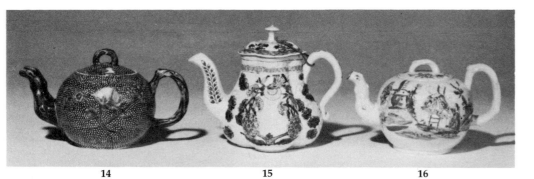

14              15              16

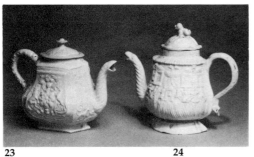

17      18      19

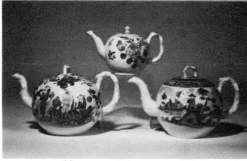

20    21    22

**15.** A polychrome Jacobite teapot and cover, circa 1745
12.5 cm. high

**16.** A polychrome teapot and cover, circa 1750
15.5 cm. wide

**17.** A blue-ground oviform teapot and cover, circa 1755
17 cm. wide

**18.** A mottled rose-ground teapot and cover, circa 1755
16.5 cm. wide

**19.** A mottled blue-ground teapot and cover, circa 1755
20 cm. wide

**20.** A polychrome teapot and cover, circa 1755
20.5 cm. wide

**21.** A polychrome teapot and cover, circa 1755
15.5 cm. wide

**22.** A polychrome teapot and cover, circa 1755
21 cm. wide

**23.** A royalist teapot and cover, circa 1745
15 cm. wide

**24.** A teapot and cover, circa 1745
16 cm. wide

**25.** A blue and white jug, circa 1760
14 cm. high

**26.** An incised Portobello teapot and cover, circa 1745
19 cm. high

**27.** A polychrome teapot and cover in the Kakiemon palette, circa 1750
13.5 cm. high

**28.** A King of Prussia commemorative teapot and cover, circa 1757
19 cm. wide

**29.** A coffee-pot and cover, circa 1750
21 cm. high

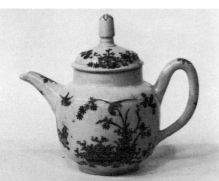

23              24

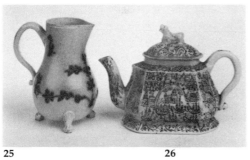

25              26

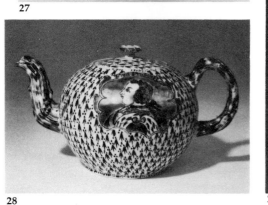

27

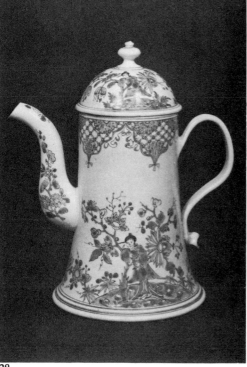

28                    29

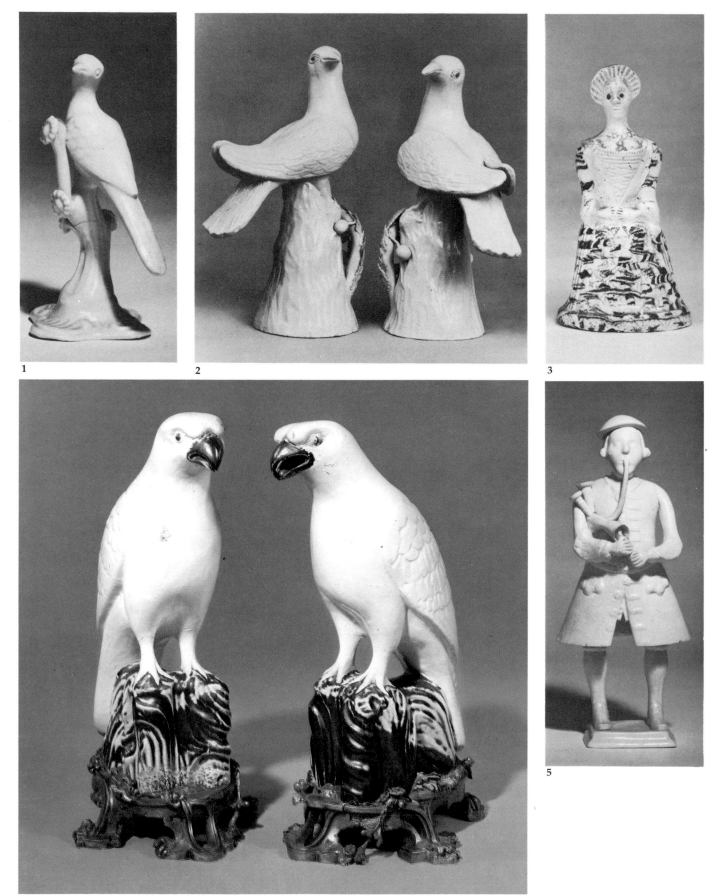

1

2

3

4

5

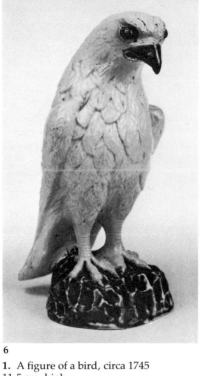

6

1. A figure of a bird, circa 1745
11.5 cm. high

2. A pair of doves, circa 1740
26.5 cm. high

3. An agateware figure of a lady,
circa 1745
14 cm. high

4. A pair of white ormolu-
mounted figures of hawks, circa
1755
27.5 cm. high

5. A figure of a bagpiper, circa
1740
23 cm. high

6. A figure of a hawk, circa 1750
23 cm. high

7. A coloured figure of a hawk,
circa 1755
18.5 cm. high

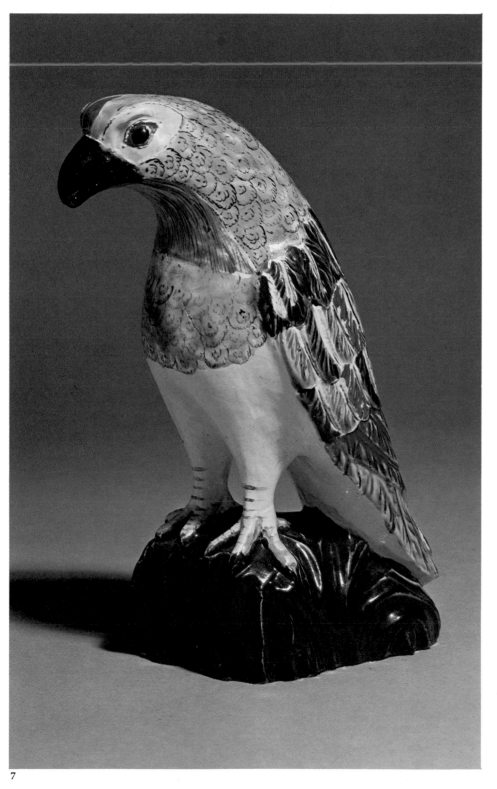

7

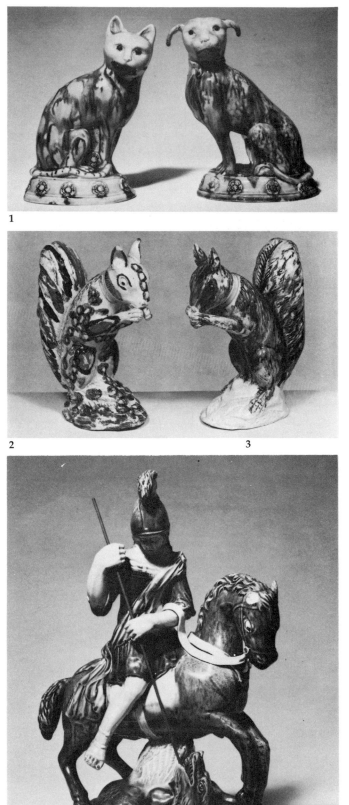

1. A pair of pearlware figures of a dog and cat, circa 1780
21.5 cm. high

2. A figure of a squirrel, circa 1780
18.5 cm. high

3. A figure of a squirrel, circa 1780
18.5 cm. high

4. A Ralph Wood figure of a squirrel, circa 1795
18 cm. high

5. A Ralph Wood group of St. George and the Dragon, circa 1775
28 cm. high

6. A Ralph Wood figure of a mounted officer, circa 1775
14 cm. wide

7. A Ralph Wood figure of Benjamin Franklin, the base inscribed Dr. Franklin, circa 1790
34.5 cm. high

8. An Enoch Wood equestrian group of William III, circa 1790
41.5 cm. high

9. A Ralph Wood Fair Hebe jug modelled by Jean Voyez, circa 1790
21 cm. high

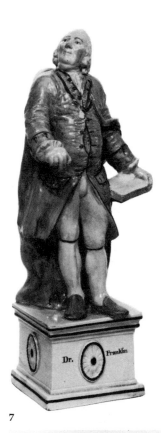

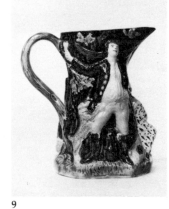

**10.** A pair of Ralph Wood lions circa 1775
28 cm. wide

**11.** A Ralph Wood teapot and cover, circa 1775
27.5 cm. long

**12.** A Ralph Wood figure of a retriever, impressed R. Wood, circa 1775
18 cm. wide

**13 and 13A.** An oval biscuit plaque, by Enoch Wood, modelled with the Deposition of Christ on the Cross, after Rubens, the reverse inscribed, signed Enoch Wood sculpsit, 1777
49.5 cm. x 37.5 cm.

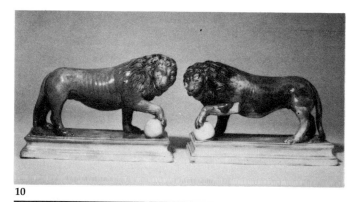

10

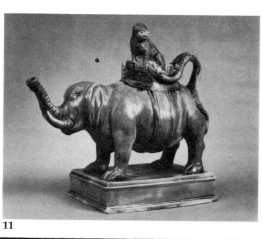

11

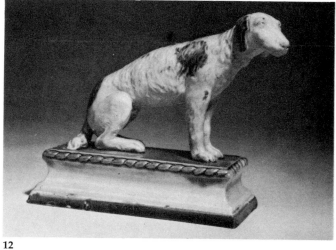

12

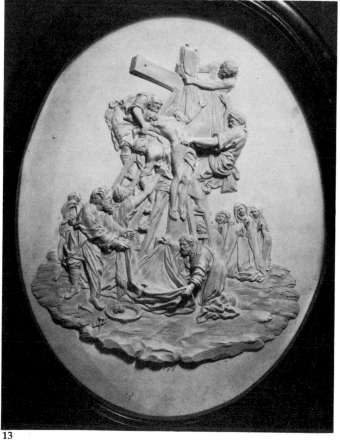

13

13A

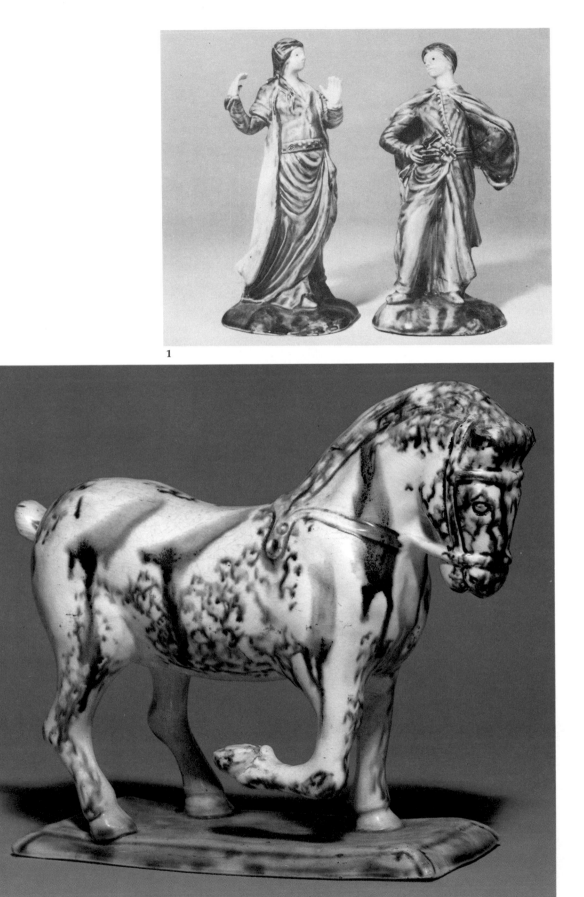

1

2

1.  A pair of Whieldon figures of a Turk and companion, circa 1760
18.5 cm. high

2.  A Whieldon figure of a Suffolk punch, circa 1760
21 cm. wide

3.  A pair of Whieldon figures of buffaloes, circa 1760
25 cm. long

4.  A pair of Whieldon figures of a lion and a lioness, circa 1745
15 cm. long

5.  A Whieldon conical coffee-pot and domed cover, circa 1760
23 cm. high

6.  A Whieldon agateware chocolate pot and cover, circa 1745
19.5 cm. high

7.  A figure of an owl, circa 1750
20.5 cm. high

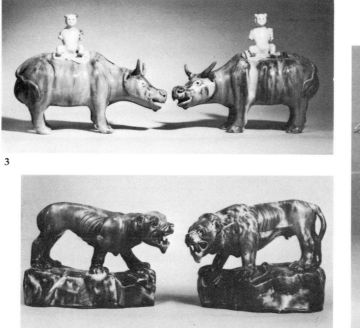

3

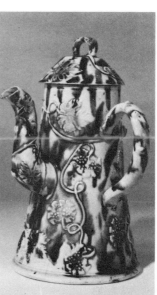

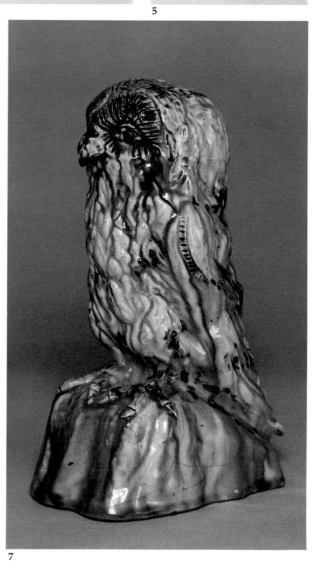

4

5

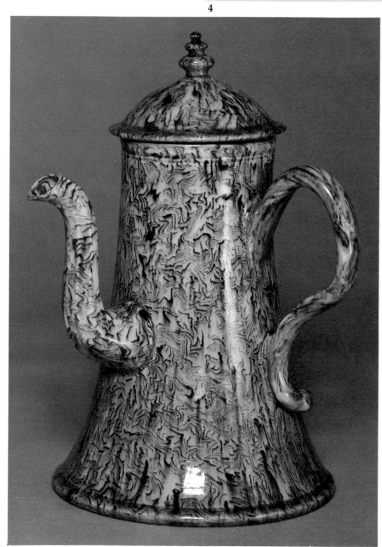

6

7

1

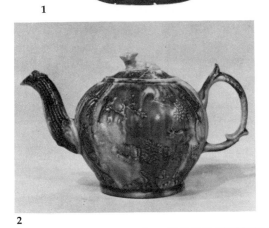

2

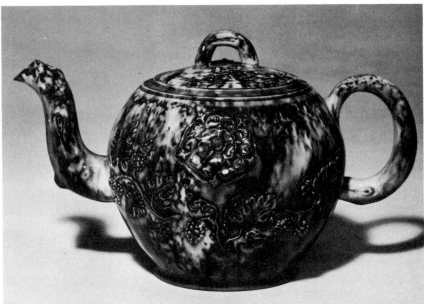

3

4

**1.** A Staffordshire solid agate pecten-shell teapot and cover, circa 1750
18.5 cm. wide

**2.** A Whieldon "Landskip" teapot and cover, modelled by William Greatbatch, circa 1760
20 cm. wide

**3.** A Whieldon globular teapot and cover, circa 1760
19 cm. wide

**4.** A pair of Whieldon cornucopia, circa 1760
31 cm. high

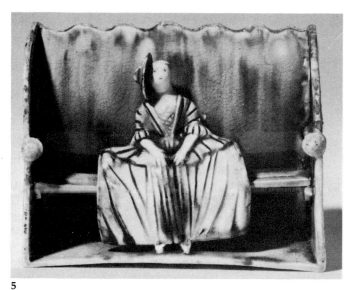

**5**

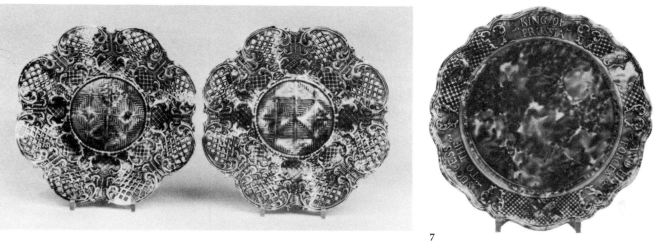

**6**                                                                      **7**

**5.** A Whieldon pew figure, circa
1750
11.5 cm. wide

**6.** A pair of Whieldon pierced
lobed circular dishes, circa 1750
25.5 cm. diam.

**7.** A Whieldon King of Prussia
commemorative plate, circa 1750
23 cm. diam.

**8.** A Whieldon pineapple-
moulded rectangular teacaddy,
circa 1760
11.5 cm. high

**9.** A Bovey Tracey saltglaze
square teacaddy, inscribed
Susanna Savery July ye 19th,
1770
13 cm. high

**10.** A Whieldon cauliflower
square teacaddy, circa 1760
10.5 cm. high

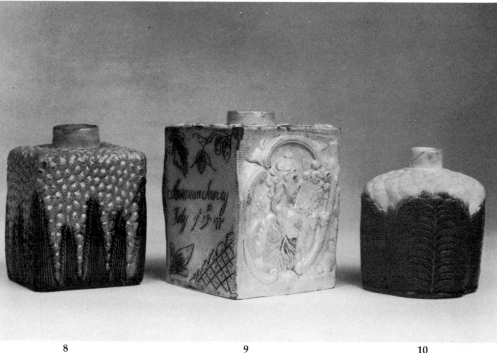

**8**                          **9**                          **10**

1

2

3

4

**1.** A Wedgwood & Bentley black basalt fox-mask stirrup-cup, impressed lower-case mark on an ear, and a metal mould similarly modelled, circa 1775
13 cm. long

**2.** A Wedgwood & Bentley black basalt figure of Hogarth's dog, Trump, after the terracotta by Roubiliac, circa 1775
28 cm. x 16 cm.

**3.** A redware globular teakettle, cover, and stand with engine-turned decoration, impressed seal marks, circa 1765
the kettle 24 cm. wide

**4.** A massive Wedgwood & Bentley compressed urn-shaped porphyry vase and cover, impressed Wedgwood & Bentley Etruria mark within a circle, circa 1775

**5.** A four-colour Jasper urn-shaped vase, moulded with a frieze of Hercules in the Garden of the Hesperides after a design by John Flaxman, impressed mark and H, circa 1785
40 cm. high

Sir William Hamilton's collection, which arrived at the British Museum in 1772, caused great interest. It included a vase or hydria, B.M. no. E 224, which was painted by the Meidias painter with the subject of "Herakles in the Garden of the Hesperides". Flaxman based his designs for a Wedgwood plaque with the same subject on the design of this vase. In the Wedgwood catalogue of 1787, no. 275, this is documented as Hercules in the Garden of the Hesperides from a beautiful Etruscan vase in the collection of Sir William Hamilton, & now in the British Museum, Aug. 1787.

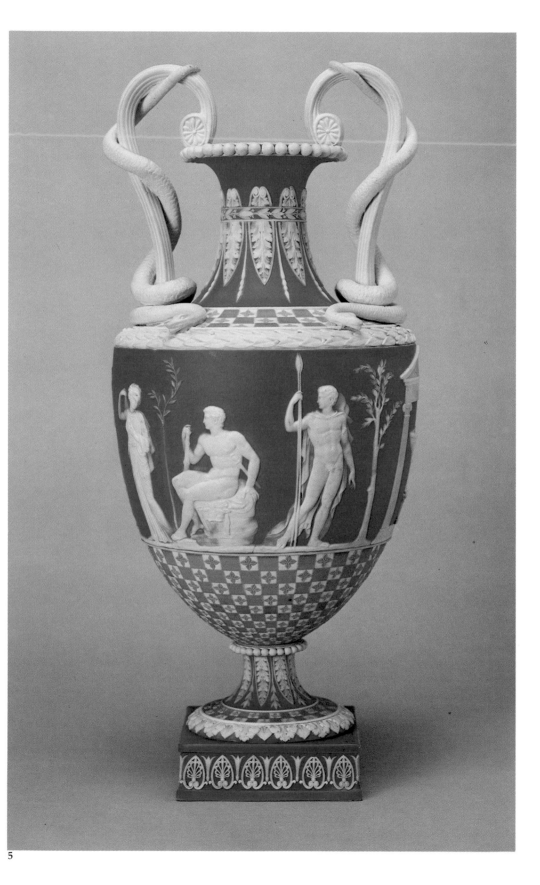

5

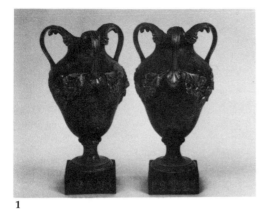

1

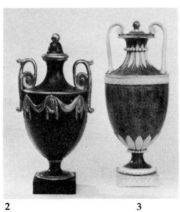

2          3

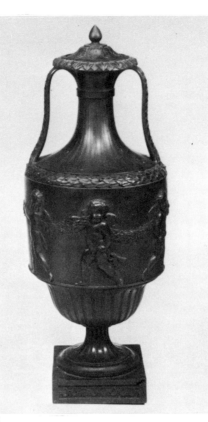

4

5

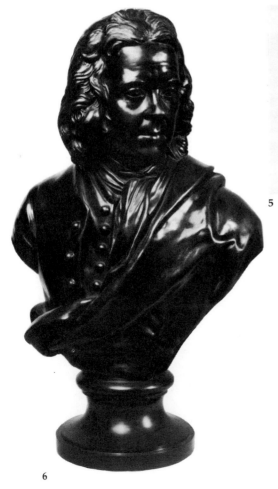

6

7

8

**1.** A pair of Wedgwood & Bentley porphyry vases, impressed Wedgwood & Bentley Etruria marks, circa 1775
21.5 cm. high

**2.** A Palmer agate creamware urn-shaped vase and cover, impressed H. Palmer, Hanley, circa 1775
24 cm. high

**3.** A Wedgwood & Bentley variegated urn-shaped two-handled vase and cover, impressed lower-case mark, circa 1775
27 cm. high

**4.** A Wedgwood & Bentley black basalt two-handled vase and cover, by Hackwood, impressed Wedgwood & Bentley mark, circa 1775
40 cm. high

**5.** A pair of Wedgwood & Bentley black basalt vases and covers, the bases with impressed circular Wedgwood & Bentley Etruria marks, circa 1775
30.5 cm. high

**6.** A Wedgwood & Bentley black basalt bust of Boerhave, impressed upper-case mark, circa 1775
43 cm. high

**7 and 8.** A pair of Wedgwood & Bentley variegated creamware fish-tail ewers, impressed Wedgwood & Bentley Etruria marks, circa 1775
31 cm. high

**9.** A Wedgwood & Bentley black basalt library bust of Homer, the socle with upper-case mark, circa 1780
34.5 cm. high

**10.** A pair of Wedgwood & Bentley black basalt two-handled vases after Hackwood, Wedgwood & Bentley Etruria marks, circa 1775
29 cm. high

**11.** A Wedgwood & Bentley black basalt two-handled vase, Wedgwood & Bentley Etruria mark, circa 1775
35.5 cm. high

**12.** A pair of Palmer black basalt two-handled vases and cover, impressed H. Palmer, Hanley mark, circa 1780
25.5 cm. high

**13.** A Wedgwood & Bentley black basalt urn-shaped two-handled vase and cover, impressed lower-case mark, circa 1775
26 cm. high

**14.** A Neale solid agate vase and cover, impressed Neale Hanley mark, circa 1775
26.5 cm. high

9

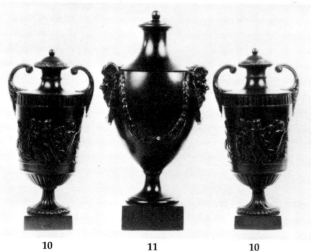

10          11          10

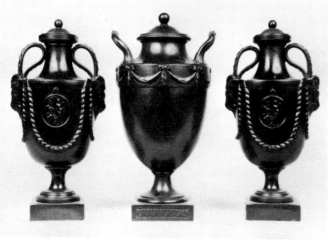

12          13          12

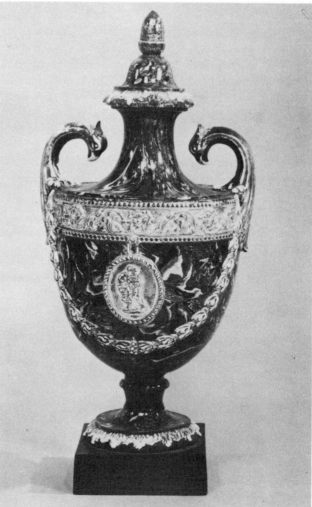

14

1

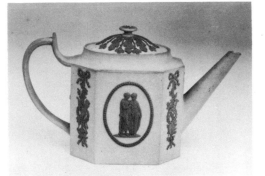

2

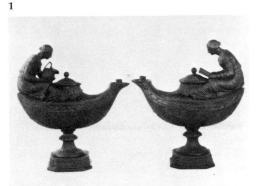

3

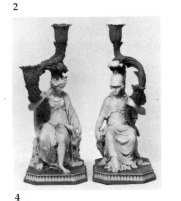

4

**1.** A Wedgwood & Bentley buff stoneware pestle and mortar, impressed Wedgwood & Bentley, lower-case mark to the mortar, circa 1780
11 cm. diam.
Wedgwood supplied his friend Joseph Priestley with mortars for his researches

**2.** A caneware octagonal teapot and cover, impressed mark, circa 1790
21 cm. wide

**3.** A pair of black basalt oil lamps, impressed marks, circa 1785
20 cm. wide

**4.** A pair of blue and white jasper candlestick figures, circa 1785
35 cm. high

**5.** A creamware cylindrical tankard transfer-printed by Sadler & Green, Danish silver mounts inscribed with the date 1781, impressed lower-case mark
16 cm. high

**6 and 6A.** A dark slate blue Portland Vase, from the first series, circa 1790
26.5 cm. high, 18 cm. diam.
Wedgwood was lent the Barberini Vase in 1786 for the purpose of copying it. By 1790 fifty examples had been made, sixteen of which are still known to exist.

**7.** One of a pair of blue and white jasper salts, impressed marks and 3, circa 1785
8.5 cm. wide

**8.** A blue and white jasper campana vase, impressed mark, circa 1785
33 cm. high

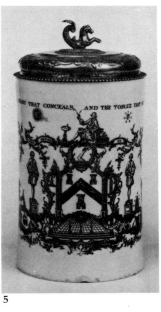

5

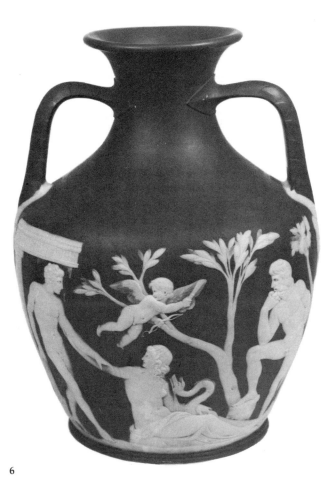

6

6A

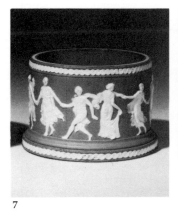

7

**9.** A pair of agateware dolphin vases, taperstick covers, and stoppers, impressed marks, circa 1780
19.5 cm. high

**10.** A pair of creamware vases and covers, circa 1790
44.5 cm. high

**11.** A blue and white jasper Michelangelo vase, impressed mark, circa 1785
28.5 cm. high

**12.** A blue and white jasper coffee-cup and saucer, impressed marks, circa 1785

**13.** A black and white jasper teacup and saucer, impressed marks, circa 1800

**14.** A blue and white jasper beaker and a trembleuse saucer, the beaker with impressed lower-case mark, the saucer with impressed mark, circa 1785

**15.** A creamware armorial dinner service, impressed upper-case mark, circa 1790
The arms are those of Isted impaling Brabant

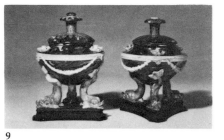

9

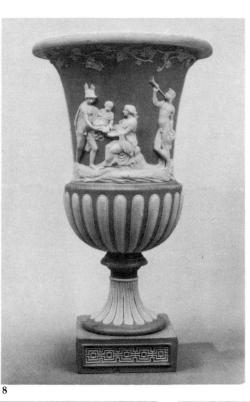

8

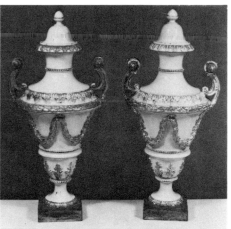

10

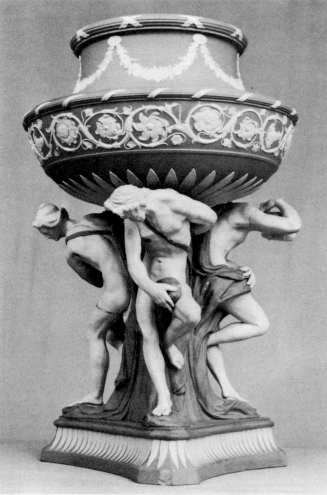

11

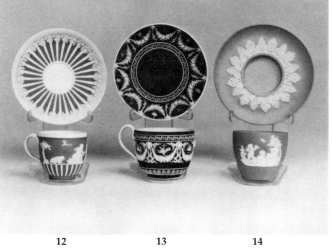

12          13          14

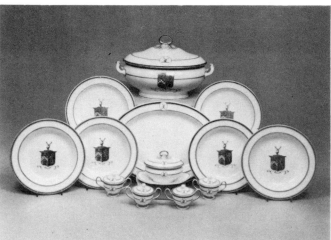

15

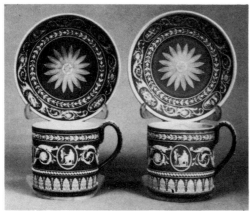

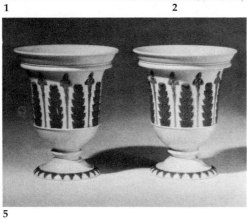

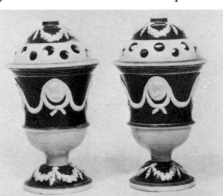

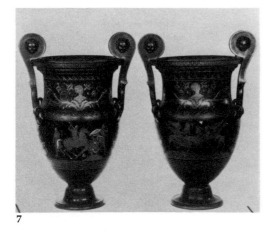

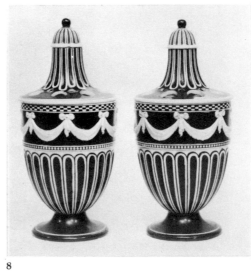

1. A pale green and white jasper coffee-can and saucer, impressed marks, circa 1800

2. A blue and white jasper coffee-can and saucer, impressed marks, circa 1800

3. An encaustic decorated black basalt canopic vase and cover, circa 1800 '
24 cm. high

4. A blue and white jasper canopic vase and cover, impressed Wedgwood mark, circa 1800
26 cm. high

5. A pair of smearglazed stoneware three-colour urn-shaped vases, impressed marks and RK, circa 1810
10.5 cm. high

6. A pair of creamware marbled pot-pourri vases and covers, circa 1800
21.5 cm. high

7. A pair of black basalt encaustic decorated kraters, impressed marks, circa 1800
65 cm. high

8. A pair of pearlware pot-pourri vases and covers, impressed marks, circa 1815
26 cm. high

10

11

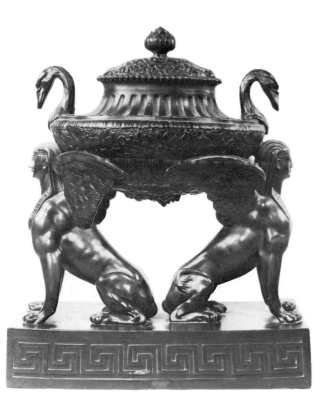

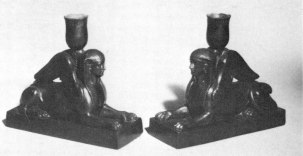

12

9

**9.** A black basalt double sphinx centre piece, impressed upper-case mark circa 1800
39 cm. high

**10.** A terracotta bust of Matthew Prior, impressed mark, circa 1810
19 cm. high

**11.** A creamware cruet, impressed marks, circa 1810
17 cm. wide

**12.** A pair of black basalt sphinx candlesticks, impressed marks, circa 1810
15 cm. wide

**13.** A rosso antico incense-burner and pierced cover, impressed mark, circa 1805
13 cm. high

**14.** A black basalt inkwell, with stylised scrolls in rosso antico, impressed mark, circa 1790
21 cm. long

**15.** A pearlware moonlight-lustre nautilus-shell tureen and stand, impressed marks, circa 1810
22.5 cm. wide

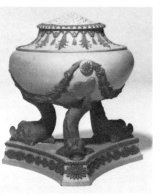

13

14

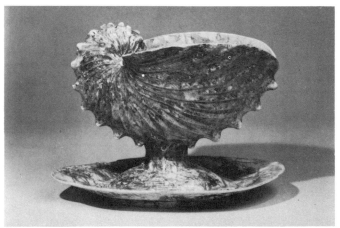

15

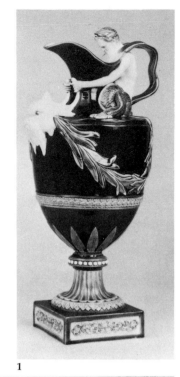

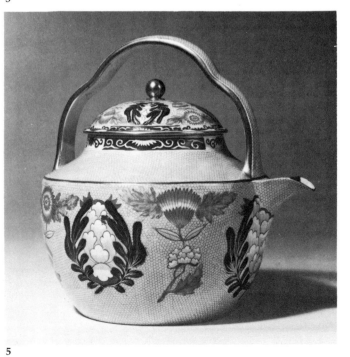

1

2

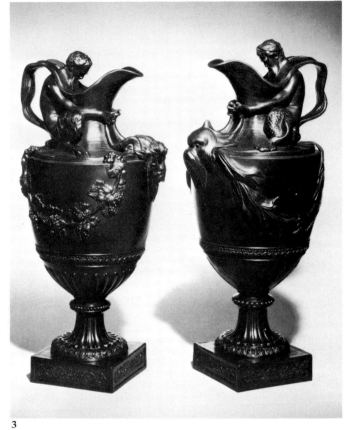

3

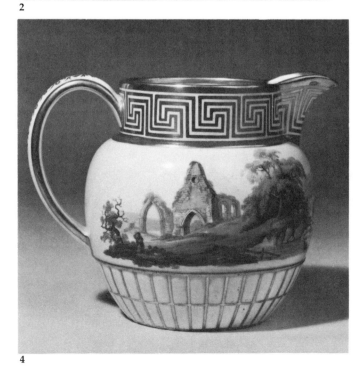

4

5

1.  A majolica water ewer after the model by John Flaxman, impressed mark, circa 1870
43 cm. high

2.  A drabware breakfast-service, impressed marks, circa 1815

3.  A pair of black basalt wine and water ewers modelled by John Flaxman, impressed marks, circa 1830
39.5 cm. high

4.  A pearlware oviform jug, impressed mark, circa 1815
16 cm. high

5.  A pearlware tea kettle and cover, impressed marks, circa 1815

6.  A black basalt globular two-handled pot-pourri vase, lid, and pierced cover, impressed mark, circa 1815
29.5 cm. high

7.  A buff caneware garniture of three jardinières, impressed marks, circa 1820
15.5 cm. to 8.5 cm. wide

8.  A pair of caneware spill-vases, impressed marks, circa 1820
15 cm. high

9.  A caneware and grey stoneware chess set modelled by John Flaxman, circa 1820
from 6.5 cm. to 10 cm. high

10.  Part of a buff caneware tea-service, impressed lower-case marks, circa 1780

11.  A stone china dinner-service, blue printed marks, circa 1830

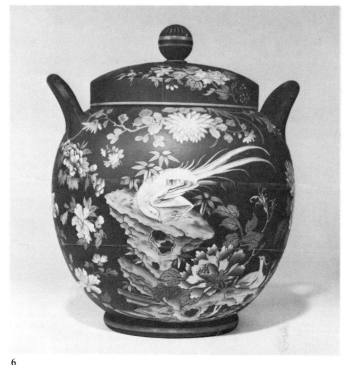

6

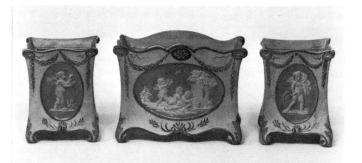

7

8

9

10

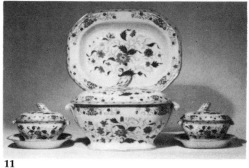

11

17

**1.** A Wedgwood & Bentley slate blue and white jasper medallion of George III, impressed lower-case mark, contemporary frame, circa 1780
5.4 cm. high

**2.** A Wedgwood & Bentley slate blue and white jasper medallion of Benjamin Franklin, impressed lower-case mark, contemporary frame, circa 1775
5.4 cm. high

**3.** A Wedgwood & Bentley pale blue and white jasper medallion of Frederick II, King of Prussia, impressed lower-case mark, circa 1775
5.4 cm. high

**4.** A Wedgwood & Bentley pale blue and white jasper medallion impressed lower-case mark, circa 1775
5.4 cm. high

**5.** A Wedgwood & Bentley grey-blue and white jasper medallion of Boileau, impressed lower-case mark, circa 1775
5.4 cm. high

**6.** A Wedgwood & Bentley grey-blue and white jasper medallion of Voltaire, impressed lower-case mark, circa 1775
5 cm. high
Modelled by William Hackwood

**7.** A pair of pale blue and white jasper medallions of George III and Queen Charlotte, impressed marks, circa 1780
8.3 cm. high

**8.** A blue and white jasper medallion of Edmund Burke, circa 1790
8 cm. high

**9.** A green and white jasper medallion of the Marquis of Stafford, impressed mark, contemporary frame, circa 1790
9 cm. high

**10.** A blue and white jasper medallion of Leopold, Emperor of Germany, impressed mark, contemporary frame, circa 1790
9 cm. high

**11.** A blue and white jasper medallion of George III, impressed mark, circa 1780
9 cm. high

**12.** A blue and white jasper medallion of Charles James Fox modelled by John Flaxman, impressed mark, circa 1790
9.5 cm. high

**13.** A blue and white jasper medallion of Lord Hood, impressed mark, circa 1790
9.5 cm. high

**14.** A pale-blue jasper medallion of Thomas Pitt, first Lord Camelford, impressed mark, circa 1785
9 cm. high

**15.** A blue and white jasper medallion of James Fothergill, impressed mark, circa 1780
9.5 cm. high

**16.** A blue and white jasper medallion of Prince Edward of Brunswick, impressed mark, circa 1790
9 cm. high

**17.** A frame of twenty-seven jasper cameos, the majority with classical figures in white relief on dipped blue jasper grounds, some with lapidary polished edges, including a circular horse study after George Stubbs and four white jasper trial pieces, circa 1785
1.5 cm. to 5.5 cm. high

**18 and 19.**  A pair of Wedgwood & Bentley and blue and white jasper rectangular plaques, impressed upper-case marks, circa 1778
each plaque 16 x 40cm. long
Modelled by John Flaxman between 1777 and 1779 and apparently taken from the Sarcophagus of the Muses in the Salle des Caryatides of the Louvre, formerly in the Albani Collection

**20**  A selection of coloured Jasper scent-bottles, circa 1790
6.5 cm to 15 cm. high

**21.**  A blue and white jasper rectangular plaque, impressed mark twice, circa 1787
23 cm. x 24.5 cm.
Modelled in January and March 1787 to commemorate the Treaty of Commerce signed at Versailles, September 27, 1786

**22.**  A green and white jasper rectangular plaque, impressed mark, circa 1787
24 cm. x 26.5 cm.

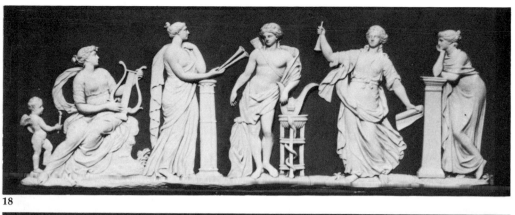

18

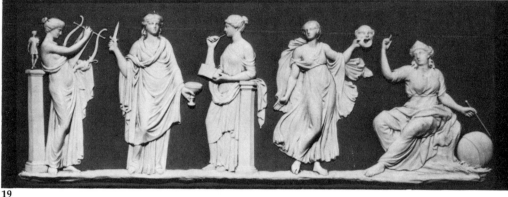

19

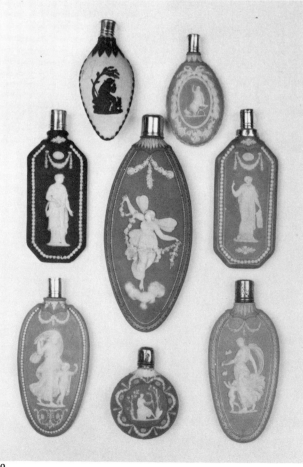

20

21

22

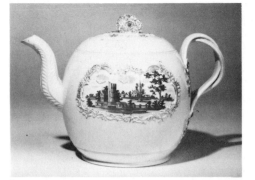

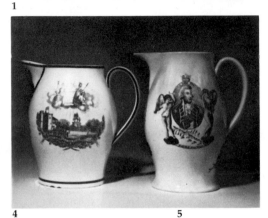

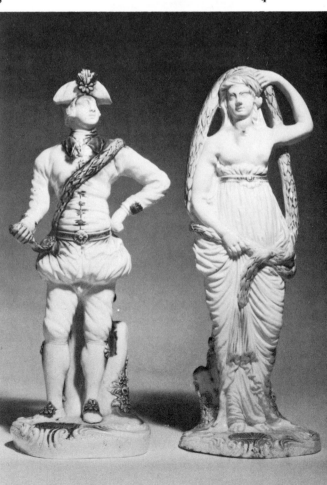

**1.** An oviform teapot and cover painted in the Robinson and Rhodes workshop, probably Yorkshire, circa 1765
24.5 cm. wide

**2.** A Leeds plaque, 1790-1800
22.5 cm. high

**3.** A documentary Glasgow (Delftfield) pearlware model of a Scottish kirk, inscribed Delftfield August 5th 1789
30.5 cm. wide

**4.** A Liverpool commemorative baluster jug, inscribed "let the prisoners go free give God praise Jubilee 25 Octr. 1809", and "Happy would England be could George but live to see Another Jubilee", with G III R 50 above, the inscription J & L Bradbury 1810
23 cm. high

**5.** A Liverpool baluster jug with the inscription "Admiral Lord Nelson and the glorious first of August, 1798"
24.5 cm. high

**6.** A Leeds cocklepot, circa 1790
54 cm. high

**7.** The Mackintosh pair of Leeds figures of Hamlet and Ophelia, circa 1775
32 cm. high

9　　　　　　　　　　　10

11　　　　　　12　　　　　13

**8.** A set of seven Dutch decorated sacramental plates, probably Liverpool, circa 1790
25 cm. diam.

**9.** Dutch decorated plate, impressed 2 mark, circa 1790
25.5 cm. diam.

**10.** Dutch decorated plate, circa 1790
25.5 cm. diam.

**11.** A Leeds (Rhodes decorated) polychrome coffee-pot and cover, circa 1775
23 cm. high

**12.** A Leeds coffee-pot and cover circa 1775
25.5 cm. high

**13.** A Leeds fluted coffee-pot and cover, circa 1775
23 cm. high

**14.** A Liverpool (Herculaneum) plaque, printed in black after the portrait by Gilbert Stewart of George Washington, circa 1800
13 cm. high

**15.** Part of a Leeds tea-service painted in the manner of David Rhodes, circa 1775

**16.** Part of a Leeds armorial dinner service, with the full achievement of Grant of Grant, circa 1790

8

14

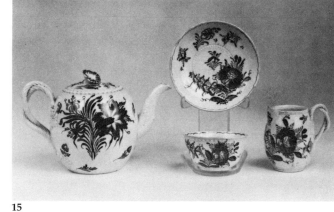

15

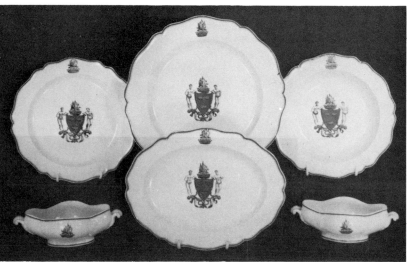

16

1

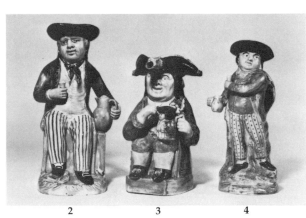

2          3          4

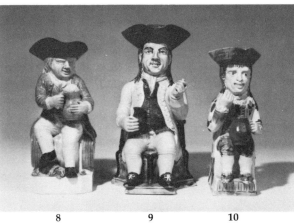

5          6          7

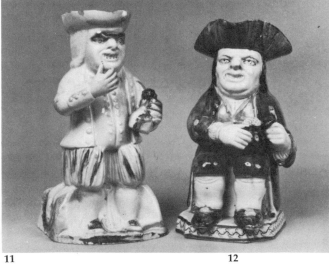

8          9          10

11                        12                        13

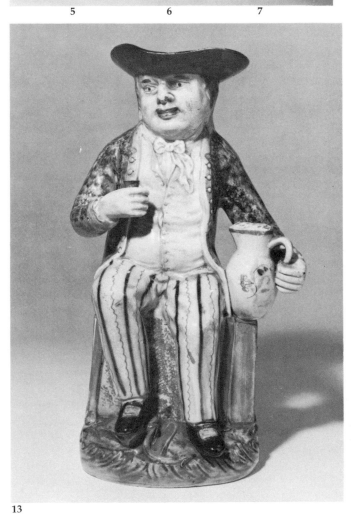

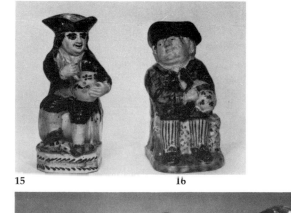

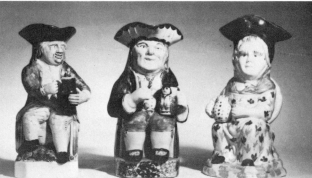

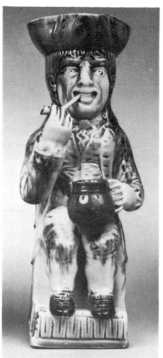

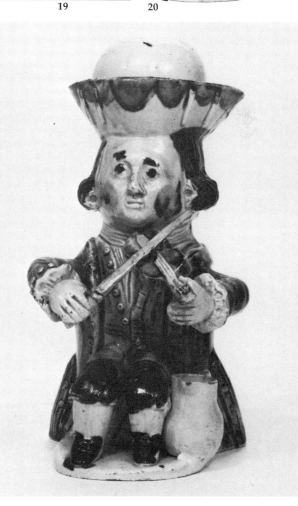

15        16

17        18        19        20

14

21

**1.** A Staffordshire Napoleonic bear-jug and cover, circa 1810
27.5 cm. high

**2.** A Ralph Wood planter toby jug circa 1780
30 cm. high

**3.** A Yorkshire puzzle toby jug, impressed crown mark, perhaps Middlesbrough, circa 1820
25.5 cm. high

**4.** A Yorkshire hearty good fellow jug, circa 1820
28 cm. high

**5.** An Enoch Wood parson toby jug circa 1800
21 cm. high

**6.** A Yorkshire toby jug, circa 1800
18.5 cm. high

**7.** A Ralph Wood toby jug, circa 1775
16.5 cm. high

**8.** A Ralph Wood sailor toby jug, circa 1775
24.5 cm. high

**9.** A Ralph Wood squire toby jug circa 1780
28 cm. high

**10.** A Ralph Wood "Thin Man" toby jug, circa 1780
24 cm. high

**11.** A Staffordshire toby jug of Admiral Howe, circa 1775
25 cm. high

**12.** A Staffordshire toby jug, circa 1800
25 cm. high

**13.** A Staffordshire Lord Howe toby jug, the base inscribed Lord Hou (sic), circa 1815
29 cm. high

**14.** A Ralph Wood "Thin Man" toby jug, circa 1775
25 cm. high

**15.** A Whieldon Admiral Lord Howe toby jug, circa 1800
25 cm. high

**16.** A Whieldon toby jug of the Welsh country gentleman, circa 1750
23 cm. high

**17.** A Ralph Wood toby jug, circa 1780
25 cm. high

**18.** A Portobello toby jug and cover, circa 1820
25 cm. high

**19.** A Yorkshire Martha Gunn toby jug, circa 1800
26.5 cm. high

**20.** A Yorkshire pottery Bacchus jug, circa 1800
30.5 cm. high

**21.** An Astbury fiddler jug and cover, cira 1740
18.5 cm. high

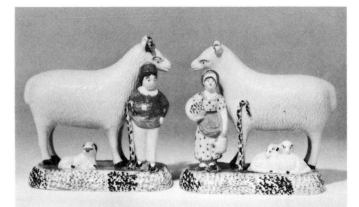

1

2

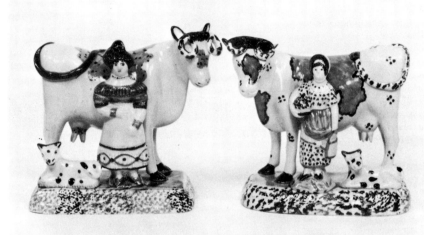

3

4

5

6

1.  A pair of Yorkshire sheep-groups, circa 1785
15 cm. wide

2.  A Newcastle (St. Anthony's) pearlware cow-group, circa 1800
12.5 cm. wide

3.  A Don pottery model of a cow, circa 1790
16 cm. wide

4.  Another Don pottery model of a cow, circa 1790
16 cm. wide

5.  A Yorkshire group of a horse trampling on a man, circa 1800
18.5 cm. wide

6.  A Yorkshire pearlware figure of a lion, circa 1800
33 cm. wide

7.  A Yorkshire figure of an officer, circa 1800
37 cm. high

8.  A pair of Yorkshire creamware standing figures of officers, circa 1780
18 cm. high

9.  A pair of Yorkshire figures of mounted officers, circa 1800
22.5 cm. high

10.  A Yorkshire pearlware figure of a stallion, circa 1790
36 cm. wide

11.  A pair of Dixon Austin & Co. figures of Summer and Winter, impressed mark, 1820-1826
23 cm. high

8

7

9

10

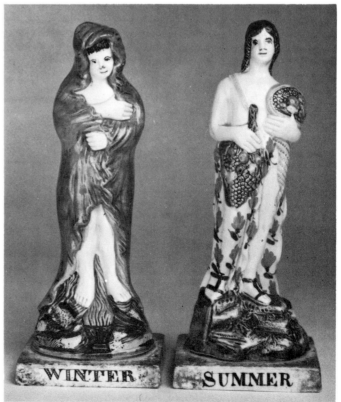

11

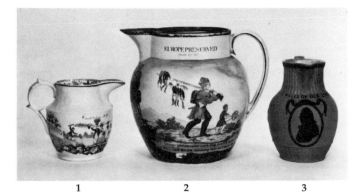

1    2    3

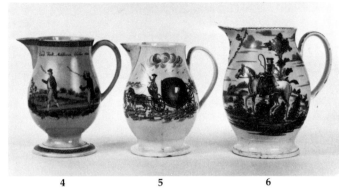

4    5    6

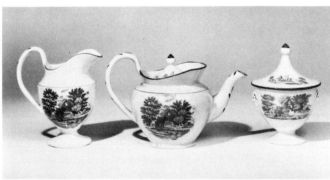

7

**1.** A Staffordshire reform jug, circa 1820
16 cm. high

**2.** A Staffordshire jug with the burning of Moscow, inscribed and dated Sept. 14th 1812
26.5 cm. high

**3.** A caneware jug with Admiral Lord Nelson, probably Adams, circa 1810
19.5 cm. high

**4.** A pearlware jug painted with the London and Liverpool Expedition through Birmingham and inscribed David Holt Middlewich, Cheshire 1800
23 cm. high

**5.** A Leeds creamware coaching jug inscribed Daniel Herbert 1780
21 cm. high

**6.** A Leeds creamware jug inscribed William Preston, 1776
25 cm. high

**7.** A Wood yellow-glazed pearlware tea-service, impressed mark Wood, circa 1810

**8.** An Enoch Wood bust of John Milton, circa 1800
29.5 cm. high

**9.** A Wood and Caldwell bust of Tsar Alexander, the reverse impressed Alexander Act.35/ Moscow Burnt/Europe preserved, 1812, impressed mark Wood, Caldwell, Burslem, &/ Staffordshire, circa 1812
30 cm. high

**10.** A Prattware bust of Charlotte Corday, circa 1800
29.5 cm. high

**11.** An Obadiah Sherratt bust of the Rev. John Wesley, circa 1820
30.5 cm. high

**12.** A copper lustre jug, circa 1815
14 cm. high

**13.** A copper lustre jug in the manner of Adam Buck, circa 1815
15 cm. high

**14.** A pair of Wilson copper-lustre ice-pails, covers, and liners, impressed marks, circa 1810
26.5 cm. high

**15.** A Staffordshire pearlware Admiral Nelson commemorative jug, circa 1805
12.5 cm. high

**16.** A set of four Prattware figures emblematic of the seasons, circa 1800
19 cm. high

**17.** Part of a Staffordshire pearlware dinner-service, circa 1815

**18.** A set of three Castleford obelisks, circa 1800
23 cm. and 27.5 cm. high

**19.** A Staffordshire silver resist lustre jardinière, circa 1800
21.5 cm. wide

**20.** A documentary creamware figure of a standing lion, by Benjamin Plant of Lane End, the base inscribed in incised script, B. Plant Lane End, circa 1815
39 cm. wide

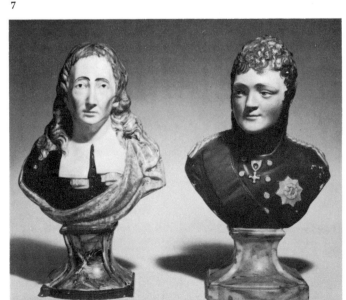

8    9

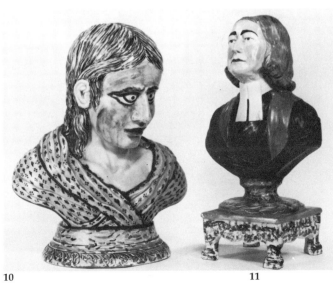

10    11

12

13

14

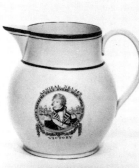

15

16

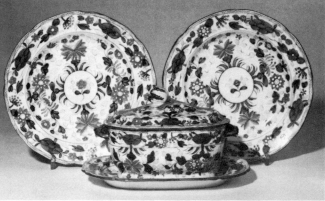

17

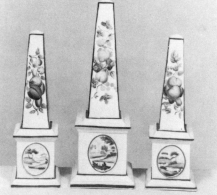

18

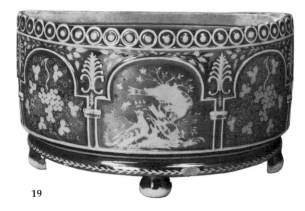

19

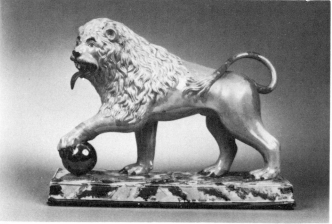

20

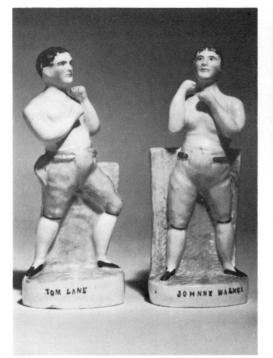

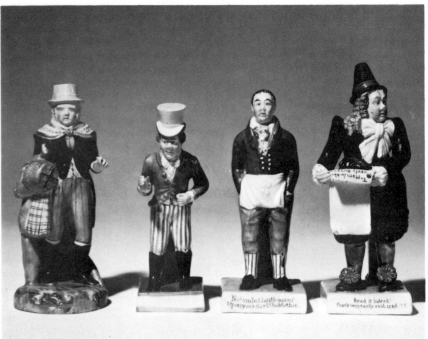

1                                    2              3              4              5

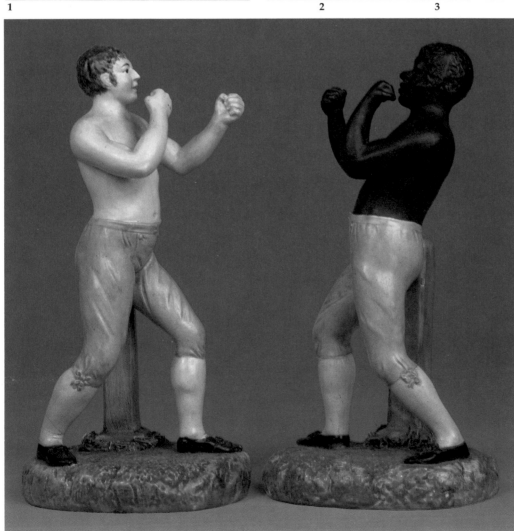

6

1. A pair of Staffordshire figures of Johnny Walker and Tom Lane, circa 1848
19 cm. high

2. A Staffordshire figure of John Liston as Lubin Log, circa 1830
17 cm. high

3. A Staffordshire figure of John Liston as Paul Pry, circa 1830
15 cm. high

4. A Staffordshire figure of John Liston as Sam Swipes, circa 1825
16 cm. high

5. An Enoch Wood figure of John Liston as Van Dunder, impressed mark, circa 1825
18.5 cm. high

6. A pair of Staffordshire figures of Tom Cribb and Tom Molineux, circa 1811
22.5 cm. high

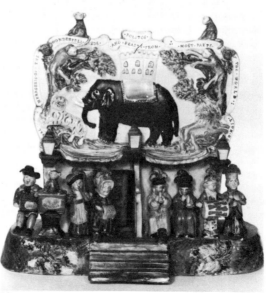

7.  A pair of Staffordshire figures of the Lion and the Unicorn, circa 1820
14.5 cm. high

8.  A Staffordshire group of the Lion and the Unicorn either side of the Royal Arms, circa 1862
15 cm. high

9.  An Obadiah Sherratt group of the Death of Monro, circa 1820
37 cm. wide

10.  An Obadiah Sherratt bull-baiting group of Now Captain Lad, circa 1820
36.5 cm. wide

11.  A Staffordshire pearlware oval plaque, the reverse indistinctly inscribed and dated 1821
18 cm. high

12.  A Prattware oval plaque moulded and painted with a figure of Charles II, 1800-1820
35.5 cm. wide

13.  A Staffordshire pearlware oval portrait plaque of Joseph Lownds, the reverse inscribed Joseph Lownds/Mould Maker Etruria/ by Charles Bailey/ December 17th/1811
18.5 cm. high

14.  An Obadiah Sherratt circus group of Polito's Menagerie, circa 1808
29.5 cm. high

# EUROPE: Location of Potteries

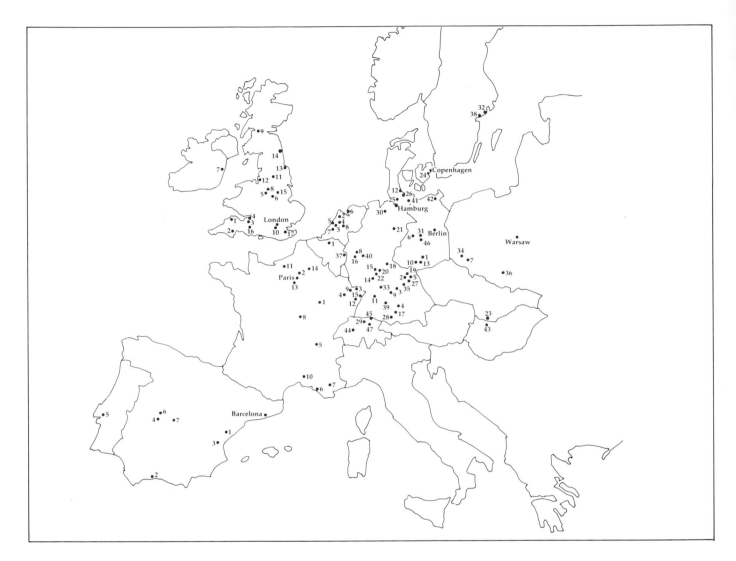

# ITALY: Location of Potteries

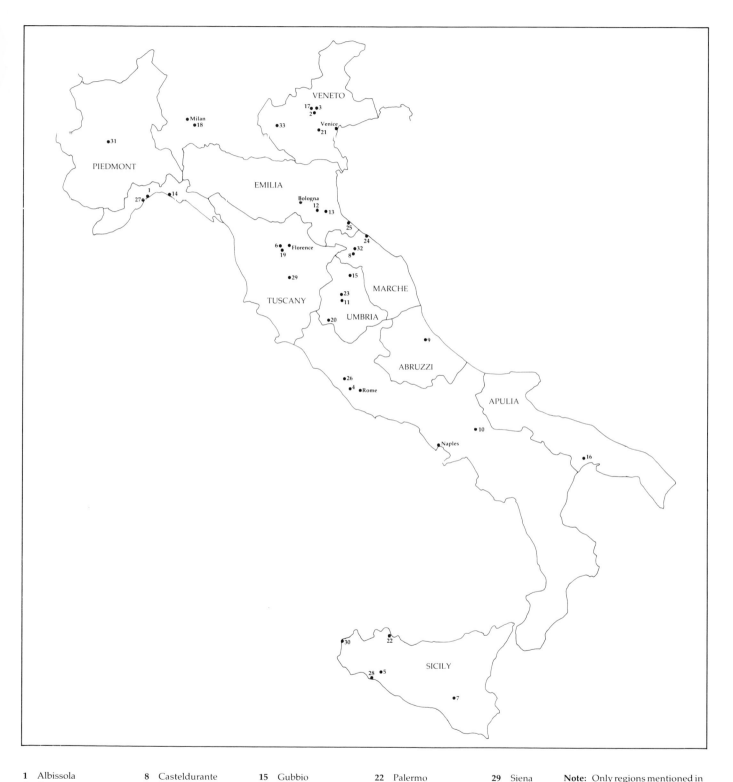

| | | | | | | | | | |
|---|---|---|---|---|---|---|---|---|---|
| **1** | Albissola | **8** | Casteldurante | **15** | Gubbio | **22** | Palermo | **29** | Siena |
| **2** | Angarano | **9** | Castelli | **16** | Laterza | **23** | Perugia | **30** | Trapani |
| **3** | Bassano di Sutri | **10** | Cerreto Sannita | **17** | Le Nove | **24** | Pesaro | **31** | Turin |
| **4** | Bassano Romano | **11** | Deruta | **18** | Lodi | **25** | Rimini | **32** | Urbino |
| **5** | Burgio | **12** | Faenza | **19** | Montelupo | **26** | S. Quirico d'Orcia | **33** | Verona |
| **6** | Caffaggiolo | **13** | Forli | **20** | Orvieto | **27** | Savona | | |
| **7** | Caltagirone | **14** | Genoa | **21** | Padua | **28** | Sciacca | | |

**Note:** Only regions mentioned in the text have been indicated on the map

# GLOSSARY

**a candelieri**: decoration with grotteschi symmetrically placed, used at Casteldurante, Gubbio, Deruta, and Urbino and described by Picolpasso
**à la palette**: particularly brilliant petit feu decoration used at Marseilles
**a quartieri**: Italian maiolica patterns using a design divided into four or more compartments radiating from the centre
**a zaffera**: thick cobalt oxide decoration used on early Florentine maiolica
**ajouré**: pierced
**albarello**: a tall, slightly waisted storage jar for dry drugs
**alzata**: a dish on a raised foot; a tazza
**Bartmannkrug**: a jug with a bearded mask below the spout
**Bellarmine**: a globular or pear-shaped stoneware bottle with a moulded, bearded mask and often a coat of arms
**berrettino**: a pale blue tin-glaze ground colour used on Italian maiolica from about 1520, when it was first recorded at Faenza
**bianco sopra bianco**: decoration on tin-glazed earthenware in opaque white on a slightly bluish or greyish ground, found on Italian maiolica from the early sixteenth century and on eighteenth-century English delft, as well as in Scandinavia and France
**bleu persan**: a brilliant dark blue ground colour developed at Nevers, inspired by Persian sources and used on faience in the second half of the seventeenth century, with opaque white, yellow, and orange applied over it. The style was copied on Dutch and English (Lambeth) delftware
**bough pot**: a pot or vase in which cut sprays of flowering shrubs or trees are inserted through holes in the cover
**bragget pot**: a slipware cylindrical vessel with loop handles and sometimes a cover, used in late seventeenth-century England for bragget (a drink of ale, honey, and spices associated with Bragget Sunday in the middle of Lent)
**campana vase**: a vase with loop handles and a flared rim, inspired by the ancient Greek krater
**candiana**: maiolica in the Isnik style made in or near Padua, so called from a mistaken impression that it came from Crete
**caudle cup**: a small covered cup with a saucer and one or two handles for caudle (a warm gruel usually made for invalids)
**compendiario**: a decorative style used on late sixteenth– and early seventeenth-century Italian maiolica, in which a palette often limited to greyish-blue and shades of yellow and orange is used, leaving large areas of the white ground exposed
**coperta**: a flashing of transparent glaze applied to Italian maiolica at a second firing to enhance the depth of the colours and the surface sheen
**crespina**: a fluted dish on a foot
**documentary**: describing examples which throw light on the history of ceramics, such as pieces signed by a modeller or decorator, bearing an unusual mark or an informative inscription
**écuelle**: a covered soup-cup with a stand
**Enghalskrug**: a narrow-necked jug with a handle linking lip and body, often with a pewter lid
**famiglia gotica**: decorative treatment including stylized Gothic foliage, used at Faenza and elsewhere in the late fifteenth century
**famille rose**: decoration of Chinese inspiration, in which an opaque enamel colour varying from pink to a purplish rose is prominent
**famille verte**: decoration of Chinese inspiration, so called because of its most obvious feature, a brilliant, transparent, green enamel
**fuddling cup**: three to six small cups joined and connected internally so that a person drinking from any one could drain them all; made in the seventeenth and eighteenth centuries in Holland, England, and Germany
**gallyware**: a seventeenth-century expression used to distinguish tin-glazed from other earthenware

**grand feu**: the kiln used for firing the body and glaze of porcelain or tin-enamel ware decorated with high-temperature colours (about 1100 to 1450 degrees Centigrade)
**Humpen**: a German tankard or mug
**ingobbio**: the thick tin glaze used in Tuscany in the fifteenth century
**istoriato**: decorated with scenes in a polychrome, pictorial style evolved on Italian maiolica in Casteldurante and Urbino in the sixteenth century. At first confined to the well of plates and dishes, the decoration later spread over the whole surface. The mythological, biblical, or genre subjects were often derived from engravings of the work of major artists of the day
**oak-leaf**: a stylized motif of acorns, oak leaves, and intertwined branches, found on fifteenth-century Tuscan maiolica
**pancake plate**: a Dutch Delft plate without a border, thus resembling a pancake
**petit feu**: the muffle kiln used to fix enamel colours to the glaze of porcelain and certain sorts of pottery, at a temperature from 700 to 900 degrees Centigrade. Objects so fired were enclosed in a protective container or muffle to guard them from the flames and smoke
**posset pot**: a vessel with up to eleven handles and sometimes a cover, used for making and drinking posset (hot milk curdled by wine or ale and often spiced)
**puzzle jug**: a jug with a globular body and a cylindrical neck, which is pierced to make ordinary pouring impossible. The rim has from three to seven spouts in the neck, one of them linked to the base of the jug by a concealed tube or siphon. The other spouts have to be covered before the contents can be poured out
**Schnelle**: a slender, tapering, stoneware tankard, usually with three panels of biblical or mythological subjects in relief, made in the sixteenth century at Siegburg in the Rhineland. It has a hinged pewter or silver lid
**Schwarzlot**: black monochrome decoration found on faience, porcelain, and glass, principally used by German Hausmaler during the last quarter of the seventeenth century and the first half of the eighteenth. Iron-red is sometimes used as well
**scodella**: a small two-handled porringer
**sgraffito**: decoration made by scratching or incising a design through slip or glaze to reveal the body beneath
**sponged**: describing the mottled effect of applying a colour or a glaze by dabbing it on to the body
**sprigged**: describing the process of attaching ornaments to the body of an object with thin slip, evolved in German stoneware and developed in Staffordshire
**stile gotico**: see **famiglia gotica**
**tazza**: a centre dish with a large, shallow bowl, with or without handles, resting on a stem base or a low foot
**tondino**: a plain circular dish or plaque
**vaso a palla**: a spherical jar

# FURTHER READING

## SPAIN AND PORTUGAL

**De Lasarte, Juan Ainaud.** *Ars Hispaniae: Historia Universal del Arte Hispanico.* Madrid, 1952.
**Frothingham, Alice Wilson.** *Lustreware of Spain.* New York, 1951.
**Marti, Manuel Gonzalez.** *Ceramica del Levante Espanol.* Barcelona, 1944.
**Van De Put, Albert.** *Hispano-Moresque Ware of the Fifteenth Century.* London, 1904.

## ITALY

**Bellini, Mario and Conti, Giovanni.** *Maioliche Italiane del Rinascimento.* Milan, 1964.
**Donatone, Guido.** *La Maiolica di Laterza.* Bari, 1980.
**Ferrari, Oreste and Scavizzi, Guiseppe.** *Maioliche Italiane del Seicento e Settecento.* Milan, 1965.
**Giacomotti, Jeanne.** *Catalogue des Majoliques des Musées Nationaux.* Paris, 1974.
*Maioliche di Lodi, Milano e Pavia.* Poldi-Tezzoli Museum, Milan, 1964.
**Rackham, Bernard.** *Catalogue of Italian Maiolica.* Two volumes. Victoria and Albert Museum, London, 1940.
**Rackham, Bernard.** *Islamic Pottery and Italian Maiolica.* London, 1959.
**Rackham, Bernard.** *Italian Maiolica.* London, 1952.

## FRANCE

**Chomtret, J. and others.** *Répertoire de la Faïence Française.* Six volumes. Paris, 1932.
*Faïences Françaises.* Galeries Nationales du Grand Palais, Paris, 1980.
**Giacomotti, Jeanne.** *French Faience.* Fribourg, 1963.
*L'Oeuvre des Hannong: Faïence de Strasbourg et Haguenau.* Musée des Arts Décoratifs, Palais Rohan, Strasbourg, 1975.

## NORTHERN EUROPE and THE NETHERLANDS

**Bauer, Margrit.** *Europaïsche Fayencen.* Frankfurt am Main, 1977.
**De Jonge, C.H.** *Delft Ceramics.* Tübingen, 1969.
**Kiss, Ákos.** *Baroque Pottery in Hungary.* Budapest, 1966.
**Klinge, Ekkart.** *Deutsches Steinzeug der Renaissance und Barockzeit.* Hetjens-Museum, Düsseldorf, 1979.
**Reisebeiter, O.** *Die Deutschen Fayencen des 17. und 18. Jahrhunderts.* Leipzig, 1921.
**Stöhr, August.** *Deutsche Fayencen und Deutsches Steingut.* Berlin, 1920.
**Uldall, Kai.** *Gammel Dansk Fajence.* Copenhagen, 1967.

## ENGLAND

**Britton, Frank.** *English Delftware in the Bristol Collection.* London, 1982.
**Garner, F.H. and Archer, Michael.** *English Delftware.* Second edition. London, 1972.
**Grant, M.H.** *The Makers of Black Basaltes.* London, 1910.
**Mankowitz, Wolf.** Wedgwood. London, 1953. Third edition, 1980.
**Ray, Anthony.** *English Delftware Pottery in the Robert Hall Warren Collection, Ashmolean Museum, Oxford.* London, 1968.
**Towner, Donald.** *Creamware.* London, 1978.
**Towner, Donald.** *English Cream-coloured Earthenware.* London, 1957.

# PRICE LIST

In some cases it has not been possible to give prices for the objects illustrated. The prices shown below refer to the final bids at the time of sale, exclusive of any premium or local taxes. Many apparent variations in prices can be accounted for by differences in the condition of individual items. While every care has been taken in compiling this list, accuracy cannot be guaranteed.

The place of sale is indicated as follows:
A: Amsterdam (prices in guilders)
E: a house sale in England (pounds, unless guineas are specified by g. A guinea was £1.05.)
G: Geneva (Swiss francs)
L: London (pounds, unless guineas are specified by g.)
M: Madrid (thousands of pesetas)
NY: New York (dollars)
R: Rome (thousands of lire)

Prices from sales other than those in New York are also given in the dollar equivalent at the time of sale. When the price indicated is that of two or more objects in the same lot, the number of pieces is indicated as follows:
(pr): pair
(6): the number of pieces

| Page | | Place | Date | Price (local) | Price ($ US) |
|---|---|---|---|---|---|
| Frontisp. | | L | 10.10.83 | 18,000 | 26,951 |

**INTRODUCTION**

| Page | | Place | Date | Price (local) | Price ($ US) |
|---|---|---|---|---|---|
| 6 | 1 | L | 28.3.83 | 4,800 | 7,157 |
| | 2 | L | 13.6.83 | 38,000 | 58,894 |
| 7 | 3 | — | —— | —— | —— |
| 8 | 1 | L | 19.5.75 | g.4,500 | 10,970 |
| 9 | 2 | L | 28.3.83 | 2,400 | 3,578 |

**SPAIN AND PORTUGAL**

| Page | | Place | Date | Price (local) | Price ($ US) |
|---|---|---|---|---|---|
| 10 | 1 | NY | 21.4.79 | —— | 60,000 |
| 12 | 1 | L | 5.4.66 | g.480 | 1,406 |
| | 2 | L | 5.4.66 | g.420 | 1,230 |
| | 3 | L | 5.4.66 | g.480 | 1,406 |
| | 4 | L | 19.5.75 | 2,370 | 5,503 |
| | 5 | L | 16.6.69 | g.280 | 703 |
| | 6 | L | 5.4.66 | g.980 | 2,874 |
| | 7 | R | 16.2.78 | 450 | 523 |
| | 8 | L | 14.11.77 | 1,400 | 2,547 |
| | 9 | R | 16.2.78 | 480 | 523 |
| | 10 | L | 29.6.81 | 900 | 1,778 |
| | 11 | L | 14.4.80 | 160 | 355 |
| 13 | 12 | L | 27.5.68 | g.100 | 251 |
| | 13 | L | 27.5.68 | g.320 | 803 |
| | 14 | L | 27.5.68 | g.90 | 226 |
| | 15 | L | 14.4.80 | 180 | 399 |
| | 16 | L | 14.4.80 | 260 | 576 |
| | 17 | L | 14.4.80 | 1,200 | 2,660 |
| | 18 | L | 14.4.80 | 2,200 | 4,876 |
| | 19 | — | —— | —— | —— |
| | 20 | L | 29.11.82 | 450 | 735 |

| Page | | Place | Date | Price (local) | Price ($ US) |
|---|---|---|---|---|---|
| 13 | 21 | L | 29.11.82 | 450 | 735 |
| 14 | 1 | L | 21.6.76 | 4,000 | 7,062 |
| | 2 | L | 21.6.76 | 2,200 | 3,884 |
| 15 | 3 | L | 21.6.76 | 2,200 (pr) | 3,884 |
| 16 | 1 | L | 4.12.72 | g.620 | 1,628 |
| | 2 | L | 4.12.72 | g.440 | 1,153 |
| | 3 | G | 22.4.70 | 500 | 116 |
| | 4 | L | 14.4.80 | 200 | 443 |
| | 5 | L | 14.4.80 | 230 | 510 |
| | 6 | L | 5.4.66 | g.800 | 2,344 |
| | 7 | L | 14.4.80 | 220 | 488 |
| | 8 | L | 14.4.80 | 200 | 443 |
| | 9 | G | 22.4.70 | 950 | 220 |
| | 10 | L | 14.4.80 | 310 | 687 |
| | 11 | L | 14.4.80 | 250 | 554 |
| | 12 | L | 14.4.80 | 160 | 355 |
| 17 | 13 | M | 16.5.74 | 380 | 6,618 |
| | 14 | L | 5.4.66 | g.240 | 703 |
| | 15 | L | 5.4.66 | g.200 | 586 |
| | 16 | L | 5.4.66 | g.800 | 2,344 |
| | 17 | L | 5.4.66 | g.340 | 996 |
| | 18 | L | 5.4.66 | g.240 | 703 |
| | 19 | L | 5.4.66 | g.300 | 879 |
| | 20 | L | 13.5.63 | g.580 | 1,705 |
| | 21 | L | 24.11.69 | g.230 | 577 |
| | 22 | L | 13.5.63 | g.70 | 206 |
| | 23 | L | 13.5.63 | g.180 | 529 |
| 18 | 1 | L | 21.6.76 | 12,000 | 21,185 |
| | 2 | L | 21.6.76 | 2,800 | 4,943 |
| 19 | 3 | L | 23.2.81 | 8,000 | 18,394 |
| 20 | 1 | L | 4.10.76 | 170 | 279 |
| | 2 | L | 4.10.76 | 250 | 410 |
| | 3 | L | 4.10.76 | 180 | 295 |
| | 4 | L | 27.10.76 | g.350 | 602 |
| | 5 | L | 27.10.76 | g.700 | 1,205 |
| | 6 | L | 27.10.76 | g.250 | 430 |
| | 7 | L | 3.10.83 | 1,600 | 2,396 |
| | 8 | L | 20.11.70 | 7,000 | 1,623 |
| | 9 | L | 12.4.76 | 1,000 | 1,848 |
| 21 | 10 | L | 14.11.77 | 200 | 364 |
| | 11 | L | 14.11.77 | 200 | 364 |
| | 12 | L | 4.10.82 | 1,300 | 2,207 |
| | 13 | L | 15.10.80 | 450 | 1,087 |
| | 14 | L | 12.4.76 | 1,200 | 2,218 |

**ITALY PRE-1600**

| Page | | Place | Date | Price (local) | Price ($ US) |
|---|---|---|---|---|---|
| 22 | 1 | L | 14.4.80 | 65,000 | 144,066 |
| 24 | 1 | L | 14.4.80 | 550 | 1,219 |
| 26 | 1 | L | 14.4.80 | 2,800 | 6,206 |
| | 2 | L | 21.6.76 | 4,000 | 7,062 |
| | 3 | L | 21.6.76 | 8,000 | 14,123 |
| 27 | 4 | L | 21.6.76 | 5,000 | 8,827 |
| | 5 | L | 21.6.76 | 4,000 | 7,062 |
| | 6 | L | 21.6.76 | 1,200 | 7,119 |
| | 7 | L | 14.4.80 | 46,000 | 101,954 |
| 28 | 1 | L | 16.6.69 | g.1,000 | 2,510 |
| | 2 | L | 16.6.69 | g.480 | 1,205 |
| | 3 | L | 19.5.75 | g.1,000 | 2,438 |
| | 4 | L | 14.4.80 | 500 | 1,108 |
| 29 | 5 | L | 21.6.76 | 8,500 | 15,006 |
| | 6 | L | 19.5.75 | g.1,500 | 3,657 |
| | 7 | G | 20.11.70 | 8,000 | 1,855 |
| | 8 | L | 24.10.67 | g.3,800 | 10,972 |
| 30 | 1 | L | 28.3.83 | 42,000 | 62,622 |
| 31 | 2 | L | 21.6.76 | 9,500 | 16,772 |
| | 3 | L | 19.5.75 | g.4,000 | 9,751 |
| 32 | 1 | L | 21.6.76 | 2,000 | 3,581 |
| 33 | 2 | R | 10.5.79 | —— | —— |
| | 3 | R | 10.5.79 | 1,200 | 1,410 |
| | 4 | R | 10.5.79 | —— | —— |

| Page | | Place | Date | Price (local) | Price ($ US) |
|---|---|---|---|---|---|
| 33 | 5 | R | 10.5.79 | 1,100 | 1,293 |
| | 6 | R | 10.5.79 | 200 | 235 |
| | 7 | R | 10.5.79 | 1,100 | 1,293 |
| | 8 | L | 2.7.79 | 380 | 859 |
| | 9 | L | 2.7.79 | 300 | 678 |
| | 10 | R | 29.9.77 | 700 | 792 |
| | 11 | R | 29.9.77 | 550 | 623 |
| | 12 | R | —— | —— | —— |
| | 13 | R | —— | —— | —— |
| | 14 | R | 10.5.79 | 1,600 | 1,880 |
| | 15 | R | 10.5.79 | 2,400 | 2,820 |
| | 16 | L | 2.7.79 | 1,000 | 2,260 |
| | 17 | L | 2.7.79 | 1,300 | 2,938 |
| 34 | 1 | L | 18.5.70 | g.400 | 1,006 |
| | 2 | L | 14.7.80 | 6,200 | 14,708 |
| | 3 | L | 18.5.70 | g.450 | 1,132 |
| | 4 | L | 6.3.78 | 1,300 | 2,482 |
| | 5 | L | 21.6.76 | 7,300 | 12,888 |
| | 6 | L | 4.4.77 | 8,000 | 13,753 |
| 35 | 7 | L | 26.6.78 | 14,000 | 25,760 |
| 36 | 1 | L | 4.4.77 | 5,200 | 8,939 |
| | 2 | L | 23.2.81 | 480 | 1,104 |
| | 3 | L | 4.10.76 | 1,700 | 2,787 |
| | 4 | L | 24.2.75 | g.1,300 | 3,268 |
| | 5 | L | 21.6.76 | 12,000 | 21,185 |
| | 6 | L | 4.12.62 | g.420 | 1,238 |
| | 7 | L | 23.5.66 | g.300 | 879 |
| 37 | 8 | L | 5.4.82 | 4,900 | 8,679 |
| | 9 | L | 2.7.79 | 2,400 | 5,424 |
| | 10 | L | 2.7.79 | 1,500 | 3,390 |
| | 11 | L | 23.11.81 | 820 | 1,560 |
| | 12 | L | 23.11.81 | 520 | 990 |
| | 13 | L | 28.6.82 | 800 | 1,406 |
| | 14 | L | 2.7.79 | 2,000 | 4,520 |
| | 15 | L | 4.4.79 | 4,500 | 7,736 |
| 38 | 1 | L | 14.4.80 | 9,500 | 21,055 |
| | 2 | L | 14.4.80 | 12,000 | 26,597 |
| | 3 | L | 19.5.75 | g.4,500 | 10,970 |
| 39 | 4 | L | 17.2.69 | g.380 | 957 |
| | 5 | L | 4.10.76 | 5,000 | 8,197 |
| | 6 | L | —— | —— | —— |
| | 7 | L | 4.4.77 | 4,800 | 8,252 |
| | 8 | L | 2.7.79 | 5,000 | 11,301 |
| 40 | 1 | R | 29.9.77 | 2,800 | 3,170 |
| | 2 | L | 17.2.69 | g.480 | 1,209 |
| | 3 | L | 17.2.69 | g.400 | 1,008 |
| | 4 | L | 17.2.69 | g.380 | 957 |
| | 5 | L | 6.3.78 | 6,500 | 12,408 |
| | 6 | L | 2.7.79 | 2,500 | 5,650 |
| | 7 | L | 2.7.79 | 1,700 | 3,842 |
| | 8 | L | 2.7.79 | 2,000 | 4,520 |
| 41 | 9 | L | 17.2.69 | 1,000 | 2,510 |
| | 10 | L | 18.5.70 | g.1,600 | 4,025 |
| | 11 | L | 29.11.82 | 1,000 | 1,633 |
| | 12 | E | 18.4.77 | 1,300 | 2,235 |
| | 13 | R | 12.6.73 | 6,000 | 10,325 |
| | 14 | L | 2.7.79 | 1,200 | 2,712 |
| | 15 | L | 2.7.79 | 2,500 | 5,650 |
| | 16 | L | 14.4.80 | 800 | 1,773 |
| | 17 | L | 19.5.75 | g.180 | 439 |
| | 18 | L | 19.5.75 | g.320 | 780 |
| | 19 | L | 19.5.75 | g.580 | 1,414 |
| | 20 | L | 19.5.75 | g.300 | 731 |
| | 21 | L | 19.5.75 | g.650 | 1,585 |
| | 22 | L | 19.5.75 | g.550 | 1,341 |
| 42 | 1 | L | 5.2.79 | 650 | 1,303 |
| | 2 | L | 21.6.76 | 2,000 | 3,531 |
| | 3 | L | 21.6.76 | 1,800 | 3,178 |
| | 4 | L | 2.7.79 | 30,000 | 67,804 |
| 43 | 5 | L | 2.7.79 | 1,500 | 3,390 |

| Page | | Place | Date | Price (local) | Price ($ US) |
|---|---|---|---|---|---|
| 43 | 6 | L | 2.7.79 | 5,000 | 11,301 |
| 44 | 1 | L | 21.6.75 | 12,000 | 21,185 |
| | 2 | L | 2.7.79 | 23,000 | 51,983 |
| 45 | 3 | L | 12.4.76 | 3,200 | 5,914 |
| | 4 | L | 29.6.81 | 2,200 | 4,347 |
| | 5 | L | 29.11.82 | 500 | 817 |
| | 6 | L | 5.4.66 | g.360 | 1,055 |
| | 7 | L | 17.2.69 | g.720 | 1,814 |
| | 8 | L | 17.2.69 | g.320 | 803 |
| | 9 | L | 24.11.80 | 2,250 | 5,393 |
| | 10 | L | 29.5.62 | g.700 | 2,064 |
| 46 | 1 | L | 2.7.79 | 6,500 | 14,691 |
| | 2 | L | 21.6.76 | 2,500 | 4,414 |
| | 3 | L | 21.6.76 | 2,200 | 3,884 |
| 47 | 4 | L | 21.6.76 | 2,500 | 4,414 |
| | 5 | L | 19.5.75 | g.1,000 | 2,438 |
| | 6 | L | 14.4.80 | 9,000 | 19,948 |
| 48 | 1 | L | 14.4.80 | 7,500 | 16,623 |
| | 2 | L | 6.3.78 | 1,700 | 3,245 |
| | 3 | L | 29.11.82 | 2,000 | 3,266 |
| | 4 | L | 6.3.78 | 1,900 | 3,627 |
| | 5 | L | 25.11.78 | g.450 | 926 |
| 49 | 6 | L | 4.10.82 | 1,100 | 1,868 |
| | 7 | L | 14.7.80 | 1,600 | 3,796 |
| | 8 | L | —— | —— | —— |
| | 9 | L | 5.4.66 | g.170 | 498 |
| | 10 | L | 6.3.78 | 1,200 | 2,291 |
| | 11 | L | 6.3.78 | 500 | 945 |
| 50 | 1 | L | 14.4.80 | 9,000 | 19,948 |
| | 2 | L | 27.10.75 | 1,500 | 3,083 |
| 51 | 3 | L | 5.4.82 | 14,000 | 24,797 |
| | 4 | L | 2.7.79 | 12,000 | 27,121 |
| 52 | 1 | L | 22.6.65 | g.40 | 117 |
| | 2 | L | 22.6.65 | g.400 | 1,174 |
| | 3 | L | 22.6.65 | g.52 | 152 |
| | 4 | L | 6.3.78 | 3,200 | 6,109 |
| | 5 | L | 20.11.67 | g.280 | 808 |
| | 6 | L | 6.3.78 | 1,200 | 2,291 |
| | 7 | L | 27.7.79 | 10,000 | 22,601 |
| 53 | 8 | R | 14.11.73 | 1,100 | 1,865 |
| | 9 | L | 18.5.70 | g.1,000 | 2,515 |
| | 10 | L | 27.10.75 | g.500 | 1,079 |
| | 11 | L | 18.5.70 | g.600 | 1,509 |
| | 12 | L | 6.3.78 | 1,900 | 3,627 |
| | 13 | L | 27.5.68 | g.900 | 2,262 |
| 54 | 1 | L | 29.11.82 | 600 | 980 |
| | 2 | L | 29.11.82 | 1,000 | 1,633 |
| | 3 | L | 23.2.81 | 8,500 | 19,544 |
| 55 | 4 | L | 22.6.65 | g.360 | 1,057 |
| | 5 | L | 22.6.65 | g.340 | 998 |
| | 6 | L | 2.7.79 | 1,200 | 2,291 |
| 56 | 1 | L | 28.6.82 | 2,000 | 3,515 |
| | 2 | L | 5.2.79 | 2,200 | 4,408 |
| | 3 | L | 20.11.67 | g.800 | 2,310 |
| 57 | 4 | L | 23.2.81 | 1,400 | 3,219 |
| | 5 | L | 29.11.82 | 700 | 1,143 |
| | 6 | L | 6.3.78 | 1,500 | 2,863 |
| | 7 | L | 6.3.78 | 350 | 668 |
| | 8 | L | 4.4.77 | 3,000 | 5,157 |
| | 9 | L | 23.11.81 | 2,000 | 3,806 |
| | 10 | G | 14.11.73 | 1,500 | 2,543 |
| 58 | 1 | L | 2.7.79 | 14,000 | 31,642 |
| | 2 | L | 21.6.76 | 4,800 | 8,474 |
| | 3 | L | 12.4.76 | 9,500 | 17,557 |
| 59 | 4 | L | 2.7.79 | 32,000 | 72,324 |
| | 5 | L | 5.10.76 | 8,100 | 13,279 |
| | 6 | L | 21.6.76 | 7,500 | 13,241 |
| 60 | 1 | G | 22.4.70 | 26,000 | 6,030 |
| | 2 | L | 4.4.77 | 4,100 | 7,048 |
| | 3 | L | 4.4.77 | 2,800 | 4,813 |

| Page | | Place | Date | Price (local) | Price ($ US) |
|---|---|---|---|---|---|
| 60 | 4 | L | 14.7.80 | 7,000 | 16,605 |
| | 5 | L | 29.6.81 | 1,300 | 2,568 |
| | 6 | L | 4.10.76 | 2,600 | 4,262 |
| 61 | 7 | L | 6.3.78 | 1,300 | 2,482 |
| | 8 | G | 22.4.70 | 24,500 | 5,862 |
| | 9 | L | 12.4.76 | 2,200 | 4,066 |
| | 10 | L | 4.4.77 | 3,000 | 5,157 |
| | 11 | L | 6.3.78 | 650 | 1,241 |
| | 12 | L | 4.10.82 | 1,700 | 2,886 |
| | 13 | L | 27.10.75 | g.400 | 863 |
| | 14 | L | 27.10.75 | g.900 | 1,942 |
| | 15 | L | 4.4.77 | 3,000 | 5,157 |
| | 16 | L | 24.11.69 | g.400 | 1,008 |
| | 17 | L | 29.12.82 | 3,500 | 5,665 |
| 62 | 1 | L | 21.6.76 | 13,000 | 22,950 |
| | 2 | L | 21.6.76 | 3,800 | 6,708 |
| | 3 | L | 2.7.79 | 4,000 | 9,040 |
| 63 | 4 | L | 21.6.76 | 3,800 | 6,708 |
| | 5 | L | 21.6.76 | 3,800 | 6,708 |
| | 6 | L | 21.6.76 | 24,000 | 42,371 |
| 64 | 1 | L | 4.4.77 | 2,500 | 4,298 |
| | 2 | L | —— | —— | —— |
| | 3 | L | 29.11.82 | 9,000 | 14,698 |
| | 4 | L | 14.7.80 | 1,100 | 2,609 |
| | 5 | L | 3.12.73 | g.4.500 | 10,959 |
| 65 | 6 | L | 14.4.80 | 2,400 | 5,319 |
| | 7 | L | 24.4.67 | g.500 | 1,444 |
| | 8 | L | 12.4.76 | 10,500 | 19,405 |
| 66 | 1 | L | 21.6.76 | 11,000 | 19,420 |
| | 2 | L | 21.6.76 | 5,500 | 9,710 |
| | 3 | L | 21.6.76 | 17,500 | 30,895 |
| 67 | 4 | L | 21.6.76 | 4,000 | 7,062 |
| | 5 | L | 4.4.77 | 8,000 | 13,753 |
| | 6 | L | 2.7.76 | 32,000 | 57,165 |
| 68 | 1 | L | 24.11.80 | 2,450 | 5,872 |
| | 2 | R | 12.6.73 | 4,000 | 6,883 |
| | 3 | R | 12.6.73 | 2,400 | 4,130 |
| | 4 | L | 14.4.80 | 1,500 | 3,325 |
| 69 | 5-6 | L | 29.11.82 | 1,800 (2) | 2,940 |
| | 7 | L | 14.11.77 | 850 | 1,546 |
| | 8 | L | 29.5.62 | g.360 | 1,061 |
| | 9 | L | 24.11.80 | 800 | 1,917 |
| | 10 | L | 24.11.80 | 850 | 2,037 |
| | 11 | L | 2.11.64 | g.480 | 1,408 |
| | 12 | L | 27.10.75 | g.720 | 1,554 |
| | 13 | L | 27.10.75 | g.720 | 1,554 |
| 70 | 1 | L | 3.12.73 | g.23,000 | 56,010 |
| | 2 | L | 14.4.80 | 46,000 | 101,954 |
| | 3 | L | 26.6.78 | 8,500 | 15,615 |
| 71 | 4 | L | 21.6.76 | 3,500 | 6,179 |
| | 5 | L | 21.6.76 | 2,800 | 4,943 |
| | 6 | L | 21.6.76 | 20,000 | 35,309 |
| 72 | 1 | L | 25.6.65 | g.440 | 1,292 |
| | 2 | L | 25.6.65 | g.360 | 1,057 |
| | 3 | L | 8.4.75 | g.2,800 | 6,970 |
| | 4 | L | 2.7.79 | 3,500 | 7,910 |
| | 5 | L | 22.6.65 | g.340 | 998 |
| | 6 | L | 4.4.77 | 480 | 825 |
| | 7 | L | 22.6.65 | g.350 | 1,027 |
| | 8 | L | 22.6.65 | g.260 | 763 |
| | 9 | R | 12.6.73 | 1,500 | 2,581 |
| | 10 | L | 6.12.71 | g.3,000 | 7,689 |
| | 11 | L | 16.6.69 | g.950 | 2,384 |
| | 12 | L | 16.6.69 | g.980 | 2,459 |
| 73 | 13 | L | 4.10.76 | 2,900 | 4,754 |
| | 14 | L | 8.4.75 | g.5,000 | 12,075 |
| | 15 | L | 14.4.80 | 2,300 | 5,098 |
| | 16 | L | 29.11.82 | 3,500 | 5,716 |
| | 17 | E | 22.9.75 | - | - |
| | 18 | L | 25.11.68 | g.1200 | 3,016 |

| Page | | Place | Date | Price (local) | Price ($ US) |
|---|---|---|---|---|---|
| 73 | 19 | NY | 13.6.81 | ——— | 19,000 |
| | 20 | L | 27.10.75 | g.2,500 | 5,396 |
| | 21 | L | 5.4.66 | g.280 | 820 |
| | 22 | L | 10.6.69 | g.1,050 | 2,635 |
| | 23 | L | 22.6.65 | g.1,800 | 5,285 |
| | 24 | L | 29.5.62 | g.1,700 | 5,012 |
| | 25 | L | 4.4.77 | 3,500 | 6,017 |
| | 26 | L | 24.11.69 | ——— | ——— |
| | 27 | L | 27.10.75 | g.2,400 | 5,180 |
| 74 | 1 | L | 21.6.76 | 8,000 | 14,124 |
| | 2 | L | 21.6.76 | 8,000 | 14,124 |
| | 3 | L | 2.7.79 | 17,000 | 38,422 |
| 75 | 4 | L | 21.6.76 | 2,200 | 3,884 |
| | 5 | L | 21.6.76 | 7,000 | 12.358 |
| | 6 | L | 14.4.80 | 6,400 | 14,184 |
| 76 | 1 | L | 27.10.75 | g.950 | 2,050 |
| | 2 | L | 21.6.76 | 1,100 | 1,942 |
| | 3 | E | 18.4.77 | 1,400 | 2,407 |
| | 4 | E | 18.4.77 | 650 | 1,117 |
| | 5 | L | 12.4.76 | 2,000 | 3,696 |
| | 6 | L | 19.5.75 | 2,800 | 6,501 |
| | 7 | L | 29.6.81 | 800 | 1,581 |
| | 8 | R | 14.11.73 | 900 | 1,526 |
| | 9 | L | 2.7.79 | 3,500 | 7,910 |
| | 10 | L | 2.7.79 | 5,500 | 12,431 |
| | 11 | L | 2.7.79 | 4,300 | 9,719 |
| | 12 | L | 2.7.79 | 4,300 | 9,719 |
| | 13 | L | 23.11.81 | 2,800 | 5,328 |
| 77 | 14 | L | 2.7.79 | 6,200 | 14,013 |
| | 15 | L | —— | —— | —— |
| | 16 | L | 23.5.66 | g.260 | 762 |
| | 17 | L | 14.7.80 | 8,000 | 18,978 |
| | 18 | L | 2.7.79 | 2,200 | 4,972 |
| | 19 | L | 2.7.79 | 2,500 | 5,650 |
| | 20 | L | 2.7.79 | 3,200 | 7,232 |
| | 21 | L | 2.7.79 | 5,000 | 11,301 |
| | 22 | L | 23.2.81 | 2,700 | 6,208 |
| | 23 | L | 14.4.80 | 800 | 1,773 |
| | 24 | L | 27.5.62 | g.110 | 324 |
| | 25 | L | 14.4.80 | 1,100 | 2,438 |
| 78 | 1 | L | 21.6.76 | 7,500 | 13,241 |
| 79 | 2 | L | —— | —— | —— |
| | 3 | L | 26.10.59 | g.130 | 383 |
| | 4 | L | 26.10.59 | g.95 | 280 |
| | 5 | R | 14.11.73 | 1,500 | 2,543 |
| | 6 | L | 16.6.69 | 1,100 | 2,761 |
| | 7 | L | 5.4.82 | 1,400 | 2,480 |
| | 8 | L | 19.5.75 | g.4,800 | 11,701 |
| | 9 | R | 29.6.78 | 4,500 | 7,629 |
| 80 | 1 | L | 22.6.65 | g.320 | 940 |
| | 2 | L | 22.6.65 | g.85 | 250 |
| | 3 | L | 22.6.65 | g.400 | 1,174 |
| | 4 | L | 22.6.65 | g.340 | 998 |
| | 5 | L | 2.7.79 | 1,300 | 2,938 |
| | 6 | L | 14.4.80 | 3,400 | 7,536 |
| 81 | 7 | L | 29.11.82 | 1,000 | 1,633 |
| | 8 | L | 29.5.62 | g.160 | 472 |
| | 9-10 | L | 23.2.81 | 1,400 (pr) | 3,219 |
| | 11 | L | 4.10.76 | 450 | 738 |
| | 12 | L | 2.7.79 | 7,000 | 15,821 |
| | 13 | L | 2.7.79 | 2,000 | 4,520 |
| | 14 | L | 23.2.81 | 2,200 | 5,058 |
| 82 | 1-2 | L | 29.6.81 | 600 (2) | 1,185 |
| | 3 | L | 5.4.82 | 1,100 | 1,948 |
| | 4 | L | 2.7.79 | 6,000 | 13,561 |
| 83 | 5 | L | 14.11.77 | 2,300 | 4,184 |
| | 6 | R | 12.6.73 | 3,000 | 5,163 |
| | 7-8 | L | 23.2.81 | 750 (pr) | 1,724 |
| | 9 | L | 2.7.79 | 3,800 | 8,588 |
| 84 | 1 | L | 12.4.76 | 1,400 | 2,587 |

| Page | | Place | Date | Price (local) | Price ($ US) |
|---|---|---|---|---|---|
| 84 | 2 | L | 27.10.75 | g.630 | 1,360 |
| | 3 | L | 19.5.75 | g.950 | 2,316 |
| | 4 | L | 5.4.82 | 5,000 | 8,856 |
| | 5 | L | 5.2.79 | 1,300 | 2,605 |
| | 6 | L | 17.2.69 | g.280 | 703 |
| 85 | 7 | L | 14.11.77 | 600 | 1,091 |
| | 8 | L | 14.4.80 | 850 | 1,884 |
| | 9 | L | 5.4.66 | g.95 | 279 |
| | 10 | L | 14.11.77 | 400 | 728 |
| | 11 | L | 24.11.80 | 1,000 | 2,397 |
| | 12 | L | 5.4.82 | 3,000 | 5,314 |
| | 13 | L | 14.7.80 | 1,500 | 3,558 |
| 86 | 1 | L | 21.6.76 | 11,000 | 19,420 |
| 87 | 2 | L | 14.7.80 | 1,500 | 3,558 |
| | 3 | L | 14.4.80 | 800 | 1,773 |
| | 4 | L | 14.4.80 | 1,600 | 3,546 |
| | 5 | L | 8.4.74 | 1,000 | 2,415 |
| 88 | 1 | L | 14.7.80 | 1,500 | 3,558 |
| | 2 | L | 28.6.82 | 1,200 | 2,109 |
| | 3 | L | 28.6.82 | 900 | 1,582 |
| | 4 | L | 28.6.82 | 850 | 1,494 |
| | 5-6 | L | 29.11.82 | 1,100 (pr) | 1,796 |
| | 7 | L | 18.5.70 | g.300 | 755 |
| | 8 | L | 5.4.66 | g.460 | 1,348 |
| | 9 | L | 14.11.77 | 5,200 | 9,459 |
| 89 | 10 | L | 4.10.76 | 3,200 | 5,246 |
| | 11 | L | 3.12.73 | g.1,550 | 3,775 |
| | 12 | L | 4.4.77 | 1,150 | 1,977 |
| | 13 | L | 14.11.77 | 140 | 255 |
| | 14 | L | 5.4.82 | 3,500 | 6,199 |
| | 15 | L | 24.2.75 | g.550 | 1,383 |
| 90 | 1 | L | 29.11.82 | 600 | 980 |
| | 2 | L | 14.11.77 | 1,400 | 2,547 |
| | 3 | L | 21.6.76 | 3,000 | 5,296 |
| 91 | 4 | L | 4.10.82 | 1,400 | 2,377 |
| | 5 | L | 4.10.82 | 200 | 340 |
| | 6 | L | 4.10.82 | 650 | 1,104 |
| | 7 | L | 21.6.76 | 1,500 | 2,648 |
| | 8 | L | 21.6.76 | 4,800 | 8,474 |
| 92 | 1 | L | 23.11.81 | 1,100 | 2,093 |
| | 2 | L | 29.5.62 | g.1,000 | 2,948 |
| | 3 | L | 2.11.64 | g.40 | 117 |
| | 4 | L | 8.4.74 | g.700 | 1,691 |
| | 5 | L | 28.6.82 | 1,800 | 3,164 |
| 93 | 6 | L | 4.10.82 | 200 | 340 |
| | 7 | L | 5.4.66 | g.210 | 615 |
| | 8 | L | 23.11.81 | 1,000 | 1,903 |
| | 9 | R | 12.6.73 | 2,500 | 4,302 |

### ITALY POST-1600

| Page | | Place | Date | Price (local) | Price ($ US) |
|---|---|---|---|---|---|
| 94 | 1 | L | 2.7.79 | 3,500 | 7,910 |
| 95 | 2 | R | 30.4.82 | 16,800 | 12,727 |
| 98 | 1 | L | 5.4.82 | 300 | 531 |
| | 2 | L | 5.4.82 | 1,200 | 2,125 |
| | 3 | L | 5.4.82 | 280 | 496 |
| | 4 | L | 28.6.82 | 1,100 | 1,933 |
| | 5 | L | 27.10.75 | g.1600 | 3,453 |
| | 6 | L | 4.4.77 | 950 | 1,633 |
| | 7 | L | 18.4.77 | 500 | 860 |
| | 8 | L | 5.4.66 | g.110 | 322 |
| | 9 | L | 19.5.75 | g.650 | 1,585 |
| | 10 | L | 19.5.75 | g.550 | 1,341 |
| | 11 | L | 28.6.82 | 250 | 439 |
| | 12 | L | 28.6.82 | 400 | 703 |
| | 13 | L | 28.6.82 | 260 | 457 |
| 99 | 14 | L | 28.6.82 | 500 | 879 |
| | 15 | L | 28.6.82 | 300 | 527 |
| | 16 | L | 28.6.82 | 380 | 668 |
| | 17 | L | 28.6.82 | 280 | 492 |
| | 18 | L | 28.6.82 | 260 | 457 |

| Page | | Place | Date | Price (local) | Price ($ US) |
|---|---|---|---|---|---|
| 99 | 19 | L | 28.6.82 | 280 | 492 |
| | 20 | L | 5.4.66 | g.70 | 205 |
| | 21 | L | 6.3.78 | 900 | 1,718 |
| | 22 | L | 12.4.76 | 1,400 | 2,587 |
| | 23 | L | 6.3.78 | 900 | 1,718 |
| 100 | 1 | L | 23.11.81 | 1,000 | 1,903 |
| | 2 | L | 24.11.80 | 750 | 1,798 |
| | 3 | L | 23.2.81 | 800 | 1,839 |
| | 4 | L | 5.4.82 | 3,200 | 5,668 |
| | 5 | L | 5.4.82 | 1,000 | 1,771 |
| | 6 | L | 5.4.82 | 2,800 | 4,959 |
| | 7 | L | 14.7.80 | 1,100 | 2,609 |
| | 8 | L | 14.11.77 | 3,000 | 5,457 |
| 101 | 9 | L | 14.4.80 | 1,300 | 2,881 |
| | 10 | L | 14.4.80 | 500 | 1,108 |
| | 11 | L | 23.2.81 | 1,350 | 3,104 |
| | 12 | L | 23.2.81 | 2,200 | 5,058 |
| | 13 | L | —— | —— | —— |
| | 14 | L | —— | —— | —— |
| | 15 | L | 29.6.81 | 1,100 | 2,173 |
| | 16 | L | 29.6.81 | 1,400 | 2,766 |
| | 17 | L | 3.10.83 | 1,400 | 2,096 |
| 102 | 1-6 | L | 20.11.67 | g.700 (6) | 2,021 |
| | 7 | G | 22.4.70 | 3,600 | 834 |
| | 8 | G | 22.4.70 | 3,600 | 834 |
| 103 | 9 | L | 14.11.77 | 400 | 728 |
| | 10 | L | 14.4.80 | 1,200 | 2,660 |
| | 11 | L | 14.4.80 | 2,500 | 5,541 |
| | 12 | L | 4.10.82 | 1,300 | 2,207 |
| | 13 | L | 4.10.82 | 950 | 1,613 |
| | 14 | L | 29.6.81 | 550 | 1,087 |
| | 15 | L | 29.6.81 | 350 | 692 |
| | 16 | L | 14.4.77 | 500 | 860 |
| | 17 | L | 14.11.77 | 220 | 400 |
| | 18 | L | 23.2.81 | 1,700 | 3,909 |
| 104 | 1 | G | 20.11.70 | 2,000 | 464 |
| | 2 | L | 23.2.81 | 1,550 | 3,564 |
| | 3 | R | 10.5.79 | 1,600 | 1,880 |
| | 4 | L | 14.11.77 | 780 | 1,418 |
| | 5 | E | 26.9.79 | 1,900 | 4,179 |
| | 6 | L | 23.11.81 | 2,800 | 5,328 |
| 105 | 7 | L | 4.10.82 | 600 | 1,019 |
| | 8 | L | —— | —— | —— |
| | 9 | L | —— | —— | —— |
| | 10 | L | 4.4.77 | 600 | 1,031 |
| | 11 | L | 24.2.75 | g.340 | 855 |
| | 12 | L | 24.2.75 | g.500 | 1,257 |
| | 13 | R | 10.5.79 | 2,800 | 3,290 |
| 106 | 1 | L | 14.7.80 | 260 | 617 |
| | 2 | L | 6.3.78 | 270 | 515 |
| | 3 | L | 29.6.81 | 650 | 1,284 |
| | 4 | L | 23.2.81 | 450 | 1,035 |
| | 5 | L | 14.11.77 | 1,150 | 2,092 |
| | 6 | L | 6.3.78 | 1,000 | 1,909 |
| 107 | 7 | G | 20.11.70 | 1,600 | 371 |
| | 8 | G | 18.11.70 | 3,500 | 812 |
| | 9 | L | 5.4.82 | 1,200 | 2,125 |
| | 10 | L | 24.11.80 | 1,100 | 2,636 |
| | 11 | L | 14.11.77 | 1,300 | 2,365 |
| | 12 | L | 27.10.75 | g.900 | 1,942 |
| 108 | 1 | L | 4.10.82 | 220 | 374 |
| | 2 | L | 4.10.82 | 900 | 1,528 |
| | 3 | R | 29.9.77 | 1,400,000 | 1,585 |
| | 4 | L | 4.4.77 | 1,000 | 1,719 |
| | 5 | L | 14.4.80 | 600 | 1,330 |
| | 6 | R | 10.5.79 | 1,300 | 1,528 |
| | 7 | R | 10.5.79 | 1,300 | 1,528 |
| | 8 | L | 14.4.80 | 350 | 776 |
| | 9 | L | 27.6.66 | g.420 | 1,230 |
| 109 | 10 | R | 29.9.77 | 850 | 962 |

| Page | | Place | Date | Price (local) | Price ($ US) |
|---|---|---|---|---|---|
| 109 | 11 | R | 29.9.77 | 2,000 | 2,264 |
| | 12 | L | 5.2.79 | 190 | 381 |
| | 13 | R | 29.9.77 | 1,200 | 1,358 |
| | 14 | R | 29.9.77 | 1,000 | 1,132 |
| | 15 | E | 14.10.80 | 180 | 435 |
| | 16 | L | 5.2.79 | 450 | 902 |
| | 17 | L | 5.2.79 | 280 | 561 |
| | 18 | L | 3.10.83 | 400 | 599 |
| | 19 | L | 3.10.83 | 950 | 1,422 |
| | 20 | L | 3.10.83 | 280 | 419 |
| 110 | 1 | L | 6.3.78 | 1,000 | 1,909 |
| | 2 | R | 29.9.77 | 450 | 509 |
| | 3 | R | 29.9.77 | 650 | 736 |
| | 4 | R | 29.9.77 | 600 | 679 |
| | 5 | L | 23.11.81 | 750 | 1,427 |
| | 6 | R | 29.9.77 | 350 | 396 |
| | 7 | R | 29.9.77 | 650 | 736 |
| | 8 | L | 29.12.82 | 1,100 | 1,780 |
| | 9 | L | 18.5.70 | g.200 | 503 |
| 111 | 10 | R | 29.9.77 | 450 | 509 |
| | 11 | R | 29.9.77 | 450 | 509 |
| | 12 | R | 29.9.77 | 2,000 | 2,264 |
| | 13 | R | 29.9.77 | 2,800 | 3,170 |
| | 14 | L | 24.2.75 | g.350 | 880 |
| | 15 | R | 29.9.77 | 450 | 509 |
| | 16 | R | 16.2.78 | 2,200 | 2,559 |
| 112 | 1 | R | 10.5.79 | 750 | 881 |
| | 2 | R | 10.5.79 | 700 | 823 |
| | 3 | R | 10.5.79 | 650 | 764 |
| | 4 | L | 14.4.80 | 660 | 1,463 |
| | 5 | L | 23.11.81 | 280 | 533 |
| | 6 | L | 24.2.75 | g.400 | 1,006 |
| 113 | 7 | L | 6.3.78 | 700 | 1,336 |
| | 8 | L | 28.6.82 | 200 | 351 |
| | 9 | L | 28.6.82 | 200 | 351 |
| | 10 | L | 3.10.83 | 1,800 | 2,695 |
| | 11 | L | 14.11.77 | 260 | 473 |
| | 12 | L | 19.5.75 | 240 | 557 |
| 114 | 1-2 | L | 4.10.76 | 1,800 (pr) | 2,951 |
| | 2 | L | 4.10.76 | 1,800 | 2,951 |
| | 3 | L | 29.6.81 | 1,700 | 3,359 |
| | 4 | L | 29.6.81 | 750 | 1,482 |
| | 5 | L | 14.4.80 | 320 | 709 |
| | 6 | L | 5.4.82 | 6,000 | 10,627 |
| 115 | 7 | L | 29.11.82 | 650 | 1,062 |
| | 8 | L | 29.11.82 | 550 | 898 |
| | 9 | L | 29.11.82 | 350 | 572 |
| | 10 | L | 29.11.82 | 260 | 425 |
| | 11 | L | 14.7.80 | 1,200 | 2,847 |
| | 12 | L | 14.7.80 | 130 | 308 |
| | 13 | L | 4.10.82 | 320 | 543 |
| | 14 | L | 4.10.82 | 250 | 424 |
| | 15 | L | 4.10.82 | 280 | 475 |
| | 16 | | —— | —— | —— |
| | 17 | L | 14.4.80 | 500 | 1,108 |
| | 18 | L | 14.11.77 | 1,300 | 2,365 |
| | 19 | L | 14.11.77 | 700 | 1,273 |
| 116 | 1 | G | 20.11.70 | 1,300 | 301 |
| | 2 | L | 24.11.80 | 900 | 2,157 |
| | 3 | R | 14.11.73 | 800 | 1,356 |
| | 4 | R | 14.11.73 | 1,000 | 1,695 |
| | 5 | L | 4.4.77 | 280 | 481 |
| | 6 | L | 15.6.79 | 380 | 449 |
| | 7 | R | 15.6.79 | 380 | 449 |
| | 8 | R | 15.6.79 | 480 | 568 |
| | 9 | R | 15.6.79 | 600 | 710 |
| | 10 | R | 15.6.79 | 440 | 520 |
| | 11 | R | 15.6.79 | 540 | 639 |
| | 12 | R | 15.6.79 | 360 | 426 |
| | 13 | R | 15.6.79 | 550 | 650 |

| Page | | Place | Date | Price (local) | Price ($US) |
|---|---|---|---|---|---|
| 117 | 14 | L | 5.4.82 | 650 | 1,151 |
| | 15 | L | 5.4.82 | 600 | 1,063 |
| | 16 | L | 5.4.82 | 600 | 1,063 |
| | 17 | L | —— | —— | —— |
| | 18 | L | 14.11.77 | 150 | 273 |
| | 19 | L | 5.4.82 | 880 | 1,559 |
| | 20 | L | 4.10.82 | 280 | 475 |
| | 21 | L | 4.10.82 | 320 | 543 |
| | 23 | L | 4.10.82 | 140 | 238 |
| | 24 | L | 4.10.82 | 280 | 475 |
| 118 | 1 | L | 5.2.79 | 380 | 761 |
| | 2 | R | 29.9.77 | 1,400 | 1,585 |
| | 3 | R | 29.9.77 | 400 | 453 |
| | 4 | R | 29.9.77 | 600 | 679 |
| | 5 | R | 29.9.77 | 400 | 453 |
| | 6 | L | 24.11.80 | 180 | 431 |
| | 7 | L | 24.11.80 | 220 | 527 |
| | 8 | R | 16.2.78 | 450 | 523 |
| | 9 | R | 16.2.78 | 700 | 814 |
| | 10 | R | 16.2.78 | 280 | 326 |
| | 11 | R | 6.11.78 | 4,800 | 5,700 |
| | 12 | L | —— | | —— |
| 119 | 13 | L | 27.5.68 | g.12,500 | 31,421 |
| | 14 | R | 10.3.77 | 5,500 | 6,205 |
| | 15-16 | L | 21.6.65 | g.580 (6) | 1,703 |
| 120 | 1 | R | 10.5.79 | —— | —— |
| | 2 | R | 10.5.79 | | —— |
| | 3 | R | 10.5.79 | 2,600 | 3,055 |
| | 4 | R | 10.5.79 | —— | —— |
| | 5 | R | 10.12.82 | 2,400 | 1,716 |
| | 6 | L | 18.5.70 | g.200 | 503 |
| | 7 | L | 13.3.67 | —— | —— |
| 121 | 8 | L | 21.6.76 | 280 | 494 |
| | 9 | L | 21.6.76 | 250 | 441 |
| | 10 | L | 28.10.74 | g.210 | 514 |
| | 11 | L | 29.6.81 | 550 | 1,087 |
| 122 | 1 | R | 29.9.77 | 600 (2) | 679 |
| | 2 | R | 29.9.77 | 750 | 849 |
| | 3 | R | 29.9.77 | 800 (3) | 906 |
| | 4 | R | 29.9.77 | 250 (2) | 283 |
| | 5 | R | 29.9.77 | 450 | 509 |
| | 6 | R | 29.9.77 | 140 | 158 |
| | 7 | R | 29.9.77 | 400 | 452 |
| | 8 | R | 29.9.77 | 450 | 509 |
| | 9 | R | 29.9.77 | 1,500 | 1,698 |
| | 10 | R | 29.9.77 | 1,600 | 1,811 |
| | 11 | R | 29.9.77 | 600 | 679 |
| | 12 | R | 29.9.77 | 1,050 | 1,189 |
| | 13 | R | 29.9.77 | 900 | 1,019 |
| | 14 | R | 29.9.77 | 650 | 736 |
| | 15 | R | 29.9.77 | 600 | 679 |
| | 16 | R | 29.9.77 | 500 | 566 |
| 123 | 17 | L | 29.6.81 | 350 | 692 |
| | 18 | R | 29.9.77 | 1,400 | 1,585 |
| | 19 | R | 29.9.77 | 2,200 | 2,490 |
| | 20 | R | 29.9.77 | 800 | 906 |
| | 21 | R | 29.9.77 | 380 | 430 |
| | 22 | L | 24.11.80 | 280 | 671 |
| | 23 | L | 28.6.82 | 500 | 879 |
| | 24 | L | 6.3.78 | 1,300 | 2,482 |
| 124 | 1 | R | 29.6.78 | 600 | 698 |
| | 2 | R | 29.6.78 | 900 | 1,048 |
| | 3 | R | 29.4.82 | 1,800 | 1,364 |
| | 4 | L | 14.11.77 | 150 | 273 |
| | 5 | L | 14.11.77 | 180 | 327 |
| | 6 | R | 10.3.82 | 1,600 | 1,238 |
| | 7 | L | 3.10.83 | 1,800 | 2,695 |
| 125 | 8 | L | 24.11.80 | 1,500 | 3,595 |
| | 9 | R | 6.11.78 | 850 | 1,009 |
| | 10 | L | 23.11.81 | 720 | 1,370 |

| Page | | Place | Date | Price (local) | Price ($US) |
|---|---|---|---|---|---|
| 125 | 11 | L | 14.4.80 | 1200 | 2,660 |
| | 12 | L | —— | —— | —— |

## NORTHERN EUROPE

| Page | | Place | Date | Price (local) | Price ($US) |
|---|---|---|---|---|---|
| 126 | 1 | A | 7.12.82 | 57,000 | 21,328 |
| 128 | 1 | L | 3.10.83 | 1,500 | 2,246 |
| | 2 | L | 3.10.83 | 2,600 | 3,893 |
| 129 | 3 | L | 3.10.83 | 5,800 | 8,684 |
| 131 | 1 | L | 3.10.83 | 16,000 | 23,956 |
| 132 | 1 | L | 23.11.81 | 1,000 | 1,903 |
| | 2 | L | 23.2.81 | 1,800 | 4,139 |
| | 3 | L | 14.7.80 | 500 | 1,186 |
| | 4 | L | 23.11.81 | 380 | 723 |
| | 5 | L | 24.11.80 | 2,000 | 4,794 |
| | 6 | A | 14.5.82 | 16,000 | 6,238 |
| 133 | 7 | L | 5.2.79 | 1,200 | 2,405 |
| | 8 | L | 5.2.79 | 1,600 | 3,206 |
| | 9 | L | 13.3.67 | g.380 | 1,097 |
| | 10 | L | 13.3.67 | g.420 | 1,213 |
| | 11 | L | 6.3.78 | 1,600 | 3,054 |
| | 12 | L | 6.3.78 | 1,700 | 3,245 |
| 134 | 1 | L | 27.10.75 | g.400 | 863 |
| | 2 | L | 23.11.82 | 18,360 | 29,192 |
| | 3 | L | 26.3.69 | g.2,500 | 6,274 |
| | 4 | L | 23.2.81 | 600 | 1,380 |
| | 5 | A | 14.5.82 | 6,000 | 2,339 |
| | 6 | A | 14.5.82 | 4,800 | 1,871 |
| | 7 | A | 14.5.82 | 14,000 | 5,458 |
| | 8 | A | 14.5.82 | 8,500 | 3,314 |
| | 9 | L | 23.2.81 | 800 | 1,839 |
| | 10 | L | 23.10.81 | 920 | 1,696 |
| | 11 | L | 23.10.81 | 1,500 | 2,765 |
| | 12 | L | 23.10.81 | 420 | 774 |
| | 13 | L | 23.10.81 | 700 | 1,291 |
| 135 | 14 | L | 27.10.75 | 504 | 1,036 |
| | 15 | L | 12.4.76 | 1,400 | 2,587 |
| | 16 | L | 14.7.80 | 500 | 1,186 |
| | 17 | L | 4.10.82 | 700 | 1,188 |
| | 18 | L | 24.11.80 | 260 | 623 |
| | 19 | L | 14.4.80 | 280 | 621 |
| | 20 | L | 4.10.76 | 450 | 738 |
| | 21 | L | 4.10.76 | 400 | 656 |
| 136 | 1 | L | 14.4.80 | 1,150 | 2,549 |
| | 2 | L | 14.4.80 | 750 | 1,662 |
| | 3 | L | 14.4.80 | 1,200 | 2,660 |
| | 4 | L | 24.11.80 | 180 | 431 |
| | 5 | L | 14.7.80 | 1,500 | 3,558 |
| | 6 | L | 14.7.80 | 200 | 474 |
| | 7 | L | 27.10.75 | g.400 | 863 |
| | 8 | L | 27.10.75 | g.550 | 1,187 |
| | 9 | L | 14.7.80 | 350 | 830 |
| | 10 | L | 14.7.80 | 200 | 474 |
| | 11 | L | 5.4.82 | 300 | 531 |
| | 12 | L | 5.4.82 | 550 | 974 |
| | 13 | L | 5.4.82 | 120 | 213 |
| 137 | 14 | L | 14.7.80 | 380 | 901 |
| | 15 | L | 14.4.80 | 900 | 1,995 |
| | 16 | L | 24.11.80 | 800 | 1,917 |
| | 17 | L | 24.11.80 | 800 | 1,917 |
| | 18 | L | 24.11.80 | 340 | 815 |
| | 19 | L | 24.11.80 | 340 | 815 |
| | 20 | L | 4.10.76 | 1,000 | 1,639 |
| | 21 | L | 24.11.80 | 700 | 1,678 |
| | 22 | L | 24.11.80 | 1,800 | 4,314 |
| | 23 | A | 14.5.82 | 8,500 | 3,314 |
| 138 | 1 | L | 29.12.82 | 800 | 1,295 |
| | 2 | L | 23.2.81 | 1,700 | 3,909 |
| | 3 | L | 27.10.75 | g.420 | 906 |
| | 4 | L | 29.6.81 | 1,500 | 2,964 |
| | 5 | L | 29.6.81 | 2,400 | 4,742 |

| Page | | Place | Date | Price (local) | Price ($US) |
|---|---|---|---|---|---|
| 138 | 6 | L | 4.10.76 | 95 | 156 |
| | 7 | L | 24.11.80 | 900 | 2,157 |
| 139 | 8 | L | 24.11.80 | 600 | 1,438 |
| | 9 | L | 29.6.81 | 2,000 | 3,951 |
| | 10 | L | 14.7.80 | 190 | 451 |
| | 11 | L | 29.6.82 | 2,812 | 1,600 |
| | 12 | L | 29.6.82 | 320 | 562 |
| | 13 | L | 29.6.82 | 950 | 1,670 |
| | 14 | L | 4.10.82 | 850 | 1,443 |
| 140 | 1 | L | 18.5.70 | g.1,450 | 3,647 |
| | 2 | L | 14.4.80 | 750 | 1,662 |
| | 3 | L | 14.4.80 | 750 | 1,662 |
| | 4 | L | 6.3.78 | 500 | 954 |
| | 5 | L | 6.3.78 | 350 | 668 |
| | 6 | L | 6.3.78 | 400 | 764 |
| | 7 | L | 29.11.82 | 200 | 327 |
| | 8 | L | 14.11.77 | 400 | 728 |
| | 9 | L | 29.11.82 | 750 | 1,225 |
| 141 | 10 | L | 23.2.81 | 1,100 | 2,529 |
| | 11 | L | 14.7.80 | 1,500 | 3,558 |
| | 12 | L | 14.7.80 | 550 | 1,305 |
| | 13 | L | 24.2.75 | g.1,250 | 3,142 |
| | 14 | L | 23.11.81 | 720 | 1,370 |
| | 15 | L | 23.11.81 | 1,350 | 2,569 |
| | 16 | L | 23.11.81 | —— | —— |
| | 17 | L | 6.3.78 | 750 | 1,432 |
| | 18 | L | 6.3.78 | 600 | 1,145 |
| | 19 | L | 6.3.78 | 700 | 1,336 |
| | 20 | L | 28.10.74 | g.320 | 784 |
| | 21 | L | 28.10.74 | g.260 | 637 |
| | 22 | L | 28.10.74 | g.80 | 196 |
| 142 | 1 | L | 4.10.82 | 320 | 543 |
| | 2 | L | 4.10.82 | 380 | 645 |
| | 3 | L | 14.7.80 | 750 | 1,779 |
| | 4 | L | 14.7.80 | 500 | 1,186 |
| | 5 | L | 27.10.75 | g.110 | 237 |
| | 6 | L | 24.2.75 | g.420 | 1,056 |
| | 7 | L | 24.2.75 | g.580 | 1,458 |
| | 8 | L | 24.2.75 | g.450 | 1,131 |
| | 9 | L | 14.7.80 | 680 | 1,613 |
| | 10 | L | 14.7.80 | 460 | 1,091 |
| | 11 | L | 24.2.75 | g.1,150 | 2,891 |
| 143 | 12 | L | 24.11.80 | 380 | 911 |
| | 13 | L | 24.11.80 | 280 | 671 |
| | 14 | L | 24.11.80 | 220 | 527 |
| | 15 | L | 29.6.81 | 650 | 1,284 |
| | 16 | L | 4.10.82 | 220 | 373 |
| | 17 | L | 18.5.70 | g.360 | 906 |
| | 18 | L | 14.7.80 | 280 | 664 |
| | 19 | L | 14.7.80 | 250 | 593 |
| | 20 | L | 14.7.80 | 820 | 1,945 |
| | 21 | L | 14.7.80 | 500 | 1,186 |
| | 22 | L | 14.4.80 | 700 | 1,551 |
| | 23 | L | 14.4.80 | 400 | 887 |
| 144 | 1 | L | 24.2.75 | g.1600 | 4,022 |
| | 2 | L | 4.10.76 | 1,200 | 1,967 |
| | 3 | L | 6.3.78 | 1,300 | 2,482 |
| | 4 | L | 6.3.78 | 600 | 1,145 |
| | 5 | L | 6.3.78 | 1,550 | 2,959 |
| | 6 | L | 27.10.75 | 378 | 777 |
| | 7 | L | 27.10.75 | 273 | 561 |
| | 8 | L | 27.10.75 | 609 | 1,252 |
| | 9 | L | 14.11.77 | 450 | 819 |
| | 10 | L | 24.2.75 | g.280 | 704 |
| | 11 | L | 24.2.75 | g.260 | 654 |
| | 12 | L | 24.2.75 | g.650 | 1,634 |
| | 13 | L | 24.2.75 | g.420 | 1,056 |
| | 14 | L | 24.2.75 | g.240 | 603 |
| | 15 | L | 24.2.75 | g.480 | 1,207 |
| 145 | 16 | L | 29.6.81 | 280 | 553 |

| Page | | Place | Date | Price (local) | Price ($ US) |
|---|---|---|---|---|---|
| 145 | 17 | L | 29.6.81 | 550 | 1,087 |
| | 18 | L | 29.6.81 | 780 | 1,542 |
| | 19 | L | 29.6.81 | 320 | 632 |
| | 20 | L | 29.6.81 | 600 | 1,185 |
| | 21 | L | 26.6.78 | 2,000 | 3,674 |
| | 22 | L | 26.6.78 | 2,900 | 5,327 |
| | 23 | L | 6.3.78 | 460 | 878 |
| | 24 | L | 6.3.78 | 1,000 | 1,909 |
| | 25 | L | 6.3.78 | 600 | 1,145 |
| | 26 | L | 24.2.75 | g.200 | 503 |
| | 27 | L | 24.2.75 | g.300 | 754 |
| | 28 | L | 24.2.75 | g.400 | 1,006 |
| | 29 | L | 14.7.80 | 650 | 1,542 |
| | 30 | L | 14.7.80 | 680 | 1,613 |
| 146 | 1 | L | 12.4.76 | 1,700 | 3,142 |
| | 2 | L | 12.4.76 | g.2,500 | 4,851 |
| | 3 | L | 12.4.76 | g.4,200 | 8,150 |
| | 4 | L | 18.5.70 | g.1,500 | 3,773 |
| | 5 | L | 30.6.75 | g.2,600 | 6,228 |
| | 6 | L | 28.6.82 | 5,000 | 8,788 |
| 147 | 7 | L | 23.11.81 | 750 | 1,427 |
| | 8 | L | 3.10.83 | 6,000 | 8,984 |
| | 9 | L | 23.11.81 | 480 | 913 |
| | 10 | L | 23.2.81 | 850 | 1,954 |
| | 11 | L | 27.10.75 | g.500 | 1,079 |
| | 12 | L | 27.10.75 | g.350 | 755 |
| | 13 | L | 12.4.76 | 550 | 1,016 |
| | 14 | L | 12.4.76 | 350 | 647 |
| 148 | 1 | L | 24.11.80 | 280 | 671 |
| | 2 | L | 14.11.77 | 750 | 1,364 |
| | 3 | L | 29.6.81 | 1,300 | 2,568 |
| | 4 | L | 24.2.75 | g.340 | 855 |
| | 5 | L | 24.2.75 | g.300 | 754 |
| | 6 | L | 12.4.76 | 1,350 | 2,495 |
| | 7 | L | 28.6.82 | 200 | 351 |
| 149 | 8 | L | 4.4.77 | 310 | 533 |
| | 9 | L | 14.11.77 | 300 | 546 |
| | 10 | L | 14.11.77 | 250 | 455 |
| | 11 | L | 29.6.81 | 110 | 217 |
| | 12 | L | 29.6.81 | 380 | 751 |
| | 13 | L | 12.4.76 | 1,900 | 3,511 |
| 150 | 1 | L | 14.11.77 | 2,000 | 3,638 |
| | 2 | L | 12.4.76 | 320 | 591 |
| | 3 | L | 12.4.76 | 300 | 554 |
| | 4 | G | 17.11.80 | 4,000 | 2,316 |
| | 5 | G | 12.5.80 | 3,800 | 2,286 |
| | 6 | L | 28.6.82 | 750 | 1,318 |
| | 7 | L | 5.2.79 | 500 | 1,002 |
| 151 | 8 | L | 4.10.82 | 240 | 407 |
| | 9 | L | 4.10.82 | 320 | 543 |
| | 10 | L | 4.10.82 | 260 | 441 |
| | 11 | L | 23.11.81 | 500 | 951 |
| | 12 | L | 6.3.78 | 7,400 | 14,126 |
| | 13 | L | 14.11.77 | 170 | 309 |
| 152 | 1 | A | 24.10.79 | 8,500 | 4,284 |
| | 2 | L | 24.10.66 | g.380 | 1,113 |
| | 3 | L | 28.3.66 | g.60 | 176 |
| | 4 | L | 26.6.78 | 650 | 1,194 |
| | 5 | L | 3.10.83 | 2,000 | 2,995 |
| | 6 | L | 26.6.78 | 900 | 1,653 |
| | 7 | L | 6.3.78 | 650 | 1,241 |
| 153 | 8 | L | 23.2.81 | 1,100 | 2,529 |
| | 9 | L | 14.7.80 | 550 | 1,305 |
| | 10 | L | 26.6.78 | 950 | 1,745 |
| | 11 | L | 29.6.81 | 100 | 198 |
| | 12 | L | 14.7.81 | 1,000 | 1,876 |
| | 13 | L | 3.12.62 | g.320 | 943 |
| | 14 | L | 3.10.83 | 2,200 | 3,294 |
| 154 | 1 | L | 2.12.74 | g.5,500 | 13,860 |
| | 2 | L | 2.12.74 | g.4,500 | 11,340 |

| Page | | Place | Date | Price (local) | Price ($ US) |
|---|---|---|---|---|---|
| 154 | 3 | L | 24.2.75 | g.550 | 1,383 |
| | 4 | L | 6.3.78 | 900 | 1,718 |
| 155 | 5 | L | 12.4.76 | 240 | 443 |
| | 6 | L | 17.6.68 | g.1,500 | 3,770 |
| | 7 | L | 23.11.81 | 1,100 | 2,093 |
| | 8 | L | 26.6.78 | 13,500 | 2,480 |
| | 9 | L | 14.11.77 | 450 | 819 |
| | 10 | L | 16.6.69 | g.900 | 2,259 |
| | 11 | G | 12.5.80 | 3,200 | 1,925 |
| | 12 | L | 6.3.78 | 400 | 764 |
| 156 | 1 | L | 24.11.69 | g.280 | 703 |
| | 2 | L | 16.6.69 | g.500 | 1,255 |
| | 3 | L | 4.12.72 | g.900 | 2,364 |
| | 4 | L | 23.11.81 | 4,500 | 8,563 |
| | 5 | L | 24.2.75 | g.520 | 1,307 |
| | 6 | L | 12.4.76 | 200 | 370 |
| | 7 | L | 24.11.80 | 220 | 527 |
| | 8 | L | 24.11.80 | 500 | 1,198 |
| | 9 | L | 24.11.69 | g.280 | 703 |
| | 10 | L | 23.11.81 | 1,300 | 2,474 |
| | 11 | L | 23.11.81 | 240 | 457 |
| 157 | 12 | L | 17.2.69 | g.500 | 1,255 |
| | 13 | L | 16.6.69 | g.500 | 1,255 |
| | 14 | L | 23.11.81 | 280 | 533 |
| | 15 | L | 12.4.76 | 170 | 314 |
| | 16 | L | 24.2.75 | g.1,250 | 3,142 |
| | 17 | L | 6.3.78 | 800 | 1,527 |
| | 18 | L | 23.11.81 | 500 | 951 |
| 158 | 1 | L | 6.3.78 | 780 | 1,489 |
| | 2 | L | 5.2.79 | 400 | 802 |
| | 3 | L | 24.2.75 | g.700 | 1,760 |
| | 4 | L | 28.6.82 | 120 | 211 |
| | 5 | L | 28.6.82 | 140 | 246 |
| | 6 | L | 26.6.78 | 4,500 | 8,267 |
| 159 | 7 | L | 5.2.79 | 320 | 641 |
| | 8 | L | 6.3.78 | 550 | 1,050 |
| | 9 | L | 28.3.66 | g.100 | 293 |
| 160 | 1 | L | 28.3.65 | g.520 | 1,527 |
| | 2 | G | 12.5.80 | 3,000 | 1,805 |
| | 3 | G | 26.4.72 | 4,000 | 1,047 |
| | 4 | L | 6.3.78 | 600 | 1,145 |
| | 5 | G | 7.5.79 | 3,800 (4) | 2,199 |
| 161 | 6 | L | 29.6.81 | 80 | 158 |
| | 7 | L | 29.6.81 | 620 | 1,225 |
| | 8 | L | 14.11.77 | 200 | 364 |
| | 9 | L | 28.3.65 | g.100 | 294 |
| | 10 | G | 3.12.82 | 10,000 | 4,869 |
| | 11 | L | 29.6.81 | 400 | 790 |
| 162 | 1 | E | 26.9.79 | 6,000 | 13,195 |
| | 2 | L | 24.10.67 | g.1,700 | 4,908 |
| | 3 | G | 17.11.80 | 7,500 | 4,342 |
| | 4 | L | 2.11.64 | g.92 | 270 |
| 163 | 5 | L | 26.6.78 | 2,200 | 4,041 |
| | 6 | L | 28.6.82 | 300 | 527 |
| | 7 | L | 5.2.79 | 850 | 1,703 |
| | 8 | G | 17.11.80 | 4,800 | 2,779 |
| | 9 | G | 17.11.80 | 3,200 | 1,853 |
| | 10 | L | 5.4.82 | 3,000 | 5,314 |
| 164 | 1 | G | 12.5.80 | 7,500 | 4,513 |
| | 2 | L | 4.10.76 | 350 | 574 |
| | 3 | L | 22.3.65 | g.230 | 675 |
| | 4 | L | 14.4.80 | 230 | 510 |
| | 5 | L | 4.4.77 | 550 | 946 |
| | 6 | L | 6.3.78 | 1,300 | 2,482 |
| | 7 | L | 4.10.82 | 1,200 | 2,037 |
| 165 | 8 | L | 4.10.82 | 950 | 1,613 |
| | 9 | L | 24.2.75 | — | — |
| | 10 | G | 17.11.80 | 900 | 521 |
| | 11 | L | 27.11.68 | g.270 | 679 |
| | 12 | L | 17.5.68 | g.420 | 1,056 |

| Page | | Place | Date | Price (local) | Price ($ US) |
|---|---|---|---|---|---|
| 165 | 13 | L | 29.11.82 | 220 | 359 |
| | 14 | G | 17.11.80 | 3,000 | 1,737 |
| | 15 | L | 18.5.70 | g.400 | 1,006 |
| **FRANCE** | | | | | |
| 166 | 1 | L | 5.2.79 | 11,500 | 23,044 |
| 168 | 1 | L | 4.10.83 | 1,400 | 2,096 |
| | 2 | L | 4.10.83 | 1,000 | 1,497 |
| 170 | 1 | L | 4.10.83 | 17,000 | 25,453 |
| 171 | 2 | NY | 9.6.79 | — | — |
| | 3 | L | 4.10.83 | 2,600 | 3,893 |
| 172 | 1 | L | 21.6.76 | 4,000 | 7,062 |
| | 2 | L | 12.4.76 | 700 | 1,294 |
| | 3 | L | 4.10.76 | 600 | 984 |
| 173 | 4 | L | 19.7.51 | 1,102 | 3,086 |
| | 5 | L | 28.6.51 | 861 | 2,411 |
| 174 | 1 | L | 23.11.81 | 320 | 609 |
| | 2 | L | 14.11.77 | 700 | 1,273 |
| | 3 | L | 14.11.77 | 340 | 618 |
| | 4 | E | 26.9.79 | 3,400 | 7,477 |
| 175 | 5 | G | 20.11.70 | 2,800 | 649 |
| | 6 | L | 24.2.75 | g.400 | 1,008 |
| | 7 | L | 26.6.78 | 840 | 1,543 |
| | 8 | L | 14.4.80 | 200 | 443 |
| | 9 | L | 5.4.82 | 220 | 390 |
| 176 | 1 | L | 14.4.79 | 1,000 | 2,073 |
| | 2 | L | 14.4.79 | 550 | 1,140 |
| | 3 | L | 14.7.80 | — | — |
| | 4 | L | 23.11.81 | 380 | 723 |
| 177 | 5 | L | 14.4.80 | 1,400 | 3,103 |
| | 6 | L | 3.10.83 | 600 | 898 |
| | 7 | L | 19.5.75 | g.1,000 | 2,438 |
| | 8 | L | 18.5.70 | g.130 | 327 |
| | 9 | L | 18.5.70 | g.250 | 629 |
| 178 | 1 | L | 21.6.76 | 950 | 1,677 |
| | 2 | L | 21.6.76 | 300 | 530 |
| 179 | 3 | L | 21.6.76 | 450 | 794 |
| | 4 | L | 21.6.76 | 1,000 | 1,765 |
| | 5 | L | 21.6.76 | 350 | 618 |
| 180 | 1 | L | 14.7.80 | 1,300 | 3,084 |
| | 2 | L | 6.3.78 | 600 | 1,145 |
| | 3 | L | 5.2.79 | 160 (pr) | 321 |
| | 4 | L | 5.2.79 | 120 | 241 |
| | 5 | L | 28.10.74 | g.190 | 465 |
| | 6 | L | 16.6.69 | g.190 | 477 |
| | 7 | L | 27.10.75 | 280 | 576 |
| | 8 | L | 14.4.80 | 240 | 532 |
| | 9 | L | 14.4.80 | 600 | 1,330 |
| | 10 | L | 14.4.80 | 260 | 576 |
| 181 | 11 | L | 16.3.59 | g.220 | 649 |
| | 12 | L | 30.6.60 | 252 | 708 |
| | 13 | L | 29.6.81 | 1,000 | 1,976 |
| | 14 | L | 28.3.66 | g.750 | 2,197 |
| 182 | 1 | E | 26.6.79 | 14,000 | 29,551 |
| | 2 | L | 14.4.80 | 400 | 887 |
| | 3 | L | 5.2.79 | 140 | 281 |
| | 4 | L | 5.2.79 | 140 | 281 |
| | 5 | G | 20.11.70 | 17,000 | 3,942 |
| 183 | 6 | L | 28.10.74 | g.40 | 98 |
| | 7 | L | 28.10.74 | g.70 | 171 |
| | 8 | L | 28.10.74 | g.75 | 184 |
| | 9 | L | 28.10.74 | g.45 | 110 |
| | 10 | L | 28.10.74 | g.75 | 184 |
| | 11 | L | 28.10.74 | g.44 | 108 |
| | 12 | L | 28.10.74 | g.90 | 220 |
| | 13 | L | 28.10.74 | g.130 | 318 |
| | 14 | L | 28.10.74 | g.30 | 73 |
| | 15 | L | 24.11.69 | — | — |
| | 16 | G | 20.11.70 | 11,000 | 2,551 |
| | 17 | L | 24.11.69 | g.150 | 376 |

| Page | Place | Date | Price (local) | Price ($ US) |
|---|---|---|---|---|
| 183 18 | L | 12.4.76 | 240 | 444 |
| 184 1 | G | 2.10.69 | — | — |
| 2 | L | 17.6.68 | g.320 | 804 |
| 3 | L | 6.3.78 | 400 | 764 |
| 4 | G | 17.11.80 | 7,000 | 4,053 |
| 5 | L | 23.11.81 | 1,100 | 2,093 |
| 6 | G | 12.5.80 | 8,500 | 5,114 |
| 7 | L | 6.3.78 | 2,800 | 5,345 |
| 8 | L | 6.3.78 | 850 | 1,623 |
| 9 | G | 3.12.82 | 1,700 | 827 |
| 10 | G | 3.12.82 | 1,000 | 487 |
| 185 11 | L | 26.6.79 | 1,000 | 2,111 |
| 12 | L | 24.2.75 | g.600 | 1,508 |
| 13 | G | 12.5.80 | 1,600 | 963 |
| 14 | L | 12.5.80 | 2,500 | 1,504 |
| 15 | L | 23.2.81 | 600 | 1,380 |
| 16 | L | 16.6.69 | g.1900 | 4,768 |
| 17 | G | 12.5.80 | 2,500 | 1,504 |
| 18 | G | 12.5.80 | 1,300 | 782 |
| 19 | L | 14.4.80 | 560 | 1,241 |
| 20 | L | 23.11.80 | 800 | 1,917 |
| 21 | L | 23.11.80 | 280 | 671 |
| 186 1 | G | 9.5.82 | 22,000 | 11,291 |
| 2 | G | 9.5.82 | 24,000 | 12,318 |
| 3 | G | 9.5.82 | 4,000 | 2,053 |
| 4 | G | 9.5.82 | 12,000 | 6,159 |
| 187 5 | G | 9.5.82 | 7,000 | 3,593 |
| 6 | G | 9.5.82 | 7,000 | 3,593 |
| 7 | G | 9.5.82 | 45,000 | 23,097 |
| 188 1 | L | 21.6.76 | 300 | 530 |
| 2 | L | 6.3.78 | 500 | 954 |
| 3 | L | 4.10.76 | 260 | 426 |
| 4 | L | 18.5.70 | g.550 | 1,384 |
| 5 | L | 30.6.75 | g.280 | 671 |
| 6 | L | 30.6.75 | g.150 | 359 |
| 7 | L | 16.6.69 | g.1,900 | 4,768 |
| 8 | L | 2.11.64 | g.560 | 1,642 |
| 9 | L | 17.2.69 | g.1,900 | 4,768 |
| 189 10 | L | 28.6.82 | 950 | 1,670 |
| 11 | L | 21.6.76 | 900 | 1,589 |
| 12 | L | 21.6.76 | 700 (6) | 1,236 |
| 13 | L | 21.6.76 | 300 | 530 |
| 14 | L | 12.4.76 | 1,000 | 1,848 |
| 15 | L | 28.10.74 | g.850 | 2,143 |
| 16 | L | 28.10.74 | g.2,000 | 5,040 |
| 17 | L | 26.6.78 | — | — |
| 18 | L | 20.4.64 | — | — |
| 190 1 | G | 9.5.82 | 6,000 | 3,080 |
| 2 | G | 9.5.82 | 6,000 | 3,080 |
| 3 | G | 9.5.82 | 2,800 | 1,437 |
| 4 | G | 9.5.82 | 7,500 | 3,849 |
| 191 5 | E | 26.6.79 | 3,500 | 7,388 |
| 6 | G | 9.5.82 | 5,000 | 2,566 |
| 7 | G | 9.5.82 | 5,000 | 2,566 |
| 192 1 | L | 2.11.64 | g.560 | 1,642 |
| 2 | L | 17.6.68 | g.2,400 | 6,033 |
| 3 | L | 17.6.68 | g.1,300 | 3,268 |
| 4 | L | 5.6.61 | g.310 | 912 |
| 5 | L | 6.3.78 | 3,500 | 6,681 |
| 6 | L | 5.6.61 | — | — |
| 7 | L | 5.6.61 | g.320 | 942 |
| 8 | L | 6.3.78 | 4,200 | 8,017 |
| 9 | L | 2.2.81 | 1,900 | 4,369 |
| 193 10-11 | L | 23.2.81 | 930 (6) | 2,138 |
| 12 | L | 5.6.81 | g.2,000 | 5,885 |
| 13 | L | 23.2.81 | 900 | 2,069 |
| 14 | L | 5.6.61 | — | — |
| 194 1 | G | 12.5.80 | 10,500 | 6,318 |
| 2 | L | 28.3.83 | 3,800 | 5,666 |
| 3 | L | 28.3.83 | 7,000 | 10,437 |

| Page | Place | Date | Price (local) | Price ($ US) |
|---|---|---|---|---|
| 195 4 | L | 12.7.65 | g.220 | 646 |
| 5 | G | 12.5.80 | 1,700 | 1,023 |
| 6 | G | 12.5.80 | 3,000 | 1,805 |
| 7 | G | 12.5.80 | 2,800 | 1,685 |
| 8 | G | 12.5.80 | 3,800 | 2,286 |
| 9 | G | 12.5.80 | 3,800 | 2,286 |
| 10 | G | 20.11.70 | 35,000 | 8,117 |
| 196 1 | L | 26.6.78 | 1,000 | 1,837 |
| 2 | G | 17.11.80 | 5,500 | 3,184 |
| 3 | L | 14.4.80 | 3,000 | 6,649 |
| 4 | G | 17.11.80 | 22,000 | 12,738 |
| 5 | L | 28.10.74 | g.1,000 | 1,788 |
| 6 | L | 6.3.78 | 850 | 1,623 |
| 7 | L | 17.2.69 | g.1,000 | 2,510 |
| 8 | L | 17.2.69 | g.1,400 | 3,514 |
| 9 | L | 6.3.78 | 5,500 | 10,499 |
| 197 10 | L | 24.11.69 | g.200 | 504 |
| 11 | L | 29.6.81 | 260 | 514 |
| 12 | L | 24.2.75 | g.400 | 1,008 |
| 13 | L | 14.4.80 | 320 | 709 |
| 14 | L | 5.2.79 | 1,500 | 3,006 |

## THE NETHERLANDS

| Page | Place | Date | Price (local) | Price ($ US) |
|---|---|---|---|---|
| 198 1 | E | 26.9.79 | 55,000 | 120,956 |
| 199 2 | A | 24.10.79 | 12,000 | 6,047 |
| 200 1 | L | 14.4.80 | 7,000 | 15,515 |
| 201 2 | L | 3.10.83 | 2,400 | 3,593 |
| 202 1 | A | 11.6.80 | 12,000 | 6,188 |
| 203 2 | A | 27.10.83 | 30,000 | 10,274 |
| 204 1 | A | 14.5.82 | 200 | 78 |
| 2 | A | 14.5.82 | 240 | 94 |
| 3 | A | 14.5.82 | 160 | 62 |
| 4 | A | 14.5.82 | 220 | 86 |
| 5 | A | 14.5.82 | 160 | 62 |
| 6 | A | 14.5.82 | 200 | 78 |
| 7 | L | 5.2.79 | 320 | 641 |
| 8 | L | 14.4.80 | 320 | 709 |
| 9 | L | 24.1.77 | 180 | 308 |
| 205 10 | L | 4.10.82 | 80 | 136 |
| 11 | L | 4.10.82 | 150 | 255 |
| 12 | L | 5.4.82 | 600 | 1,063 |
| 13 | L | 24.11.80 | 5,000 | 11,984 |
| 14 | L | 28.6.82 | 600 | 1,055 |
| 15 | L | 28.6.82 | 220 | 387 |
| 206 1 | A | 24.10.79 | 35,000 | 17,638 |
| 207 2 | A | 11.6.80 | 7,000 | 3,609 |
| 3 | A | 24.10.79 | 2,400 | 1,209 |
| 4 | A | 24.10.79 | 9,000 | 4,536 |
| 5 | A | 24.10.79 | 1,600 | 806 |
| 6 | A | 24.10.79 | 6,800 | 3,427 |
| 7 | A | 24.10.79 | 8,000 | 4,032 |
| 8 | A | 24.10.79 | 5,500 | 2,772 |
| 208 1 | A | 24.10.79 | 14,000 | 7,055 |
| 2 | A | 24.10.79 | 4,500 | 2,268 |
| 3 | L | 4.10.76 | 500 | 820 |
| 4 | L | 25.11.68 | g.300 | 754 |
| 5 | L | 29.6.81 | 1,150 | 2,272 |
| 6 | L | 2.11.64 | g.980 | 2,874 |
| 209 7 | A | 11.6.80 | 5,500 | 2,836 |
| 8 | A | 24.10.79 | 700 | 353 |
| 9 | A | 24.10.79 | 5,000 | 2,520 |
| 10 | A | 24.10.79 | 4,000 | 2,016 |
| 11 | A | 24.10.79 | 2,100 | 1,058 |
| 12 | A | 24.10.79 | 8,000 | 4,032 |
| 13 | A | 24.10.79 | 11,000 | 5,543 |
| 14 | NY | 14.10.83 | — | 1,900 |
| 210 1 | A | 24.10.79 | 2,400 | 1,209 |
| 2 | A | 24.10.79 | 4,000 | 2,016 |
| 3 | A | 24.10.79 | 4,000 | 2,016 |
| 4 | A | 24.10.79 | 13,000 | 6,551 |

| Page | Place | Date | Price (local) | Price ($ US) |
|---|---|---|---|---|
| 210 5 | A | 24.10.79 | 24,000 | 12,095 |
| 6 | A | 24.10.79 | 9,000 | 4,536 |
| 211 7 | L | 25.6.79 | 24,450 | 51,345 |
| 212 1 | L | 4.10.76 | 260 | 426 |
| 2 | L | 23.2.81 | 220 | 506 |
| 3 | L | 23.2.81 | 600 | 1,380 |
| 4 | L | 23.2.81 | 170 | 391 |
| 5 | L | 4.10.82 | 550 | 934 |
| 6 | L | 4.10.82 | 160 | 272 |
| 7 | L | 4.10.82 | 100 | 170 |
| 8 | L | 16.6.71 | g.2,500 | 6,407 |
| 9 | L | 11.4.80 | 1,000 (pr) | 2,216 |
| 10 | L | 18.5.70 | g.180 | 453 |
| 213 11 | L | 4.10.76 | 1,100 | 1,803 |
| 12 | L | 14.11.77 | 220 | 400 |
| 13 | L | 19.5.75 | g.100 | 244 |
| 14 | L | 19.5.75 | g.90 | 219 |
| 15 | L | 19.5.75 | g.280 | 683 |
| 16 | L | 29.6.81 | 750 (6) | 1,482 |
| 17 | L | 29.6.81 | 480 | 948 |
| 18 | L | 29.6.81 | 300 | 593 |
| 19 | L | 18.5.70 | g.1,150 | 2,893 |
| 20 | L | 18.5.70 | g.750 (pr) | 1,887 |
| 214 1 | L | 6.3.78 | 12,000 | 22,907 |
| 2 | A | 24.10.79 | 15,000 | 7,559 |
| 215 3 | A | 24.10.79 | 20,500 | 10,331 |
| 4 | A | 24.10.79 | 35,000 | 17,638 |
| 5 | A | 24.10.79 | 10,000 | 5,040 |
| 6 | A | 11.6.80 | 2,000 | 1,031 |
| 216 1 | L | 4.10.82 | 150 | 255 |
| 2 | L | 14.7.80 | 1,400 | 3,321 |
| 3 | L | 8.4.74 | g.880 | 2,162 |
| 4 | L | 12.4.76 | 580 | 1,072 |
| 5 | L | 8.4.74 | g.1,050 | 2,580 |
| 6 | L | 8.4.74 | g.750 | 1,843 |
| 7 | L | 8.4.74 | g.420 | 1,032 |
| 217 8 | L | 28.6.82 | 550 | 967 |
| 9 | L | 28.6.82 | 1,700 | 2,988 |
| 10 | L | 14.4.80 | 420 | 931 |
| 11 | L | 18.5.70 | g.900 | 2,264 |
| 12 | A | 11.6.80 | 2,200 | 1,134 |
| 13 | L | 24.11.69 | g.240 | 604 |
| 218 1 | A | 24.10.79 | 8,200 | 4,132 |
| 2 | A | 24.10.79 | 8,000 | 4,032 |
| 3 | A | 24.10.79 | 17,500 | 8,819 |
| 4 | A | 24.10.79 | 13,000 | 6,551 |
| 5 | A | 24.10.79 | 16,000 | 8,063 |
| 6 | A | 24.10.79 | 3,800 | 1,915 |
| 219 7 | A | 24.10.79 | 7,800 | 3,528 |
| 8 | A | 24.10.79 | 9,500 | 4,788 |
| 9 | A | 24.10.79 | 4,200 | 2,117 |
| 10 | A | 24.10.79 | 3,000 | 1,512 |
| 11 | L | 24.10.79 | 6,900 | 3,477 |
| 220 1 | L | 12.4.76 | 450 | 832 |
| 2 | L | 29.6.81 | 400 (3) | 790 |
| 3 | L | 29.6.81 | 180 | 356 |
| 4 | L | 29.6.81 | 110 | 217 |
| 5 | L | 29.6.81 | 200 (2) | 395 |
| 6 | L | 29.6.81 | 270 (3) | 533 |
| 7 | L | 29.6.81 | 320 (2) | 632 |
| 8 | L | 29.6.81 | 180 | 356 |
| 9 | L | 29.6.81 | 170 | 336 |
| 10 | L | 12.4.76 | 500 | 924 |
| 11 | L | 12.4.76 | 220 | 407 |
| 12 | A | 26.3.76 | 380 | 141 |
| 221 13 | L | 29.6.81 | 150 | 296 |
| 14 | L | 29.6.81 | 90 | 178 |
| 15 | L | 29.6.81 | 130 | 256 |
| 16 | L | 12.4.76 | 240 | 444 |
| 17 | L | 23.2.81 | 180 (2) | 414 |

| Page | Place | Date | Price (local) | Price ($ US) |
|---|---|---|---|---|
| 221 18 | L | 23.2.81 | 150 | 345 |
| 19 | L | 23.2.81 | 100 | 230 |
| 20 | L | 29.6.81 | 220 | 435 |
| 21 | L | 29.6.81 | 300 | 593 |
| 22 | L | 29.6.81 | 150 | 296 |
| 23 | L | 14.11.77 | 4,100 | 7,458 |
| 24 | L | 8.4.74 | g.900 | 2,259 |
| 25 | L | 12.4.76 | 480 | 887 |
| 26 | L | 28.6.82 | 320 | 562 |
| 222 1 | L | 14.11.77 | 130 | 236 |
| 2 | A | 27.10.83 | 2,600 | 890 |
| 3 | L | 14.7.80 | 1,150 | 2,728 |
| 4 | L | 4.10.76 | 220 | 361 |
| 5 | L | 4.10.76 | 260 | 426 |
| 6 | L | 12.4.76 | 520 | 961 |
| 7 | L | 4.10.76 | 1,700 | 2,787 |
| 8 | L | 7.6.66 | g.52 | 152 |
| 9 | L | 7.6.66 | g.115 | 336 |
| 10 | L | 7.6.66 | g.68 | 199 |
| 223 11 | E | 26.9.79 | 10,000 | 21,992 |
| 12 | L | 14.4.80 | 600 | 1,330 |
| 13 | L | 12.4.76 | 400 | 739 |
| 14 | L | 30.4.79 | 900 (2) | 1,866 |
| 15 | L | 4.10.76 | 300 (2) | 492 |
| 16 | L | 4.10.76 | 500 | 820 |
| 224 1 | L | 4.4.77 | 650 | 1,117 |
| 2 | E | 26.9.79 | 3,500 | 7,697 |
| 3 | L | 29.6.81 | 500 | 988 |
| 4 | L | 29.6.81 | 140 | 277 |
| 5 | L | 29.6.81 | 70 | 138 |
| 6 | L | 29.6.81 | 150 | 296 |
| 7 | L | 14.7.80 | 320 | 759 |
| 225 8 | L | 14.11.77 | 440 | 800 |
| 9 | L | 14.7.80 | 280 | 664 |
| 10 | L | 14.7.80 | 90 | 213 |
| 11 | L | 29.6.81 | 1,000 | 1,976 |
| 12 | A | 27.10.83 | 2,200 | 753 |
| 13 | L | 14.7.80 | 4,800 | 11,387 |
| 14 | L | 14.7.80 | 380 | 901 |
| 15 | A | 20.10.77 | 4,500 | 1,847 |
| 226 1 | L | 5.4.65 | g.58 | 170 |
| 2 | L | 5.4.82 | 320 | 567 |
| 3 | A | 26.3.76 | 1,500 | 557 |
| 4 | L | 29.6.81 | 350 | 692 |
| 227 5-6,8 | L | 24.2.75 | g.850 (9) | 2,137 |
| 7 | L | 28.10.74 | g.1,600 | 3,919 |
| 227 9 | L | 14.7.80 | 110 | 261 |
| 10 | L | 14.7.80 | 120 | 285 |
| 11 | L | 24.11.80 | 350 | 839 |
| 12 | L | 4.10.76 | 950 | 1,557 |
| 228 1 | L | 18.5.70 | g.360 | 906 |
| 2 | L | 14.11.77 | 160 | 291 |
| 3 | L | 14.11.77 | 2,100 | 3,820 |
| 4-5 | L | 24.11.80 | 900 (2) | 2,157 |
| 6 | L | 18.5.70 | g.3,200 | 8,049 |
| 7 | L | 18.5.70 | g.850 | 2,138 |
| 229 8-9 | L | 12.4.76 | 450 (2) | 832 |
| 10 | A | 25.3.76 | —— | —— |
| 11 | L | 4.10.76 | 1,300 | 2,131 |
| 12 | L | 4.10.82 | 800 | 1,358 |
| 230 1 | A | 13.5.82 | 4,400 | 1715 |
| 2 | A | 13.5.82 | 4,800 | 1,871 |
| 3 | A | 13.5.82 | 1,800 | 702 |
| 4 | A | 13.5.82 | 1,800 | 702 |
| 5 | A | 13.5.82 | 6,500 | 2,534 |
| 6 | A | 13.5.82 | 2,600 | 1,014 |
| 7 | A | 13.5.82 | 2,800 | 1,092 |
| 8 | A | 13.5.82 | 5,500 | 2,144 |
| 9 | A | 13.5.82 | 3,000 | 1,170 |
| 10 | A | 13.5.82 | 1,100 | 429 |
| 230 11 | A | 13.5.82 | 4,500 | 1,754 |
| 12 | A | 13.5.82 | 2,000 | 780 |
| 231 13 | A | 13.10.81 | 2,600 | 1,046 |
| 14 | A | 13.10.81 | 1,100 | 442 |
| 15 | A | 13.10.81 | 1,500 | 603 |
| 16 | A | 13.10.81 | 1,400 | 563 |
| 17 | A | 13.10.81 | 3,000 | 1,207 |
| 18 | A | 13.10.81 | 4,500 | 1,810 |
| 19 | A | 13.10.81 | 4,500 | 1,810 |
| 20 | A | 13.10.81 | 1,800 | 724 |
| 21 | A | 13.10.81 | 800 · | 322 |
| 22 | A | 13.10.81 | 1,500 | 603 |
| 23 | A | 13.10.81 | 8,200 | 3,298 |
| 24 | A | 13.10.81 | 1,000 | 402 |
| 232 1 | L | 28.6.82 | 480 | 844 |
| 2 | L | 18.5.66 | g.160 | 469 |
| 3 | L | 12.4.76 | 230 | 425 |
| 4 | L | 14.11.77 | 450 | 819 |
| 233 5-6 | L | 24.2.75 | g.400 (2) | 1,006 |
| 7 | L | 5.4.65 | g.36 | 106 |
| 8 | L | 4.4.77 | 680 | 1,169 |

## ENGLAND: DELFT

| Page | Place | Date | Price (local) | Price ($ US) |
|---|---|---|---|---|
| 234 1 | NY | 6.3.81 | —— | 22,000 |
| 2 | L | 10.10.83 | 3,000 | 4,492 |
| 3 | L | 10.10.83 | 1,600 | 2,396 |
| 4 | L | 10.10.83 | 1,800 | 2,695 |
| 236 1 | L | 6.12.82 | 4,500 | 7,283 |
| 2 | L | 10.10.83 | 4,500 | 6,738 |
| 237 3 | L | 10.10.83 | 1,600 | 2,396 |
| 4 | L | 10.10.83 | 1,500 | 2,246 |
| 5 | L | 10.10.83 | 1,600 | 2,396 |
| 238 1 | L | 19.4.81 | 190 | 414 |
| 2 | L | 19.4.81 | 2,200 | 4,795 |
| 3 | L | 19.4.81 | 130 | 283 |
| 4 | L | 2.11.81 | 320 | 609 |
| 5 | L | 2.11.81 | 280 | 533 |
| 6 | L | 2.11.81 | 190 | 362 |
| 7 | L | 2.11.81 | 800 | 1,522 |
| 8 | L | 2.11.81 | 500 | 951 |
| 9 | L | 2.11.81 | 380 | 723 |
| 10 | L | 2.11.81 | 120 | 228 |
| 11 | L | 9.7.73 | g.150 | 394 |
| 12 | L | 17.5.76 | 200 | 362 |
| 13 | L | 29.1.79 | 110 | 221 |
| 14 | L | 29.1.79 | 190 | 381 |
| 239 15 | L | 2.6.75 | g.520 | 1,246 |
| 16 | L | 7.11.77 | 1,000 | 1,819 |
| 17 | L | 17.5.76 | 420 | 760 |
| 18 | L | 22.10.79 | 320 | 687 |
| 19 | L | 5.3.73 | g.80 | 206 |
| 20 | L | 8.5.67 | g.120 | 346 |
| 21 | L | 1.6.70 | g.130 | 327 |
| 240 1 | L | 25.9.78 | 1,000 | 1,958 |
| 2 | L | 2.11.81 | 1,800 | 3,425 |
| 3 | L | 4.6.79 | 550 | 1,161 |
| 4 | L | 24.1.77 | 500 | 857 |
| 5 | L | 12.7.82 | 1,500 | 2,602 |
| 6 | L | 12.7.82 | 1,050 | 1,822 |
| 241 7 | L | 21.5.73 | g.1,700 | 4,379 |
| 8 | L | 7.11.77 | 2,000 | 3,638 |
| 9 | L | 19.4.81 | 1,400 | 3,051 |
| 10 | L | 19.4.81 | 1,150 | 2,506 |
| 11 | L | 19.4.81 | 3,200 | 6,974 |
| 12 | L | 8.12.80 | 880 | 2,063 |
| 13 | L | 8.12.80 | 1,450 | 3,400 |
| 14 | L | 8.12.80 | 500 | 1,172 |
| 15 | L | 19.4.81 | —— | —— |
| 16 | L | 19.4.81 | 600 | 1,308 |
| 17 | L | 19.4.81 | 550 | 1,199 |
| 241 18 | L | 2.6.75 | g.750 | 1,797 |
| 19 | L | 8.12.80 | 2,200 | 5,159 |
| 20 | L | 29.3.71 | g.40 | 103 |
| 21 | L | 29.3.71 | —— | |
| 242 1 | L | 7.7.75 | g.400 | 917 |
| 2 | L | 17.7.72 | g.1,350 | 3,546 |
| 3 | L | 17.7.72 | g.700 | 1,838 |
| 4 | L | 29.3.71 | g.420 | 1,076 |
| 5 | L | 15.5.78 | 1,100 | 2,000 |
| 6 | L | 17.7.72 | g.880 | 2,311 |
| 7 | L | | —— | —— |
| 8 | L | | —— | —— |
| 243 9 | L | 22.5.72 | g.220 | 578 |
| 10 | L | 18.2.80 | 1,200 | 2,748 |
| 11 | L | 17.7.72 | g.320 | 840 |
| 12 | L | 17.7.72 | g.400 | 1,051 |
| 13 | L | 17.7.72 | g.400 | 1,051 |
| 14 | L | 17.7.72 | g.450 | 1,182 |
| 15 | L | 17.7.72 | g.620 | 1,628 |
| 243 16 | L | 7.11.77 | 820 | 1,492 |
| 17 | L | 2.6.75 | g.500 | 1,198 |
| 244 1 | L | 17.5.76 | 350 | 634 |
| 2 | L | 29.1.79 | 1,000 | 2,005 |
| 3 | L | 30.5.77 | 170 | 292 |
| 4 | L | 19.7.76 | 140 | 250 |
| 5 | L | 29.3.71 | g.210 | 538 |
| 6 | L | 29.3.71 | g.150 | 384 |
| 7 | L | 5.6.78 | 800 | 1,470 |
| 245 8 | L | 5.4.65 | g.32 | 94 |
| 9 | L | 5.4.65 | g.22 | 65 |
| 10 | L | 11.10.71 | g.150 | 384 |
| 11 | L | 29.3.71 | g.100 | 256 |
| 12 | L | 29.3.71 | g.45 | 115 |
| 13 | L | 17.5.76 | 120 | 217 |
| 14 | L | 12.7.82 | 280 | 486 |
| 15 | L | 12.7.82 | 260 | 451 |
| 16 | L | 2.6.75 | g.750 | 1,797 |
| 246 1 | L | 15.12.75 | g.1,000 | 2,123 |
| 2 | L | 4.12.67 | g.150 | 433 |
| 3 | L | 12.7.82 | 300 | 520 |
| 4 | L | 15.5.78 | 1,400 | 2,545 |
| 5 | L | 9.6.80 | 1,600 | 3,738 |
| 247 6 | L | 2.6.75 | g.170 | 407 |
| 7 | L | 2.6.75 | g.240 | 575 |
| 8 | L | 9.6.80 | 320 | 748 |
| 9 | L | 29.1.79 | 2,800 | 5,614 |
| 10 | L | 13.7.81 | 2,800 | 5,253 |
| 11 | L | 13.7.81 | 800 | 1,501 |
| 12 | L | 13.7.81 | 190 | 356 |
| 13 | L | 29.1.79 | 95 | 190 |
| 14 | L | 29.1.79 | 480 | 962 |
| 248 1 | L | 19.5.80 | 800 | 1,842 |
| 2 | L | 10.12.79 | 300 | 660 |
| 3 | L | 14.10.68 | g.700 | 1,760 |
| 4 | L | 24.1.77 | 650 | 1,114 |
| 5 | L | 10.12.79 | 3,000 | 6,600 |
| 6 | L | 29.1.79 | 4,000 | 8,020 |
| 249 7 | L | 4.6.79 | 160 | 338 |
| 8 | L | 21.7.80 | 500 | 1,186 |
| 9 | L | 3.2.75 | g.4,500 | 11,312 |
| 10 | L | 3.2.75 | g.2,700 | 6,787 |
| 11 | L | 9.3.70 | g.750 | 1,887 |
| 12 | L | 19.5.80 | 280 | 645 |
| 250 1 | L | 6.12.82 | 3,800 | 6,150 |
| 2 | L | 6.12.82 | 1,200 | 1,942 |
| 3 | L | 6.12.82 | 4,000 | 6,474 |
| 4 | L | 6.12.82 | 1,700 (2) | 2,752 |
| 5 | L | 6.12.82 | 1,100 | 1,780 |
| 6 | L | 30.5.77 | 600 | 1,031 |
| 7 | L | 18.2.80 | 500 | 1,145 |

| Page | | Place | Date | Price (local) | Price ($ US) |
|---|---|---|---|---|---|
| 250 | 8 | L | 4.6.79 | 190 | 401 |
| | 9 | L | 4.6.79 | 250 | 528 |
| | 10 | L | 4.6.79 | 190 | 401 |
| | 11 | L | 19.4.81 | —— | —— |
| 251 | 12 | L | 2.6.75 | g.450 | 1,078 |
| | 13 | L | 19.4.82 | 320 | 567 |
| | 14 | L | 29.1.79 | 280 | 561 |
| | 15 | L | 14.12.81 | 1,300 | 2,478 |
| 252 | 1 | L | 14.2.72 | g.40 | 105 |
| | 2 | L | 14.2.72 | g.100 | 263 |
| | 3 | L | 14.2.72 | g.70 | 184 |
| | 4 | L | 9.10.67 | g.440 | 1,270 |
| | 5 | L | 2.6.75 | g.300 | 719 |
| | 6 | L | 2.6.75 | g.2,600 | 6,228 |
| | 7 | L | 2.6.75 | g.700 | 1,677 |
| | 8 | L | 30.5.77 | 400 | 687 |
| | 9 | L | 30.5.77 | 240 | 412 |
| | 10 | L | 17.5.76 | 1,300 | 2,353 |
| 253 | 11 | L | 17.5.76 | 260 | 471 |
| | 12 | L | 15.12.75 | g.100 | 212 |
| | 13 | L | 2.6.75 | g.50 | 120 |
| | 14 | L | 2.6.75 | g.150 | 359 |
| | 15 | L | 30.5.77 | 120 | 206 |
| | 16 | L | 4.6.79 | 120 | 253 |
| | 17 | L | 4.6.79 | 95 | 201 |
| | 18 | L | 22.10.79 | 2,700 | 5,793 |
| | 19 | L | 4.6.79 | 200 | 422 |
| | 20 | L | 4.6.79 | 220 | 464 |
| 254 | 1 | L | 9.6.80 | 840 | 1,962 |
| | 2 | L | 8.12.80 | 48 | 113 |
| | 3 | L | 8.12.80 | 65 | 152 |
| | 4 | L | 8.12.80 | 50 | 117 |
| 255 | 5 | L | 16.7.79 | 220 | 497 |
| | 6 | L | 16.7.79 | 220 | 497 |
| | 7 | L | 16.7.79 | 180 | 407 |
| | 8 | L | 15.5.78 | 1,400 | 2,545 |
| 256 | 1 | L | 14.12.81 | 130 | 248 |
| | 2 | L | 14.12.81 | 130 | 248 |
| | 3 | L | 14.12.81 | 130 | 248 |
| | 4 | L | 8.12.80 | 120 | 281 |
| | 5 | L | 8.12.80 | 80 | 188 |
| | 6 | L | 8.12.80 | 110 | 258 |
| | 7 | L | 8.12.80 | 40 | 94 |
| | 8 | L | 8.12.80 | 120 | 281 |
| | 9 | L | 8.12.80 | 80 | 188 |
| | 10 | L | 8.12.80 | 20 | 47 |
| | 11 | L | 8.12.80 | 45 | 106 |
| | 12 | L | 8.12.80 | 55 | 129 |
| | 13 | L | 10.12.79 | 110 | 242 |
| 257 | 14 | L | 9.10.67 | g.420 | 1,213 |
| | 15 | L | 17.5.76 | 550 | 996 |
| | 16 | L | 22.10.79 | 140 | 300 |
| | 17 | L | 29.1.79 | 5,000 | 10,025 |

## ENGLAND: POTTERY

| Page | | Place | Date | Price (local) | Price ($ US) |
|---|---|---|---|---|---|
| 258 | 1 | L | 13.6.83 | 14,000 | 21,698 |
| 261 | 1 | L | 13.6.83 | 2,800 | 4,340 |
| 262 | 1 | L | 9.6.80 | 4,500 | 1,051 |
| | 2 | L | 18.2.80 | 3,200 | 7,328 |
| 263 | 3 | L | 6.10.70 | g.1,400 | 3,528 |
| | 4 | L | 17.4.72 | g.130 | 341 |
| | 5 | L | 18.11.74 | g.8,000 | 19,595 |
| 264 | 1 | L | 14.2.72 | g.1,350 | 3,546 |
| | 2 | L | 19.4.81 | 190 | 414 |
| | 3 | L | 19.4.81 | 160 | 349 |
| | 4 | L | 19.4.81 | 150 | 327 |
| | 5 | L | 14.2.72 | g.1,550 | 4,071 |
| | 6 | L | 18.11.74 | g.650 | 1,638 |
| | 7 | L | 9.6.80 | 100 | 234 |
| | 8 | L | 9.6.80 | 110 | 257 |

| Page | | Place | Date | Price (local) | Price ($ US) |
|---|---|---|---|---|---|
| 264 | 9 | L | 10.12.79 | 150 | 330 |
| 265 | 10 | L | 21.7.54 | g.230 | 676 |
| | 11 | L | 9.6.80 | 500 | 1,168 |
| | 12 | L | 7.7.75 | g.1,500 | 3,440 |
| | 13 | L | 14.12.81 | 2,600 | 4,957 |
| | 14 | L | 9.6.80 | 2,00 | 4,672 |
| 266 | 1 | L | 6.10.70 | g.450 | 1,134 |
| | 2 | L | 6.10.70 | g.160 | 408 |
| | 3 | L | 14.12.81 | 3,200 | 6,101 |
| | 4 | L | 29.1.79 | 700 | 1,403 |
| | 5 | L | 17.5.81 | 400 | 836 |
| | 6 | L | 21.7.80 | 2,400 | 5,693 |
| 267 | 7 | L | 9.6.80 | 240 | 561 |
| | 8 | NY | 4.11.81 | - | 6,500 |
| | 9 | L | 9.6.80 | 950 | 2,219 |
| 268 | 1 | L | 17.11.75 | g.30 | 65 |
| | 2 | L | 5.3.73 | g.75 | 193 |
| | 3 | L | 7.7.75 | g.1,300 | 2,982 |
| | 4 | L | 16.7.79 | 320 | 723 |
| | 5 | L | 30.5.77 | 350 | 601 |
| | 6 | L | 17.5.76 | 70 | 127 |
| | 7 | L | 16.7.79 | 140 | 316 |
| 269 | 8 | L | 22.5.72 | g.120 | 315 |
| | 9 | L | 19.5.80 | 450 | 1,036 |
| | 10 | L | 16.3.81 | 460 | 1,026 |
| | 11 | L | 16.3.81 | 950 | 2,119 |
| | 12 | L | 16.7.79 | 340 | 768 |
| | 13 | L | 10.12.79 | 300 | 660 |
| | 14 | L | 10.12.79 | 100 | 220 |
| 270 | 1 | L | 18.10.76 | 2,000 | 3,279 |
| | 2 | L | 19.5.80 | 14,000 | 3,223 |
| | 3 | L | 19.5.80 | 700 | 1,612 |
| | 4 | L | 25.9.78 | 170 | 333 |
| 271 | 5 | L | 25.9.78 | 350 | 685 |
| | 6 | L | 10.5.80 | 700 | 1,612 |
| | 7 | L | 18.2.80 | 320 | 733 |
| | 8 | L | 18.2.80 | 950 | 218 |
| | 9 | L | 19.5.80 | 2,600 | 5,986 |
| | 10 | L | 19.5.80 | 3,000 | 6,907 |
| 272 | 1 | L | 8.12.80 | 80 | 188 |
| | 2 | L | 8.12.80 | 200 | 469 |
| | 3 | L | 4.6.79 | 300 | 633 |
| | 4 | L | 18.2.80 | 950 | 2,175 |
| | 5 | L | 15.5.78 | 450 | 818 |
| | 6 | L | 9.6.80 | 130 | 304 |
| | 7 | E | 14.10.80 | 250 | 604 |
| | 8 | L | 4.6.79 | 280 | 591 |
| | 9 | L | 4.6.79 | 320 | 675 |
| | 10 | L | 18.3.74 | g.270 | 663 |
| | 11 | L | 9.6.80 | 260 | 607 |
| | 12 | L | 7.7.75 | g.1,500 | 3,440 |
| 273 | 13 | L | 8.12.80 | 280 | 657 |
| | 14 | L | 8.12.80 | 320 | 750 |
| | 15 | L | 8.12.80 | 300 | 703 |
| | 16 | L | 8.12.80 | 220 | 516 |
| | 17 | L | 2.11.81 | 280 | 533 |
| | 18 | L | 2.11.81 | 900 | 1,713 |
| | 19 | L | 2.11.81 | 750 | 1,427 |
| | 20 | L | 2.11.81 | 500 | 951 |
| | 21 | L | 2.11.81 | 1,150 | 2,188 |
| | 22 | L | 2.11.81 | 1,200 | 2,284 |
| | 23 | L | 25.9.78 | 280 | 548 |
| | 24 | L | 25.9.78 | 260 | 509 |
| | 25 | L | 7.7.75 | g.190 | 436 |
| | 26 | L | 7.7.75 | g.850 | 1,950 |
| | 27 | L | 18.3.74 | g.800 | 1,965 |
| | 28 | L | 18.2.80 | 450 | 1,030 |
| | 29 | L | 10.10.66 | g.130 | 381 |
| 274 | 1 | L | 19.5.80 | 350 | 806 |
| | 2 | L | 18.10.76 | 4,000 | 6,557 |

| Page | | Place | Date | Price (local) | Price ($ US) |
|---|---|---|---|---|---|
| 274 | 3 | L | 16.7.79 | 550 | 1,243 |
| | 4 | L | 18.2.80 | 6,500 | 14,884 |
| | 5 | L | 19.5.80 | 2,200 | 5,065 |
| 275 | 6 | L | 17.5.76 | 4,200 | 7,603 |
| | 7 | L | 4.6.79 | 6,500 | 13,720 |
| 276 | 1 | L | 18.2.80 | 2,000 | 4,580 |
| | 2 | L | 14.6.65 | g.185 | 543 |
| | 3 | L | 14.6.65 | g.95 | 279 |
| | 4 | L | 15.5.78 | 1,000 | 1,818 |
| | 5 | L | 18.2.80 | 350 | 801 |
| | 6 | L | 18.2.80 | 1,200 | 2,748 |
| | 7 | L | 9.11.70 | g.310 | 855 |
| | 8 | L | 19.5.80 | 750 | 1,727 |
| | 9 | L | 22.5.72 | g.290 | 762 |
| 277 | 10 | L | 17.5.81 | 1,400 | 2,926 |
| | 11 | L | 18.10.76 | 1,800 | 2,951 |
| | 12 | L | 19.5.80 | 1,000 | 2,302 |
| | 13 | L | 24.4.60 | g.30 | 88 |
| 278 | 1 | L | 18.2.80 | 1,650 | 3,778 |
| | 2 | L | 19.5.80 | 1,800 | 4,144 |
| 279 | 3 | L | 19.5.80 | 2,800 | 6,447 |
| | 4 | L | 18.10.76 | 1,200 | 1,967 |
| | 5 | L | 18.2.80 | 1,600 | 3,664 |
| | 6 | NY | 6.3.81 | —— | 11,000 |
| | 7 | NY | 6.3.81 | —— | 5,000 |
| 280 | 1 | L | 13.2.78 | 700 | 1,358 |
| | 2 | L | 6.10.70 | g.280 | 704 |
| | 3 | L | 18.2.80 | 700 | 1,603 |
| | 4 | L | 18.2.80 | 600 | 1,374 |
| 281 | 5 | L | 18.2.80 | 1,300 | 2,977 |
| | 6 | L | 16.7.79 | 780 | 1,763 |
| | 7 | L | 16.7.79 | 300 | 678 |
| | 8 | L | 16.7.79 | 180 | 407 |
| | 9 | L | 16.7.79 | 300 | 678 |
| | 10 | L | 16.7.79 | 85 | 192 |
| 282 | 1 | L | 24.1.77 | 1,200 | 2,056 |
| | 2 | L | 21.5.73 | 1,400 | 3,435 |
| | 3 | L | 25.9.78 | 900 | 1,762 |
| | 4 | NY | 21.4.82 | —— | 14,300 |
| 283 | 5 | NY | 21.4.82 | —— | 12,100 |
| 284 | 1 | L | 27.5.76 | g.2,700 | 6,582 |
| | 2 | L | 17.5.76 | 260 | 471 |
| | 3 | L | 17.5.76 | 600 | 1,086 |
| | 4 | L | 16.5.66 | g.640 | 1,875 |
| | 5 | L | 29.3.71 | g.600 | 1,538 |
| | 6 | L | 19.7.76 | 1,000 | 1,786 |
| | 7-8 | E | 2.6.78 | 1,000(pr) | 1,837 |
| 285 | 9 | L | 25.9.78 | 650 | 1,272 |
| | 10 | L | 27.5.75 | g.1,600 | 3,901 |
| | 11 | L | 27.5.75 | 9.950 | 2,316 |
| | 12 | L | 19.7.76 | 350 | 625 |
| | 13 | L | 19.7.76 | 600 | 1,072 |
| | 14 | L | 16.1.71 | g.130 | 333 |
| 286 | 1 | L | | —— | —— |
| | 2 | L | 10.12.79 | 450 | 990 |
| | 3 | L | 14.2.72 | g.380 | 998 |
| | 4 | L | 1.6.70 | g.800 | 2,016 |
| | 5 | L | 17.5.76 | 950 | 1,720 |
| | 6 | L | 30.11.64 | g.2,900 | 8,504 |
| | 7 | L | 25.9.78 | 250(pr) | 489 |
| | 8 | L | 24.2.77 | 1,400 | 2,394 |
| | 9 | L | 2.11.81 | 1,500 | 2,854 |
| | 10 | L | 25.4.60 | g.150 | 442 |
| | 11 | L | 18.10.76 | 700 | 1,148 |
| | 12 | L | 16.7.79 | 420 | 949 |
| | 13 | L | 16.7.79 | 220 | 497 |
| | 14 | L | 16.7.79 | 260 | 588 |
| | 15 | L | 30.5.77 | 1,300 | 2,234 |
| 288 | 1 | L | 30.5.77 | 390 | 670 |
| | 2 | L | 30.5.77 | 420 | 722 |

| Page | | Place | Date | Price (local) | Price ($ US) |
|---|---|---|---|---|---|
| 288 | 3 | L | 30.5.77 | 980 | 1,604 |
| | 4 | L | 16.12.63 | g.78 | 229 |
| | 5 | L | 25.9.78 | 170 | 333 |
| | 6 | L | 6.10.70 | g.95 | 239 |
| | 7 | L | 18.12.72 | g.3,200 | 8,405 |
| | 8 | L | 6.10.70 | g.80 | 201 |
| 289 | 9 | L | 6.10.70 | g.650 | 1,635 |
| | 10 | L | 13.2.78 | 450 | 873 |
| | 11 | L | 10.12.79 | 320 | 704 |
| | 12 | L | 25.9.78 | 700 | 1,370 |
| | 13 | L | 9.6.80 | 380 | 888 |
| | 14 | L | 17.5.76 | 500 | 905 |
| | 15 | L | 4.6.79 | 650 | 1,372 |
| 290 | 1 | L | 16.7.79 | 220 | 497 |
| | 2 | L | 13.7.81 | 550 | 1,032 |
| | 3 | L | 25.9.78 | 550 | 1,077 |
| | 4 | L | 9.6.80 | 110 | 257 |
| | 5 | — | —— | | —— |
| 291 | 6 | L | 18.2.80 | 400 | 916 |
| | 7 | L | 26.1.70 | g.600 | 1,509 |
| | 8 | L | 13.2.78 | 550 | 1,067 |
| | 9 | L | 8.12.80 | 2,800 | 6,565 |
| | 10 | L | 18.10.76 | 3,000 | 4,918 |
| | 11 | L | 16.3.81 | 2,800 | 6,245 |
| 292 | 1 | L | 25.9.78 | 180 | 352 |
| | 2 | L | 25.9.78 | 180 | 352 |
| | 3 | L | 25.9.78 | 170 | 333 |
| | 4 | L | 25.9.78 | 150 | 294 |
| | 5 | L | 25.9.78 | 160 | 313 |
| | 6 | L | 25.9.78 | 160 | 313 |
| | 7 | L | 25.9.78 | 500 | 979 |
| | 8 | L | 21.7.69 | g.80 | 201 |
| | 9 | L | 21.7.69 | g.90 | 226 |
| | 10 | L | 21.7.69 | g.140 | 351 |
| | 11 | L | 21.7.69 | g.80 | 201 |
| | 12 | L | 21.7.69 | g.75 | 188 |
| | 13 | L | 21.7.69 | g.80 | 201 |
| | 14 | L | 21.7.69 | g.85 | 213 |
| | 15 | L | 21.7.69 | g.85 | 213 |
| | 16 | L | 21.7.69 | g.85 | 213 |
| | 17 | L | 25.9.78 | 750 | 1,468 |
| | 18-19 | L | 25.9.78 | 7,500 | 14,681 |
| 293 | 20 | L | 7.11.77 | —— | —— |
| | 21 | L | 25.9.78 | 1,000 | 1,958 |
| | 22 | L | 25.9.78 | 400 | 783 |
| 294 | 1 | L | 4.6.79 | 380 | 802 |
| | 2 | L | 6.3.67 | g.35 | 101 |
| | 3 | L | 4.6.79 | 450 | 950 |
| | 4 | L | 22.10.79 | 300 | 644 |
| | 5 | L | 22.10.79 | 280 | 601 |
| | 6 | L | 6.3.67 | g.300 | 866 |
| | 7 | L | 19.5.80 | 1,400 | 3,223 |
| 295 | 8 | L | 11.10.71 | g.300 | 769 |
| | 9 | L | 15.5.78 | 250 | 454 |
| | 10 | L | 15.5.78 | 250 | 454 |
| | 11 | L | 6.3.67 | g.80 | 231 |
| | 12 | L | 6.3.67 | g.30 | 87 |
| | 13 | L | 6.3.67 | g.80 | 231 |
| | 14 | L | 24.1.77 | 150 | 257 |
| | 15 | L | 16.7.79 | 400 | 904 |
| | 16 | E | 22.9.75 | —— | —— |
| 296 | 1 | L | 18.12.72 | g.350 | 919 |
| | 2 | L | 19.5.80 | 650 | 1,497 |
| | 3 | L | 19.5.80 | 750 | 1,727 |
| | 4 | L | 19.5.80 | 240 | 553 |
| | 5 | L | 19.5.80 | 320 | 737 |
| | 6 | L | 19.5.80 | 300 | 691 |
| | 7 | L | 19.5.80 | 300 | 691 |
| | 8 | L | 13.7.81 | 780 | 1,463 |
| | 9 | L | 13.7.81 | 700 | 1,313 |

| Page | | Place | Date | Price (local) | Price ($ US) |
|---|---|---|---|---|---|
| 296 | 10 | L | 13.7.81 | 800 | 1,501 |
| | 11 | L | 7.11.77 | 550 | 1,000 |
| | 12 | L | 7.11.77 | 260 | 473 |
| | 13 | L | 22.10.79 | 380 | 815 |
| 297 | 14 | L | 25.9.78 | 650 | 1,272 |
| | 15 | L | 6.10.70 | g.170 | 428 |
| | 16 | L | 6.10.70 | g.420 | 1,056 |
| | 17 | L | 19.5.80 | 700 | 1,612 |
| | 18 | L | 19.5.80 | 260 | 599 |
| | 19 | L | 19.5.80 | 600 | 1,381 |
| | 20 | L | 21.7.80 | 250 | 593 |
| | 21 | L | 6.10.70 | g.820 | 2,063 |
| 298 | 1 | L | 18.2.80 | 750 | 1,717 |
| | 2 | L | 18.2.80 | 240 | 550 |
| | 3 | L | 1.6.70 | g.130 | 327 |
| | 4 | L | 1.6.70 | g.140 | 352 |
| | 5 | L | 19.5.80 | 1,000 | 2,302 |
| | 6 | L | 19.5.80 | 260 | 599 |
| 299 | 7 | L | 15.5.78 | 600 | 1,091 |
| | 8 | L | 18.2.80 | 340 | 779 |
| | 9 | L | 19.5.80 | 1,500 | 3,454 |
| | 10 | L | 19.5.80 | 2,200 | 5,065 |
| | 11 | L | 16.7.79 | 200 | 452 |
| 300 | 1 | L | 9.11.70 | g.42 | 106 |
| | 2 | L | 9.11.70 | g.75 | 189 |
| | 3 | L | 9.1170 | g.110 | 278 |
| | 4 | L | 27.5.75 | g.190 | 463 |
| | 5 | L | 27.5.75 | g.280 | 683 |
| | 6 | L | 27.5.75 | g.550 | 1,340 |
| | 7 | L | 4.6.79 | 600 | 1,266 |
| | 8 | L | 19.5.80 | 140 | 322 |
| | 9 | L | 19.5.80 | 160 | 368 |
| | 10 | L | 9.11.70 | g.130 | 327 |
| | 11 | L | 9.11.70 | g.75 | 189 |
| 301 | 12 | L | 17.5.76 | 100 | 181 |
| | 13 | L | 17.5.76 | 100 | 181 |
| | 14 | L | 30.5.77 | 1,200 | 2,062 |
| | 15 | L | 22.10.79 | 100 | 215 |
| | 16 | L | 1.6.70 | g.110 | 277 |
| | 17 | L | 9.6.80 | 1,000 | 2,336 |
| | 18 | L | 14.10.63 | g.100 | 294 |
| | 19 | L | 9.3.70 | g.34 | 86 |
| | 20 | L | 19.5.80 | 380 | 875 |
| 302 | 1 | L | 19.5.80 | 600 | 1,381 |
| | 2 | L | 19.5.80 | 120 | 276 |
| | 3 | L | 19.5.80 | 90 | 207 |
| | 4 | L | 19.5.80 | 140 | 322 |
| | 5 | L | 19.5.80 | 110 | 253 |
| | 6 | L | 19.5.80 | 1,100 | 2,533 |
| 303 | 7 | L | 29.3.71 | g.180 | 461 |
| | 8 | L | 29.3.71 | g.240 | 615 |
| | 9 | L | 1.6.70 | g.620 | 1,560 |
| | 10 | L | 6.10.70 | g.200 | 503 |
| | 11 | L | 18.2.80 | 250 | 572 |
| | 12 | L | 17.5.76 | 200 | 362 |
| | 13 | L | 18.2.80 | 260 | 595 |
| | 14 | L | 6.10.70 | g.750 | 1,887 |

# INDEX

Names of people, places, and potteries are included in the index.